W9-ABG-404

Late Modernism

Politics, Fiction, and the Arts Between the World Wars

Tyrus Miller

UNIVERSITY OF CALIFORNIA PRESS

Berkeley / Los Angeles / London

University of California Press
Berkeley and Los Angeles, California

University of California Press, Ltd.
London, England

© 1999 by
The Regents of the University of California

Library of Congress Cataloging-in-Publication Data

Miller, Tyrus, 1963–
 Late modernism : politics, fiction, and the arts between the world
wars / Tyrus Miller.
 p. cm.
 Includes bibliographical references and index.
 ISBN 0-520-21035-2 (alk. paper)
 ISBN 0-520-21648-2 (pbk. : alk. paper)
 1. English fiction—20th century—History and criticism.
2. Modernism (Literature)—Great Britain. 3. American fiction—
20th century—History and criticism. 4. Politics and literature—
History—20th century. 5. Barnes, Djuna—Criticism and
interpretation. 6. Lewis, Wyndham, 1882–1957—Fictional works.
7. Beckett, Samuel, 1906– —Fictional works. 8. Political fiction—
History and criticism. 9. Modernism (Literature)—United States.
10. Loy, Mina—Insel. I. Title.
PR888.M63M55 1999
823'.91209112—dc21 98-27436
 CIP

Printed in the United States of America
9 8 7 6 5 4 3 2 1

For Deanna, with love

Contents

Illustrations

Acknowledgments

I am indebted to many people for their advice, help, and support from the inception of this book to its present form, and I am delighted to be able to express my gratitude to them here.

In the course of my project, I have been the beneficiary of several grants, which offered both funding and intellectual community for my work: a Stanford Humanities Center grant, a Fulbright Scholarship in Austria, a Whiting Fellowship, a Stanford Post-Doctoral Scholarship in English, and Griswold Fund support from Yale University. These have been essential for the timely completion of this book.

I was able to read work on Wyndham Lewis for a Stanford University English Department symposium and a faculty works-in-progress group at Yale University; my thanks to all who offered their criticisms and comments in these forums. For my research on Djuna Barnes, I would like to thank Elizabeth Alvarez and the helpful staff at the University of Maryland Library; they made my visit to the Djuna Barnes papers not only fruitful and efficient but pleasant as well. I would also like to thank Ron Rebholz, who as chair of the Stanford English Department subsidized my travel to this collection. My work on Mina Loy was helped by the critical comments of the participants of the conference on 1930s poetry at the University of Maine, especially Keith Tuma and Susan Dunn, and more recently, by several stimulating conversations about Loy with Rachel Potter. I have also benefited from consulting the Loy manuscript collections at Yale University's Beinecke Library.

I have enjoyed the advice and support of several people who contributed in tangible and intangible ways to the completion of this book: Elaine Chang, George Dekker, Johanna Drucker, Ann Gaylin, Ursula Heise, Ursula König, Hans and Irmi Löschner, Kathy Ogren, Linda Peterson, Brian Rourke, George Stade, Richard Terdiman, Lilliane Weissberg, and Daniela Weitensfelder. Karla Oeler deserves thanks for her translations from obscure Russian sources, which have helped me uncover the mysteries of Beckett's "Bim and Bom"; Katerina Clark also pointed out additional sources on this question. Edward Lintz provided crucial help in the obtaining of permissions and in the preparation of the manuscript.

Peter Brooks, David Halliburton, Robert Harrison, Michael Holquist, Wayne Koestenbaum, David Quint, Gilbert Sorrentino, Elide Valarini, Alexander Welsh, and Hayden White read and offered advice on chapters or on the manuscript as a whole; their help has been invaluable. Lawrence Rainey deserves special thanks for a very careful and critical reading of the manuscript in its entirety, shortly before its submission; he helped me to iron out several rough spots and to heighten a number of key arguments. I would also like to thank my readers for the University of California Press, Peter Nicholls and Thomas Harrison, and my editors, William Murphy, Linda Norton, and Julie Brand.

I have saved for last those for whom the formalities of an acknowledgment fall so far short of my debt to them that the normal phrases seem to betray rather than express my feelings. To my parents, who have watched my peregrinations with a minimum of skepticism and a maximum of love and support, I can finally say, Here it is. To Marjorie Perloff, my mentor, inspiration, and most stringent critic, go my profoundest thanks: Your generosity, enthusiasm, support, and friendship have been priceless to me for close to a decade now; I couldn't have done it without you. Finally, and above all, to my wife, Deanna Shemek—my thanks leave me speechless. I hope that our life together may hint to you the depth of my gratitude for all you have done and will do for me in years to come: "his thoughts, the stream / and we, we two, isolated in the stream / we also: three alike—."

Theorizing Late Modernism

We lived under the shadow of two movements that affected all Europe: modernism and collectivism.

Noel Annan, *Our Age*

Introduction

The Problem of Late Modernism

We are not only the "last men of an epoch." . . . *We are the first men of a Future that has not materialized. We belong to a "great age" that has not "come off."*

Wyndham Lewis, 1937

There is no avant-garde, only those who are left behind.

Motto from art-text by Richard Tipping, 1993

I

Since the late 1920s, it has become an increasingly central part of the avant-garde's vocation to profess its lack of vocation. The statements of Wyndham Lewis and Richard Tipping, separated by more than fifty years, are a case in point. A similar thought animates both artists, that the avant-garde has failed—that it has never ceased to fail—to deliver on its historical promise to "materialize" an unprecedented future in prophetic works of art. For Lewis, the modernist painter, novelist, and polemical "blaster," this realization was sobering. It became the occasion for stock-taking works like his memoirs of World War I, *Blasting and Bombardiering,* and his post–World War II autobiography, *Rude Assignment;* it was a spur to rethink past experiences and hunker down to the much bleaker future that had come to pass despite all avant-garde "renewals." For the young Australian postmodernist Tipping, in contrast, the late-twentieth-century dissipation of vanguardist pretenses offers a happy freedom to make art playfully, with little concern for who

might be following him and whither. If no one really knows which way things are going, he suggests, why not just go your own way? (Perhaps not accidentally, some of Tipping's best works are humorously modified road signs.) Lewis stoically bestows an epitaph on the grave of the fallen modernist legend; his postmodernist successor discovers a place—as good as any—to begin to dance.

Conceptions of modernism and the avant-garde, as even a limited survey will suggest, are shaped by factors that go well beyond narrowly aesthetic concerns. These may include, among a welter of other elements, particularities of nationality, ethnicity, gender, and sexuality; questions of political engagement; concrete experiences of wars and other important historical events; developments in technology; and religious beliefs. Moreover, insofar as terms like "modernism" and "avant-garde" are used historically to situate a selection of artists and works within a certain geography and time span, they are subject to the conceptual, narrative, and figural parameters that shape all historical writing.[1] Simply put, as we write the cultural history of the twentieth century, we spin out stories of artists, writers, thinkers, movements, and the works they conjured into life; and we weave these stories into the larger fabric of social and political history. Our historical plots have beginnings, middles, and ends; births and deaths occur; there are fixed settings and spaces of errancy; times of decision and dreamtimes in which the logic of the day seems suspended or deranged. Within these bounds we delineate our heroes and villains, setting them on their fatal paths to perdition or bringing them through narrow escapes from the grips of enchanters with resonant foreign names. Yet all the while our choices as to place and period, our selections of "characters" and of their deeds, are being swayed by a powerful, invisible force field of stories twice- and thrice-told, stories learned far too well and recounted on demand.

Modernism has generated a number of different stories, many of which have become familiar to the point of becoming a kind of academic folk wisdom: modernism is the liberation of formal innovation; the destruction of tradition; the renewal of decadent conventions or habit-encrusted perceptions; the depersonalization of art; the radical subjectivization of art. And so on. Despite the diversity and contradictory nature of opinions about what modernism is (or was), however, the study of modernism has tended to be dominated by one very broad and richly embellished story: its "Book of Genesis," which narrates its creation out of the spirit of revolt against the nineteenth century, whether that age be conceived as bourgeois or socialistic, Victorian or Biedermeier, positivis-

tic or decadent and symbolistic. The grand narrative in the study of modernism has been that of its beginnings: "origins," "rise," "emergence," "genealogy," are key terms in this ever more nuanced account. Granted this point, one may go on to observe how much this center of gravity in traditional modernist studies accords with the ideology of modernist aesthetics as such. From writer-critics like Ezra Pound and T. S. Eliot to their latter-day heirs in the academy, critics have defined the movement in large part with figurative and evaluative underpinnings of modernism itself, with the Poundian imperative to "Make It New." In authoritative cultural histories of modernism such as Allan Janik and Stephen Toulmin's *Wittgenstein's Vienna*, Carl Schorske's *Fin-de-Siècle Vienna*, and Stephen Kern's *The Culture of Time and Space* and in major studies of literary modernism such as Hugh Kenner's *The Pound Era*, Marjorie Perloff's *The Futurist Moment,* and Michael Levinson's *The Genealogy of Modernism,* the accent has fallen on relatively unitary and "vital" moments of its development. In the continental context, this critical emphasis has meant giving pride of place to the cubist and futurist movements before World War I and to the avant-garde ferment of the twenties. Only recently have scholars begun to address the less coherent fate of modernist culture in 1930s France, while the fascinating cultural history of Vienna after the founding of the republic all but disappears behind the crowd of studies dedicated to the pre–World War I ferment.[2] In the Anglo-American context, the imagist and vorticist movements and the postwar Paris expatriate scene likewise receive a disproportionate amount of critical attention, because they identify clear communities of rebel experimenters working in emerging modes and forms.[3]

In the present study of modernism during the late 1920s and 1930s, I have turned this historiographic telescope the other way round, to focus on modernism from the perspective of its end.[4] I develop my argument in two major parts. The first of these, "Theorizing Late Modernism," sets the literature of these years in its broad cultural and political context while elaborating a revisionary model for understanding modernist writing in this transitional period. The second, "Reading Late Modernism," considers in detail the writings and related works— visual, critical, political, and cultural-polemical—of Wyndham Lewis, Djuna Barnes, and Samuel Beckett, who serve in this book as exemplary late modernist figures. I conclude with a coda chapter on a posthumously published novel by the Anglo-expatriate poet and artist, Mina Loy. Loy's *Insel* gives a fictionalized account of her experiences working in the early 1930s as a procurer of modern paintings for her son-in-law's

New York gallery. Her narrator's ill-fated adventures with an ineffectual German painter suggest the baneful short-circuiting of the once-energizing connection of modernist literature and modern visual arts. Indeed, in its wider implications, Loy's book registers a trembling of the whole artistic field, from writing to painting to photography and cinema, and the threat these new plate tectonics of culture posed to the social "islands" where modernist poet and painter had together found temporary refuge. The ending of *Insel* stands as an emblem of the end of an artistic epoch: the seedy painter who never paints and the aging writer who futilely seeks to squeeze some inspiration out of an artist-hero meet for the last time, tacitly agree that their alliance has not panned out, and part ways with a sense of relief.

My concentration on these authors is motivated by two impulses, the first evaluative, the latter strategic. Let me lay down my cards in advance: I seek to make a case for the importance of these authors and works and to elevate their status in the canons of twentieth-century literature as now taught in the American university. Bluntly stated, the majority of the works I discuss in this study are just not read—and not only by the half-mythical "common reader," stunted by the profitable conformism of mass-market publishing and the eviscerated budgets for public libraries, but even by scholars and teachers of modernist literature. I attempt to account historically for the feeble presence of these works in the protocols of our collective reading. But I must add that the conditions that brought these works lame-footed and stuttering into the world are, precisely, historical, and thus part of a past that may be surveyed, criticized, and superseded. It is high time to get on with the task of reading these works and discovering what we have missed by accepting critical bedtime tales as truth and letting our uneasy questions go to sleep.

Beyond this plea for revaluation, however, I also seize on these writings for strategic purposes. They form something of a vanishing point for the perspective lines projected by works in several different artistic fields, as well as by the political and critical discourses current in the late 1920s and 1930s and by diverse popular tendencies of the day. Careful reading of these works, together with the reconstruction of their context, shows the tacit dialogue they conducted with the other arts. It reveals how they sought to bind the restless, disturbing collective energies of recorded music, fashion, advertising, radio, and film; and it exposes to critical view the stigmata where mass politics and urban life left their forceful signatures.

When the history of modernist literature is considered in this way, from the perspective of its latter years, an alternative depiction of modernism becomes possible. At first glance, late modernist writing appears a distinctly self-conscious manifestation of the aging and decline of modernism, in both its institutional and ideological dimensions.[5] More surprising, however, such writing also strongly anticipates future developments, so that without forcing, it might easily fit into a narrative of emergent postmodernism.[6] This problem points to a central paradox of late modernist literature in English: its apparent admixture of decadent and forward-looking elements and its consequent lack of a clearly defined place in the dominant frameworks of twentieth-century criticism. It is as if the phosphorescence of decay had illumined the passageway to a reemergence of innovative writing after modernism. Ultimately, I wish to suggest, the writing of this period has much to teach us about the broader shape of twentieth-century culture, both preceding and following the years between the wars. Yet the double life of this significant body of writing—its linkage forward into postmodernism and backward into modernism—has not, by and large, been accounted for by critics and historians of the period.

II

The earliest and still one of the best diagnoses of the new literary dispensation that emerged in the 1930s may be found in George Orwell's 1935 review of Henry Miller's *Tropic of Cancer* and, at greater length, in his extensive essay on Miller and the significance of his work, "Inside the Whale." The review is largely subsumed into the later essay, so I will not discuss its contents in detail. Orwell, however, opens his remarks on Miller with a lurid and extreme image evoking an uncanny automatic mechanism that functions even after death. He is speaking of literature and its ability to face up to or avert its eyes from the perilous condition of the present: "Modern man is rather like a bisected wasp which goes on sucking jam and pretends that the loss of its abdomen does not matter. It is some perception of this fact which brings books like *Tropic of Cancer* (for there will probably be more and more of them as time goes on) into being."[7]

In 1935 this characterization of "modern man" might have seemed hyperbolic and shrill; by the time "Inside the Whale" appeared in 1940,

with Nazi victories blanketing the map of Europe and British capitula-
tion to the mad Charlie Chaplin emperor in Berlin a very real possibil-
ity, it was hard not to concur with Orwell's pessimism, if not his precise
diagnosis. In forty pages of brilliant, undeceived examination of the
main lines of twentieth-century British writing, Orwell diagnoses the
condition of literature in England on the brink of a total war for sur-
vival. He reveals the collective psychology underlying the epochal shifts
in authorial stance and popular taste from the Georgian decades of A. E.
Housman and H. G. Wells, to the modernist revolt of T. S. Eliot and
James Joyce, to the "Boy Scout atmosphere of bare knees and commu-
nity singing" he sensed in the leftish boosterism of W. H. Auden,
Stephen Spender, Cecil Day-Lewis, and company—all set against a
background of political, military, and human horrors: the Molotov-
Ribbentrop pact to divide up Poland between Germany and Russia, the
mechanized drone of Stuka dive bombers and Panzer brigades, and the
stifled cries of the concentration camps.

The historical panorama that Orwell sets out with such unforgiving
concision serves to foreground the peculiar homelessness of Miller's
work in this history. Miller, quite simply, doesn't fit in the big picture of
his times. Out of frank disbelief, Miller avoids the progressive commit-
ments of the Edwardians and the communist enthusiasms of the Auden
generation; neither, however, does he exhibit, modernist-style, any faith
in the power of carefully crafted, difficult art to redeem the squalid real-
ities of his subproletarian existence. If these large-scale tendencies of
attitude and taste had once been, for better or worse, conditions of pos-
sibility for an enduring English literature, Miller, in contrast, heralds an
altogether different future in which literature as such is endangered by
a world much too much with it. Miller's work, Orwell writes, "is a
demonstration of the *impossibility* of any major literature until the world
has shaken itself into its new shape."[8] For Orwell, Miller is more than
just a writer; he is the unlaureled proseist of middle-class unemploy-
ment, the pulverization of professional society in train from the late
1920s on—the collective *désoeuvrement* of the middle strata, not just in
the sense that the heirs of the Edwardian bourgeoisie were without jobs,
but also, more fundamentally, that they were bereft of vocation, of any
calling in which they might sincerely believe. Miller writes neither to
praise collective idleness nor to ally himself rhetorically with the grave-
diggers of a dying culture, signing on to a future utopia of labor and
endeavoring to bury it. It is in this "neither-nor" that Orwell detects a
new tone, and identifies in it the endgame of modern individualistic cul-

ture, with the late modernist torso gyrating mechanically while the head no longer serves to guide it and no limb propels it on.

Unfortunately, few critics have developed in a systematic manner Orwell's essayistically formulated insight. Among contemporary scholars of modernist culture, the architectural historian Charles Jencks has made a compelling case for employing the notion of late modernism in critical discussions of twentieth-century architecture and, by extension, the other arts as well.[9] Jencks designates as "late modernist" the persistence in architectural practice of an avant-garde moralism, utopianism, and purist style after the classic period of International-style architectural modernism (1920–1960). "Late modern" architecture, Jencks argues, *coexists* with the postmodernism that emerges in the 1960s. By comparison to either modernism or late modernism, postmodernist architecture is pluralist and populist in its ethos, intentionally addressing different "taste cultures" from the general public to elite, knowledgeable constituencies, capable of appreciating inside jokes and learned references. Postmodernist architects are unashamedly historicist in their use of ornament and ironic allusion to earlier buildings, which may be freely drawn from for figural and structural ideas. More generally, postmodern architecture abandons the central concern of modern architects with the autonomy of form and its exhaustive display of function. The modernist supercategory "form-equals-function" yields to a diversified concern with meaning, sensuality, and context; symbolism, allegory, and narrative return as major artistic resources. In contrast, late modernism represents a kind of exasperated heightening of the logic of modernist architecture itself. Architectural late modernism is, Jencks writes, "pragmatic and technocratic in its social ideology and from about 1960 takes many of the stylistic ideas and values of modernism to an extreme in order to resuscitate a dull (or clichéd) language" (15).

Two aspects of Jencks's argument are useful for my considerations of late modernist literature. First, he emphasizes the overlap and coexistence of late modernism and postmodernism. These are not successive stages but rather alternative responses to the legacy of modernism and its possible continuation. Second, he recognizes that these terms cannot be defined simply as a matter of style, for they also embrace aspects of social ideology and artistic ethos as well. As Jencks remarks, "To call a late modernist a postmodernist is tantamount to calling a Protestant a Catholic because they both practice a Christian religion" (16). And if the Thirty-Something Year War that followed on the schisming of modernism has left the artistic field razed and the scattered troops looting

whatever they came across in their retreat, Jencks's point still stands. The choices for artists working in the wake of modernism had real stakes, and these stakes have not been sufficiently recognized in the rush to postmodernism: art's relation to the past, its address to a public, and its stance toward the society and politics of the day. On this, I cannot express my agreement with Jencks too strongly. The extension of Jencks's arguments to literature, however, is limited by his specific concentration on architecture, which has a distinct stylistic and institutional history. Architectural modernism had its first heave with the socialist urbanism of the late 1920s and 1930s and its second wind with the urban development after World War II, whereas literary modernism peaked much earlier and, free of any strong ties to economic and political institutions, much more feebly. Hence, one should expect that "late modernist" literature would have an analogously different historical shape than that of architecture. In contrast with different building forms, differences in *literary* architectonics have few direct social effects; hence, questions of ethos and social vision have a less direct translation into formal considerations than in architecture. Moreover, no "postmodernist" complement existed at the moment that late modernist literature made its first appearance—as I am arguing, around 1926. Instead, this emergent literature appears in tandem with a still developing corpus of high modernism. James Joyce's *Finnegans Wake*, Virginia Woolf's *The Waves* and *Between the Acts*, Ezra Pound's *Cantos*, Aldous Huxley's *Eyeless in Gaza*, and other monuments of high modernism share the field with a new generation of late modernist works.

Fredric Jameson, in his celebrated writings on postmodernism, acknowledges the need for an intermediary concept to characterize the cultural products of the "transition" between modernism and postmodernism, although he leaves the task of theorizing this interim largely to others. Somewhat grudgingly, he admits that "we should probably . . . make some place . . . for what Charles Jencks has come to call 'late modernism'—the last survivals of a properly modernist view of art and the world after the great political and economic break of the Depression, where, under Stalinism or the Popular Front, Hitler or the New Deal, some new conception of social realism achieves the status of momentary cultural dominance by way of collective anxiety and world war."[10] As exemplary "late modernists" in literature, Jameson mentions Vladimir Nabokov, Samuel Beckett, Charles Olson, and Louis Zukofsky, "who had the misfortune to span two eras and the luck to find a time capsule of isolation or exile in which to spin out unseasonable

forms" (305). The concept of late modernism was, indeed, already implicit in Jameson's earlier study of Wyndham Lewis, whose "prophetic assault on the very conventions of the emergent modernism" presaged the "contemporary poststructuralist aesthetic, which signals the dissolution of the modernist paradigm."[11] He goes on to note that "Lewis cannot be fully assimilated to the contemporary textual aesthetic without anachronism" (or as Jameson might now write, it would be *ahistorical* to call Lewis "postmodernist"). Nevertheless, Lewis's out-of-phase relation to modernism, his anachronistic "kinship with us" (20), constitutes a central focus of Jameson's study. In my own account as well, Lewis—as cultural critic, painter, and novelist—plays a crucial role in the late modernist breakup and reconfiguration of earlier "high" modernism.

Examining modern and postmodern modes of irony in *Horizons of Assent,* Alan Wilde offers a more elaborated description of late modernism than Jameson's. His conception has two major elements. First, it represents a welcome attempt to break down the overly schematic opposition of modernism and postmodernism in literary history. To "do justice" to the "jagged course of literary history," Wilde feels the need for a third term: "Late modernism interposes a space of transition, a necessary bridge between more spacious and self-conscious experimental movements [i.e., modernism and postmodernism—T.M.]."[12] Second, through close reading of works by Christopher Isherwood and Ivy Compton-Burnett, Wilde contrasts the qualities of irony that characterize modernist and late modernist fiction. Modernist irony, Wilde argues, helps bring to life a richly inclusive and interconnected fictional world as a symbolic compensation for the chaos and impoverishment of modern life. The modernist work registers these modern social realities deeply even in its negative relation to them; its formal and stylistic difficulties testify to the strains suffered in keeping the world at bay. In contrast, late modernist irony engages with social realities less profoundly and offers no embracing vision in which the contradictions of modern life would be resolved. The late modernist text, no doubt, turns to the reader a more reserved and diplomatic face than that of the fractious modernist monster. But monsters also have their poignance, and sweetness and clarity are dearly bought: high modernism's "generosity and breadth—its desire to restore significance to a broken world" (119)—are abandoned in the late modernist work as so much useless baggage.

In his study *Postmodernist Fiction,* Brian McHale makes an analogous attempt to find a place for works that are caught in the no-man's-

land between the camps of modernist and postmodernist fiction. Like Wilde, he seeks both to account for historical change and transition in the modes of writing and to identify distinct stylistic and formal characteristics of these transitional works. He distinguishes modernist and postmodernist fictions in terms of their overall "set" toward reality. Modernist fiction, McHale suggests, is predominantly "epistemological" in nature: it seeks, despite the confusing webs of psychic, perceptual, and social facts, to *disclose* a coherent, knowable world. Postmodernist fiction, in contrast, functions differently. Relinquishing the modernist quest to know "the" world, it *invents* possible worlds; postmodernist fiction is, in McHale's terms, *ontological,* world-making, rather than world-disclosing. Between these two possibilities, McHale posits a third mode, which unsettles the opposition between the epistemological and ontological dominants. He identifies this possibility, notably, with Samuel Beckett's post–World War II trilogy (as well as Alain Robbe-Grillet's *nouveau roman*): "Here, we might say, modernist poetics begins to *hemorrhage,* to leak away—though not fatally, since it is still (barely) possible to recuperate these internal contradictions by invoking the model of the 'unreliable narrator,' thus stabilizing the projected world and reasserting the epistemological dominant of the text."[13] Such works, which McHale designates "limit-modernist" texts, are marked precisely by their oscillation between the dominant features of modernist and postmodernist fiction.

All three critics make important contributions to formulating a poetics of late modernism. Jameson's imperative to historicize the moments of literary change; Wilde's choice of the 1930s as the point of departure for late modernism; and McHale's excellent description of the formal workings of late modernist texts have strongly influenced the model I develop. Yet for each, late modernism amounts to little more than a peripheral issue, a bit of detail work on the capacious but drafty house of fiction built by Modernism, Postmodernism, and Co.

The "unseasonable forms" spun out by late modernist writers, however, signify more than just patchwork in the otherwise unbroken facade of literary history. Untimely phenomena like late modernist fiction represent breaking points, points of nonsynchronism, in the broad narrative of twentieth-century cultural history. They embody the force of the *exception* within what might be called "the negative invariance of history," its tendency to conserve institutions and processes in the midst of historical change.[14] Accordingly, the works of late modernist literature should not be viewed simply as cultural curiosities salvaged from time,

aesthetic souvenirs that exert their unsettling fascination by reviving an already moribund modernism. Rather, they mark the lines of flight artists took where an obstacle, the oft-mentioned "impasse" of modernism, interrupted progress on established paths. Facing an unexpected stop, late modernists took a detour into the political regions that high modernism had managed to view from the distance of a closed car, as part of a moving panorama of forms and colors. The cultural products of this period both are and are not "of the moment." Precisely in their untimeliness, their lack of symmetry and formal balance, they retain the power to transport their readers and critics "out of bounds"—to an "elsewhere" of writing from which the period can be surveyed, from which its legitimacy as a whole might be called into question.[15]

Late modernist writing was not particularly successful in either critical or commercial terms, and each work tended toward formal singularity, as if the author had hit a dead end and had to begin again. In content, too, these works reflected a closure of the horizon of the future: they are permeated with a foreboding of decline and fall, of radical contingency and absurd death. Thus John Hawkes, in his statement for a 1962 forum, "Fiction Today," characterized Djuna Barnes as an exemplar for the contemporary writer of "experimental fiction," a pathbreaker whose work bears signs of her passage through the funereal spaces of modernism's demise:

Like the poet, the experimental fiction writer . . . enters his created world . . . with something more than confidence and something less than concern over the presence of worms in the mouth. Like the poem, the experimental fiction is an exclamation of psychic materials which come to the writer all readily distorted, prefigured in that nightly inner schism between the rational and the absurd. And the relationship between the sprightly destructive poem and the experimental novel is not an alliance but merely the sharing of a birthmark: they come from the same place and are equally disfigured from the start.[16]

Late modernists like Barnes, Hawkes suggests, carry the signs of death on their faces, the disfigured countenances they show to their postmodern successors. Paradoxically, however, these very signs of disfiguration charge their work with its contemporaneity, its ability to speak to the writers of the present day.[17]

The backward-turned glance by which one may read and interpret such funereal signs is what Walter Benjamin described in his *Trauerspiel* and Baudelaire studies as an "allegorical optic." The allegorical optic seeks its truth in the mortified ruin of the work (or here, in the

undoing of a whole literary movement and aesthetic). It is a critical gaze that shatters the unity of the object at hand into fragments: "In the field of allegorical intuition the image is a fragment, a rune. Its beauty as a symbol evaporates when the light of divine learning falls upon it. The false appearance of totality is extinguished. For the *eidos* disappears, the simile ceases to exist, and the cosmos it contained shrivels up. The dry rebuses which remain contain an insight, which is still available to the confused investigator."[18] Yet this optic, which I apply to the works of late modernism, seeing in them splinter-products of a shattered "classic" modernism, replicates the late modernist's already belated relation to high modernism as ruin. Late modernist writers were divested, by political and economic forces, of the cultural "cosmos"—the modernist "myth," in its most encompassing sense—in which the singular works of high modernism seemed components of an aesthetically transfigured world. In the empty spaces left by high modernism's dissolution, late modernists reassembled fragments into disfigured likenesses of modernist masterpieces: the unlovely allegories of a world's end.

In such works the vectors of despair and utopia, the compulsion to decline and the impulse to renewal, are not just related; they are practically indistinguishable. As Benjamin writes, "This is the essence of melancholy immersion: that its ultimate objects, in which it believes it can most fully secure for itself that which is vile, turn into allegories, and that these allegories fill out and deny the void in which they are represented, just as, ultimately, the intention does not faithfully rest in the contemplation of bones, but faithlessly leaps forward to the idea of resurrection" (232–233). Sinking themselves faithlessly into a present devoid of future, into a movement grinding to a halt and an aesthetic on the threshold of dissolution, the writers of late modernism prepared themselves, without hope, to pass over to the far side of the end.

III

In 1930, under the title "Crisis of the Novel," Benjamin reviewed Alfred Döblin's recently published novel *Berlin Alexanderplatz*.[19] Before turning to his more specific comments on Döblin's urban epic, he offers general remarks on the state of the European modern novel at the end of the 1920s. Benjamin suggests that there are two equally authoritative but antithetical strains of modernist novel. Together they constitute the extremes of a schismed field of modernist narrative, and

the tension between the two models is the clearest index of the crisis to which his title refers.

The first tendency is represented by André Gide's *The Counterfeiters* and finds its theoretical expression in the same author's "Journal of *The Counterfeiters*." Gide advances there his idea of the *roman pur* (pure novel), in which no element would be extraneous and in which the main idea expressed would be the process of the novel's composition itself. Character, plot, theme, dialogue, and even reading would all be immanent to the single thread of the writing:

I should like events never to be related directly by the author, but instead exposed (and several times from different vantages) by those actors who will be influenced by those events. In their account of the action I should like the events to appear slightly warped; the reader will take a sort of interest from the mere fact of having to *reconstruct*. . . .

Thus the whole story of the counterfeiters is to be discovered only in a gradual way through the conversations, by which all the characters will portray themselves at the same time.[20]

Gide's highly involuted, unified, self-referential composition stands in stark contrast to the second tendency, which Benjamin sees exemplified and theorized by Döblin. Benjamin (following Döblin's own essay "The Construction of the Epic Work") calls this second tendency "epic"; its main characteristics are its orientation toward everyday speech and the use of montage techniques to open the literary work to an array of extraliterary contents. If Gide's subtle hand is discernible over all his materials, all the more so as he retreats from direct authorial address, then Döblin's authorial presence is nearly eclipsed by the heterogeneous materials he assembles. "So thick is this montaging," Benjamin writes, "the author has difficulty getting a word in among it" (233).

In delineating two extreme tendencies in modernist fiction—the first marked by purity, formal mastery, and orientation toward unique interiorized experience; the second, by heterogeneity of materials, montage techniques, and orientation toward everyday life and speech—Benjamin clearly intended to map out a field of possibilities for the modern novel. At the same time, however, his essay has a precise historical aim: to identify the marked tendency toward polarized extremes that was characteristic of the period. It was not one or the other that was the most significant historical symptom; it was their tense coexistence. Precisely this had come to the fore and called for critical analysis. Benjamin emphasized that historical features of both past and present become visible

only at specific moments and in specific situations. The 1930s, with its extreme tension and conflicts, was just such a "horizon of legibility" for modernism, a "late modernist" moment in which stock of the overall shape of modernism could be taken.

Benjamin's distinction between two poles of novelistic writing bears a marked similarity to Peter Nicholls's recent, more general consideration of the "divergences" internal to both modernist and postmodernist writing.[21] Nicholls bases his discussion on Jean-François Lyotard's concepts of "discourse" and "figure." In *Discours, figure,* Lyotard argues that discourse, conceived by structuralists as a closed and self-referential grid of linguistic differences, always opens out onto a space and time incommensurable with the linguistic system. This otherness, language's "depth element," disrupts the systematicity of discourse and transgresses its generic forms. Lyotard calls the disruptive otherness within discourse the "figural."[22] Nicholls adopts these two notions, opposed but also mutually imbricated, to define two interrelated poles of modernism, depending on whether the element of discursive mastery or figural disruption predominates.

Like Benjamin, Nicholls seeks to corrrelate compositional and generic features of texts with their social meanings, to discern how the form of works and their historical situation coincide or clash. Notably, Nicholls attempts to distinguish between Anglo-American and continental modernisms on the basis of these tendentially different relations to signification. Anglo-American modernism, with its "stress on *technique* as mastery," assumes that "non-signifying effects must be seen to be won from the effort of signification (from the 'combat of arrangement,' in Pound's phrase)" (10). In contrast, Nicholls suggests that a continental modernism like German expressionism tends toward the "figural" dominant, which mobilizes "a non-semiotic dimension which subverts the order of discourse" (12). "Here," he writes, "'good form' seems always about to mutate into its opposite, to yield something which the structure cannot contain or speak" (12).

Nicholls's notion of this internal divergence in modernism is highly suggestive and has implications far beyond the scope of his arguments. For example, it suggests a basis for the different qualities of modernism as manifest in the various literary genres. The choice of genre is inseparable from the tendency toward discursive mastery or figural transgression of discourse. The novel, with its sedimented history, its well-codified conventions, and its strong ties to narrative forms, would seem by nature to tend toward an aesthetic of discursive mastery. The "main-

stream" of European high modernist fiction—Proust, Gide, Mann, Hesse, Svevo, Broch, Musil, Joyce, Woolf (and others)[23]—focused on the problem of mastering a chaotic modernity by means of formal techniques: ironic detachment; highly mediated and multiperspectival narration; narrative involution and self-referentiality; stylistic ostentation; use of large-scale symbolic forms; dramatization of states of consciousness, including the author's own. In contrast, the disruptive effects of the figural tend to appear most evidently in genres other than the novel: in avant-garde poetry like that of William Carlos Williams; in the invented or wholly reinvented genres employed by Gertrude Stein (her "portraits," "tender buttons," "geographies," "operas," and "plays"); in the unstable mixtures of critical discourse, prose poetry, and narration characteristic of surrealist antinovels like André Breton's *Nadja* and Louis Aragon's *Paris Peasant;* or in the aphoristic "thought-pictures" of Walter Benjamin's *One-Way Street* and Ernst Bloch's *Traces.*[24]

I want to underscore, moreover, that this dual aspect of modernist writing is not just a retrospective fantasy of literary theorists, critics, and historians. Indeed, as a way of thinking about modernist writing, it adopts and sharpens to a critical schema the less systematic views of modernist writers themselves about their artistic field and their role in it. This self-understanding can be detected in Joyce's lingering doubt, recounted approvingly to Richard Ellmann by Samuel Beckett, that he "may have oversystematized *Ulysses.*"[25] Similarly, in a letter from the summer of 1930 to his friend Thomas MacGreevy, Beckett would remark of Marcel Proust, "He is so absolutely the master of his own form that he becomes its slave as often as not."[26] Both remarks show Beckett thinking about his high modernist predecessors and zeroing in on the fissile point of the high modernist work, the tension between global form and molecular detail. In a more far-reaching example, we can gauge the breadth of modernism's artistic field by juxtaposing two extremes: Eliot's famous essay " *Ulysses,* Order, and Myth," published in *The Dial* in November 1923,[27] and Beckett's diary entry from January 1937, a text that amounts to an implicit commentary on the whole project of a modernism crowned by its masterpieces *Ulysses* and *The Waste Land.* Eliot predicts the end of the novel as a literary genre on grounds that the age demands a stricter form and finds in *Ulysses* the lineaments of that rigor. As Eliot adumbrates it, Joyce's "mythical method" is a technique of disciplining and unifying the anarchic, senseless whirl of splinters that characterizes contemporary history. Beckett, in contrast, writes: "I am not interested in a 'unification' of the historical chaos any

more than I am in the 'clarification' of the individual chaos, and still less in the anthropomorphisation of the inhuman necessities that provoke the chaos. What I want is the straws, flotsam, etc., names, dates, births and deaths, because that is all I can know."[28] Eliot's appeal to myth is at once epistemological and religio-political. It offers the possibility of aesthetically mastering a plethora of desacralized, fragmented facts, turning them into singular works of art; in turn, it also conjures the formal authority by which these facts may be selected, shaped, and reinvested with sacred meaning. By contrast, Beckett's antimythic, pessimistic positivism, which heightens the ineluctability of facts precisely in their multitudinous facticity, forecloses in advance any such aesthetic putschism in life, literature, or politics. It matters little in this context whether Eliot's characterization of *Ulysses* accurately describes either Joyce's intention or the functioning of the text itself, or whether Beckett could relinquish formal mastery so totally in his strategic celebration of the smithereen. I take Eliot's and Beckett's antithetical views as ideal types, marking out a field, and as striking signs of the underground historical passage being negotiated—in letters, notebooks, conversations, unpublished works—throughout the years between the world wars, a long labor of cultural transformation largely hidden until the whole development surfaced one day to stay.

If these historical considerations are taken together with Nicholls's claim that Anglo-American modernism decidedly tended toward an aesthetic of formal mastery centered on the novel, they lay the basis for both a formal and a historical understanding of late modernist writing. Late modernism was, in the first instance, a reaction to a certain type of modernist fiction dominated by an aesthetics of formal mastery, and it drew on a marginalized "figural" tendency within modernism as the instrument of its attack on high modernist fiction. It is crucial here to underscore the term "tendency," for late modernist writing is not defined by a rigidly defined set of formal features, as if suddenly at the turn of 1927 all poets began writing sonnets of thirteen lines. Indeed, late modernist writers energetically sought to deflate the category of form as a criterion for judging literary works. For the latter-day reader, their works reveal how contingent was the modernist buildup of form and formal mastery, crucially important to the advances of a small, prestigious group of writers and critics, but by no means coextensive with the field of modernism as such—particularly when one began to consider writers outside the canonized mainstream for political reasons, as was Wyndham Lewis; for reasons of gender and sexuality, as were Djuna

Barnes and Mina Loy; and for national reasons, as was Beckett. If modernist poetics are a mesh of interrelated statements, evaluations, and judgments, then late modernist writing is the product of the pressure of historical circumstances on that mesh, which threatens to fray or break at its weakest points. Late modernism does indeed deform and change the shape and function of that network; yet it also heightens latent strains within it. Like a red-headed child in a family of blonds, the recessive traits of this body of works reveal what lay hidden in modernism's genetic past all along—an unassimilated heritage of the continental avant-gardes; a pariahed corpus of works tainted with satirical, documentary, or argumentative elements; the unsung and often unpublished works of founding modernist women like Gertrude Stein and Mina Loy.

In their struggle against what they perceived as the apotheosis of form in earlier modernism, late modernist writers conjured the disruptive, deforming spell of laughter. They developed a repertoire of means for unsettling the signs of formal craft that testified to the modernist writer's discursive mastery. Through a variety of satiric and parodic strategies, they weakened the formal cohesion of the modernist novel and sought to deflate its symbolic resources, reducing literary figures at points to a bald literalness or assimilating them to the degraded forms of extraliterary discourse. They represent a world in free fall, offering vertiginously deranged commentary as word, body, and thing fly apart with a ridiculous lack of grace. Three snapshots of this hilarious descent:

"I am so terribly glad you like me—I like you very much!"
The delicious confession because of the exciting crudity of words thrills him, it has the sanctity of a pact that a kiss alone could properly seal and he pauses in confusion; then big burning Gretchen he yodels on putting into clumsy brazen words all the sentimental secrecies coveted by the Fausts with jammy and milky appetites in the dark ages of simplicity.[29]

She had a beaked head and the body, small, feeble, and ferocious, that somehow made one associate her with Judy; they did not go together. Only severed could any part of her have been called "right." . . . Her body suffered from its fare, laughter and crumbs, abuse and indulgence. But put out a hand to touch her, and her head moved perceptibly with the broken arc of two instincts, recoil and advance, so that the head rocked timidly and aggressively at the same moment, giving her a slightly shuddering and expectant rhythm.[30]

Then Watt said, Obscure keys may open simple locks, but simple keys obscure locks never. But Watt had hardly said this when he regretted having done so. But then it was too late, the words were said and could never

be forgotten, never undone. But a little later he regretted them less. And a little later he did not regret them at all. And a little later they pleased him again, no less than when they had first sounded, so gentle, so cajoling, in his skull. And then again a little later he regretted them again, most bitterly. And so on.[31]

The object of derision here is so closely intertwined with the order and choice of words used to enact the ridicule that they merge in a single rhythm of phrasing just below the threshold of laughter. As I will suggest in my next chapter, these texts dramatize a particularly violent discombobulation of body and thought, a mirthless comedy of bodily discomposure. They hover at an unstable point between one extreme, the author's capture of laughter and reduction of it to literary representations, and the other, its liberation once more from the text through the reader's laughter. Through such means, too, late modernist works dramatized the comic fragility of modernist attempts to contain contingency and violence aesthetically, through literary form. Within the late modernist novel, the formal "lapses" bound to laughter allowed expression of those negative forces of the age that could not be coaxed into any admirable design of words: its violence, madness, absurd contingencies, and sudden deaths.

Late modernist writing thus coheres as a distinctive literary "type" within the historical development of modernist literature, serving as an index of a new dispensation, a growing skepticism about modernist sensibility and craft as means of managing the turbulent forces of the day. Viewed from the narrow perspective of literary form, late modernist writing weakens the relatively strong symbolic forms still evident in high modernist texts. It reopens the modernist enclosure of form onto the work's social and political environs, facilitating its more direct, polemical engagement with topical and popular discourses.[32] From the point of view of the external context, it also registers the ways in which intense social, political, and economic pressures of the period increasingly threatened the efficacy of high modernist form. These converging historical vectors are powerfully evident in the literary texts of those authors on whom the second part of this study focuses, authors who wrote their primary works of fiction after the modernist "boom" of the early twenties. Emerging in Lewis's *The Apes of God* and *The Childermass*, in Barnes's *Ryder* and *Nightwood*, and in Beckett's *More Pricks Than Kicks* and *Murphy*, late modernist fiction took a detour from the high modernist road and consciously struck out on the byways and footpaths where the modernist movement had begun to stray.

IV

I must acknowledge from the outset the problem of inclusion that any such term as "late modernism" entails. Like its parent concepts "modernism" and "postmodernism," the notion of "late modernism" suffers from two notable difficulties. First is the problem of defining its chronological boundaries. Period terms tend to suggest, even when this assumption is not made explicit, an essential correspondence between the "spirit of the age" (or, for the historical materialist, the social history of a period) and representative works of art. Modernist works are, in this view, synecdoches of "the modern age"; postmodernist works likewise express the "postmodern condition." But when exactly, skeptics often ask, do these begin and end? And why can we find works that seem "postmodern" in the "modern" age or even earlier? The second problem is related but of even greater practical consequence for the critic: the problem of selection. What is included by the category, and what is left out? On what basis does the critic select a "representative" canon of "late modernist" works?

The selection of a representative canon, I would argue, can never be unassailable, given the selectiveness that haunts even the most careful and detailed exposition of a period. Moreover, as I have already remarked, I am quite consciously engaging in a labor of critical advocacy, of "making the case" for a body of works, and in that sense, also of trying to establish a canon for which "late modernism" would be a legitimate and illuminating critical and historical designation. Canons may be either consciously shaped or unconsciously adopted; with respect to the surprisingly stable canon of modernist authors and works, I seek to tip the balance toward a knowing partiality. In turn, my readers will have to judge whether they find compelling the reasons I offer for preferring a "bad new" modernist canon, stood up on still-tottering feet, over a "good old" one, squatly resting on a plinth of tacit beliefs and received ideas. Lest, however, my attempt to define a distinct late modernist mode and to heighten divisions within the broad field of modernist art and literature appear a mere critical *coup-de-main*, I will make my claims as clear and explicit as possible.

First, the writers I discuss as representative late modernists are directly linked only by loose affiliation. They shared certain common influences, read and published in some of the same or similar journals, and had some friends and associates in common. They do not, however, represent a "movement" in the sense of having self-consciously formulated goals

and formal organization to implement those goals. Here, it is useful to remember that terms like "modernism," "late modernism," "postmodernism," and so on, are the tools of the historians, professional assigners of labels not always chosen by the original participants. As C. Barry Chabot remarks on the provenance of the term "modernism": "'Modernism' is not a term equivalent to 'Imagism,' 'Futurism,' 'Surrealism,' 'Vorticism' and the like, which refer to specific schools or movements; instead, it is the term invoked to suggest what such particular and divergent programs have in common. It is a *period* concept; and its use involves the claim that in the end, and whatever their obvious difference, the individual energies of the time possess enough family resemblances that it makes sense to refer to them collectively."[33] "Late modernism," like "modernism," refers to a significant set of family resemblances between writers during a certain period of time. It is a construction of the work of analysis, which allows these resemblances to be disclosed and judged. As a historical category, it stands and falls on the persuasiveness with which it helps bring these resemblances to light.

Second, as already suggested, literary modernism has a number of divergent tendencies. As Chabot aptly notes, literary modernism "possesses nothing comparable to the Seagram Building" (34), a clear-cut monument of the modernist aesthetic in architecture. To speak of a late modernist reaction to modernism, then, requires the prior establishment of just what modernism the late modernists were attacking. In my interpretive chapters, I seek first to discover the process by which the individual writers came to break with modernism as they conceived it. Each had a different position within the broad circles of Anglo-American modernism; each understood "modernism" in somewhat different but nonetheless related ways. I consider the particularity of their reactions to their own individual conception of modernism but with an eye toward the "family resemblances" they share with other late modernists.

Third, I attempt to reveal how the responses of late modernists to modernism, individually inflected as they were, were decisively shaped by common biographical and contextual factors. These commonalities account for the clustering of late modernist works within a limited number of years and justify the use of a periodizing term. Moreover, they legitimate a central aspect of my interpretive procedure: the reading of formal and figurative characteristics as indices of the author's relation to his or her context.

Fourth, the late modernist response to modernism is inseparable from its emergence as a *historically* codified phenomenon. Modernism had to

have aged, had to have become in a way "historical," had to have entered into a certain stage of canonization, for the kind of writing I discuss to be possible. By the twenties a canon of modernist authors and evaluative judgments about their works had begun to find general acceptance among critics and even among the general reading public. Joseph Conrad, for example, writes in his 1920 preface to *Under Western Eyes* (published originally in 1911) how the book was a failure with the English public when it first appeared, because of the modernist "detachment" of its narration. He received his "reward," he notes, only six years later, when the events in Russia created a context for his work to be understood and positively reevaluated.[34] Not just from Conrad, however, but also from Henry James, Ford Madox Ford, D. H. Lawrence, James Joyce, and Virginia Woolf, among others, a positive and broadly accepted image of the "modern novel" in English emerged at this time.[35] Late modernist fiction can, in fact, be understood as a reaction to a nascent canon of modernist writers and the aesthetic they represented. Late modernism makes self-conscious the limits of this model of modernism, centered on what Nicholls calls discursive mastery, and hence forecloses it as a dominant tendency. This sense of bringing modernism to a close reveals itself, allegorically, in the authors' different handling of literary form and in their works' less unified but more direct response to the historical currents in which they were written and read.

Fifth, this allegorical significance is available largely in retrospect, to the critic and historian. From a latter-day perspective, individual works of late modernist fiction can be interpreted as allegories of the end of modernism. While no single work exhaustively defines this historical phase of modernist writing, each represents a radiant fragment of the whole. Moreover, as allegories of the end of modernism, works of late modernism can be interpreted as anticipations of a time after modernism, literally "postmodernism." Understood as fragments of a future to be fulfilled, they can be, and often have been, crucial influences on later writers.

V

In the preceding pages, I have attempted to define why the works of the later 1920s and 1930s deserve a second, more systematic look by readers and scholars of modern writing. I have also made the case for reopening the conceptual pigeonholes into which we have been encour-

aged to put twentieth-century writing, housing in separate chambers the caged eagle of modernism and the spangled parakeet of postmodernism. But if late modernism is no more than a passageway between these two cages, which otherwise remain closed worlds, it still has relatively little to offer readers of today, outside specialists in the field.

Peter Bürger, however, has argued that the very relevance of the arts in the contemporary world is at stake in understanding the fate of modernism: "One could . . . claim that all relevant art today defines itself in relation to modernism. If this is so, then a theory of contemporary aesthetics has the task of conceptualizing a dialectical continuation of modernism."[36] By rethinking in this book the aesthetics of modernism and the question of its relevance in light of its undeniable historical "decline," I seek to rise to Bürger's provoking challenge. I place late modernist writing in the early-twentieth-century context of shifting hierarchies within the arts, intensive development of the mass media, and traumatic events of social and political history—historical trends that were incipient for high modernist writers, yet not so ineluctably part of the "weather" as they would become during the 1930s. These developments opened new fault lines in both individual and collective experience, splits that today we have reinhabited but hardly repaired; late modernists laid the foundations for this dangerous way of dwelling. Taking their stand upon the shifting seismic plates of European society between two catastrophic wars, late modernist writers confronted no less an issue than the survival of individual selves in a world of technological culture, mass politics, and shock experience, both on the battlefield and in the cities of the intervening peace.

As I will show, these writers perceived as a general state of affairs a kind of all-pervasive, collective, and incurable shell-shock, from which all suffer and which need not have trench experience as its precondition (though for many, of course, it did). Everyone, they suggest, has a bit of the automaton about him or her; it follows from the conditions of history within which we must make our selves, our lives, our cities. The distinction between the vital and the mechanical had become less sharp in the interwar years; the world of things had never seemed more animated, while the question "Does life live?" lost its apparent nonsensicality for masses of people. Yet the late modernist writers also discovered the ethical ground of their work in a seeming imperfection in the process: the arrested state of this movement toward the efficient robot, the failure to complete this mechanization of the body through to its end, the comical inability of humans to consummate the man-machine.

This ethical impulse was inseparable from a kind of bitter comedy. Laughter, itself a kind of spasmodic automatism only marginally distinct from the laughable mechanism of our embodied existence, can help serve to convince us that a self, however minimal, is still there. *Rideo ergo sum*. The self confirms itself in laughter, persists in the interval between automatism and its comic reflex. It is within this inescapable comedy that all are compelled to play—this condition in which, as Wyndham Lewis put it, "*everyone* should be laughed at or else *no one* should—[37] that both solidarity and difference must find their future ground. These literary works of late modernism represent the initial, tentative steps in its exploration. Accordingly, in the chapter that follows, I attempt to provide readers with a broad topographical map of this terrain, this "riant spaciousness," before passing on to examine in detail some of its specific zones and features in the latter half of the book.

The End of Modernism

Rationalization, Spectacle, and Laughter

The First World War, as writers, historians, and other scholars of culture have persuaded us, marked a radical divide in the experience of millions of Europeans, altering forever how they saw themselves, their fellow men and women, and the forms of collective power at once frighteningly remote and dangerously proximate to the most intimate dimensions of life. Many of the crucial changes brought about by the war impose themselves on the eye, from the large-scale corporate reorganization of the economy and the state to meet the needs of reconstruction, to highly personal shifts in the relations of the sexes and corresponding ideas of masculinity and femininity. Less evident, and hence less well documented, however, is the intricate rhythm with which these changes interacted, reinforcing and canceling one another in sudden volumes and voids over the entire period from the armistice until the full-scale return to war with Dunkirk and the London Blitz. The influence of the war, much more fluid and fieldlike than is often appreciated, by no means touched only on the traumatized participants in the war effort, nor did it last only through the years of reconstruction, when the home economies and institutions sought to absorb the turbulent force of weary, embittered, shell-shocked armies, whether victorious or defeated.

In focusing on the role of trench warfare in shaping "modern memory," Paul Fussell's classic study of war writing brought to light the Great War's subjective logic: the tragic lag in culture that sent young men to war armed with late Victorian conceptions and brought them

back into a peacetime society with a psychic armor, thrown up in the trenches, permanently raised. For extreme cases like the trench poet Ivor Gurney, history had lost all boundaries. It was all war, everywhere; he died in 1937 in a mental asylum, convinced that the fighting was still going on outside. Late modernism, however, lies both a step back from and a step beyond such extremity, in the tributary channels by which memories and experiences of the war were transmitted from partici-pants to readers and from generation to generation. The passages back to this collective catastrophe are more devious, often interrupted and difficult to retrace. But one key late modernist writer has left a broken but still discernible trail connecting late modernism to its generative matrix in the years of war: Wyndham Lewis. For Lewis, the Great War retained its dreadful echo well into the 1930s, when the rising tensions between European nations had once again made mass slaughter present to the imagination of intellectuals and populace alike. It is thus with Lewis's war memoirs, *Blasting and Bombardiering*, published only two years before Hitler's invasion of Poland, that I begin.

I

In the introduction to *Blasting and Bombardiering* (1937), Lewis divides the twentieth century into three historical "segments"—the War, the Post-War, and the post–Post-War: "The War is such a tremen-dous landmark that locally it imposes itself upon our computations of time like the birth of Christ. We say 'pre-war' and 'post-war,' rather as we say B.C. or A.D. . . . I find a good way of dating after the War is to take the General Strike, 1926, as the next milestone. Then began a period of a new complexion. It was no longer 'post-war.' We needn't *call* it anything. It's just the period we're living in today."[1] As we later discover, this periodization reflects Lewis's own career, which he takes to be exemplary. As a painter and as the explosive charge behind the journal *Blast,* Lewis was central to the pre–World War I avant-garde. Yet the war and its aftermath, he suggests, opened a hiatus in his career. Lewis had gained public notoriety for his vorticist paintings, for *Blast,* and for his debut novel *Tarr* (first version, 1918).[2] But after *Tarr,* he writes, "I buried myself. I disinterred myself in 1926, the year of the General Strike—but as a philosopher and critic. This was considered very confusing."[3] Similarly, despite early successes, Lewis's work as a novelist would really only take off after this period of "hibernation," which was of decisive importance for his later career.

Although in many ways idiosyncratic, Lewis could in one crucial respect claim to represent a broader current. Older in years and artistic tenure than many writers starting out in the 1920s, Lewis, like them, nonetheless had to begin his career (over) in the changed circumstances of the "postwar." Lewis's colleagues like Joyce and Eliot (both non-combatants in World War I), whom he had initially outstripped in artistic initiative, had in the early twenties rapidly achieved worldwide fame as the avatars of a new age in literature. Their works became a standard against which others, whether for or against modernist writing, defined themselves. Lewis, who never gained anything like their notoriety, considered himself artistically at least their equal and in many respects their superior. Yet he too found himself, much to his displeasure, in the ranks of those writing in the shadow of *Ulysses* and *The Waste Land*.

The war and its immediate literary aftermath gave contemporaries the strong impression of a historical turning point, which they interpreted in a number of contradictory ways. In England, for example, widely accepted historicocultural myths emerged: "the old men" who had wantonly sacrificed the younger generation to hold on to power in the boardroom and bedroom; the tragic "death of old England" (a pastoral fox-hunting preserve, laid waste by modernity); and a fatal decline attributed to "the missing generation" of frontline soldiers, England's best-and-brightest having been (allegedly) killed off in the trenches.[4] The young Americans who came to Europe tended to see the postwar condition more positively than their English counterparts: a liberation from the strictures of puritanical America and the discovery of community, fun, sexual freedom, abundant drink, and literary fame on the Continent. In either case, however, the five years after the end of the war formed a historical parenthesis of sorts, beyond which, as Lewis put it, a "period of a new complexion began." Those writers who wished to extend the modernist legacy beyond this point indeed re-created it in the image of illustrious forbears, following their example and competing with their achievements. Yet by the late twenties, they had also come to realize that the modernist's goal of a "legendary translation of external life" (Baudelaire) faced peculiar challenges that their forerunners had not experienced.[5]

As the twenties passed, postwar modernists became increasingly aware of the difference between themselves and their now-famous predecessors. The early period of modernism, from about 1910 to 1918, had been especially characterized by two polar extremes. On the one hand, some modernist writers strongly asserted the autonomy of art

from social norms. The value of works lay in formal originality, which in turn was an index of the individual author's craft, vision, awareness, and labor. On the other hand, the first, heady phase of avant-garde activity had burst onto the scene with cubism, futurism, expressionism, vorticism, and early dadaism. For all their differences, which they heightened in combat with one another, these groups shared their collective orientation, which in some cases even evolved into a kind of anonymity for individual artists and writers. It is only to the specialist's eye that the differences between the analytic cubist works of Pablo Picasso and Georges Braque appear; likewise, the dadaists relished the polemical negation of individual style in their use of ready-made materials and chance.

The tremendous energy of modernism's first phase lay not only in the turbulent force of individual movements and voices but also in the tense interplay between different components of its field, the thrilling sense of a powerful, all-sided development of the arts. The more the combat within the modernist field escalated, so it seemed, the more productive the arts would become. This fortuitous convergence of forces, however, had serious limits. The enormous heave forward in the arts had been contingent on the rapid transnational communication of ideas and personnel in the years before World War I and on the vigorous assimilation of new technologies and scientific theories in popularized, triumphalist ways. The ritualized belligerence of prewar modernism was rendered more earnest, however, by the bloody national conflict that engulfed Europe. By the immediate postwar years, the movement had already begun to show signs of drift, neoclassical reaction, and nationalist or provincialist obstacles to new ideas. A cunning dialectic had seized the process of stylistic innovation, confronting the writer with historical limits and threatening to exhaust modernism's dynamic from within.[6] At the same time, external events impinged on the arts and their practitioners.

Following World War I, modernism's resistance to integration by extra-artistic institutions eroded from two sides. Modernist artists were actively challenged by the politicized avant-gardes (i.e., dada, surrealism, Russian constructivism) and also by new forms of culture with direct social utility (modern typography and design, photojournalism, cinema, jazz and revue culture, etc.). An emblematic encounter is the Berlin dadaists' blisteringly sarcastic attack on the painter Oskar Kokoschka, who had complained that machine-gun fire during the Spartacist uprising in Berlin had damaged a painting gallery. With their

radical politics and skepticism about anything but a throwaway culture, the Berlin dadaists could almost welcome the machine gunning of painting and certainly rated a few lost paintings very low against a lost revolution. Both trends—the politicization of the avant-gardes and the devaluation of the traditional arts—impelled artists to rethink their practice and reinvent the functions, forms, and contexts of artworks. The political avant-gardes noisily asserted the duty of artists to inter-vene—as artistic producers, not private citizens—in social life, while the new media took on a centrality that even the most popular artist had never imagined. Modernism's radical autonomy appeared increasingly fragile, increasingly difficult to sustain, in the face of these new histori-cal pressures.

Even if modernists could disdain or ignore these trends, however, they were faced with another difficulty: a slackening of the critical ten-sion between modernist art forms and modern society. Modernism itself had found a certain scurrilous success, or at least some of its represen-tatives, more or less worthy of the title, had achieved popular notoriety. The high calling of art that the modernists professed to follow had fallen prey to fashion and proven susceptible to banalization and vul-garizing imitation. Wyndham Lewis bitterly satirized the "apes of god" playing at bohemian existence, buying up fashionably humble studios in the artists' quarters at prices far beyond the means of struggling artists. Others, like Djuna Barnes, resorted to stealth and travel to maintain their distinction:

> Djuna Barnes, author of *Ryder*, returned to Montparnasse for a glimpse and fled to Vienna. . . .
> "Montparnasse," she said, "has ceased to exist. There is nothing left but a big crowd."[7]

As the fashion took hold, the cafés of Paris became more crowded with tourists seeking a look at the "lost generation" than with the writers and artists who ostensibly made up the spectacle.[8] The myth of modernism regarded itself in public, while the authentic item conducted its business elsewhere, often in obscurity and poverty.

As these writers discovered, however, such efforts to preserve a cre-ative island from the vulgar could succeed all too well. Fashion was fickle, but isolation had drawbacks as well—and might last indefinitely. Late modernist writers were forced to come to terms with this predicament, not merely as the given context in which they worked, but indeed as the conscious point of departure for their art. The detached stance and styl-

istic rigor of later modernist writing continued to put the crowd at a dis-
tance. Yet the heroism of this gesture, common to modernist writers
from Baudelaire to Joyce, had become grimly farcical, as it revealed a
social automatism controlling the artist presumably its master.[9]

Through the new array of modernist literary techniques, Fredric
Jameson has argued, the fractured experience of individual subjects in
the age of imperialism could be transformed into the building blocks of
formally dazzling works of art. Yet by transfiguring the private world in
this way, such works serve to evade the historical or political situation
that lies beyond the rarefied zones of inner feeling and thought: "The
perfected poetic apparatus of high modernism represses History just as
successfully as the perfected narrative apparatus of high realism did the
random heterogeneity of the as yet uncentered subject. At that point,
however, the political, no longer visible in the high modernist texts, any
more than in the everyday world of bourgeois life, and relentlessly driv-
en underground by accumulated reification, has at last become a gen-
uine Unconscious."[10] Jameson contrasts this radical repression of his-
tory with the still-"leaky" forms of the protomodernist *romancier*
Joseph Conrad. In Conrad's works, he argues, history juts through the
very literary forms meant to hold the world of aggravated political
struggle at bay. Late modernism, two decades later, once again loosens
the modernist dominance of form and allows a more fluid, dialogic rela-
tion with the immediate historical context. It accomplished this unbind-
ing of the work at the cost of abandoning the modernist gold standard:
form as the universal currency in which aesthetic value could be mea-
sured and circulated.

Writing politically committed literature represented one obvious
and, to many, attractive way for writers to break out of their evident
predicament. For a brief but fascinating period, writers as diverse as
W. H. Auden, Stephen Spender, Cecil Day-Lewis, George Orwell, and
Rex Warner (only to mention major British writers) found ways of hold-
ing in tension political and literary demands. They allowed these often-
contradictory strains to play themselves out in challenging, enduring
works of poetry and fiction. Yet despite the general sense of the thirties
as a highly politicized decade, many other important writers of the
period could not and did not link their writing to the vicissitudes of
political engagement. Retrospectively, and especially from the perspec-
tive of the postcommunist present, it is necessary to reexamine with-
out prejudice our ideas about this "noncommittal" stance, and above
all, as itself being a kind of political choice. It is possible to see in the

late modernists' "choice not to choose" something other than the simple dichotomy of engagement versus escapism. In a preface to his belated war chronicle/epic poem *In Parenthesis*, which appeared alongside Wyndham Lewis's war memoir *Blasting and Bombardiering* in 1937, the Welsh poet David Jones explicates his title as a rebus of his deep perplexity about where to stand as a writer in the postwar world. Jones explains that he called his book *In Parenthesis* because it was written "in a kind of space between—I don't know between quite what—but as you turn aside to do something." Jones's title is also significant, "because for us amateur soldiers (and especially for the writer, who was not only amateur, but grotesquely incompetent, a knocker-over of piles, a parade's despair) the war was a parenthesis . . . and also because our curious type of existence here is altogether in parenthesis."[11] Jones's sense of being betwixt and between two catastrophically opposed camps, massed for battle, captures something of a mood shared to a greater or lesser extent by many writers of these years.

Late modernist writers in no way ignored their social context; in fact, they were deeply troubled by their inability to keep it at a manageable distance. Their literary structures tottered uneasily between vexed acknowledgment and anxious disavowal of social facts, suggesting that their relation to history was far more complex than that of simple "repression." Indeed, if we wanted to carry out the psychic metaphor of Jameson's "political unconscious," which presupposes that narrative forms efficaciously limit the impact of history on literature, for late modernism we would have to speak of a *failure* to repress, a failure of the forms to contain the turbulent historical energies that sweep through late modernist works. These works are perforated and torn by their relation to history, which is here occulted beneath a dense textual tangle and there exposed in transparent allusion and bald polemic. These writers recognized the demands that the "external" world made on the "homemade" world of their art, yet they lent little credence to the current politico-aesthetic responses. This lack of credible options, however, left them all the more aware of their nakedness before the social facts. Reflecting on their own practice, they discerned in the evolution of modern writing disturbing changes in the ways in which literature was produced and read. Yet unable to formulate any radical alternative to the modernist legacy within which they continued to work, they labored to tunnel through it, undermining and leaving it behind in a painstaking pursuit of literary "failure"—isolated, furtive, and uncertain of allies.

II

The decade following World War I saw an unprecedented rationalization of social life in Europe and the United States, the subordination of previously distinct spheres to impersonal or collective aims.[12] The systematic and active organization of society by the state, a process greatly intensified by the need to mobilize human and material resources for the war and again by the economic crisis of 1929,[13] was experienced by many artists as an encroachment on their authenticity and autonomy, a devaluation of their individual experience. Their apparent loss of priority called for a response, for a renegotiated connection of experience and value, for new ways of creating artworks and of living the artist's life.

Just after the war, in his well-known address "Science as Vocation," Max Weber confronted the radicalized students' demands for "community" and "personality" and drew the implications for German intellectual life of the American-style rationalization of the university currently in train. Understood in the context of cultural trends extending beyond the university, his penultimate paragraph sounds peculiarly like a manifesto for high modernism, a refocusing of values on the personal experience and awareness of an individual thinker, obeying "the demon who holds the fibers of his very life":

The fate of our times is characterized by rationalization and intellectualization and, above all, by the 'disenchantment of the world.' Precisely the ultimate and most sublime values have retreated from public life either into the transcendental realm of mystic life or into the brotherliness of direct and personal human relations. It is not accidental that our greatest art is intimate and not monumental, nor is it accidental that today only within the smallest and intimate circles, in personal human situations, in *pianissimo,* that something is pulsating that corresponds to the prophetic *pneuma,* which in former times swept through the great communities like a firebrand, welding them together. If we attempt to force and to "invent" a monumental style in art, such miserable monstrosities are produced as the many monuments of the last twenty years. If one tries intellectually to construe new religions without a new and genuine prophecy, then, in an inner sense, something similar will result, but with still worse effects. An academic prophecy, finally, will create only fanatical sects but never a genuine community.[14]

The whole modernist gambit is here *in nuce.* Weber's ideal producer of culture turns toward the intimate and private as an appropriate—indeed, as *the* sole appropriate—response to the present social situation, displacing politics onto questions of technique and commitment to

one's calling. He rejects any "inauthentic" dialogue of the artist with public trends and projects a merely possible community, now necessarily highly restricted, which would grow out of the "authentic" relation of artist or thinker to his own work in progress.[15]

One common tendency among modernist artists was indeed to accept social rationalization as fate. Shortly before he acceded to the directorship of the Bauhaus in 1930, Ludwig Mies van der Rohe concluded an address to the Werkbund in Vienna with the following remarks:

> The new age is a fact; it exists independently of whether we say "yes" or "no" to it.
> But it is neither better nor worse than any other age. It is purely an established fact and intrinsically indifferent to values. . . .
> Let us accept as a fact the changed economic and social conditions.
> All these things take their preordained and value-blind course.[16]

Mies goes on to argue that the problem of values thus becomes crucial and that artists must strive to set new values. Yet in pursuing this goal, in seeking an adequate response to the cold facts of social rationalization, many artists drew different conclusions than did Weber. Whereas Weber set up the lonely researcher as hero, these artists attempted to relate their work positively to the rationalization process, thus shifting attention away from individual, subjective experience in favor of precise production and representation of *objects*.[17] This general orientation toward the object embraced such different projects as the pedagogy and design work of the Bauhaus, the architecture of Le Corbusier, the broad efforts of Soviet constructivism and productivism, and the Neue Sachlichkeit movement in Germany after the stabilization in the mid-1920s. A 1923 collaboration between the Russian theater director Vsevolod Meyerhold and the artist Lyubov Popova, *The Earth in Turmoil*, can serve here as an emblematic, if somewhat hyperbolic, example. Popova's stage setting incorporated a number of real objects as props, including "a coffin, a red pall, a small machine gun, bicycles, weapons, a field kitchen, 3 field telephones, one camp bed, one field pack, one large table, maps, 2 typewriters, 2 aeroplanes."[18] Cinematic technology, with its means to render objects in motion with photographic exactitude, also played a notable role in the staging. Popova employed a three-dimensional screen, a film projector, a film camera, films, slides, and Vertov's landmark film, *Kino Pravda*.[19] This engagement with real mechanical objects and new media technologies, however, was charac-

teristic not just of constructivist theater but of all major spheres of con-
structivist culture, ranging from reportage literature to industrial design
to graphic art.[20] Sergei Tretiakov, one of the strongest advocates of
"factographic" reportage and the fusion of book and newspaper as a
new collective art form, went so far as to call for a new type of literature
about objects, "biographies of things": "Books like *Wood, Cereal, Iron,
Flax, Cotton, Paper, Locomotive, Business* have not yet been written. We
need them."[21] In architecture and design-oriented art outside Soviet
Russia, the object-sphere was granted similar privilege; here too, like-
wise, photographic and other reproduction processes were incorpo-
rated into artistic production.[22] Unlike their Soviet counterparts, most
of these movements assumed some form of capitalism as the social
frame for their work. Nevertheless, they substituted function for expres-
sion and affirmed an ethics of work and technique, giving a generally
social-democratic and industrial cast to their activities. The Bauhaus
director Lázló Moholy-Nagy—the modernist in machinist's overalls,
the artist as engineer—embodied this heroic affirmation of system over
self, this shift from artworks by individual artists into the collective pro-
duction and consumption of designed objects.[23]

At the same time, however, industrial design and other economically
lucrative art practices were conduits for aesthetic concerns into the
experience of everyday spaces and things. The special place of "art" as
an independent domain in society became ever more restricted, as tra-
ditional modes of art no longer held the monopoly on aesthetic plea-
sure.[24] Beauty was now as close as the stylized coffee cup on the break-
fast table, or the streamlined table and chair in which one sat to have
that coffee. At once the material of the senses and, when industrially
produced, also the tangible embodiment of utility and technicity, the
world of objects seemed to offer a space in which contradictory
demands for rationality and individual experience might be brought to
a higher harmony.[25]

For writers—in contrast to designers, graphic artists, architects,
typographers, and photographers—the opportunities to intervene
directly in the industrial economy or in political life were much more
limited, confined for the most part to party propaganda or film work.[26]
We can detect in the proclamations of the surrealist leader André Breton
during the 1930s a desperate desire to circumvent the more compro-
mised choices while still connecting surrealist activity to the world of
politics and of "the object." Whereas previously surrealism had concen-
trated its efforts on opening up new states of vision, consciousness, and

sensibility, Breton declared in his 1934 address "What Is Surrealism?" that it was now engaged with the serious task of changing "the object":

I should like to draw your attention to the fact that its most recent advance is producing a *fundamental crisis of the object*. . . . Only the very close examination of the many recent speculations to which the object has publicly given rise (the oneiric object, the object functioning symbolically, the real and virtual object, the moving but silent object, the phantom object, the found object, etc.) can give one a proper grasp of the experiments that surrealism is engaged in now.[27]

Yet while this desire to intervene in the world of objects gave rise to some fascinating writing, like Breton's essay-novels *Nadja* and *L'Amour Fou*, much of surrealism's artistic practice nonetheless responds in a merely "lyrical" vein to major shifts in the social life of objects:

I for my part believe today in the possibility and the great interest of the experiment that consists of incorporating objects, ordinary or not, within a poem, or more exactly of composing a poem in which visual elements take their place between the words without ever duplicating them. It seems to me that the reader-spectator may receive quite a novel sensation, one that is exceptionally disturbing and complex, as a result of the play of words with these elements, nameable or not.[28]

The lameness of Breton's justification for his "poèmes-objets," his appeal to their shocking novelty and the sensations they evoke in the reader-spectator, suggests that this aestheticizing response was largely retrograde. As Henri Lefebvre observes about the surrealists, "Their purely verbal metamorphosis, anamorphosis or anaphorization of the relationship between 'subjects' (people) and things (the realm of everyday life) overloaded meaning—and changed nothing."[29] In his practice of the "poem-object," Breton quite simply failed to draw any radical conclusions from those social tendencies that had trained his attention on "the object" in the first place. While these works transgress the traditional boundaries between the visual and discursive arts, they were in fact vastly outstripped by similar transgressions in industrially produced objects of consumption, publicity, or mass culture from this period (a situation not lost on Marcel Duchamp already two decades earlier, or on Breton's contemporary and admirer, Walter Benjamin).

Franco Moretti has noted the crisis literature faced in the new force field of culture that emerged with undeniable intensity in the 1920s and 1930s: "At the beginning of this century what is probably the most exemplary artistic form of bourgeois civilization—written literature—

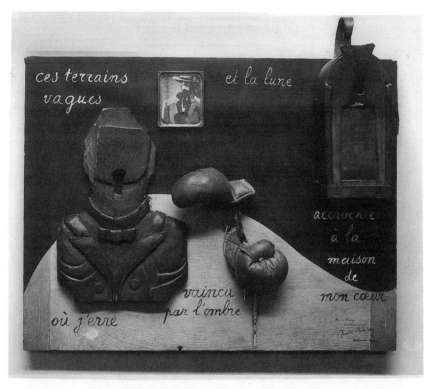

Figure 1. André Breton, *Poème-Objet*, 1941. Assemblage mounted on wood drawing board; carved wood bust of man, oil lantern, framed photograph, toy boxing gloves, 18 × 21 × 4 3/8" (45.8 × 53.2 × 10.9 cm). The Museum of Modern Art, New York. Kay SageTanguy Bequest. Photograph © 1997 The Museum of Modern Art, New York.

has passed into an unarrestable decline: what at one time had been its *specific* function has now moved and transformed itself into a constellation of cultural practices, rendering the existence of an activity exclusively devoted to this end almost superfluous."[30] Insofar as literature had a marginal place in the new economy of media and artistic practices, the historian Manfredo Tafuri is correct in arguing that "literature and art as means of recovering Totality and of transferring it to the new historic subject by election . . . were part of a design that took place in the rear guard of capitalist development."[31] In the narrow apartment left for literature in the new tower-block of the arts, one main task was proceeding apace: charting the process of the subject's disappearance, discovering its place "as an 'imperfect machine' in a social universe in

VIE DE L'OBJET

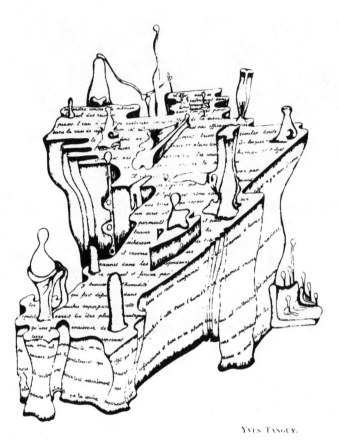

YVES TANGUY.

Figure 2. Yves Tanguy, *Vie de l'objet* (from *Le surréalisme au service de la révolution* 6, 15 May 1933). © 1998 Artists Rights Society (ARS), New York.

which the only consistent behavior is that of pure silence."[32] Orwell similarly argued that contemporary literature's sole chance at honesty lay in its facing up to the fact that literature had become impossible in the present age: "From now onwards the all-important fact for the creative writer is going to be that this is not a writer's world. That does not mean that he cannot help to bring the new society into being, but he can take no part in the process *as a writer*. For *as a writer* he is a liberal, and what is happening is the destruction of liberalism."[33] Orwell posed

the writer with a stark choice of two undesirable positions: the autism of being permanently removed from any effective participation in modern life, or the mutism of not being able to practice the free craft of writing. Lewis too captured the impossible paradox of this position with the last line of his satiric novel *The Childermass*. In the spirit world of the wartime dead, Pullman tells his comrade Satters: "Pick your feet up. If you must go nowhere, step out."[34]

A crucial locus of rationalization, and the foremost instance of the "system of objects,"[35] both impersonal and intensely stimulating, was the *metropolis*. I utilize this term in a specific sense, derived from Georg Simmel's fundamental essay "Metropolis and Mental Life" (1903). In Simmel's view, the metropolis is not just a big city. It is a big city in which bigness has taken on a functional character, in which the intricacy of functional interconnections within the city has generated a new sort of agency or subject. Simmel writes: "A man does not end with the boundaries of his body or the vicinity that he immediately fills with his activity, but only with the sum of effects that extend from him in time and space: so too a city consists first in the totality of its effects that extend beyond its immediacy."[36] Not merely its physical presence, thus, but its *effective* character, defines the metropolis. And for Simmel, one of the most important domains in which this effective character can be detected is in the psychic life of city dwellers: a modification of the nervous organism in accordance with the objectivized *Geist* of big city life.

Simmel's concept of metropolis, as Massimo Cacciari notes, thus presupposes the unsettling of individual subjectivity, a development that has often been considered typically "modern" (in Jürgen Habermas's terms, modernization is "the subordination of life-worlds under system's imperatives"[37]). Restating Simmel's view in the language of Marx and Weber, Cacciari writes: "The metropolis is . . . the phase, or the *problem*, of the rationalization of all *social* relations, which follows that of the rationalization of relations of production. . . . When the *Geist* abandons the simple and direct relations of production, it no longer creates the city but the Metropolis. It is the *Geist*, not the individual, that *of necessity* inhabits the Metropolis."[38]

The great capitals of modernity—Berlin, Paris, Vienna, London, New York, and, newly, Los Angeles—with their passion and misery, their dispossession of individuals and promise of collective fulfillment, their technological rationality and social atavism, their embodiment of history and remorseless "forgetting" of the events that transpired in them, seemed to exemplify the condition that confronted the later modernist.

This condition was, however, rarely accessible in any fully thematized or transparent way to the writer. The diagnostic role and its modulation into the prophetic was, as Lewis's René Harding (*Self-Condemned*) or Barnes's Matthew O'Connor (*Ryder* and *Nightwood*) would testify, a dubious and potentially self-condemning part to have to play. As consciousness took collective shape in the metropolis, and individual subjectivity was triumphantly pulverized, it became increasingly difficult for authors to achieve some sort of synoptic vision, to discover some place from which to narrate the whole.

While accepting a certain inevitability to the erosion of individual subjectivity, later modernist writers viewed it with considerable ambivalence, verging at times on despair. Indeed, they doubted that the process of metropolitanization could give rise to a stable, abstractly rational, collective subject. The consummate rationalization of culture in the present form of the metropolis was for them an unrealizable utopia: the process held within its dynamics its own limit, an inextinguishable trace of irrationality that would expand precisely with the progress of the *ratio*. The Austrian novelist Hermann Broch summed up the pessimism of many of his contemporaries when he wrote: "The highly developed rationality of modern metropolitan culture does not at all mitigate the human twilight, rather it intensifies it. The accepted *ratio* becomes a mere means for the satisfaction of drives and thus is robbed of its content as knowledge of the whole."[39] In the form of the metropolis, rationality had embarked on a journey to the end of the night, reducing the individual subject to (in Beckett's words) "a peristalsis of light, worming its way into the dark."[40]

This irrational subjective residue was a kind of "accursed share" left over by the structures of social rationality.[41] Affective and experiential as well as material and social elements were excluded from the functional, technical integration of social space, then shunted into a shadow existence in the social unconscious. Again, the surrealists were particularly self-conscious in strategically revaluing this debris of the social system as a protest against the values of work, technicity, and mechanical efficiency. Indeed, as Jean Baudrillard suggests, the surrealist image is hardly thinkable without its complementary opposite, the functional object of industrial design: "The Surrealist object emerges at the same epoch as the functional object, as its derision and transgression. Although they are overtly dys- or para-functional, these phantasmatic objects nevertheless presuppose . . . the advent of functionality as the universal moral law of the object, and the advent of this object itself,

separated, autonomous and dedicated to the transparency of its func-
tion."[42] The events of the late twenties and thirties, of course, provided
late modernist writers with ample evidence of the undiminished force of
this residue in social life. In the marked escalation of social conflict and
political violence, a violence that ultimately gained institutional legiti-
macy in the National Socialist and other fascist regimes, they witnessed
a veritable irruption of collective irrationality concentrated in the cities.

III

In *Minima Moralia,* reflections written in exile during World War II,
Theodor Adorno attempted to comprehend what had come to pass in
twenty years. In one section, he described the fate of modernism's drive
to produce the new. No longer confined to the autonomous sphere of
art, the dynamic of modernism had, in Adorno's view, emerged as a
general social principle. It had been taken up extra-aesthetically in large-
scale social dynamics like warfare, in which the arms race compelled an
accelerated pace of technological innovation. Likewise, previously
extra-aesthetic social spheres like labor and politics were now shaped by
aesthetic demands for beauty, intensity, and newness.[43]

Adorno situated the problem of modernism within the category of
the "New," which dictates a perpetual renewal of its object while at the
same time remaining essentially indeterminate, indifferent to the con-
crete content that may temporarily fulfill it. For Adorno, this ambigu-
ous status of newness gives aesthetic modernism, which adopts novelty
as a primary source of value, its compulsive character: "Baudelaire's
poetry . . . is full of those lightning flashes seen by a closed eye that has
received a blow. As phantasmagoric as these lights is the idea of newness
itself. What flashes thus, while serene contemplation now attains merely
the socially pre-formed plaster-cast of things, is itself repetition. The
new, sought for its own sake, . . . petrified into a conceptual scheme,
becomes in its sudden apparition a compulsive return of the old, not
unlike that in traumatic neuroses."[44]

Adorno refers to an increasingly general, collective search for new-
ness, which realizes in unanticipated ways the aesthetic-political goal of
the early avant-garde to "democratize perception" (Mina Loy) and
open art out into social life. He suggests that tendencies already present
in Baudelaire's and Richard Wagner's publicistic activities have, at this
late date, come to fruition. "Today," he writes, "the appeal to newness,

of no matter what kind . . . has become universal. . . . The decomposition of the subject is consummated in his self-abandonment to an ever-changing sameness."[45]

Implied in Adorno's formula is a historiographic hypothesis: the new war (World War II), precisely in its newness, is a recurrence brought about by the persistence of the trauma of the old one. The manifest "newness" of the present conflict, Adorno suggests, depends on a traumatic destruction of experience that allows the same to recur as if it were really new:

Just as the war lacks continuity, history, an "epic" element, but seems rather to start anew from the beginning in each phase, so it will leave behind no permanent, unconsciously preserved image in the memory. Everywhere, with each explosion, it has breached the barrier against stimuli beneath which experience . . . forms. . . . But nothing, perhaps, is more ominous for the future than the fact that, quite literally, these things will soon be past thinking on, for each trauma of the returning combatants, each shock not inwardly absorbed, is a ferment of future destruction.[46]

Adorno adapts for his social-psychological reflections the model of consciousness that Sigmund Freud developed in *Beyond the Pleasure Principle,* a model explicitly designed to explain the compulsive repetition of traumatic dreams among shell-shocked veterans of World War I. Adorno implies that the *entre-deux-guerres* period is, in a sense, one long bout of war neurosis, in which the effects of trauma have proliferated in a general contagion. Whether or not this is acceptable as social analysis, Adorno's intuition was shared by many writers and thinkers of the period, that the traumas of the 1920s and 1930s, which culminated in World War II, were somehow an immanent unfolding of an original, unassimilable disaster, the Great War.[47] Wyndham Lewis, for instance, expressed this view with epigrammatic concision: "The Great War is a magnet, the 'post-war' its magnetic field."[48]

Adorno's diagnosis of a kind of collective shell shock or, more generally, a pervasive neurasthenia in the face of a runaway modernity, is of the greatest interest for understanding the emergence of late modernism after 1926. Explicit in the extensive theoretical writings of Wyndham Lewis and the occasional criticism of Djuna Barnes and Samuel Beckett, as well as implicit in the fictional works of all three authors, is the vision of a general depersonalization and deauthentication of life in modern society.[49] Everyday life, in their view, was being increasingly penetrated by mimetic practices—role-playing, contagious imitation, "rhythmic"

forms of association, anthropomorphic "animation" of the object-world, ritualized behavior—previously confined to well-defined spheres in religious ritual, theater, and the arts. Such generalized mimetism was at once an involuntary process for individuals, a compulsory lowering of the threshold of difference between subjects and objects, their unconscious assimilation to an objective environment—and a social phenomenon consciously manipulable for political and commercial ends (for the *art,* as Lewis's book title put it, of "being ruled"). Late modernism, as it emerged in the late twenties and thirties, both reflected and reflected critically *upon* this loss of a stable, authentic social ground.[50]

As might be expected, given his commitment to theoretical and political thinking, Lewis explored this process most explicitly and extensively. Already in his essay from 1925, *The Dithyrambic Spectator,* and his 1926 treatise, *The Art of Being Ruled,* Lewis had advanced his privileged image for the mimetic contamination of subject and object: the bringing of spectators onto the stage. This image, as Lewis employs it, is not so much a metaphor as the focal pivot of a broad social panorama: the influx of "life" into the theatrical spectacle signifies reflexively the outflow of "theater" into political, cultural, and sexual life. The boundaries of art dissolve in ritualized, aestheticized social practices: "Very rapidly the banks of spectators turn into a great assembly of 'amateurs' once more. Then it is that the phase left out by Miss [Jane] Harrison occurs: that namely in which a collective 'play' is engaged in, in which no 'real' or 'practical' issues are involved."[51] In *The Art of Being Ruled,* Lewis opens his chapter entitled "The Disappearance of the Spectator" with a question: "Should there be 'players' and 'livers,' art and life, or only one thing?"[52] He goes on to make the political and aesthetic parameters of this question abundantly clear: "The new theater of Russia aims at emphasizing a collective personality rather than an individual one, at expressing masses not men. . . . So we see the simultaneous disappearance of the *author* and of the *actor,* to all intents and purposes" (*AOBR,* 158). Lewis's discussion of these changes drew heavily on recent works of cultural reportage about the Soviet Union, among others, Michael Farbman's *After Lenin* (1924), Huntly Carter's *The New Theatre and Cinema of Soviet Russia* (1925), and René Fülöp-Miller's evocatively illustrated and compendious study, *The Mind and Face of Bolshevism* (1926). Lewis views this perilous breakdown of distinction—between subject and object, between spectator and spectacle, between producer and consumer—and the subsumption of art into everyday life as expressed integrally in both social revolution (Lewis criticizes

communism *and* fascism on this point) and the revolutionary aesthetics of the avant-garde.

The centrality of this analysis to Lewis's overall critique of modernism cannot be overestimated: it informs in equal part his expostulations against his modernist colleagues in "The Revolutionary Simpleton" section of *Time and Western Man* and his criticisms of surrealism in *The Diabolical Principle*, his polemic against *transition*'s Joyce-affiliated editors.[53] By 1934, the date of Lewis's second major blast against a number of key modernists, *Men Without Art*, his sense of a rupture with a previous order and a concomitant derealization of social life had become all the more radical:

An artist who is not a mere entertainer and money-maker, or self-advertising gossip-star, must today be penetrated by a sense of the great discontinuity of our destiny. At every moment he is compelled to be aware of that different scene . . . behind all that has been familiar for so long to all the nations of the Aryan World. Nothing but a sort of Facade is left standing . . . before which fustian property (labelled *The Past*, a cheap parody of *Ancien Régime*, with feudal keeps in the middle distance), the Gossip-column Class bask in enormous splashy spot-lights of publicity. It is what is behind the Facade that alone can be of any interest in such a pantomime.[54]

Ultimately, Lewis concludes that this flattening of the present into a scenario, with the past as its stage properties, is the beginning of generalized "play": "it is the end of history, and the beginning of historical pageant and play. But we are all compelled, to some extent, to enter into the spirit of the comedy—that is the humble message of this book." (*MWA*, 165).

I want to suggest here (and later demonstrate in greater detail) that a similar vision of a nascent "society of the spectacle" animates the literary thinking of Barnes and Beckett. In their fiction, the social analysis remains more immanent, embedded in formal and imagistic aspects rather than being discursively manifest. But in their scattered criticism of this period, even Barnes and Beckett reveal a concern with the contemporary "derealization" of reality, its progressive replacement with simulacra and spectacles. Thus, in an article in the December 1929 *Theatre Guild*, Barnes dons a prophetic mask to pose the question, "Why Actors?" Barnes implies that theater is a general, even anthropological, condition and that "we are all"—the author included—"compelled to enter into the spirit of the comedy" (Lewis). She writes: "Because I am a holy man . . . I have seen many sorrowful things. Men wanting to be Napoleon, and women wanting to be Helen of Troy, and little children

wanting to be policemen. Therefore this passion in the human heart to be something it is not, is no secret to me, yet it troubles me, for I am not sure if it is true aspiration or a terrible and unholy criticism of the Most High, and this I must know, for I myself have wanted to be other than I am."[55] Beckett, in keeping with his early philosophical concerns, gives this derealization of reality an ontological and epistemological spin. In his survey "Recent Irish Poetry" he thus speaks of "the break-down of the object, whether current, historical, mythical or spook," and a "breakdown of the subject,"[56] while in a review of the Irish playwright Sean O'Casey he refers to a "dramatic dehiscence, mind and world come asunder in irreparable dissociation."[57]

IV

Beckett's "dramatic dehiscence" and Lewis's "disappearance of the spectator" point to a shared sense that their contemporary reality—both subjective and objective—was somehow becoming "less real." Both testify to a blurring of sharp boundaries between subject and object; and both register the diffuse feeling of disorientation that per-vaded the inner and outer worlds in which the modern subject moved. The outer world—of crowded streets, of department stores, of movie houses, of political rallies—had taken on fantastic, aestheticized shapes once found only in dreams, paintings, or fiction. The inner life, in con-trast, had appropriated the object-world in which people lived and moved, now taking the shape of a city street, later of a shop window, then perhaps of a cinema or a fascist parade.[58] It is in response to this new configuration of self and its boundaries that late modernism finds its contextual and affective basis. For once the stable line between sub-ject and object began to lose its sharpness, thickening and breaking apart in complex rhythms, a whole series of precepts central to earlier modernism had to be rethought. The heroic subjectivity of the inno-vating artist; the organic convergence of form and content in a symbolic unity set down by the artist on paper, on canvas, in stone; the exhibi-tion of stylistic mastery as a criterion of value; the belief in an underly-ing mythic or aesthetic order to history; and the possibility of redeem-ing tradition through its transfiguration into art—all these basic tenets of modernism's aesthetic ideology were put in doubt by the object's new dispensation, at least for those artists willing to extend their uneasy intuitions to their practice.

Since I have argued for the historically situated nature of late modernism, it is appropriate to approach a definition by considering a work of the period in question. In his 1934 book *Men Without Art,* Wyndham Lewis offers an extended explanation and justification of his own writing as defined against several of his contemporaries. It is this text, then, that will provide my point of departure for a more specific depiction of late modernism's physiognomic traits.

· · ·

Lewis begins his exposition by noting the problem of his own situation as an artist: "I am a satirist. . . . But I am not a moralist. . . . [I]t is these two facts, taken together, which constitute my particular difficulty" (*MWA, 87*). Lewis notes that traditionally the satirist needed the moral sanction of the community to do what he does: launch satirical attacks and provoke laughter. Yet Lewis believes that shared moral values have evaporated and feels no moral solidarity with others. He is forced, under these circumstances, to consider the possibility of "nonethical satire," "'satire' for its own sake," to justify his own case.

What is notable in Lewis's discussion is his intense self-consciousness about his own lack of determinate social location. As an artist, his identification with a community, the Rebel Arts group or the vorticists or even the "men of 1914," was a thing of the past. His attacks on his former colleagues in *Time and Western Man* and on the Sitwell and Bloomsbury coteries in *The Apes of God* had severed whatever links remained. He was no less clear about the impossibility of his "situation" in the political domain, to which, in fact, his views on "nonethical satire" represented a practical response (as did, in another vein, his ambivalent embrace of fascism). Thus, in his 1937 autobiography, *Blasting and Bombardiering,* Lewis wrote: "Nineteen-thirty-seven is a grand year. We are all in the melting pot. I resist the process of melting so have a very lively time of it. I know if I let myself melt I should get mixed up with all sorts of people I would sooner be dead than mixed into. But that's the only sense in which I'm conservative. It's myself I want to conserve. I wouldn't lift a finger to conserve any 'conservative' institution. I think they ought to be liquidated without any exception at all."[59] Lewis's nonethical satire is written by an authorial subject in extremis: one revolutionary enough to wish all existing institutions liquidated but without solidarity with any collective or community; one threatened with extinction and hence dedicated foremost to self-preservation.

The identity of such a threatened subject is guaranteed, in the last instance, by its discreteness and self-continuity—qualities symbolized above all by the integrity of the individual body. As Lewis's chapter "The Piecemealing of the Personality" in *The Art of Being Ruled* suggests, he thus conceives the primary threat to the subject to be *dismemberment* (a thinly metaphorical fate that Lewis often renders literal in his fictional works, through scenes of decapitation and other bodily violence):[60] "Continuity, in the individual as in the race, is the diagnostic of a civilized condition. If you can break this personal continuity in an individual, you can break *him*. For *he* is that continuity. It is against these *joints* and sutures of the personality that an able attack will always be directed" (*AOBR*, 204). Yet satire, in its scurrilous abuse of grotesques and "puppets" (a prominent word in Lewis's satiric lexicon), discloses precisely the vulnerability of everyone to such attack on the "integrity" of body and of person:

It is unnecessary to enumerate the tragic handicaps that our human conditions involve—the glaring mechanical imperfections, the nervous tics, the prodigality of objectless movement—the, to other creatures, offensive smells, disagreeable moistures—the involuntary grimace, the lurch, roll, trot or stagger which we call our *walk*—it is only a matter of degree between us and the victim of locomotor-ataxy or St. Vitus's dance. (*MWA*, 93)

"Unnecessary" it may be, but satire will address itself precisely to enumerating and even exaggerating the fragility, friability, and permeability of the human body.

Laughter, to which Lewis assigns a highly specific function, serves to resolve this apparent contradiction. For laughter, in Lewis's view, functions to inoculate the organism against the buffetings it faces from without: "Laughter . . . has a function in relation to our tender consciousness. . . . It is the preserver much more than the destroyer" (*MWA*, 89). It is an "anti-toxin of the first order" (*MWA*, 93). It protects the "tender consciousness"—which Lewis always sees as endangered by the modern "climate"—by hardening up the organism, "stiffening" it: "There is a stiffening of Satire in everything good, of 'the grotesque,' which is the same thing" (*MWA*, 99).[61] The laughter evoked by satire, if it is to have this "healthy" effect, must be diffuse and impersonal: "in a sense, *everyone* should be laughed at or else *no one* should be laughed at. It seems that ultimately that is the alternative" (*MWA*, 89).

At this point, Lewis draws out the implications of this view that "everyone should be laughed at." Clearly, he says, this goes against the

grain of our decency: we normally suppress our laughter at the deformed and infirm. Yet to justify his theory, Lewis proposes to take the issue to its extreme. He conjures up the image of laughter in the face of the recent trench warfare:

So far so good: but what of the shell-shocked man, for instance? He is often very funny, and it is very difficult not to laugh. But that is like laughing at the contortions of a dying man, and it would be too brutal a society that made a habit of laughing at its shell-shocked persons—especially as it would be to the society of the laughers to which ultimately the responsibility for these disfigurements would have to be brought home. Therefore there is no society that does not refrain from guffawing at the antics, however "screamingly funny," of its shell-shocked men and war-idiots, and its poison-gas morons, and its mutilated battle-wrecks. (*MWA*, 92)

If this passage is almost painful to read, it is not (for me, at least) because of the "brutality" it seems to suggest in its author. On the contrary, for all the pretense of "coolness," one senses a vertiginous hysteria: the price exacted from its author to suppress a rising scream. Lewis evokes here a kind of unspoken primal scene of his writing: the loss of bodily and affective control before the sight of shocked, damaged, mutilated human bodies—the everyday world of wartime Flanders and Passchendaele.

Peter Sloterdijk has noted how Thomas Mann anatomized the cynical laughter of the Weimar years in three terrible scenes in *The Magic Mountain*. The first two scenes relate the involuntary laughter of interlocutors who have heard matter-of-fact accounts of the corpses, pulmonectomies, and other grim details of the sanitorium. The last scene of laughter, however, is of a different order: a pure automatism, like Ezra Pound's imagined "laughter out of dead bellies." A patient having a lung operation breaks into laughter out of "pleural shock," a reflex of the pleura being palpitated: "I heard myself laughing, while I was kicking the bucket, but not like a human laughs, but rather, that was the most disgraceful and nauseating laughter I have heard in all my life, for the palpitation of the pleura, gentlemen, that is as if one were being tickled in the utmost shameless, most exaggerated and most inhuman way."[62]

This laughter, like the laughter of dying bodies and of soldiers driven mad by the sight of them, a laughter utterly unrelated to any spiritual response, is strictly a limit-experience. It is what Lewis calls "perfect laughter," which, he says, "would be inhuman" (*MWA*, 92). Yet below this limit is another zone of laughter minimally touched by moral consciousness or personal concern. It confronts the absurd as a component

of the anthropological condition, yet preserves the historical memory implied in thinking the limit of a laughter of "pleural shock" or of a belly convulsed by shrapnel. Lewis suggests that such a laughter is essentially reflexive, "non-personal and non-moral": "And it enters fields which are commonly regarded as the preserve of more 'serious' forms of reaction. There is no reason at all why we should not burst out laughing at a foetus, for instance. We should after all only be laughing *at ourselves!*—at ourselves early in our mortal career" (*MWA,* 92). It is the self-reflexive laughter ("laughing at ourselves!") of the survivor in the face of alterity and death, the subject's minimum self-confirmation, the minimal trace of the instinct for self-preservation. I laugh, therefore I (still) am.

Laughter has an intimate relationship with the situation of the embodied subject in external space, a fact that should give pause considering Lewis's insistence—both in his theory of satire and in his criticism of other modernists—on spatiality over time and physical exteriority over psychological interiority. As I will discuss *Time and Western Man* in greater detail later, here I want to take up Lewis's expressed preference for the "ossature" and "shell" of the living organism (his "favorite part" being the dead one) over its soft, fluxive innards. Likewise, he prefers "the rigid stylistic articulations of the grasshopper," the outer armor as it were, to "the jellyfish" (*MWA,* 99).

This imagery, hinging on the distinction of inside and outside, unconscious and conscious, and surface and depth, is reminiscent of Freud's depiction in *Beyond the Pleasure Principle* of consciousness as a rigidified, deadened shield against excess stimuli from without. Freud evolved this theoretical model, as I have already noted, in response to the traumatic dreams of shell-shock victims in World War I. These dreams seemed to contradict the psychoanalytic model of dreams as wish fulfillment and thus impelled Freud to postulate the "death drive" to explain the conservative repetition, seemingly "beyond the pleasure principle" evident in wish fulfillment dreams, of such traumatic dreams. In developing his argument, Freud employs a largely unstated but crucial analogy between the shattered experience of the adult shell-shock victim and the inchoate experience of the infant, regressing across the divide of adult speech from the postlinguistic tics and abreactions of the trauma patient to the prelinguistic pulses and affects of the prelinguistic human animal. To survive, the trench soldier needed to inure himself against the constant bursting of flares, the thunderous noise, the confusion and bloody terror of artillery bombardment. Yet this process

is, Freud suggests, only an extreme—and sadly ineffective—version of the normal condition of the human organism in the world. In infancy, however, the balance of external and internal forces is so much skewed toward the stimuli coming from outside that the child's experience is as potentially devastating as that of the soldier. Freud's task, then, is to explain why soldiers get shell shocked from trench warfare, while babies, under normal circumstances, do not end up traumatized by their surroundings.

By way of an answer, Freud offers the hypothesis that our conscious psychic life serves to channel and screen external stimuli that would be overpowering energies were their intensity not reduced. This consciousness originates in a kind of deadening of the sensory system that spans the mind and body, a devitalizing of sensory life in order to delay the reactions of the body and allow an interval of choice and reflection. Freud uses the metaphor of a hull of inorganic armor around a vital core, a hardened sheath formed of blasted layers of once-sensitive matter, which serves the life of the whole by suffering the storm of stimuli coming in from the outer world:

Its outermost surface ceases to have the structure proper to living matter, becomes to some degree inorganic and thenceforward functions as a special envelope or membrane resistant to stimuli. In consequence, the energies of the external world are able to pass into the next underlying layers, which have remained living, with only a fragment of their original intensity. . . . By its death, the outer layer has saved all the deeper ones from a similar fate—unless, that is to say, stimuli reach it which are so strong that they break through the protective shield. . . . The protective shield is supplied with its own store of energy and must above all endeavor to preserve the special modes of transformation of energy operating in it against the effects threatened by the enormous energies at work in the external world—effects which tend towards a levelling out of them and hence towards destruction.[63]

For Freud, consciousness, in contrast to traditional images of it as active, living soul, is a rigidified, deadened filter against experience—a hard outer shell, sacrificed to preserve life and prevent breaching of the inner organism by all but the most violent of shocks (like the war experience manifest in traumatic dreams).

Max Horkheimer and Theodor Adorno reinterpret Freud's image of defensive hardening culturally and politically. They suggest that an emphasis on "coldness" and "hardness"—so much a part of the political discourse of the German right, and for Lewis, significantly, the pri-

mary quality of satire—can be seen as a corporeal defense against the "seduction" of pure space, the death-drive understood as an assimilation to the dangerous extensiveness of inanimate nature.[64] Idiosyncrasy—often the occasion of laughter—represents for them a potential dissonance in human spatiality, which may set in motion a dialectic of dissolution and defensive stiffening:

In idiosyncrasy, individual organs escape from the control of the subject, and independently obey fundamental biological stimuli. The ego which experiences such reactions . . . is not wholly in control of itself. For a few moments these reactions effect an adaptation to circumambient, motionless nature. But as the animate approaches the inanimate, and the more highly-developed form of life comes closer to nature, it is alienated from it, since inanimate nature, which life in its most vigorous form aspires to become, is capable only of wholly external, spatial, relationships. Space is absolute alienation. When men try to become like nature they harden themselves against it. Protection as fear is a form of mimicry. The reflexes of stiffening and numbness in humans are archaic schemata of the urge to survive: by adaptation to death, life pays the toll of its continued existence.[65]

As Lewis suggests in his remark on satire, however, laughter may, like mimicry, fulfill a defensive function against a threatening "outside." Laughter may turn back self-reflexively on the subject, "stiffening" the self against danger, marking that minimal "spatial" difference between conscious life and the pure extensivity of dead nature: a difference that preserves the subject, however diminished, in situations of adversity.

In an extraordinary remark in his 1948 essay on Charlie Chaplin, the film critic André Bazin draws together these threads of laughter, self-defense, and mimicry in an example taken from contemporary popular culture. Bazin notes, in passing, how many of Chaplin's gags involved a peculiar way of "brushing aside danger": "'Camouflage' is not really the right term. It is more properly a form of mimicry. One might go so far as to say that the defense reflexes of Charlie end in a reabsorption of time by space."[66] Echoing the analysis of insect mimetism advanced by Roger Caillois during the 1930s,[67] also a crucial influence on Horkheimer and Adorno, Bazin's comments suggest that Chaplin's comedy depends on a kind of mechanical interruption of the flow of images and a breaking apart of the organic structure of movement. Such an interruption, however, is nothing more than a capacity implicit in the technical medium and apparatus of film itself, which simulates continuous motion by projecting a steady stream of discrete, slightly different images. Supplementing Bazin's claim that time is reabsorbed by space,

then, we might say that Chaplin's organic body becomes a mimetic extension of cinematic technology, which breaks down movement into constitutive fragments, discarding some while isolating and accentuating others. Having incorporated the technical principle of montage into his physical movements, Chaplin is able to mirror it back to the camera in embodied form. By perfecting the equivalence between his body and the "cinematic body" produced by the camera, Chaplin becomes the very allegory of cinema in its inaugural phase and the changes in experience it will precipitate.

Bazin continues his discussion by elaborating the image of the comic film star as mimetic insect:

The painted canvas tree in which Charlie is hiding blends in with the trees of the forest in a way that is quite "hallucinating." One is reminded of those little stick-like insects that are indiscernible in a clump of twigs or those little Indian insects that can take on the appearance of leaves, even leaves that caterpillars have nibbled. The sudden vegetable-like immobility of Charlie-the-tree is like an insect playing dead, as is his other gag in *The Adventurer* when he pretends to have been killed by a shot from a gun. But what distinguishes Charlie from the insect is the speed with which he returns from his condition of spatial dissolution into the cosmos, to a state of instant readiness for action. Thus, motionless inside his tree he flattens out, one after the other, with swift precise movements of his "branches," a file of German soldiers as they come within range. (149)

Both Bazin's rejected metaphor of "camouflage" and Chaplin's repeated regression into the backdrop before the oncoming column of German soldiers underscore how closely the issue of mimicry was tied to the historical context of war—for Chaplin, World War I, for Bazin, more immediately, World War II. At the same time, Bazin implicitly seconds Lewis's conception of a self-reflexive, defensive laughter, finding it in the laughable mimicry of the beleaguered little man. Chaplin's characteristic rhythm of fall and recomposure in the face of superior powers, human or mechanical, evoked a new sort of minimal self, as much corporeal as psychic, as much technical as organic, and held together by stiffening bonds of a laughter without exterior object.

In her essay "Place Names," Julia Kristeva explores precisely this minimal articulation of space in relation to the child's acquisition of language and the eventual sublimation of spatiality in syntactic structures. One section of the essay, entitled "Space Causes Laughter," considers precisely the scenario I pose above—but here not with respect to the

regression of a formed subject, rather with the nascence of the subject, the progression of the infant toward speaking/forming. Kristeva evokes a scene of a primary fusion of scattered elements in a crystallizing burst of laughter:

Voice, hearing, and sight are the archaic dispositions where the earliest forms of discreteness emerge. The breast, given and withdrawn; lamplight capturing the gaze; intermittent sounds of voice or music—all these meet with anaclisis [the "leaning" of one drive on another, for example, oral erotic drives on hunger—T.M.] . . . , hold it, and thus inhibit and absorb it in such a way that it is discharged and abated through them. . . . At that point, breast, light, and sound become a *there:* a place, a spot, a marker. The effect . . . is no longer quiet but laughter. The imprint of an archaic moment, the threshold of space, the "chora" as primitive stability absorbing anaclitic facilitation, produces laughter.[68]

This archaic laughter of the infant is, Kristeva emphasizes, unconnected to a "sense of humor," which "presupposes the superego and its bewilderment" (284). But it responds sensitively to temporary derangements of space such as distorted faces, caricatures, vertiginous movements, and falls. It absorbs and discharges the rapid, violent, excessive "facilitations" of the body in space: "they stop there, impart the jolt—laughter. Because it was bounded but not blocked, the rate of facilitation discards fright and bursts into a jolt of laughter" (284)."

This account, transferred from the nascent self of the infant to the marginal, endangered self of the adult in extremis, resonates strongly with Lewis's image of a laughter linked to self-affirmation rather than humor. Lewis, though at times very funny, nonetheless opposes "humor," "clowning," and mere "fun making." Already in the opening pages of *Tarr,* Lewis puts his eponymous hero up to an attack on "the University of Humour that prevails everywhere in England as the national institution for developing youth."[69] "Humour," Tarr argues, "paralyses the sense for Reality and wraps people in a phlegmatic and hysterical dream-world."[70] Two decades later, speaking on BBC Radio, Lewis would make the distinction between humorous and satiric laughter explicit: "Satire laughs as much as humour laughs. But satire laughs differently. In the satirist's laughter good humour is not implicit. But it would not be accurate to say that, in consequence, bad humour is of the essence of his mirth. . . . He merely takes his laughter more seriously, as it were. Laughter for him is an explosive agency, and its object is to blast, rather than to tickle."[71] His "humor" is a serious matter,

occasioned more by a spatial disturbance (an "explosive agency") than by anything "funny." It serves to absorb shock experience and to deflect it aggressively outward as self-preserving laughter.

Late modernist writing seeks to provoke this "serious," aggressive laughter. It is a deliberate conjuring, through the deformation of the body, through the evocation of its vulnerable "joints and sutures," its unpleasant "moistures" and "smells," of that "riant spaciousness" (Kristeva) that ends in laughter. Lewis thus writes:

> "Satire" . . . refers to an "expressionist" universe which is reeling a little, a little drunken with an overdose of the "ridiculous"—where everything is . . . *steeped* in a philosophic solution of the material, not of mirth, but of the intense and even painful sense of the absurd. It is a time, evidently, in which *homo animal ridens* is accentuating . . . that wild nihilism that is a function of reason and of which his laughter is the characteristic expression. (*MWA*, 232)

Satire, which Lewis often puts in scare quotes to indicate his unconventional "late modernist" definition, is thus the art of a *minima moralia*, the voice of "damaged life" persisting at the threshold of disappearance as a self.

. . .

Late modernist texts are, of course, complex literary structures, not tissues of pure laughter. Yet their forms have more than a casual relation to laughter. As Georges Bataille suggests, laughter suppresses knowledge, affirming and canceling it at the same time:

> He who laughs does not, theoretically, abandon his knowledge, but he refuses, for a time—a limited time—to accept it, he allows himself to be overcome by the impulse to laughter, so that what he knows is destroyed, but he retains, deep within, the conviction that it is not, after all, destroyed. When we laugh we retain deep within us that which is suppressed by laughter, but it has been only artificially suppressed.[72]

What Bataille describes psychologically as a relation between the mind, laughter, and knowledge can also, however, be understood in textual and rhetorical terms. In his studies of Rabelais, in fact, Bakhtin made precisely this translation from laughter as an affective expression to laughter as a formal component of texts. He argues that laughter can be "reduced," that is, sedimented into forms that preserve its disruptive force while restricting its active presence: "Under certain conditions

and in certain genres . . . laughter can be reduced. It continues to deter-mine the structure of the image, but it itself is muffled down to the min-imum: we see, as it were, the track left by laughter in the structure of represented reality, but the laughter itself we do not hear."[73] As a for-mal component of texts, laughter gives rise to modes of irony, parody, and satire in which the literal, denotative sense of a text is convulsed by a disruptive negation or deformation of sense. In works of reduced laughter, the text's form and figures are "altered," made other, blurred by a rhythm of doubling in which meanings are alternately posited and canceled. Through its reduction, its containment in generic forms and conventions that silence its explicit presence, laughter moves from folk practices and rituals (i.e., carnival, the feast) into the forms of discourse and, ultimately, the history of literary genres.[74]

Intuitively, it causes us no particular problem to grasp that there might be a relation between laughter and textual forms. After all, it is common enough that texts make us laugh, which at least suggests the possibility of moving from one to the other. Yet on reflection, the way in which this happens seems rather mysterious. How is it that some-thing as abstract and disembodied as, say, a description in a book brings about such a concrete, bodily response as laughter? It is even less clear how the process might be turned around: how physically embodied laughter could become virtual in language, "reduced," sedimented in textual forms. While Bakhtin's remarks are enormously provocative, one quickly reaches problems in explaining exactly how this process might work. Is the idea of "reduced" laughter just a clever theoretical cipher, a convenient way for Bakhtin to move between social context and textual forms without really explaining the mechanisms involved? For Bakhtin, I am tempted to answer this question in the affirmative. I also believe, however, that Bakhtin's sense of a transitive relation between embodied laughter and textual forms is correct and can be put on firmer theoretical grounds. For this task, it is necessary to turn to Freud's 1905 study of jokes, but to put it to somewhat unexpected use. For it is not Freud's psychoanalytic theory of jokes that offers the cru-cial key to this puzzle of relating laughter to textual form but rather his discussions of phenomena excluded from the ambit of psychoanalytic theory because they need not entail the workings of the unconscious: smut and the comic.

The first key lies in verbal behavior that is related to jokes but that exists on their margins: "smut." Freud argues in the third chapter of his study, "The Purposes of Jokes," that in certain situations a speaker uses

obscene language as a means of seduction; the speaker is trying to make the interlocutor *see*, in imagination, the sexual content of the words, and thus to arouse. If the attempt works, words pass rapidly into action, the clothes come off, and as Francesca tells a horrified Dante, they "read no more that day." If, however, the immediate aim is somehow inhibited, by situation or by the interlocutor's refusal, obscene speech takes on a peculiar autonomy, becoming a pleasurable end in itself. It is this autonomized obscenity that constitutes, properly speaking, smut. "Since the sexual aggressiveness is held up in its advance towards the act," Freud writes, "it pauses at the evocation of the excitement and derives pleasure from the signs of it in the woman" (Freud assumes that the seducer is male and the seduced is female).[75] This account provides us with an important analogy to Bakhtin's idea of "reduced laughter," for smut, in Freud's view, is "reduced arousal." In smutty speech, the words remain charged with a latent residue of the sexual scene and may suddenly modulate back toward action if the context changes—the nosy neighbor leaves, the interlocutor has a third double martini, "Old Blue Eyes" comes on the radio, and so on.

In Freud's account of smut, the affective force of the words, their ability to cause arousal, depends on a capacity of language that he leaves relatively unthematized here but that forms an important part of his theory of dreams: the intertranslatability of words and images. Words can conjure up images of the body, can make us see a sexual content, and can *affect* bodies by means of this capacity. In his chapter "Jokes and the Species of the Comic," Freud offers a theory of how the affective interface between psychic and corporeal acts arises, to explain how, for example, incongruities of movement or scale can make us laugh. He suggests that perceptions of space and motion come about imitatively. The imitative performance of movements sets a standard of "innervatory sensation," which can then be remembered even in the absence of an actually performed movement. In this way, embodied perceptions of actual objects, spaces, or movements can become memories of embodied states, which have the ability to affect the body when reactivated. In a provocative extension of these ideas, Freud goes on to suggest that our ways of expressing ourselves, not only gesturally, but also verbally and even conceptually, retain elements of these mimetically learned states. He calls this intermixture of embodied perceptions and affects with verbal and conceptual expressions "ideational mimetics." Thus, to take a simple example, our conventional use of metaphors of largeness and smallness reveals traces of our mimetic relations to objects and

spaces. Finally, Freud suggests that these mimetics not only form part of our intersubjective communication, for example in language, but also underlie *intrasubjective* processes like imagination.

This discussion of ideational mimetics is highly suggestive for our attempt to consider how texts and laughter might be transitively related, as Bakhtin's notion of "reduction" suggests. Freud, in essence, posits imitative activity as the crucial missing link that articulates the complex relations among language, imagination, affectivity, and embodiment. Moreover, if, as I have indicated, one of the essential historical characteristics of the interwar years is an enforced drive to imitation (what I call "generalized mimetism"), then Freud's theory suggests that late modernist literature may be registering a crucial change in the "ideational mimetics" of the period—that stock of figures, narrative structures, and images of voice that testify to the lived experience of the body in a determinate social space. The ideational mimetics of late modernism reveal the desperately heightened incongruities in the social experience of artists between the wars—incongruities that provoked self-reflexive laughter.

In texts structured in this way by reduced forms of laughter, open laughter only breaks out at points where the force of incongruity exceeds the containing energies of the image, at sites where figures rupture and forms fail. In late modernist works, accordingly, self-reflexive laughter bursts out above all at moments of maximum stress on characters, pushed to the limits of madness, dissociation, and death. The potential for such eruptive manifestations of laughter, however, underscores the tenuous nature of all such containing structures of literary form. Though from the position of the threatened subject, a writing structured around self-reflexive laughter may represent a potential foothold against disintegration, it nonetheless offers a significantly weaker formal principle than more symbolically unified modes. Laughter is at once articulated and mobile; it has an ambivalent relation to form. As Helmut Plessner writes: "To laughing . . . belongs . . . the significant and conscious relating of an expression to its occasion, an expression which breaks out eruptively, runs its course compulsively, and lacks definite symbolic form."[76]

In the case of late modernist writing the "occasion" is the writing itself, which seeks to provoke self-reflexive laughter as its "significant" and "conscious" expression. Yet as such, this intention represents a very weak organizing basis—an almost substanceless subjective ground for giving form to a work. This hypothesis is confirmed by the observable

lack of formal solidity in late modernist works, an absence of overall symbolic form, which runs the gamut from pastiche in works like Barnes's *Ladies Almanack* to out-and-out collapses of large-scale form in Beckett's *Dream of Fair to Middling Women* and Lewis's *The Childermass*. By comparison, the remnants of the *Bildungsroman* used by Joyce and Lawrence, the adventure genres adapted by Conrad, the tightly symmetrical structures of the late James, even the buried mythic underpinnings of *Ulysses* and *The Waste Land* represent relatively strong symbolic constructions for the author to renew creatively. Whether by compulsion or deliberate strategy, the late modernist writer stood opposed to the discursive mastery of earlier modernists.

With these general theoretical observations in mind, we can now turn briefly to Samuel Beckett and Djuna Barnes, to indicate how their work is animated by similar concerns as those expressed by Lewis, if in less openly polemical and programmatic ways.

V

Beckett's writing, like Lewis's, arises out of an analogous reflection on a peculiar type of laughter as the zero degree of subjectivity—a condition shared by the artist, his characters, and his reader/spectators. Critics have often pointed to Nell's observation in *Endgame* as a kind of encapsulated version of Beckett's tragicomic vision: "Nothing is funnier than unhappiness, I grant you that."[77] Less often remarked is the way that *laughter,* not happiness or unhappiness per se, is primarily at stake in Nell's meditation. For she goes on to say: "Yes, yes, it's the most comical thing in the world. And we laugh, we laugh, with a will, in the beginning. But it's always the same thing. Yes, it's like the funny story we have heard too often, we still find it funny, but we don't laugh any more" (19). This concern with laughter (and its disappearance) is consonant with the play as a whole, in which laughter, even where cruel or bitter, is an index of a minimal residue of humanness. Thus, asked to survey the horizon, Clov quips (pointing the telescope at the audience), "I see . . . a multitude . . . in transports . . . of joy," then turns to Hamm and asks, "Well? Don't we laugh?" Hamm replies: "I don't," and Clov concurs: "Nor I" (29).

Beckett's dramatic works of the fifties, with their post-*Unnameable* return to embodied characters and a comparatively "expansive" space of play, can be seen as recurring to the late modernist mode of the thirties

and early forties, after the admitted exhaustion of the trilogy and "texts for nothing."[78] And in fact, Beckett's last English novel, *Watt*, contains a meditation closely connected to the scenes from *Endgame* quoted above: in my view, a genuinely *theoretical* reflection on the nature of laughter. Its fictional framing is minimal, coming as it does in the long freestanding monologue of the departing servant Erskine to the newly arrived Watt:

Of all the laughs that strictly speaking are not laughs, but modes of ululation, only three I think need detain us, I mean the bitter, the hollow and the mirthless. They correspond to successive . . . excoriations of the understanding, and the passage from the one to the other is the passage from the lesser to the greater, from the lower to the higher, from the outer to the inner, from the gross to the fine, from the matter to the form. The laugh that now is mirthless once was hollow, the laugh that once was hollow once was bitter. And the laugh that once was bitter? Eyewater, Mr. Watt, eyewater. But do not let us waste our time with that. . . . The bitter, the hollow and—Haw! Haw!— the mirthless. The bitter laugh laughs at that which is not good, it is the ethical laugh. The hollow laugh laughs at that which is not true, it is the intellectual laugh. Not good! Not true! Well well. But the mirthless laugh is the dianoetic laugh, down the snout—Haw!—so. It is the laugh of laughs, the *risus purus,* the laugh laughing at the laugh, the beholding, the saluting of the highest joke, in a word the laugh that laughs—silence please—at that which is unhappy.[79]

Three things are notable about Erskine's remarks on laughter. First is that from the start he focuses on a particular kind of laughter: "strictly speaking not laughs, but modes of ululation . . . successive excoriations of the understanding." In short, this laughter has nothing to do with the laughter of humor but is rather a specifically satiric laughter, an exasperation of the mind and a lamentative howling. Erskine underscores this difference between ordinary laughter and satiric laughter by situating the latter above the "tragic" affects on his hierarchy of value. Thus, below the lowest mode of satiric laughter, the "bitter," is "eyewater" (i.e., tears), peremptorily dismissed as a waste of time.

Second, the lower two planes of satiric laughter, the bitter and the hollow, correspond to the objects of traditional satire: the bitter laugh is aimed at the unjust ("that which is not good") and is thus "ethical"; the hollow laugh is aimed at the untrue and is thus "intellectual." The modes of satire that provoke these forms of laughter depend on a stable position in ethical norms in the first case, in knowledge in the other. The satirist must him- or herself know the good and the true, and s/he

may assume the existence of at least a few listeners who also know them and who can thus understand the satire. But the last plane of laughter, the mirthless, occupies a strange, placeless, asocial space: the threshold—an originary *in*-adequation—between the mind and the world. The mirthless laugh is "dianoetic," pertaining to thinking, and specifically to a thinking that attempts to extend beyond the inherent properties of the mind itself. It laughs at unhappiness, which begins, Erskine implies, not with unhappy circumstances but with recognizing the world's alterity as such.

Finally, this laughter—as with Lewis's—is self-reflexive. The mind's recognition of the world's alterity is also a self-recognition. The mirthless laugh is the event of this recognition. It is the trace of consciousness confronting its minimal condition, the "beholding . . . of the highest joke," the genesis of consciousness *as* unhappy consciousness. The mind is unhappy and laughs at (the) unhappiness, which is itself: "the laugh laughing at the laugh." Such self-reflexivity should not, however, be understood as an example of the high modernist turn to authorial subjectivity as the basis of symbolic unity and, correlatively, its highlighting of epistemological questions (for example, the ironic occultation of truth in Conrad's novels). On the contrary, Beckett's assumption of an originary "infelicity" of mind and emphasis on "mirthless" laughter implicitly debunks the high modernist paradigm and its traffic in epistemological conundrums. Beckett disenchants the whole question of truth in favor of exploring epistemically contingent, "ungrounded" phenomena of pleasure, pain, social power, and death. "Yes or no?" Beckett's "seedy solipsist" Murphy asks. His free-floating commentator adds: "The eternal tautology."[80]

Unlike Lewis and Beckett, Djuna Barnes does not explicitly theorize laughter in her work. Nevertheless, implicit in her literary depictions is a problematic of threatened subjectivity and self-reflexive laughter similar to that identified in these other late modernist authors. Near the beginning of *Nightwood,* for example, the Jewish "aristocrat" Felix Volkbein finds himself at a party at Count Onatorio Altamonte's house in the company of circus actors and the ubiquitous Dr. Matthew O'Connor. Suddenly the Count makes his appearance, only to dismiss his party guests without further explanation. When the bewildered Felix asks the oxymoronically named (or hermaphroditically endowed) circus performer "Frau Mann" about the Count's authenticity, this "Lady" replies: "*Herr Gott!* . . . Am I what I say? Are you? Is the doctor? . . . Yes or no?"[81] Where everything is not what it seems, Frau Mann implies,

the very question of authenticity becomes nonsense, yes and no become tautological. Laughter, in turn, the late modernist's self-reflexive laughter, is the only appropriate response to this nonsensical world from which authenticity has been banished. Dr. O'Connor observes the scene, collecting himself in the face of the absurd through an inward-directed laughter: "The doctor was lighting a cigarette and in its flare the Baron saw that he was laughing silently" (*N*, 21). The Doctor's laughter shores up the ruins of his crumbling, night-roaming self, stopping his moral vertigo in a stiffening jolt. In a clear projection of his own desires and fears, Dr. O'Connor explains the Count's strange behavior in fancifully ribald terms. "Count Onatorio Altamonte," O'Connor claims, "suspected that he had come upon his last erection" (*N*, 21). Yet there is little need to ask how O'Connor might know of the Count's final tumescence, or whether he had guessed correctly. The Doctor's "explanation" refers first and foremost to himself. His punning play on the "last erection" before the "resurrection" is a joke on his own cockeyed condition, shuffling between the privies of Paris and the altars of its churches. He laughs self-reflexively, "hardening" himself against a threatening yet seductive loss of boundaries, maintaining his human "erection" against the temptation to dissolve himself into the darkness and night air.

Dr. O'Connor's hardening of the self through laughter stands in stark contrast to Felix's near-dissolution by it. On hearing the phrase (uttered by O'Connor) "the cold incautious melody of time crawling," Felix loses control of himself:

Felix . . . broke into uncontrollable laughter, and though this occurrence troubled him the rest of his life he was never able to explain it to himself. The company, instead of being silenced, went on as if nothing had happened. . . . This only added to the Baron's torment. He began waving his hands, saying, "Oh, please! please!" and suddenly he had a notion that he was doing something that wasn't laughing at all, but something much worse, though he kept saying to himself, "I am laughing, really laughing, nothing else whatsoever!" (*N*, 16)

I would suggest that this bizarre scene, almost incomprehensible in terms of narrative motivation, reflexively represents within the text the perilous place of Barnes's reader before her text.[82] Felix, himself precariously balanced in his own mask and costume, discovers the impossibility of *reading*—of interpreting—the unreal world of the Count's party. O'Connor's conceit ("the cold incautious melody of

time crawling") combines an evocation of infantile spatiality ("crawl-ing") and the absurd passage of time (a terrifying reality for Felix). It triggers the regressive unraveling of "the Baron's" confected identity. The demonic laugh that he hears comes from somewhere else, a sheer alterity. It is a mirthless laugh, expressing the perplexity of Barnes and her reader, to whom every form of relation to these characters is barred but one, the laughter welling up around Felix. And yet, the position of author and reader is inscribed nowhere else than within Felix himself. The laugh is self-reflexive, self-confirming, preserving the minimal con-dition of subjectivity and saving Felix from utter disintegration as a "character": "I am laughing, really laughing, nothing else whatsoever." The laugh brings him back "to himself," literally stiffening him against the next wave of the doctor's verbal onslaught: "As abruptly he sat straight up, his hands on the arms of the chair, staring fixedly at the doc-tor who was leaning forward as he drew a chair up exactly facing him" (*N*, 17).

VI

In the preceding discussion I have attempted to depict the complex web of factors that contribute to the emergence of late modernism near the end of the 1920s. I have also developed such key theoretical concepts as generalized mimetism, self-reflexive laughter, and the weakening of symbolic form in late modernist works of literature. In conclusion, I wish to offer a more general description of late modernist writing, in the form of a taxonomy of basic features. Although each of the authors I treat gives a personal inflection to the elements of the model I am defin-ing, and while the different texts of a given author manifest these ele-ments to a greater or lesser extent, I identify seven major areas of con-tinuity between them:

1) Late modernist works present a deauthenticated world in which subject and object, figure and ground, character and setting are only weakly counterposed or even partly intermingled. The different works may employ a greater or lesser degree of reference to "social reality," that is, may be more or less "mimetic" in the traditional sense. Yet whether they represent "realistically" a world where spectacle and sim-ulacra predominate and characters are near-puppets of external forces (as in Lewis's *The Revenge for Love*) or they construct a phantom het-erotopia from the start (Lewis's *The Childermass*), they are character-

ized by a disruption of stable differences and thus disclose the emergence of what I have called "generalized mimetism."

2) Both externally (in terms of the author's identification with an artistic or other social community) and internally (in terms of the author's narrative perspective as evident in literary texts), late modernism is decisively marked by a minimal "positionality" of the authorial subject. That is to say, these texts bear the marks of an author without determinate social, moral, political, and even narrative location: isolated, in drift, and unstably positioned with respect to the work. This minimal positionality stands in distinction to more traditional modes of satire, which depend on a stable basis in ethical norms or knowledge or custom, both for the satirist and for the projected audience of the satire; it also differs from the strong orchestrating role of earlier modernist authorship. The late modernist may assume neither a stable ground of values nor any commonality with an audience, nor even a subjective ground of form, beyond an anthropological minimum.

3) This "anthropological minimum" is what Lewis called "nonhuman, nonpersonal" laughter, what Beckett calls "mirthless laughter," and what I have analyzed and generalized as "self-reflexive laughter." This laughter, functioning to preserve and shore up—to "stiffen"—a subjectivity at risk of dissolution, constitutes the telos and minimum basis of formal unity for the late modernist work.

4) Following from this latter point, late modernism—in distinction to both traditional literary form and the formal principles animating earlier modernism—exhibits a major loosening of symbolic unity. Aimed at provoking self-reflexive laughter, late modernist works employ a special type of de-formed "spatial" form. This form resembles what Bakhtin calls "reduced laughter" and Kristeva calls "riant spaciousness"—a rhetorical, textual, and formal structure that occasions laughter. Such a mode of spatiality characterizes the mechanically disarticulated space of Lewis's "puppets"; the wobbly oscillations, semicircular peregrinations, and sudden disequilibrations of Beckett's tramps and clowns; and the bizarre mannerisms and tics of Barnes's "performers." Following Kristeva, I would characterize this spatiality as an irruption of a presymbolic, figural "chora" (a mobile order, rhythmically articulated) into symbolic form—a general "shaking loose" of fictional space and time into a disaggregated "choral" shape.[83]

5) Considered thematically rather than formally, "riant spaciousness" also accentuates the fragility and permeability of the human body and

its uneasy fit within the spaces around it. To put it otherwise, late modernism is marked by a predominance of grotesque bodies, motivated by the goal of provoking self-reflexive laughter.

6) One type of grotesque representation occupies a special thematic place in late modernism and should be separately mentioned: an obsessive depiction of pure corporeal automatism. Images of tics, fits, convulsions, involuntary eruptions, and more arcane phenomena like the bizarre ailments plaguing Beckett's characters or the example of "pleural shock" discussed above abound in late modernism as instances of "limit-experience." They stand as figures of an unthinkable and unrepresentable threshold: a pure laughter in which all subjectivity has been extinguished. Self-reflexive laughter may never cross or even reach this threshold, but it stands always in relation to it, as if in the field of its thanatopic magnetism.

7) Late modernism, finally, presents an image of subjectivity "at play" in the face of its own extinction. It prepares the literary ground for the anthropological "endgame" Beckett would betray to the world in the 1950s—the theatricalized gestures of the Western subject, rehearsing its final abdication.[84] Yet unlike, perhaps, the late writings of Beckett and other canonical instances of postmodernism, late modernism maintains a tenuous hold in the borderland of "mirthless laughter": a mortifying jolt that may yet work to stiffen and preserve.

Reading Late Modernism

The Self Condemned

Wyndham Lewis

I

The work of Wyndham Lewis would seem, on the face of it, an unlikely place to begin a critical discussion of *late* modernism. Lewis was, after all, a key player in the small but noisy pre–World War I British avant-garde. Already by the outbreak of the war, he had gained notoriety as the foremost representative of extreme modernism in painting and as the volcanic impulse behind the journal *Blast* (1914–1915). And while known at that time primarily as a visual artist, he had also published stories and sketches, eventually reprinted in *The Wild Body* (1927). His expressionistic play, *Enemy of the Stars,* featured violent action and screaming typography that fought for the spotlight with the manifestos in the first issue of *Blast.* This latter "drama," with its minimal plot, extraordinary science fiction-like setting, and extremities of language, probably represented the farthest frontier of experimental writing on the British scene until the publication of Woolf's *The Waves* and Joyce's *Finnegans Wake* many years later. Still finding few parallels in British or American writing, *Enemy of the Stars* stands more comfortably among the works of the early European avant-gardes, with the spectacles of Russian and Italian futurism or the violently contorted stage events of expressionism and dadaism.

Yet Lewis, as I have already noted, was interrupted in his role as leader of the British avant-garde. He went off to war in the uniform of an artillery officer; and he came back, as he regularly insisted throughout his later career, *erased:* "a man of the tabula rasa," as he would later

describe himself to Julian Symons.[1] The Great War imposed a division in his life and career, as deep and impassable as an intricate trench system. This hellish catastrophe was "more than war," Lewis would remark late in his life. "It put up a partition in one's mind; it blocked off the past literally as if a huge wall had been set up there."[2] Lewis's enormous energies were never stymied for long, however, and he began over, intensively remaking himself as the artistic lone gun, the aggressive polemicist-critic, the political enemy.

The specific forms his self-reinvention took are crucial to my account, as indices of broader shifts and ruptures within the cultural formation we have come to call modernism. Two additional reasons, however, contribute to the central role that I give Lewis in this study of late modernism. First was his torrential productivity. By 1937, according to his own account, Lewis had written twenty-four books, many of considerable scale: novels, works of criticism, polemics, political tracts, short story collections. Along with this literary production, he managed to sustain a respectable, if financially and politically hampered, career as a painter as well. The sheer volume of his production in so many areas, then, allows me not just to read "symptomatically" a few literary works for their tensions with the prestigious exemplars of modernism, an approach I necessarily take to the writings of Djuna Barnes and Samuel Beckett in the chapters that follow. Lewis's comprehensive writing practice embraces several registers and rhetorics, from publicistic harangues and popular journalism to highly erudite discussions of literature, art, and philosophy. The broadest reach of Lewis's written output creates, of itself, a significant context for understanding the more circumscribed field of "literary" (or as he put it, "formal") writings—works in which Lewis's polemic against modernism remains more tacit, expressed primarily through his handling of narrative voice, stylistic parody, and formal manipulation. Lewis devotes so many pages of his "informal" writing—pamphlets, articles, polemics, literary criticism, philosophical reflections, political commentary, letters to editors, private correspondence—to cultural, political, and autobiographical justification of his literary practice that the task of the critic becomes somewhat different than when confronting more taciturn writers like Barnes and Beckett. In Lewis's case, the critic is compelled to sift through and collate materials across the different genres and domains that engaged Lewis's energies as a writer, in order that a coherent picture of his trouble with modernism might eventually emerge.

I also give Lewis pride of place because of a peculiarity of his career, which allows us to measure with a certain precision the difference between his early and later contexts as they affected the social meaning of his writings. In a span of a few years, Lewis republished almost everything he had written before or during the war, much of it in substantially revised form. His reinvention of himself entailed a kind of repetition of his literary beginnings. But it was a repetition with a difference, a second beginning in a new political and cultural environment. In considering Lewis's acts of revision, critics have often evaluated the *stylistic* shifts that distinguish the earlier and later versions of the *Wild Body* short stories, the novel *Tarr,* and the vorticist drama *Enemy of the Stars.* I am not concerned here, however, with the question of which version is better. I seek to delineate the new discursive and practical contexts in which the works reappear, new contexts that are at least partially shaped by contemporaneous works Lewis was newly publishing alongside the republished early works. Lewis's early work, I suggest, took shape within the framework of avant-garde groupings and concerns. The republished work, in contrast, appears within the expanded framework of Lewis's intellectual activity after 1926, activity increasingly bound up with a logic of publicity, ideological conflict, and struggle over canonizing authority in literary criticism.

II

In the late 1930s, finding himself politically isolated, financially straitened, and desperate from the evident approach of another war, Wyndham Lewis took a break from his pamphlets, political tracts, and novels to compose his autobiography. This book, *Blasting and Bombardiering,* treated only one segment of the life of the fifty-five-year-old artist and writer: the years of the war and of the immediate postwar period, 1914 to 1926. Lewis viewed this work of remembrance as "a trip to a stricken area," where a "spot of tidying up had to be effected."[3] The war years and their aftermath still held for him a traumatic charge and, like a war neurosis, had to be reenacted and reexperienced. "They still have a life of sorts," he wrote, "while you live, and they just tumbled out upon the floor of time in a disorderly heap. They must almost be re-lived, for antiseptic purposes" (*B&B,* 6).

Lewis's act of memorial hygiene served equally to polish an image of his career. He was self-consciously fostering one picture of it and trying,

if possible, to preempt other views. He needed to cordon off the twelve years following 1914 and set them to order; the year 1926 had to appear a dangerous moment faced once and forever dispelled. Yet these very years continued to harken, sirenlike, back to a dead time—a time of mass death in the trenches and of artistic death in the "underground" years of Lewis's turn from painting to writing. "My first book *Tarr* was a novel (1918)," Lewis writes. "Then I buried myself. I disinterred myself in 1926, the year of the General Strike" (*B&B*, 5). Through writing, Lewis fought his way back to the surface again and struggled to remain there, wishing to avoid at any cost another descent into the trenches and the mud.

Lewis identifies his "rebirth" with a key event of mass politics, the failed General Strike, which at once exposed the moribund nature of British social institutions and revealed the unreadiness of labor to offer an alternative. It was also in this year of conflict that Lewis unleashed the first of his major polemics against the culture of modernism, *The Art of Being Ruled*, followed the next year by *Time and Western Man*. Lewis's political critique and the literary ideology of these books began to march in step; 1926 was the year in which the notorious fascist-leaning antimodernist "Enemy," Wyndham Lewis, had himself born. Lewis's parting with modernism and ambivalent turn toward fascism thus seem to pivot around this year of strikes and blasted cohorts in the modernist movement. Accordingly, through a detailed look at the various contexts and connotations implied by Lewis's reference to the General Strike in his fictions and polemics, we can discern how elaborately intertwined in Lewis's activity as a writer were his political and aesthetic concerns.

A crucial stage for these concerns was Lewis's notorious barrage against the twin camps of fashionable modernism, the Bloomsburys and the Sitwell clique, in *The Apes of God* (1930). After hundreds of pages, he brings his satiric ape hunt to its conclusion with a chapter entitled, significantly, "The General Strike." In this final chapter, having long suffered the social slings and arrows of outrageous apehood, Lewis's witless hero Dan, suspiciously resembling the young Stephen Spender, finds himself lost and alone in the midst of an unfamiliarly quiet London, paralyzed by the lack of motor traffic. The strike has shut down the buses, trams, and trains, and only the roving bourgeois volunteers, who offer rides to stranded employees, are on the streets. Dan, however, in his obliviousness to everything and all, has no idea that a strike is on and instead believes he is being propositioned by well-dressed

homosexual motorists. Indignantly, he refuses their altruistic advances. Whereas in the earlier chapters of the book, Dan fails to perceive the bourgeois class consciousness expressed in homosexuality (as Lewis believed), "The General Strike" parodically reverses and literalizes the scene; now Dan mistakes an overt expression of ruling-class activism for sexual impropriety.[4]

The chapter ends with a grotesque parody of Virginia Woolf's *Mrs. Dalloway*. Woolf's novel appeared in the year before the General Strike and comes to stand in Lewis's text as an emblematic instance of a modernism become manner and fashion. Two passages from that work contribute to Lewis's concluding chapter in *The Apes of God*. In the first of these, Woolf offers a scene in which Clarissa Dalloway's former suitor, Peter Walsh, is interrupted in his peripatetic reveries (about kissing Clarissa) by the sound of singing in the street:

A sound interrupted him; a frail quivering sound, a voice bubbling up without direction, vigour, beginning or end, running weakly and shrilly and with an absence of all human meaning into

ee um fah um so
foo swee too eem oo—

the voice of no age or sex, the voice of an ancient spring spouting from the earth; which issued, just opposite Regent's Park Tube station from a tall quivering shape, like a funnel, like a rusty pump, like a wind-beaten tree for ever barren of leaves which lets the wind run up and down its branches singing

ee um fah um so
foo swee too eem oo

and rocks and creaks and moans in the eternal breeze.[5]

Later, Woolf evokes the image of a dying woman, imagined in Elizabeth Dalloway's mind, as the noise from the parade going on below rises to her from the street:

The noise was tremendous; and suddenly there were trumpets (the unemployed) blaring, rattling about in the uproar; military music; as if people were marching; yet had they been dying—had some woman breathed her last and whoever was watching, opening the window of the room where she had just brought off that last act of supreme dignity, looked down on Fleet Street, that uproar, that military music would have come triumphing up to him, consolatory, indifferent. (138)

Lewis pastiches the two, both literalizing the free-floating image of the dying woman—in Woolf's text, a kind of indeterminate psychological

metonymy for Miss Kilman, who "liked people who were ill" (136)—
and parodically mimicking the typographical rendering of the wordless
song. In Lewis's version, it is no longer the maturely handsome Clarissa
and Peter who occupy the scene but rather the utterly decrepit Lady
Fredigonde and the shameless gold-digger Horace Zagreus. As Zagreus
proposes to Fredigonde and bends to kiss her, she hears the sound of
"Death the Drummer" in the street below:

> Their lips met, and the love-light softened the old discoloured corneous sur-
> face of the fredigondean eyeball, once a lacteous blue. Over this conven-
> tionally she dropped her lids in a token of virgin-rapture.—In the street out-
> side there was a frenzied rattle. . . . There was a drum-tap. Like rain drops,
> there was a constant tapping, a sharp drip upon the loud parchment. Then
> came the first soft crash of the attendant cymbal—it was the prelude of the
> thunder. And in the gutter the crazy instruments at last struck up their sen-
> timental jazzing one-time stutter—gutter-thunder.

> Whoddle ah *doo*
> Wen *yoo*
> Are *far*
> *Away*
> An *I*
> am *bloo*
> Whoddle ah *doo*
> Whoddlah DOOOO![6]

This concluding "emblem" of *The Apes of God,* patched together from
fragments of Woolf's precursor text, finds its visual complement in
Lewis's drawings for the book. The illustration for this concluding chap-
ter is an ape paw hanging from a chain link, which is in turn fastened to
the wall. It can be understood as the grotesque, flaccid, slavish double of
the clenched, chain-breaking fist of socialist iconography: at once the
symbol of ruling-class feebleness and, in its apish ability to mimic revo-
lutionary gestures while remaining in chains, the very instrument of con-
tinued bourgeois ascendancy. In fact, Lewis returned to the image of the
militant ape paw when he satirized the thirties poets a few years later in
his poem *One-Way Song.* Here, on the title page of the section called
"Engine Fight-Talk," his icon has recovered its erect shape after its impo-
tent collapse in the General Strike; it stands ready, in clublike, hairy
tumescence, to wage the intensifying class, age, and sex wars of the day.

Lewis, as the satiric artist, rests uncomfortably between these two
class emblems. If he associates his own reemergence as a writer and a
cultural critic with 1926, this role depends on the very indecision of that

PART XIII.

THE GENERAL STRIKE.

Figure 3. Wyndham Lewis, *The General Strike*, illustration from *The Apes of God*. Illustration copyright © 1981 by the Estate of Mrs. G. A. Wyndham Lewis by permission of the Wyndham Lewis Memorial Trust. Reprinted from *The Apes of God* with the permission of Black Sparrow Press.

year's historic event, which neither led to socialism nor allowed a confident restoration of ruling-class order. Such a catastrophic balance between opposed forces pervades Lewis's fiction both structurally and thematically, and it constitutes an essential element of his political ideology as well. Historically speaking, however, the catastrophic

equilibrium of social forces was the political condition under which fascist movements arose and were able to appeal to members of society threatened by social and economic instability. As Antonio Gramsci noted, fascist-type movements were "rendered historically effective by their adversary's inability to construct, not an inherent force of their own. Hence they are linked to a particular situation of equilibrium between the conflicting forces—both incapable in their respective camps of giving autonomous expression to a will for reconstruction."[7] The leader of the British fascists, Oswald Mosley, employed this rhetorical image of a stalemate of ideological opponents as a primary appeal for a new party of action, which could bring the positive elements of both sides out of deadlock:

The two essentials of Government are stability and progress; and the tragedy of politics is that the two, essentially coincident, are organised as contradictions. . . . The result of both systems of the great organised Parties of the State is in the end the same. Stability confused with reaction and a resistance to change, together with progress confused with obstructive debate and committee irresponsibility, end alike in chaos. Both are instruments for preventing things being done, and the first requisite of the modern age is that things be done.[8]

By 1930, when Lewis published *The Apes of God*, Britain was quickly nearing the trough of the long economic slump that only really ended with the renewal of wartime production.[9] The following year would bring disastrous electoral losses of the Labour party, disappointing many liberal intellectuals and leading to an increasing political polarization to both the right and the left, with the increasing appeal of the Communist party at one extreme and the rise of Oswald Mosley's British Union of Fascists at the other. While fascism never had the fertile territory in Britain that it had in Germany, Italy, Austria, and even France, the relative weakness of the British state after World War I did conjure for some intellectuals, Lewis among them, the specter of an interminable struggle between a moribund ruling class and a newly aggressive but still politically uncertain working class. In this context, a political third force that would call itself, as Lewis and his compatriots had once, the "Modern Movement," could find a positive echo.[10]

For Lewis, this political deadlock between social classes was redoubled in the politics of everyday life: above all, in the relations of the sexes and of the generations. In *The Apes of God*, the idea of a sex and age war is "broadcast" at the Finnian Shaw costume party by the aristocrat

Starr-Smith (probably based on the future fascist leader Mosley), a surly, super-masculine crasher attired in Italian blackshirt:

The *child-parent-war* is put across by means of the emotions aroused by the *age-complex* and the *youth-complex* dominating the first Post-war decade. The *child-parent-war* is the war next in succession to the *sex-war.* . . . (For the break-up of the aryan Family-idea, two "wars" have been arranged. The *sex-war* covers the child-parent relationship. This is a parallel "revolt." When these "wars" have been brought to bear in social life with full effect, the Family will have entirely disintegrated.) (*AOG,* 531)

I will suspend until later the question of how closely these views can be taken to express Lewis's own.[11] For now it suffices to remark that "fascist discourse" emerges in the novel in the context (postulated, at least, by Lewis) of interlocking conflicts tending to exhaust the traditional institutions of social authority.

Starr-Smith, moreover, sees social critique and revolt as already compromised by the saturation of the social field with oppositional discourses and actions. There are two consistent responses to such an analysis, between which Lewis's own political writings tend to waver. One would be commitment to some "third force" of renewal, not trapped in the conflicts of the other parties: a primary appeal of fascism at this time. The other, which probably could be considered Lewis's predominant but not always consistently held position, is a resolute suspicion of all ideology and political action.

Retrospectively, then, Lewis associated his own reemergence in 1926 with the British General Strike. This event was important ideologically for Lewis, for it revealed the fragility of the postwar consensus on which, in his view, writers like Arnold Bennett, the Sitwell clique, and the Bloomsbury circle were wholly dependent. At the same time, it revealed the relative weakness and lack of political consciousness of the forces that had most to gain from the destruction of that order—the working classes. Under these circumstances, Lewis believed, the social arena would be increasingly filled with combatants, locked in continuous struggle, but without any definitive resolution. These battles would multiply—between the sexes, races, classes, and nations—until generalized into one total but no less static Great War like the one in which Lewis had suffered a decade earlier.

Lewis's reference to the General Strike, finally, is also significant in a less direct way, for the implied analogy to his own oppositional "strike" against modernism. Lewis launched his polemic against modernism first

in his 1926 book, *The Art of Being Ruled;* he followed up the next year with "The Revolutionary Simpleton," an attack on his friend and supporter Ezra Pound. 1927 also saw the publication of *Time and Western Man,* which lambasted everyone from Stein to Einstein. Yet by 1937, when Lewis's *Blasting and Bombardiering* appeared, this association of his "revolutionary gesture" with that of the British proletariat was an ironic one, to say the least. For the General Strike, like Lewis's attempt to reform literary culture at one blow, was largely a failure. Just as the mass strikes of 1926 had fizzled due to the indifference or hostility of the public, and to compromises and betrayals by the leadership, so too, in Lewis's view, the critical putsch he had attempted had gained few followers. Neither "event," neither the large-scale political one nor the more restricted literary one, produced the revolutionary changes their authors had hoped they would—a fact painfully evident to Lewis by the mid-1930s.

With *The Art of Being Ruled, Time and Western Man,* and *The Childermass,* Lewis had sincerely hoped to reassert the artistic leadership he had once exerted in 1914 with *Blast.* Instead, he succeeded in plunging himself into ever-deeper political and artistic isolation, as his positions rigidified and his arguments became more shrill. Lewis even implies a causal link between the failed General Strike and his own backfired rebellion. The enduring fashion of the art he disliked and the pliability of the institutions he hated both pointed, in his view, to a single, hidden machinery of power. In the critical and fictional works that appear after 1926, the code of art and the code of politics become mutually translatable.

Returning to Lewis's parody of Woolf at the end of "The General Strike," I would argue that, besides the particular political valencies of the passage, it also demonstrates a salient aspect of Lewis's late modernist writing as a whole: in these works, modernistic qualities and specific antimodernist polemics are intimately related. At a surface, or let us say, *phenomenological* level, Lewis's style here is marked by the same disjunctions and perspectival estrangements that lend Woolf's prose its difficult beauty. Yet at an implicit *polemical* level—a level accessible only by establishing Lewis's passage in a particular context of personages and discourses—Lewis rejects in the most stringent terms Woolf's flowing lyricism, her stylistic applications of Bloomsbury formalist aesthetics, her rather snobbish class consciousness, and her liberal feminist outlook. Here and elsewhere, Lewis's prose becomes a curious mélange of mimicry and violent rejection. I should also note that a few years after the appearance of *The Apes of God,* Lewis made another parodic jab at

Woolf in *The Roaring Queen,* a send-up of book prizes, reviewers, and the detective-fiction craze; in 1936, the book was withdrawn by Jonathan Cape for fear of libel.[12] In his strong turn to parody and satire, then, Lewis sharpened his oppositional stance to high modernism while, paradoxically, feeding his opposition on the rich stylistic fodder and personal mythology of the writers he was attacking: Joyce, Stein, Woolf, Hemingway, Lawrence, Pound.

In his critical study *Men Without Art,* published two years after *The Apes of God,* Lewis would make his polemical attack on Woolf explicit. The stakes were, for Lewis, not so much strictly literary as critical and ideological. Lewis took up Woolf's renowned essay "Mr. Bennett and Mrs. Brown," to argue against her strictures on realism and her historicist account of why the modern novel was necessarily fragmentary and attenuated in comparison to an earlier time. Lewis's arguments boil down to two: that in linking her anti-Edwardian polemic to her feminist concerns with Mrs. Brown, Woolf was exploiting gender conflicts to advance the interests of her literary-artistic coterie, the Bloomsbury circle; and that Woolf's position presupposed and exemplified the provincialism of that clique's views—"as though," Lewis writes, "she, Bennett, Wells and Galsworthy had been the only people in the world at the time, and as if there had been no books but their books, and no land but England."[13] For Lewis, however, Woolf was merely a convenient target for attacking what he saw as the new modernist hegemony in *literary criticism,* a bloc of opinion represented above all by Eliot, Woolf, Spender, and the new Cambridge Modern English figureheads, I. A. Richards and the Leavises.[14] "The people who have been most influential in literary criticism, for a number of years now," he writes, "have been interested in the propagation of this account of things—just as the orthodox economists have, consciously or not, from interested motives, maintained in its place the traditional picture—that of superhuman *difficulty*—of some *absolute* obstructing the free circulation of the good things of life" (*MWA,* 138). Woolf, for her part, also realized that this struggle with modernist critical orthodoxy was indeed the aim of Lewis's attack. Before having even seen Lewis's *Men Without Art,* having only read an advertisement for the forthcoming book, Woolf wrote in her diary: "Now I know by reason & instinct that this is an attack; that I am publicly demolished: nothing is left of me in Oxford & Cambridge & places where the young read Wyndham Lewis" (Woolf, cited in *MWA,* 306).

One such young person was I. A. Richards's maverick student William Empson. In his 1935 study of pastoral, for example, Empson praises

Lewis's Shakespeare book, *The Lion and the Fox,* and in his discussion of *Alice in Wonderland,* he appropriates Lewis's ideas on "child-cult," first argued in *Time and Western Man.* In a late essay, a preface for John Harrison's study of the modernist right-wing, *The Reactionaries,* Empson begins with testimony to Lewis's influence on his views: "'Oh, it's a wild life in the Near West, between one revelation and another,' said Wyndham Lewis, describing the intellectual scene around him as a fun fair; that was in *Time and Western Man* (1928), and I felt the exhilaration of it, even then. Now that everything is so dismal we should look back with reverence on that great age of poets and fundamental thinkers, who were so ready to consider heroic remedies."[15] On the other hand, Lewis was not generally included in the canon of modernist works given favor in F. R. Leavis's *Scrutiny.* Typical in this regard is Leavis's own 1934 dismissal of Lewis, in an article entitled "Mr. Eliot, Mr. Wyndham Lewis and Lawrence": "No one who can read will acclaim Lawrence as a philosopher, but 'incapacity for what we ordinarily call thinking'— does this not apply far more to Mr. Wyndham Lewis than to Lawrence? . . . His pamphleteering volumes are not books; their air of sustained and ordered argument is a kind of bluff, as the reader who, having contrived to read one through, can bring himself to attempt a summary of it discovers."[16] Seconding Leavis's view was also T. R. Barnes's judgment on Lewis in his dismissive review of the 1932 critical book *Wyndham Lewis: A Discursive Exposition,* by Hugh Gordon Porteus: "That Lewis is well informed and intelligent is obvious; but the exaggerated contemporary estimate of him seems to rest on two things—the amount he has written, and his own self-advertisement. . . . Lewis, like Shaw, Wells, and the Sitwells, sells his wares. Unlike the Sitwells, he really has something for sale, but it would be absurd to take him at his own valuation. He is a symptom, not a leader, of the age."[17]

Only in this charged critical climate, in which the stakes were the direction of both extra-academic literary culture and the legitimacy of Modern English literary studies at the British university, does Lewis's satiric writing take on its full meaning: a meaning divided between its often avant-garde style and its antimodernist ideology. Discussing Lewis's much earlier vorticist paintings, Tom Normand suggests that in Lewis's visual works a similar disjunction of style and rhetorical address can be detected. Already by 1912–1913, Normand argues, Lewis's cubo-futurist vocabulary stood in tension with his developing theoretical analysis, his political and philosophical worldview that opposed futurism's vitalistic celebration of modern urban life. In Lewis's vorti-

cist works, Normand concludes, the "formalist syntax was always qual-
ified by a specific theoretical grammar."[18] If during the 1920s and
1930s, Lewis would in fact deepen and extend this "theoretical gram-
mar" which undergirded both his painting and writing, he would also
increasingly inflect his "formalist syntax" through polemical clashes and
crashes with its discursive context. As Lewis engaged more and more in
the conflict of his own ideas with those of his context, the status of the
manifest texts in which "walking ideas" collided with one another
became increasingly uncertain. Lewis's texts themselves represented
only a limited, easily deceptive part of the meaning of the "works" as
whole. For the total works, Lewis's procedures suggest, include both
the hidden polemical occasions of the texts and the aftereffects of their
release, the echoing "report" that he explicitly conspired to heighten
and extend. The work's meaning encompasses both an embedded
structure of ideas and ideology, which might contradict the surface
meaning of the text, and a dialogical, polemical relation to a context of
external discourses surrounding the text. While this layered structure is
hardly unique to Lewis's text (it may, indeed, be universal), Lewis is sin-
gular among Anglo-American modernists in his insistence on the vio-
lent separation of these domains and in his exacerbation to the breaking
point of the potential dissonance between them.

III

As might be expected, Lewis's semiallegorical associations of his own
career with large-scale social history tell only part of the story. The evi-
dence of Lewis's letters and the excellent philological material in Paul
Edwards's reedited *Time and Western Man* make it possible to describe
the immediate process by which Lewis developed his critique of mod-
ernism and evolved the critical orientation of his later fiction. For
Edwards, Lewis's publication of "The Revolutionary Simpleton," first
in *The Enemy* in January 1927 and then again the following year as the
first part of *Time and Western Man*, is not simply an index of Lewis's dis-
enchantment with modernism; it is also the very act by which Lewis
broke with its artistic cadre.[19] In "The Revolutionary Simpleton," Lewis
delivered a series of blistering attacks on Gertrude Stein, Ezra Pound,
James Joyce, Anita Loos, Charlie Chaplin, Ernst Walsh, and other impor-
tant figures of the modernist movement. If Lewis viewed 1926 as a piv-
otal year in his career, this publication played a substantial role in its
drama.

The years following the war saw the convergence of several currents in Lewis's life, work, and thinking. First, there was a crucial shift in the center of gravity in his creative life from painting to writing and a concomitant change of focus in Lewis's artistic politics. This transition was marked by three main phases: a period of relative hiatus in the years immediately following the war (about 1918–1921); Lewis's commencement of a large-scale work, *The Man of the World*, in 1922 and the composition of a philosophically oriented but generically undifferentiated mass of prose between 1922 and 1925; and his segmenting and rewriting of this aggregate as independent books from 1925 to 1928.[20] In this last phase, Lewis also revised and republished his early works *The Wild Body* and *Tarr;* his other major early text, *The Enemy of the Stars,* reappeared in revised form in 1932.

A letter to Ezra Pound dated 29 April 1925 suggests the scope of Lewis's *Man of the World* at this time and the segmenting of that work which would form the basis of the majority of Lewis's published books in the latter half of the 1920s. Lewis describes how, having failed with one publisher, he changed his mind about publishing *The Man of the World* as a single five-hundred-thousand-word book. It would have to be broken up into separate volumes, a task fortunately requiring little rewriting, since the original form of the work lent itself to this partitioning: "In each part of the original book I had repeated the initial argument, associating it with the new evidence provided by the particular material of each part."[21] Lewis goes on to enumerate the projected series of works:

One of them . . . is to be printed by Macalmon [McAlmon]. That is about the question of CLASS, but I have not got a title for it yet. There is a hundred thousand word volume, called *The Lion and the Fox* about Shakespeare, principally. There is one called *Sub Persona Infantis* which deals with a particular phase . . . of the contemporary sensibility. *The Shaman* about exoliti & sex-transformation. *The Politics of the Personality* (100 thousand) principally evidence of philosophy, one (100 thousand) called *The Politics of Philistia* & one called *The Strategy of Defeat* (40 thousand). Then there are 2 vols. (not of course part of the Man of the World) of *The Apes of God* (fiction) the first of which is nearly done. *Joint* (sketched & partly done) *Archie* (complete, thirty or forty thousand).—*The Great Fish Jesus Christ* (45 thousand). (*P/L,* 144–145)

Notable are both Lewis's encyclopedic ambition and the implied links his monumental work made between class, race, age, and sexuality in the realms of social life, politics, philosophy, and culture. Moreover,

Lewis's mention of the works of fiction that are not part of *The Man of the World* nonetheless sets the satires and fiction in the ideational cosmos formed by it, while the fiction represents a more immediate testing ground for philosophical and political ideas. At the same time, Lewis began casting about for a publisher to reissue the vorticist drama *Enemy of the Stars,* now carrying a forty-thousand-word essay in tow.[22] As with the *Man of the World* material, Lewis increasingly tied his literary works to his new commitment to theorize and polemicize directly about his social context.

The three years prior to the break in 1927 not only saw the articulation of *The Man of the World* into several separate volumes of key importance in Lewis's corpus; they also constituted a period of intensive contact between Lewis and his modernist peers, especially those of the Anglo-American expatriate scene in Paris. Lewis's connections at this time included not just the "men of 1914"—Joyce, Eliot, and Pound—with whom he is often associated in literary history and criticism, but also less olympian figures who were nonetheless integral to the financial and publication infrastructure of Paris-based modernism: Ernst Walsh (editor of *This Quarter*); Winifred Ellerman (known as "Bryher," companion of the poet H.D., novelist, and wealthy supporter of many artistic and political causes); and Robert McAlmon (novelist and editor of the Contact Press and Journal).[23] Prior to his permanent departure for Italy late in 1924 (and by correspondence afterward), Pound facilitated Lewis's approach to the Parisian circles, but he conducted his well-meant campaigns in ways guaranteed to sour his touchy friend on the whole affair. In particular, Pound sought to maintain the division of labor between Lewis as the genius of the visual arts and the other men of 1914 as the genii of the word. As Paul Edwards notes, "Pound, generous as always, wanted to 'sell' Lewis to *This Quarter* as an avant-garde painter, but this would be for Lewis only a distraction from his new career as a writer. He did not welcome such a revival of his earlier role, in which he had been thwarted in England, he believed, by the machinations of Bloomsbury."[24] Pound unsuccessfully tried to convince Lewis, who for his part was interested in publishing his new prose, that his interest in Lewis's visual artwork was not simply a scheme to reject his writing: "This does *not* mean that they wont [sic] use and pay for your text, but it does mean that they are definitely ready to lay out on doing a decent W.L. art supplement; you may remember, or you mayn't, that I tried to get Lane et al. to take a book on you, by me, WITH illustrations back in 16 or 17."[25] Pound's damage control for

This Quarter just compounded the perceived slight for Lewis. For not only did Pound's well-meaning efforts harken back nostalgically to the short-lived vorticist community (in "The Revolutionary Simpleton," Lewis would attack Pound as "A Man in Love with the Past"). It also failed to acknowledge Lewis's reemergence as a writer and cultural critic, engaged centrally with the practice and politics of *literature* in the postwar period. Lewis responded with characteristic testiness: "Dear E.P. I do not want a 'Lewis number' or anything of that sort in This Quarter or *anywhere* else, at this moment. My reasons are my own affair, although I indicated them as much as was necessary. Have I said this to you or not?"[26] Following a series of petty quarrels and more serious disagreements of outlook with Walsh, McAlmon, and Pound himself, Lewis definitively closed this chapter of his career with his publication of "The Revolutionary Simpleton."[27]

IV

Two characteristic expressions of Lewis's displacement of modernist poetics can be discovered in his fiction of the late twenties and thirties. In predominantly satiric works like *The Childermass* and *The Apes of God*, Lewis employs modernist techniques while divesting them of their thematic legitimation. They appear as mechanical and hollow, absurdly functional within the more general social and political farce portrayed in his books. These techniques are highly "inorganic" to Lewis's texts: they are not clearly motivated by events or characters and thus often appear like tics and mannerisms erupting into the text; nor are they justified by an overriding stylistic unity, as are the idiosyncratic sentence forms in James's *The Golden Bowl*, Lawrence's *The Rainbow*, Hemingway's early stories, or perhaps even Lewis's own *Tarr*.

In later works like *The Revenge for Love* and *The Vulgar Streak*, Lewis apparently renounces the disruptions of grammatical and narrative syntax characteristic of his earlier prose and returns in long stretches to something resembling classical realist style.[28] While it would be possible to see this return to order in the fiction as congruent with Lewis's desire for order in the political arena, this view would both oversimplify the relation of literary form to politics and mischaracterize Lewis's prose of this time. On the one hand, the change in style does reflect Lewis's heightened rhetorical concern to establish his literary work within a broader social context (and not just political, but also commercial). On

the other hand, I want to suggest that this "realism," this return to certain "naturalist" conventions, is not as straightforward as it might first appear. For the world it "realistically" depicts is a universally de-realized one, one permeated by mimicry, counterfeit, diversion, imposture, and spectacle: the condition of generalized mimetism. The apparent transparency of these works is an unsettling, uncanny *fiction* of reference— not because the texts disrupt referentiality, like the vorticist montage text *The Enemy of the Stars,* but because the referent is explicitly thematized by the text as a mirage. More than "realist," these works are "hyperrealist"; if in a certain sense "naturalist," they nevertheless reflect a simulacral nature, a denatured reality of spectacles, codes, and models.

Yet while one can identify a certain shift from the novels of the late twenties to the novels of the thirties, the distinction should not be exaggerated. These two phases of Lewis's writing represent inflections and developments within a common late modernist aesthetic, rather than different modes altogether. In my view, the relevant divisions in Lewis's corpus are not between an "experimental" phase (ending in the twenties) and a return to "realism" (beginning in the thirties) but rather between the earlier work up to *Tarr,* the long middle phase including the majority of Lewis's fiction and criticism, and his partial abrogation of satire in the two late novels with which he attempted to complete *The Human Age* (*Monstre Gai* and *Malign Fiesta*), twenty-five years after the first installment (*The Childermass*) appeared.[29] Within the middle period, embracing the work of the late twenties and thirties along with much of Lewis's later work, there are a number of fundamental continuities, despite the differences in surface texture and style.

In any case, the shift that occurred across the divide of 1926–1927 did register itself in Lewis's writing in points of style and general approach, but still more decisively in the relation of Lewis's literary works to the surrounding social and discursive context. In particular, Lewis sought to engage as fully as possible the political, personal, and commercial vectors of his works, understanding such "contextual" points of reference as not merely contingent to the work's artistic structure and meaning but rather as essential to its artistic design. Paul Edwards argues that Lewis refracts the formal elements of modernism through his distinct, "rhetorical" focus: "The recognizable features of a standard 'Modernist' aesthetic are present . . . but transformed by the inclusion . . . of ideological awareness."[30] Edwards goes on to note that Lewis's reputation has suffered for this ideological concern: "One reason for the lack of recognition of Lewis's Modernist aesthetic is that the

idea of the creation of a work of art as (at least partly) a self-conscious ideological critique of society is one that has a place in Marxist aesthetics, but not, until recently, in the Modernist tradition."[31] One discerns in the development of Lewis's work over the twenties and early thirties a decisive rethinking of the social and political role of the category of *form*, a category central to the aesthetic ideology of modernism, and his desire to consider form primarily as a rhetorically and politically effective artistic means.

Modernist form, as Ferenc Fehér suggests, has a paradoxical doubleness in its relation to ideology. It at once disavows it and attempts to embody it sensuously: "This art is thoroughly *free of ideology* (tolerating no interpretations, refuting all 'ideal content' imposed on it), and at the same time it is thoroughly *ideological* (in so far as the 'form,' the formed world, is, so to speak, a sensualized theorem)."[32] In its difficulty and singularity, the modernist work points to the rupture between itself and the ideological atmosphere of its readers. In its appeal to sensuous immediacy, however, it implicitly projects a reconciliation with that audience, in a utopian future perfect when it will have transformed or supplanted that ideology and can be understood transparently.

The reverse side of this utopian impulse in modernism is, however, as Stephen Spender suggests, a restriction of literature's engagement with topical, ideological issues:

Forster's antipolitics, antipower, anti-business attitude is implicit also in the novels of D. H. Lawrence, Virginia Woolf, and Aldous Huxley, which have so little else in common. The fact is that the separation of the world of private values imagined in art from the world of the public values of business, science, politics was an essential part of the victory of the generation for whom "the world changed in 1910." . . . The aim of D. H. Lawrence and Virginia Woolf was to create characters who were isolated creatures of unique awareness with sensibility transcending their material circumstances.[33]

At its most involuted, as for example with Woolf's *The Waves,* this impulse to restrict the field of experience to a succession of unique, lyrically transfigured moments became the self-reflexive thematic center and narrative telos of the work. Through her chorus of characters, Woolf decomposed everyday experience into its component sensory atoms (the following scene takes place in the midst of London):

"Look," said Rhoda; "listen. Look how the light becomes richer, second by second, and bloom and ripeness lie everywhere; and our eyes, as they range

round this room with all its tables, seem to push through curtains of colour, red, orange, umber and queer ambiguous tints, which yield like veils and close behind them, and one thing melts into another."

"Yes," said Jinny, "our senses have widened. Membranes, webs of nerve that lay white and limp, have filled and spread themselves and float round us like filaments, making the air tangible and catching in them far-away sounds unheard before."[34]

This intense abstraction from (or purification of) everyday experience placed rigid constraints on the writer, however, in key areas like choice of diction, plotting, character type, and thematic range. While Woolf's strong political concerns are in no way absent from *The Waves*, the novel's indirection and formal self-reflexivity does strongly affect the discursive range and rhetorical force with which these concerns can be expressed. A "formalist" reading of the book that fails to perceive its political aspects would be, of course, insufficient; yet given the dense thickets of prose through which these concerns must fight their way to the attention of a reader, such a reading could hardly be called aberrant. Quite the contrary, most remarkable is the degree to which the rich and detailed critical analysis that Woolf's work has garnered has become naturalized, for academic readers at least. To win some insight into how much effort has been required to educe the political content from Woolf's difficult texts, it is instructive to imagine oneself approaching a work like *The Waves* without this critical preparation of the ground.[35]

Spender's remarks on Woolf's generation, of course, also fall short generally of capturing the genuinely political *significance* of modernism's displacement of "business, science, and politics" from the more forthright treatment they had received in Edwardian naturalism to the margins and even beyond. Recent critics of modernism, following the lead, above all, of the negative aesthetics of Theodor Adorno, have emphasized the political nature of this apparent "withdrawal" through form. Peter Nicholls, for example, suggests that early modernists saw in formal artifice a critical purchase on forms of sociality that were suspect or even unendurable for them. Their commitment to form was in no way "apolitical formalism" but precisely an investment of political concerns in a practice and ideology of artistic form: "It was Baudelaire's generation which took the first step toward a substitution of the aesthetic for 'the lost terrain of social representation.' This is not to suggest that writers suddenly ceased to be oppositional, but rather that the ground of opposition shifted from political rhetoric and

polemic to literary 'style.'"[36] Nicholls goes on to argue that the symbolist tendencies in modernism, which had the most radical investment in form and artifice, should ultimately be understood as a form of social protest; for through their formal concerns the symbolists sought "to open up the divisions in subjectivity in order to call into question bourgeois ideals of rational progress and self-presence" (98). Analogously, Astradur Eysteinsson has identified modernism's political function as that of "interrupting" social modernization and rationalization and as putting brakes on the compulsory adaptation of subjective expressions to the social context in which they appear. "In refusing to communicate according to established socio-semiotic contracts," he concludes, the interruptive practices of modernism "imply that there are other modes of communication to be looked for, or even some other modernity to be created."[37] Bob Perelman, in *The Trouble with Genius,* has studied the formal innovations of Pound, Joyce, Stein, and Zukofsky as manifestations of a paradoxically political rhetoric of "genius," as expressions of their common attempt to relate to their public context through a language that proves its legitimate claim to be heard by scorning all conventions of effective public and commercial address. Modernist form, in Perelman's view, is not so much apolitical as impossibly political.

Though certainly steeped in modernism's formal innovations, Lewis rejected the modernist *politics of form:* the investment in form as the primary mediation between the writer and his or her political, ideological, and social environment. Accordingly, Lewis displaces many of the central concerns evinced by modernist writers to justify their concentration on form, an emphasis he saw as an obstacle to the writer's critical engagement of the intellect. High modernism's emphasis on interiority; its appeal to allusive "depth" and "roundness" of character; its obsessive concern with temporality and history; its foregrounding of the ways that events are psychologically mediated; its valorizing of the unique over the commonplace or stereotype; its knotty quandaries about the relation of mind and language to the world—none of these can be said to characterize Lewis's fiction, except in its parodic reference to modernist works. But above all, Lewis disavowed the utopian aspiration implicit in modernist form that the work might one day be reconciled with its audience. In polemical contrast, he set himself in direct, intransigent relation to the ideological climate of his time.

When compared to the great high modernist prose writers, Lewis

seems accordingly unconcerned with formal innovation or complexity as such. As Bernard Lafourcade has argued,

Unlike most of his contemporaries, Lewis cannot be said to be a great experimentalist or innovator in the art of the novel. The septenary construction of both *Tarr* and *The Revenge for Love* or the duodecimal structure of *Snooty Baronet* are significant but far less vital for the success of the novels than is the truly vorticist ternary structure of *To the Lighthouse*, the immensely ambitious structure of *Ulysses* or the paradoxical combinations typical of Faulkner's books (think of *Wild Palms* or *Requiem for a Nun*).[38]

Yet while Lafourcade's observation is accurate, Lewis's novels could nevertheless hardly be described as conventional. Their literary center of gravity, however, lies not in the typically modernist engrossment with form but rather with a renewed engagement with figurality and rhetoric. For Lewis, Daniel Schenker writes, "Art does have a relationship to the world . . . but this relationship is more instrumental or rhetorical than mimetic. Thus, a fictional creation's effect upon its environment is more important than either its adherence to a canon of verisimilitude or its infidelity to inherent formal principles."[39]

Not just Lewis's positive ideological interest, but also his evident abandonment of modernist formal principles in his fiction may account for his relatively low regard among critics attached to high-modernist standards. Lewis's attempt to establish his literary art on different grounds than those of his modernist peers puts him at odds with the evaluative bases of a great deal of twentieth-century Anglo-American criticism, so crucially shaped by modernist writers like T. S. Eliot, the New Critical poets, Yvor Winters, and others. Even critics like Hugh Kenner and Timothy Materer, generally sympathetic to Lewis, find his work falling short of greatness when measured against high-modernist writing. Materer, for example, judges Lewis's late modernist works on evaluative criteria that, in their appeal to vitality, roundness, and human depth, might have come straight out of E. M. Forster's *Aspects of the Novel:*

When one compares Lewis's characters to those of D. H. Lawrence and James Joyce, his creative limitation is evident. One might compare characters like Tarr, Percy Hardcaster, and René Harding to Joyce's Stephen Dedalus and Lawrence's Gerald Crich as studies in the corrosive effects of pride and intellectuality. However, Lewis does not have the complementary power to create a "woman in love" like Ursula Brangwen, or a fully realized young man like Paul Morel, or a grossly material but deeply human

character like Leopold Bloom. . . . In an atmosphere flooded with the "laughing gas of the abyss," all his characters live their fictional lives a bit groggily.[40]

One would hardly want to deny, I think, that most readers will find these characters of Lawrence and Joyce more sympathetic than most of Lewis's (though what of Lawrence's cruel, quasi-allegorical puppet, Clifford Chatterley? what of Aaron or of Kangaroo?). As a reader not wholly insensible to the attractions of Lawrence's and Joyce's best characters, I am nevertheless led to wonder whether such judgments are really cogent as criticism. Once we leave the Forsterian reading room in which all novelists write their books simultaneously in a trance of inspiration, questions of history, intention, and literary politics must again be taken up. And here it seems necessary to recall that if Lewis never managed to create a character like those of Lawrence and Joyce, it is because he perhaps never intended to, and certainly not by the midtwenties, when he had set himself the task of satirically debunking modernist prose. It seems beside the point to judge the "shortcomings" of Lewis's work according to the evaluative criteria of high modernism, a literary poetics that Lewis had himself explicitly rejected.

<p style="text-align:center">• • •</p>

I want to turn at this point from discussing the general outlines of Lewis's devaluation of form for contextual efficacy to considering some specific examples by which Lewis's relation to his context may be gauged. I am particularly interested in Lewis's relatively positive attitude toward the commercial dimensions of the work and toward the discourse of advertising, for it is here that the difference of Lewis's late modernist stance emerges most strikingly.

I will commence with the graphic shock of a peculiar juxtaposition. The facing illustrations are intended to suggest the shift in context that has occurred between the 1914 publication of Lewis vorticist drama *Enemy of the Stars* in the avant-garde journal *Blast* and its 1932 republication in book form. As Lewis suggests in his autobiography, the original version of the play was intended to assert and seal his leadership of the avant-garde circle around him. It drew its power and radicality from Lewis's privileged place as a painter, as the visual arts were clearly in advance of literary arts in terms of technical and formal innovation. "My literary contemporaries," Lewis writes, "I looked upon as too bookish

ADVERTISEMENT

THE SCENE. | **SOME BLEAK CIRCUS, UNCOVERED, CAREFULLY-CHOSEN, VIVID NIGHT. IT IS PACKED WITH POSTERITY, SILENT AND EXPECTANT. POSTERITY IS SILENT, LIKE THE DEAD, AND MORE PATHETIC.**

CHARACTERS.

TWO HEATHEN CLOWNS, GRAVE BOOTH ANIMALS

CYNICAL ATHLETES.

DRESS. **ENORMOUS YOUNGSTERS, BURSTING EVERY-WHERE THROUGH HEAVY TIGHT CLOTHES, LABOURED IN BY DULL EXPLOSIVE MUSCLES, full of fiery dust and sinewy energetic air, not sap. BLACK CLOTH CUT SOMEWHERE, NOWADAYS, ON THE UPPER BALTIC.**

VERY WELL ACTED BY YOU AND ME.

&&

Figure 4. Wyndham Lewis, *Advertisement,* page from *Enemy of the Stars.* Illustration copyright © 1981 by the Estate of Mrs. G. A. Wyndham Lewis by permission of the Wyndham Lewis Memorial Trust. Reprinted from *Blast* 1 with the permission of Black Sparrow Press.

and not keeping pace with the visual revolution. A kind of play, 'The Enemy of the Stars' (greatly changed later and published in book form) was my attempt to show them the way" (*RA,* 139). The work was, as Reed Way Dasenbrock suggests, primarily intended as a "gesture," a gesture of artistic genius, the evidence of which lay precisely in the

The National
Prime Minister

"WHAT FINANCIAL CONFIDENCE MEANS FOR YOU"

by the

Rt. Hon. WALTER ELLIOT, M.P.

*Financial Secretary
to the Treasury.*

IN THIS ISSUE OF THE

News-Letter

The National Labour Fortnightly

ON SALE TODAY

2ᵈ

2½d. Post Free
From Railway Bookstalls
and from
THE PUBLISHER, 35, PARLIAMENT ST., LONDON, S.W.1.

Figure 5. Advertisement page from *Time and Tide* magazine, 23 July 1932.

formal innovations of Lewis's text: its destruction of narrative, frag-mentation of syntax, and employment of typography and spatialized structure as primary vehicles of meaning.[41] The first version of the play appears to be a clear-cut example of the rhetoric of genius that Perel-man has identified in Lewis's main rivals in the canon of modernism, Joyce, Stein, and Pound. Indeed, Dasenbrock suggests that the impor-tance and influence of Lewis's play may lie precisely in setting the pace for such "genius writing" as Perelman discusses: "Because of its origins as a polemical demonstration, [*Enemy of the Stars*] is a peculiar, almost unreadable work. Nevertheless, it has had . . . a large (if previously undiscovered) impact on other writers. Moreover, its difficult style has been responsible for this influence" (128).

The context of the play's first appearance was, of course, the avant-garde journal *Blast*. The opening page of Lewis's text announces its tense relation with its context by playing with two distinct senses of the word *advertisement:* either the foreword of a book (as with the French, *avertissement*) or a piece of commercial publicity (as in English). The aggressive typography rhetorically underscores the vio-lent self-"advertisement" of Lewis's work; at the same time, its visual forms refer ironically to the aesthetically untamed formats of pop-ular advertising type.[42] Lewis thus suggests a complex relation of mime-sis and critical destruction of the socially given form of advertising. Advertising is at once imitated in its abstract elements—its graphic shape and typographical vigor, its "loud" tone—and shattered by a syn-tax, diction, and content that could hardly be conducive to the com-mercial aims of the form. To take one line of the play: "A leaden gob, slipped at zenith, first drop of violent night, spreads cataclysmically in harsh water of coming. Caustic Reckett's stain." Could this be under-stood as an "advertisement" for a product, for instance "Reckett's stain"? The language of the "advertisement" would seem to have the very qualities conveyed by the passage about the "product": it is a leaden, violent, harsh, caustic stain of words on the page. "Who would like to buy?"—this "ad" sneers at its consumer. At the level of style the passage is above all characterized by the explosive *tension* between the various dimensions of the text: discursive, rhythmic, syntactical, lexical, tropological, and referential. It is this dissonance, this interference—and not a "message"—that is first and foremost communicated by the passage. In this first version of *Enemy of the Stars,* thus, Lewis has absorbed the advertising message into the formal and social

mechanisms of the avant-garde work, subjecting it to the rhetorical energies of vorticist aggression.

The later, book version of the play entered into a radically different context. The war had, as Lewis himself testified, stolen the thunder of *Blast*. If the first issue, with its loud red cover and violent rhetoric, could seem somewhat prophetic of the coming conflict, the second and final issue, the so-called War Number, had been but a pale echo of the first. Still more important, however, by the republication in 1932, Lewis had emerged as a major writer and critic, while his role as a painter had diminished. The republication followed Lewis's antimodernist polemics in *The Art of Being Ruled* and *Time and Western Man* and appeared in the immediate wake of Lewis's two most notorious (and personally damaging) books: his satirical novel *The Apes of God* and his book *Hitler*, which had appeared in article form in *Time and Tide* in 1931. Dasenbrock characterizes the shift from the 1914 to the 1932 text as one of "restoration"—restoration of narrative, of syntactic continuity, indeed, of a suppressed (sub)text: "The 1932 text . . . reveals that Lewis deliberately disfigured the narrative in 1914. He had a coherent, legible narrative in mind but rewrote the play suppressing the elements that would have allowed a reader to follow that narrative readily. Only in 1932 did Lewis make available the parallel text that enabled readers to make sense of *Enemy of the Stars*, but by then no one was particularly interested" (134). Obviously, one aspect of this "return to narrative" is Lewis's increasing emphasis on rhetorical and ideological effectiveness and his accompanying devaluation of "form"; from the rigorous strictures he placed on the modernism of his peers, Lewis did not spare even his own earlier work. Yet Lewis's interest in this "restoration" is not only political, it is also aimed at finding a place for his work within the commercial and critical context. A reading of the advertisement for *Enemy of the Stars* in the 23 July 1932 issue of *Time and Tide* (where Lewis was a regular contributor, including of the articles on Hitler) makes this point almost too obviously (see fig. 5).

In this advertisement, Lewis's book is spatially apposed to the financial self-help book on the left of the page, as well as to the high-culture publication of *Chopin's Letters* with which it shares the Desmond Harmsworth box. Within the ad for Lewis's book is included a quote, which itself serves to announce the forthcoming critical work of Hugh Gordon Porteus (*Wyndham Lewis: A Discursive Exposition*) and to signify Lewis's importance as a writer, precisely because he is the object of

a critical monograph. The typography and layout and the disjunctive relation of registers could, indeed, have made this advertising page at home in the original *Blast*. But now, in 1932, it is not the *text* but the *context* of discourse within which the text as salable book appears that speaks the graphic language of the avant-garde. Whereas the early version of the text absorbed and shattered the social forms of advertising in the avant-garde work, here the avant-garde work has been reabsorbed by the discourses of the context, made to recirculate in the channels of commerce and publicity that the *Blast* version of *Enemy* had so aggressively displaced onto its avant-garde "stage."

This resocialization of the untamed avant-garde work was far from unintended. It followed consistently from Lewis's reexamination of modernist poetics. One of the most poignant—and comical—examples of this reexamination can be seen in Lewis's deluded but symptomatically important commercial schemes for the marketing of his magnum opus, *The Apes of God*. In Lewis's thinking about the book as *material* artifact, as well as in his formal, stylistic, and thematic concerns, *The Apes of God* represented a major shift from the presuppositions of modernist aesthetics.

While critics have become increasingly aware of the extent of the complex divergence between the aesthetic ideology of modernism and modernist writers' practical manipulation of publicity, few would be prepared to suggest that the idea of writing as an autonomous, professional calling standing over and against commercial vulgarization is not integral to modernist poetics and practice.[43] One can see, for example, Pound's ambivalent relation to publicity in a 1914 squabble with Amy Lowell over the public image of imagism. Lowell had published an advertisement for her book *Sword Blades and Poppy Seed* which read: "Of the poets who to-day are doing the interesting and original work, there is no more striking and unique figure than Amy Lowell. The foremost member of the 'Imagists'—a group of poets that includes William Butler Yeats, Ezra Pound, Ford Madox Hueffer—she has won wide recognition for her writing in new and free forms of poetical expression."[44] Pound raised a fuss about the ad both to Harriet Monroe, editor of *Poetry*, and to Lowell herself. To Monroe he wrote:

As to Amy's advertisement. It is, of course, comic. On the other hand, it is outrageous. . . .

If it dealt with biscuits or a brand of sardines [the publisher, Essenwei]n

and possibly the magazines publishing the adv. would be liable to prosecution. (43)

To Lowell, referring to the ad, Pound carped in a similar but expanded vein:

> In view of the above arrant charlatanism on the part of your publishers, I think you must now admit that I was quite right in refusing to join you in any scheme for turning Les Imagistes into an uncritical democracy with you as intermediary between it and the printers.
>
> [. . . .]
> I don't suppose any one will sue you for libel; it is too expensive. If your publishers "of good standing" tried to advertise cement or soap in this manner they would certainly be sued . . .
> P.S. I notice that the canny [Essenwei]n in his ad refrains from giving a leg up to any of the less well known members of the school who might have received a slight benefit from it. (44)

I have quoted at length, because these letters bring to the fore the essence of Pound's relation to publicity and professionalism. First, Pound insists on the equal status of poetry as a professional activity. It should, Pound ironically implies, be accorded equal dignity as factory work and be subject to at least the same protection under the law as industrial and consumer products (biscuits, sardines, cement, soap). In apposing it to such humble goods, it is the *autonomy* of poetry Pound is defending, however, not its lowly everydayness, as for example Eric Satie did when he proposed to write "furniture music." Second, Pound clearly objects to the vulgar commercialism and self-serving character of Lowell's advertisement. It is advancing Lowell, not writing as such, not even the group of writers (viz. his complaint that only the best-known writers were mentioned). Finally, while publicity is legitimate as a tactic for gaining recognition in a society that values poetry less than sardines and soap, it also threatens the aristocratic logic by which poetry must advance. If publicity is to be used, its employment is nonetheless dangerous and must be carefully policed. If it takes on a logic of its own, unsubordinated to the small group's end, it can lead to "uncritical democracy," the loss of clear boundaries between the public and the professional elite of poets and hence the decline in the quality of the product.

Against this backdrop of his friend's coherent but fraught attitude toward publicity, Wyndham Lewis's schemes for selling *The Apes of God* appear all the more striking. Lewis planned what he referred to as a

"speak-easy" edition of his massive satire, to be published by the Arthur Press and priced at an inexpensive 7/6d. While this edition never appeared, the following circular letter, surely composed by Lewis himself, has been preserved:

Dear Sirs,

We are shortly publishing a popular edition of Mr. Wyndham Lewis's novel, *The Apes of God*, probably at 7/6d. We are also publishing it *with advertisements*. The adverts. will not be confined to those of publishers and bookshops. We are including other adverts. of Steamship Lines, tooth-pastes, and lawn mowers.

This will be the *first novel* since the age of Dickens to carry advertisements. It will be *a unique event in the publishing world*. It is certain to arouse a great deal of interest and result in a wide publicity: and at the above price the book is certain to be very widely read.

The charge for a whole page is £5, a half page £2.10.0. We hope you will take this *unusual opportunity* of advertising in *a more permanent* form than the newspaper or the magazine offers—which once read is thrown away. *For one person who reads any given copy of a magazine, a hundred read any given copy of a book.*

As the time is short before the date fixed for our going to press, we hope you will send us your copy at once.

Faithfully yours,

THE ARTHUR PRESS (*Letters*, 196–197)[45]

This astonishing document reveals the degree to which Lewis was not only willing to acquiesce to the logic of publicity, but was actively attempting to meet commercialized, commodified discourse on its own terms. To sell *Apes* and advance his position against those attacked in the book, Lewis was projecting an inexpensive edition, which in turn committed him to selling advertising. The book itself would become the site of commercial exchange, as typographical space was divvied up at so much a page.

Still more striking, however, are the arguments with which Lewis surrounds these facts. First, he wants to break free of the book world (booksellers and publishers) and enter into the much wider industrial and consumer economies: "Steamship Lines, tooth-pastes, and lawn mowers." This goes well beyond Pound's assertions of the rights of poetry to be treated at least as well as sardines. Lewis's claim is both less rhetorical and more far-reaching. He is not ironically commenting on how little recognition his work can gain in a commodified world but is rather seriously staking a claim within the very domain of commerce. Moreover, while Lewis, like earlier avant-gardists, sets his book against

the commodified medium of the newspaper, his gesture is otherwise quite different. It is not intended, as was the case with Mallarmé, to assert the purity of his writing against the impurity of commercial discourse, nor even, as with Joyce in *Ulysses*, to create an ironic tension between the cited newspaper speech and the grand literary tapestry within which it appears.[46] On the contrary, in his competition with the newspaper, Lewis asserts the superiority of the book precisely on the newspaper's own terrain: *as an effective medium of publicity*. Lewis does not argue that the book is the repository of more enduring *cultural values* and is therefore superior to the throwaway writing in the newspaper. Rather, it is that the material form of the writing, as preserved in books, is more enduring, thus allowing it to be seen by more people for a longer cycle of circulation. Hence, Lewis concludes, advertising in books should prove more successful than newspaper ads. In setting himself up as a latter-day heir of the "age of Dickens," finally, Lewis embraces precisely the most commodified aspects of literary production in that day: subscriptions, serial production, advertisement, the thoroughgoing commercialization of authorship. It is these features of the book, before even its content is considered, which will make *Apes* a "unique event in the publishing world."

Of course, the scheme, and what seems to have been Lewis's sincere hopes for it, was ridiculously overblown. One can hardly imagine Lloyd's of London taking out a full-pager to precede the "Lesbian Ape" or the "Ape-Flagellant" chapters of Lewis's novel! But a small vestige of the plan remained in the second printing of the 1931 Nash and Grayson trade edition (the Arthur Press 1930 collector's edition of 750 copies preceded this edition). The verso of the title page was altered to register its commercial status. It reads: *"First Cheap Edition / Published November 1931 / Second Impression . . . March 1932."*[47]

V

Lewis saw in modernism, with its disaggregation of the sensorial manifold and its exaggerated concern with subjectivity, a passive reflection of the changes in the object world, the collapse of differences and the incorporation of spectacle into the texture of reality. "Oh it is a wild life that we live in the near West, between one apocalypse and another!" he wrote in his 1927 polemic, *Paleface*. "So we return to the central problem of our 'subjectivity,' which is what we have in the place of our lost

sense, and which is the name by which our condition goes."[48] Lewis's parodic adoption of modernist techniques in his works of the twenties and early thirties focused attention on the laughable paroxysms of subjectivity as it attempts to cope with a new denatured reality, while the more transparent countermodernism of the later works approached the problematic transparency of the spectacle world more directly.

Realism and satiric deformation, moreover, have a very fluid relation in Lewis's work. As Northrop Frye notes in a hostile but perceptive review, Lewis's "realism" or "naturalism" very quickly shades over into satiric phantasmagoria: "One would expect his 'external' approach to have some affinity with realism, as in Flaubert; but anything like a setting in a Lewis satire becomes a fantasy of Grand Guignol proportions. The Parisian left bank in *Tarr*, the Bloomsbury-Chelsea London of *The Apes of God*, the Toronto of *Self-Condemned* (if the reader will accept the opinion of a reviewer who lives there) are all as far out of this world as the limbo of *The Human Age*."[49] Lewis, in fact, anticipated Frye's criticism and discussed it in *Men Without Art*. In the chapter entitled "Mr. Wyndham Lewis, 'Personal-Appearance' Artist," he claims that a naturalism based on natural scientific observation would amount in effect to satire. "Satire in reality often is nothing but *the truth*," he writes, "the truth, in fact, of Natural Science. That objective, non-emotional truth of the scientific intelligence sometimes takes on the exuberant sensuous quality of creative art: then it is very apt to be called 'Satire,' for it has been bent not so much upon pleasing as upon being true" (*MWA*, 99). He considers this problem at length in the chapter that follows, entitled "Is Satire Real?" Here he argues that satire, rather than being judged by moral criteria, as good or bad, would be better judged as "real" or "unreal" (*MWA*, 111). In his conception of a satiric mode adequate to his time, Lewis attempts to negotiate a relation between satire and realism, in which the satirist's mortifying eye would serve as an accurate instrument for capturing the reality of the day. I would add that Lewis self-consciously blurs the antipodes of realism and satiric fantasy to foreground the progressive de-realization of the social world. Realist representation seizes on that world in all its uncanniness, while satiric fantasy portrays the simulated reality of spectacle more truly than a more conventional "realism" could.

In *The Apes of God*, for example, different modulations of a single description can alternate between realist description, deliberate distortion, and a mixture of the two in Lewis's detached "scientific" abstractions. Thus, for example, in Lewis's slow-motion account of the ninety-

year-old, corpulent Lady Fredigonde as she moves from one chair to another, these different modes alternate in rapid succession. Lewis begins with a neutralized physical description, which, while technically accurate, is also willfully distant from its human object. Fredigonde rises from her chair:

Without fuss the two masses came apart. They were cut open into two pieces. As her body came away from the dense bolsters of its cyclopean cradle, out into space, the skimpy alpaca forearm of the priestly Bridget, a delicate splint, pressed in against the small of the four-square back. It was applied above the region where the mid-victorian wasp-waist lay buried in adipose. (*AOG*, 22)

After the flat abstraction of the two first sentences, which could appear without incongruity in an account of a surgical operation, a more satirical vocabulary and viewpoint begins to emerge: the "cyclopean" proportions of the Lady played off against the "delicate splint" of her servant's arm, the "wasp-waist" of days gone by against the "four-square back" of latter days.

This satiric element is heightened in the next paragraph. As her body totters in her rise, so too Lewis's sentences become more centrifugal and energized:

The unsteady solid rose a few inches, like the levitation of a narwhal. . . . Something imperfectly animate had cast off from a portion of its self. It was departing, with a grim paralytic toddle, elsewhere.

The socket of the enormous chair yawned just short of her hindparts. It was a sort of shell that had been, according to some natural law, suddenly vacated by its animal. But this occupant, who never went far, moved from trough to trough—another everywhere stood hollow and ready throughout the compartments of its elaborate animal dwelling. (*AOG*, 22–23)

Here the satiric effect depends not simply on the abstraction and accentuation of physical characteristics but on the employment of metaphor: Fredigonde as a narwhal or some other lumbering, sedentary animal. In a narrow sense, Lewis "estranges" or "defamiliarizes" his object, but without any of the positive intention that Viktor Shklovsky attributed to this process.[50] Lewis's estranging descriptions do not aim to exhibit the autonomous workings of the form-giving, creative mind but rather to find some ground external to it. At best, they work to *establish*, through a distancing laughter, some objective consistency for characters that might otherwise appear mere shadows of Lewis's all-too-personal aversions.

As Fredigonde finds her destination and sits down again, Lewis accordingly lowers the satiric temperature, relinquishing the animal comparison and returning to a more straightforward description:

She lowered her body into its appointed cavity, in the theatrical illumination, ounce by ounce . . . at last riveted as though by suction within its elastic crater, corseted by its mattresses of silk from waist to bottom, one large feeble arm riding the stiff billows of its substantial fluted brim. (*AOG*, 23)

Although the figural language of "crater" and "billows" retains the afterimage of Lewis's former magnifications of scale, nothing in this passage would be out of place in a conventional realist novel.

. . .

Despite their stylistic differences, none of the passages quoted above presents any particular difficulty in terms of a primary locus for Lewis's early literary experimentation, the syntax. Unlike the vorticist prose of *The Enemy of the Stars,* the manifestos in *Blast,* and the 1918 edition of *Tarr,* this prose uses sentences with angular but grammatically correct constructions. After the first *Tarr,* as Dasenbrock points out, Lewis's "locus of innovation" is not "the individual sentence or the place where sentences join, but something much broader, the formal design of the entire novel."[51] Dasenbrock demonstrates the predominance of a circular pattern in Lewis's large-scale form, a circle that does not close but returns to the starting point with its characters dead, damaged, or hollowed out. (I think this pattern might be best described as a spiral, which is a figure of entropy.) This pattern is shared, he shows, by *The Apes of God* (written in the late twenties), *The Revenge for Love* (the thirties), and *Self-Condemned* (the fifties).[52] The passages quoted above from *The Apes of God,* however, suggest another "locus of innovation" at the micrological level, working within the paragraph and even within single sentences from time to time. I would describe this technique as Lewis's destabilizing the virtual spatiality of narration and rhetorical address—the distances and proximities implicit in the notion of "perspective" or "point of view"—and hence his disrupting the reader's ability to interpret literary utterances anthropomorphically, as the words of fictional persons.

Douglas Messerli has noted the extent to which the mediation of events through the consciousness of character-personae was, after James, canonized both in the practice of modernist writing and in the

theory of the modern novel by Percy Lubbock, Virginia Woolf, and others.[53] The use of character-personae allows the modern novelist to handle two narrational problems with a single technique. On the one hand, the character-persona allows subjectivity to be suggested and its qualities to be indirectly communicated to readers; a reader senses the "reflecting" character's generosity or interestedness, fear or decisiveness, self-repression or emotional growth, by careful attention to the specific reflection given. On the other hand, such a character also allows a deft management of "deixis," the written delineation of temporal and spatial relations that in nonwritten discourse could be given by reference to a context: before and after, outside and inside, near and far, and the like. The use of character-personae implies their "placement" as observers and narrators in a web of relations with a real and metaphorical "position." This positioning involves the characters' inclusion and exclusion from conversations, absence or presence at events, their proximity and distance from events and other characters, the transparency and opacity of the spaces within which events occur, and so on. Any and all of these aspects can enter into the author's manipulation of point-of-view techniques to create narrative tension and psychological depth. Analogously, the use of narrative personae serves to put the author at an ironic "distance" from his characters and their acts and hence from the reader as well; the reader must negotiate between identificatory intimacy with the characters and critical detachment analogous to the author's ironic withdrawal.

In Messerli's view, however, certain authors contemporaneous with modernism, most notably Gertrude Stein, Djuna Barnes, and Wyndham Lewis, disrupt this implicit web of positions through their direct employment of "voice," which displaces character from the central narrational role it plays in modernist fiction.[54] Lewis's *The Apes of God*, for example, "often appears to be narrated from the omniscient-objective viewpoint. Characters and their actions are related in such detail, in fact, that one might almost construe the fiction to represent an extreme of realist characterization, were it not that the descriptions are generally stereotypical and are so embellished with minutiae, that they imbue the book with a quality that is almost Baroque."[55] This quality can be further specified in its formal and rhetorical implications. Lewis does not generally narrate through a single persona (*Snooty Baronet* is an exception and a problematic one at that); nor does he tend to shift between different but coherent points of view linked to personae as did modernist contemporaries like Joyce, Woolf, William Faulkner, or as late as

the fifties, Malcolm Lowry. Yet neither, I would argue, does he simply employ "voice" directly to make moral judgments and advance arguments to his reader, as Messerli suggests. Rather, he intentionally destabilizes the implicit positioning on which either persona-mediated narration or direct address depends. In turn, this erosion of positionality calls in question the conventional "incarnation" of written speech as fictional *persons:* the basis of the novel as an anthropomorphic genre.

It is easiest to understand this quality of Lewis's prose by contrasting it to the positionality that is metaphorically implicit in the notion of point of view. This notion, David Bordwell has suggested, evolved out of a long history of thinking about narration ultimately reaching back to the narrative use of perspective in Renaissance painting and in Greek theater and extending once again into the photographically registered spaces of cinematic narrative.[56] More literal relations of space and story in pictorial, theatrical, and cinematic representations entered metaphorically into the modern theory of the novel with Henry James's and Percy Lubbock's notion of scenic presentation.[57] Characters and actions were to be narrated as if the book provided a window onto a scene; changes and inflections would be represented by altering the "perspective" on and "distance" from that scene, thus lending the narrative a given "tone" and degree of "reliability." These terms have, moreover, received systematic development in Wayne Booth's influential *Rhetoric of Fiction,* where different types and degrees of "distance" help to differentiate between reliable and unreliable narrators and to define the relation between the reader and "implied author."[58]

As recent theorists of enunciation in film (where the issue of scene and space is crucial) have suggested, however, theories such as Booth's depend on a slippage from the grammatical positions of "speakers" to actual positions of speaking bodies in space. Put otherwise, narrative theories that use such concepts as "distance," "perspective," and "point of view" metaphorically conflate the purely grammatical "locations of enunciation" with the actual "instances of incarnation."[59] They assume that the grammatical positions of the text coincide with real persons (or, in fiction, personlike "characters"), an anthropomorphic conception that generalizes the situation of face-to-face discourse in which "speaker" and "person" more or less coincide. The notion of "point of view," in turn, derives from this more primary anthropomorphic metaphor between enunciation and incarnation. Novels or films may indeed use "mimicking transcriptions" (751) of oral exchange, thus seeming to fill the locations of enunciation with persons; classical narrative is rooted in

such mimicry of speech. Yet if it has been the desideratum of realistic writing to bring enunciation and incarnation into alignment, this is not the only possibility open to writers. Writers in the tradition of self-reflexive fiction—Cervantes, Swift, Sterne, Beckett, and Nabokov, among others—exacerbate the *lack* of homology between enunciatory positions and "instances of incarnation" (748), thus underscoring the contrived claim fictions make on readers, their anthropomorphic pretense to have persons dwelling between their covers. Outside the norms of realism, voices may come from no apparent body, a single body may be occupied by multiple voices, or one body may be given the voice of another (as with dubbed films, which represent the zero degree of a technique that may be intensified for more unsettling effects, as when a female character speaks with the voice of a man). Film, indeed, is particularly suited to such techniques, since in contrast to the image track, which establishes a strong sense of a spatial field, cinematic sound evokes very little sense of space or direction in the film spectator.[60] While classical narrative cinema has developed a corpus of techniques like the shot-reverse shot to enforce a relation between sound and image, more innovative cinema can just as easily exploit their divergence. What emerges is a machinery of enunciation, with an unsettling, even derisive relation to the "persons" it suggests without incarnating.

Such a machinery makes its way into *The Apes of God* as an instance of Lewis's polemical and ideological *détournement* of modernist literary techniques. Lewis's most urgent polemical intent finds expression in the metaphor of "broadcasting," in which voice is separated from its visible source. This metaphor, in turn, functioned in its context as a swipe at Edith Sitwell, who on 12 June 1923 at the Aeolian Hall had offered a peculiar and scandalous performance of her poems under the title *Façade*.[61] To the strains of William Walton's score, Sitwell intoned her poems through a Sengerphone, a sound projection device like a megaphone. She was seated behind a curtain with two theatrical masks painted on it, a large Greek-looking mask and a mask of African appearance. The poems sounded from the open mouth of the central, larger mask, while the poet's brother Osbert performed the duties of the master of ceremonies through the mouth of the smaller mask. The poems, Sitwell explained in her autobiography, were primarily experiments in rhythm and sound:

At the time I began to write, a change in the direction, imagery, and rhythms in poetry had become necessary, owing to the rhythmical flaccidity, the ver-

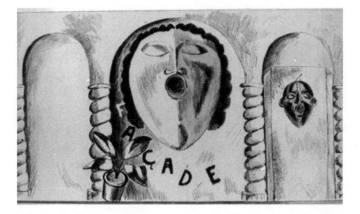

Figure 6. Frank Dobson, curtain design for Edith Sitwell's *Façade*. Originally in British *Vogue*, 15 July 1923. Reprinted by permission of David Higham Associates Limited on behalf of Francis Sitwell.

bal deadness, the dead and expected patterns, of some of the poetry immediately preceding us.

Rhythm is one of the principal translators between dream and reality. Rhythm might be described as, to the world of sound, what light is to the world of sight. It shapes and gives new meaning. . . .

The poems in *Façade* are, in many cases, virtuoso exercises in technique of an extreme difficulty.[62]

To be heard over Walton's music, Sitwell had to read at the top of her voice, chanting the words in a rapid "musical" way, which simply added to the impression that the whole spectacle was nonsensical. Together with the elaborate gimmickry of the curtain and megaphone, the first performance unleashed a storm of criticism and sneering commentary in the press. As Sitwell remarks wittily, "Never, I should think, was a larger and more imposing shower of brickbats hurled at any new work" (139).

While any claims about the "origins" of a literary work, even one as closely bound to its context as *The Apes of God,* are dubious, I believe that the issue of "broadcasting" in the novel was in large part occasioned by Lewis's reaction to this work and its performance by Edith and Osbert Sitwell. While Lewis's targeting of the Sitwells was obvious from the very beginning, to my knowledge, the specificity of Lewis's polemic has not been appreciated by either his critics or his enemies;

indeed, it may have failed, insofar as it seems to have been lost on the Sitwells themselves. Yet the association between Sitwell's *Façade* and Lewis's early drafts of *The Apes of God* goes beyond mere coincidence of dates. The Aeolian Hall performance was, in fact, the first *public* performance of *Façade;* there had been a previous performance on 24 January 1922 at the house of Osbert Sitwell in Carlyle Square. Lewis, as a letter to Osbert Sitwell dated two days after the Aeolian Hall performance reveals, had attended *both* performances. "Dear Sitwell," Lewis writes, "I enjoyed Facade, and think it was an improvement on the first performance. When we meet I will tell you" (Lewis to Sitwell, 14 June 1923). As a kind of spy in the inner circle of the Sitwell clique, then, Lewis was as intimately familiar with Edith Sitwell's "scandalous" work as anyone at that time could be. Moreover, it seems that Lewis was already at this point preparing his eventual attack on the Sitwells; his reticence in the note appears significant, for it suggests the unwillingness of the often paranoid and conspiratorial Lewis to provide his erstwhile friend Osbert Sitwell with written proof of his "approval" of *Façade,* evidence that might be turned back on him after the projected appearance of his satirical blast. In a letter from the late summer or early fall of 1923, in fact, Lewis discussed with T. S. Eliot an overdue chapter of *Apes* entitled "Mr. Zagreus and the Split Man," which appeared in the February 1924 issue of the *Criterion.* And in a letter from early in 1924 to Eliot, Lewis refers to "Lord Osmund's Lenten Party," the longest chapter in *The Apes of God,* and devoted especially to demolishing the three Sitwells; anticipating Eliot's caution, he adds: "In *Lord Osmunds Lenten party* the name Stillwell (if too suggestive of certain people) could be anything you like" (Lewis to Eliot, ca. March 1924).

Façade's title and performance setup, the poems themselves, and Sitwell's motivating ideas all were as if designed to provoke Lewis's scorn and ire. The work fit perfectly into his picture of upper-class modernist *poseurs,* who were degrading the sharply visible and intellectual in favor of the musical and rhythmic. The painted facade and megaphone, in turn, with its Wizard of Oz-like aspect, suggested the extension of the aesthetics of *Façade* into the domain of politics and manipulation of public opinion. Sitwell, in Lewis's view, had provided a glimpse of the new *political* culture, which would regiment and rule through theatrical, rhythmic spectacle, in which the voice would be technologically processed and amplified ("broadcast") while the actual sources of command would remain hidden behind a painted facade. He took Sitwell's work as a veritable symbol of the emergent political manipulation

through a generalized, pseudomodernist culture industry. About a decade later, F. R. Leavis would take up an analogous, if less elaborated, line of attack on the Sitwells, claiming that they "belonged to the history of publicity," which set off a succession of blows and counterblows in print, drawing in Lewis and Geoffrey Grigson as well.[63] Lewis's letter of 15 December 1934 to the editor of the *New Statesman and Nation* recurs to Leavis's swipe and once again evokes advertising as the proper domain of artistic "apes" like the Sitwells (as well as of his own satiric menagerie, *The Apes of God*). "This trio," Lewis writes, "*does* 'belong to the history of publicity rather than that of poetry' (*cf.* Dr. Leavis): and would you expect Milton to be correctly quoted in an advertisement for Massage or Male-corsets—or Gerard Manley Hopkins to appear without printer's errors in a blurb recommending the tired pirouettes of a Society authoress? It would be unreasonable. It would be asking too much of everybody concerned."

As developed at monstrously excessive length in *The Apes of God*, the separation of voice and body implicit in the primitive curtain and megaphone setup of *Façade* opened out into a whole "broadcasting" network, implying that Lewis's political analysis went far beyond his immediate polemical occasion. In the completed novel, the technically reproducible and manipulable nature of speech comes to the fore and the notion of literary "character" undergoes a fundamental change, as Lewis's characters reveal themselves to be technological implements through which are expressed hidden political forces. Lewis's characters, indeed, seem to talk out of speakers mounted in their meticulously described bodies, with their voices originating from some point outside the represented scene. This lack of homology between voice and body, which makes his characters and situations so uncanny, has become, with the increasing presence of recording and other media technologies, an everyday fact. Through the mediatory intervention of this technology, it has become possible to watch a television rerun of an interview with a dead rock star—an example exaggerated to underscore my point about the loss of clear enunciatory positions, yet hardly unprecedented. The recorded sound-image allows time and space to be overcome and the semblance of presence to be repeatedly evoked.

Notably, it was during the two decades following World War I that this technology became part of British everyday life on a massive scale. The incorporation of the BBC, the staggering sale of gramophones and radio sets, and the emergence of the sound film are crucial indices of this infiltration of recording and broadcast technologies. As Lewis's use of

the broadcasting metaphor in *The Apes of God* suggests, he interpreted this process above all in light of its political and ideological implications. Vice versa, the numerous passages in his work in which voice and the positions of enunciation fail to coincide should be considered in light of the politically charged emergence of media technologies.

Lewis was highly self-conscious about this relation, and notably, he himself broadcast on the BBC as early as January 1928, then three more times in the 1930s.[64] Two examples should suffice to demonstrate the close relation between disjunctive structures of voice, media technology, and politics Lewis discerned. The first is from Lewis's satiric poem "The Song of the Militant Romance," written just after the appearance of *The Apes of God* and directed especially against the *transition* program of a "Revolution of the Word." In the fourth section of the poem, Lewis presents the *transition* deformation of syntax and the standard lexicon as a destruction of the visible world of objects in favor of a generalized "gramophonics." Mimicking a *transition* "revolutionary," he writes:

> But let me have silence always, in the centre of the shouting—
> That is essential! Let me have silence so that no pin may drop
> And not be heard, and not a whisper escape us for all our spouting,
> Nor the needle's scratching upon this gramophone of a circular cosmic
> spot.
> Hear me! Mark me! Learn me! Throw the mind's ear open—
> Shut up the mind's eye—all will be music![65]

The gramophone and the radio emphasize the continuous, virtual "objects" of the auditory imagination, which Lewis presents here at the extremes of its range (silence and shouting), over the discrete objective presences that present themselves to the eye.

In his earlier work *Time and Western Man*, however, Lewis had taken up this technology in much more explicit and elaborate form. In a passage that begins by associating Proust's modernist memorial poetics with the attempts of the ancient Egyptians with their mummies and the country squire with his family portraits to preserve and reanimate the past, Lewis immediately segues into the possibility of preserving time-images technologically:

But how much more impressive would it not be if with the assistance of a gramophone and domestic cinematograph, or a vocal film, men were, in the future, able to call up at will any people they pleased with the same ease that now a dead-film star, Valentino, for instance, may be publicly resuscitated.

A quite credible domestic scene of the future is this. Mr. Citizen and his

wife are at the fireside; they release a spring and their selves of long ago fly onto a screen supplied in the Wells-like, or Low-like, Future to all suburban villas. It is a phono-film; it fills the room at once with the cheery laughter of any epoch required. "Let's have that picnic at Hampton Court in such and such a year!" Mrs. Citizen may have exclaimed. "Yes, do let's!" hubby has responded. And they live again the sandwiches, the teas in the thermos, the ginger beer and mosquitoes, of a dozen years before.

People with such facilities as that for promenades in the Past—their personal Pasts in this case—would have a very different view of their Present from us: it would be Miss Stein's "continuous Present" in fact. And all the Past would be similarly potted, it is to be assumed; celebrated heroes like Lord Kitchener would be as present to those happy people as were their own contemporary Great.

Art—whether in pictures, music, the screen, or in science or fiction—is already beginning to supply us with something of that sort.[66]

Though Lewis is scarcely speaking the language of Jean Baudrillard, his message is recognizably akin to somber postmodernist predictions that focus on the ever-greater technological power to *simulate* experience. Lewis's rather comical projection of a happy suburbanism, however, is shockingly near the mark of the early consumer society of the 1950s and 1960s, if not necessarily of the Internet wasteland of the 1990s.

Several other features of this passage bear comment, however. Foremost is the implicit political edge of Lewis's satirical "utopia." He juxtaposes a kind of middle-class Fabian socialism and progress with the highly inappropriate choice of Lord Kitchener as the "past Great" as present as ever. Lewis, as a veteran of some of the worst slaughters of World War I, knew whereof he wrote, when he conjured up the frightening revival of Kitchener's imposing countenance and commanding gesture, sending young men off to die in the trenches. Through the recording technology, Lewis intuited, history can be disembodied and then paradoxically revived at will, rather than being lived through once and allowed to pass definitively. If, however, even history has become a question of consumer choice, then it is also subject to the same techniques of persuasion and manipulation as other forms of advertisement. It offers no solid ground from which to take stock of the manifestations of the present, since even history is only part of the "continuous present." Lewis links the loss of temporal depth to the modernist antinarrative techniques most perfectly represented by the work of Stein and Joyce (and arguably, as Dasenbrock suggests, by Lewis's own early version of *Enemy of the Stars*): it is these that are the appropriate forms of representing a depthless present.[67] These political and aesthetic dimensions, moreover, are associated with

a very specific media technology, the earliest manifestation of the sound film, which Lewis calls here the "phono-film."

The precision of Lewis's reference is crucial, for it indicates the close attention Lewis paid to his context. In addition, it allows us to extrapolate more accurately what aspects of his context affected Lewis's thinking and constituted the "external" meanings of figures within his fictional writing. Lewis's term "phono-film" clearly refers to the Vitaphone sound recording process, wherein film images and gramophone tracks were synchronized to produce the sound film-images. The Vitaphone Corporation was formed in April 1926, and in August of that year the first film using the process was released.[68] The real success of the process, however, came in the spring of the following year—the year of *Time and Western Man*'s appearance—with the hit movie *The Jazz Singer*, starring Al Jolson as the Jewish boy turned black-faced jazz performer.

While this film captivated audience imaginations at the time with its story line and its technical innovation, we can today remark its strangeness, its awkward transitional moment between the directorial techniques and conventions of silent film and the new technological capacities of the sound film. As Patrick Ogle suggests, it has for most present-day viewers a "strange, almost hermaphroditic form incorporating both silent and sound techniques."[69] Most notably, the film shifts, often with great abruptness, between silent "dramatic" parts, which allowed expressive silent film acting and movement, and recorded sound parts, mostly sung, which required static tableaulike scenes to permit recording on the discs. The Vitaphone process was only used until 1930, when recording to film replaced the cumbersome and limited gramophone process. It is not too fanciful to think that Lewis was captivated precisely by the estranging qualities of the Vitaphone process and mimicked them in the narrational structure of voice in *The Apes of God*: the lack of tight correspondence between body and voice, the abrupt transitions, the highly contrived suspension of movement and plot for set-piece scenes where recorded songs or other performances can be inserted.

If it is indeed the case that *The Jazz Singer* was Lewis's paradigm case of the new technological mass culture artifact, then its specific content is also highly relevant to his satirical appropriation of it. The Jewish jazz singer in blackface clearly shaded his image of Gertrude Stein's "prose song" in *Time and Western Man* and by association, the "gramophonic" language experiments of her supporters at *transition,* against whom Lewis polemicized in *The Diabolical Principle*. In his chapter on Stein in *Time and Western Man*, Lewis refers specifically to "Miss Stein at the

Three Lives stage of her technical evolution" (*TWM*, 59)—the Jewish modernist Stein, in "blackface" for her literary mimicry of Melanctha. Indeed, the set-piece performances of Jolson, followed by the lapses into silence, have their exact counterpart in the short but wearying "jazzing" of Stein: "To an Antheil tempest of jazz it is the entire body that responds, after all. The executant tires; its duration does not exceed ten minutes or so, consecutively" (*TWM*, 59). In *The Childermass,* the feminized "Satters" becomes a stuttering parody of Stein:

"Y-y-y-y-y-y—you howwid blag-blag-blag-blag-blag-blag-blag-blag blag-blag—!"
A stein-stammer that can never reach the *guard* of blackguard hammers without stopping *blag*.[70]

Notably, it is the word *black* on which the Stein-stammer sticks, relating, in Lewis's view, Stein's linguistic "miscegenation" (Melanctha as female Al Jolson, black-faced Jew) with her frivolous *blaguer,* her interminable blather.

This intersection of race (the crossing of Jewishness and blackness), sexuality (especially cross-dressing and transgendering moments), jazz music, and media technology, however, receives its fullest (and most intentionally offensive) development in *The Apes of God*. This is above all true of the "Lord Osmund's Lenten Party" chapter, which runs for two hundred fifty pages and has twenty-three subchapters. As I will discuss *Apes* in detail in the next section, I will cite only one exemplary episode here. In this scene, the cross-dressed and high-heeled naif Dan, the hypermasculine costumed fascist and "broadcaster" of messages Starr-Smith, and a black bartender are the players. Starr-Smith ("Blackshirt") is trying to steer Dan away from the bar, under the watchful eyes of the bartender, "the Tropical Man." Instead, they engage in an unintended and grotesque dance, before moving off:

The Blackshirt started back a couple of stage-paces of pure astonishment—taken unawares. Then he approached Dan again, his jaw set, and he forced him roughly off the stool at once. . . . As Dan was pushed he swayed gracefully. There was a moment during which they both swayed hither and thither in front of the Bar, beneath the eyes of the *Tropical Man*. Then arm-in-arm with Blackshirt (who grasped his intoxicated dummy firmly under the armpits, hoping for the best) Dan moved away, with the step of an automaton—stiff, but still goat-footed. (*AOG*, 573).

Allegorical masks of blackness ("Blackshirt," "Tropical Man") and femininity waltz to a machinelike rhythm, at once automatic as a gramophone

("the step of an automaton") and atavistic as a Dionysian frenzy ("still goat-footed").

VI

Through the complicated interplay of his unruly authorial voice, his odd and multifarious narrative diction, and his shifting perceptual frames, Lewis creates the effect of sudden lurches and jolts in the "distances" of narration and rhetorical address. It is this derangement of the virtual spatiality of the text, the reader's inability to fix on a definite and consistent position from which the text is enunciated, that embeds Lewis's satirical intention in the micro- and macrological levels of his works, making a de-forming "riant spaciousness" their overall formal principle. There can be little doubt that Lewis saw this technique as integral to his critique of modernism not just as a literary tendency but also as the unwitting reflection of political, philosophical, and ideological developments to which he was opposed.

One can, in fact, already begin to trace the shift in Lewis's attitude in his responses to criticisms that friends made of his first novel, *Tarr*. Politely answering criticisms by Harriet Shaw Weaver, *Tarr*'s publisher, about the book's lack of proportion and weakness in the characterization, Lewis concedes:

The criticism you made I made myself to a friend of mine about those first chapters. I make Tarr too much my mouthpiece in his analysis of Humour etc.:= Only what you say does not apply to the fourth chapter, of Part I, in which there are, I think, no opinions, only an analysis of character and action. And you will find, in the rest of the book, that the story and the business of the story is stuck to almost entirely.=In the rest of the book the "opinions" of the principal English character do not exceed the proportion that only may be allowed, but, to be real, is necessary in describing a person like Frederick Tarr.

You must really consider the first three chapters as a sort of preface. But I will admit that Tarr has just a trifle too many of my ideas to be wholly himself, as I conceived him. (*LWL*, 76)[71]

Lewis's response reflects the modernist editorial and critical standards of the day, even as he tries to defend his creation in places. Tarr and his "opinions" become a sort of paratext, a "preface" to the real story. Moreover, the fourth chapter is presented as superior because of its immanence, its purging of "opinion"—that is, theory, polemic, ideol-

ogy—and its essential (analytic) handling of character and action. At this point, prior to articulating his political critique of modernism, Lewis still believes that it is possible for a literary character to be "wholly himself," to "live" on the page, unaffected by the clamor of ideologies, even the author's own.

Raising a criticism similar to Weaver's, T. Sturge Moore wrote Lewis in September 1918 to say that he would have liked to have seen a cleaner separation between the author and the personae of the novel; unlike Kreisler, the German protagonist, the eponymic Tarr seemed to Moore little more than a mouthpiece of the author (*LWL*, 99). Moore goes on to focus on the most discursive sections of the book, the paratextual frame where Tarr and his opinions dominate: "I rather regret the preface and epilogue; they will distract reflection from the book itself to the doctrine it will be supposed to illustrate, which is far from being so sound or certain a thing" (99). For Moore, too, the Tarr sections seem extraneous: not part of the "book itself," its autonomous literary cosmos, but of the heteronomic world of ideologies and ideas. This time, Lewis is less yielding, choosing instead to brush off the whole matter: "All I can suppose is that I am really Tarr's hero" (100). Notably, however, far from moving to remedy this "defect" in his later novels, Lewis would accentuate this infection of character and author, and of action and ideology. The "prologue and epilogue" would swell to the boundary of the book and beyond, as Lewis incorporated whole passages from his copious critical writings and wrote criticism using dialogic and fictional forms, while the "book itself," the world of rounded characters with a life of their own, would largely disappear from view. As I have suggested, this development, already anticipated in the formal awkwardness and "flawed" narration of *Tarr*, at once reveals Lewis's departure from modernist conceptions of significant form and anticipates the rhetorical tools Lewis would use in his satirical and polemical sallies.

Perhaps the most extreme example of Lewis's destruction of formed character and significant form is his "theological science-fiction"[72] *The Childermass*. In this book, no action or character is "real" or "autonomous," since both character and action emerge out of the demonic manipulation, in ideological and political debate, of the imperfectly manifest souls of the war dead. In the course of the book, Lewis offers a potpourri of parodies of modernist writers (especially Joyce and Stein) and satirizes a variety of typically modernist themes within the general frame of a utopian/dystopian fiction: a limbolike camp of the dead souls of fallen soldiers, waiting to be drawn into the "Magnetic City." Lewis's

"theoretical grammar," his "formalist syntax," and his polemical rela-
tion to context collide so violently in this work as to render parts of it
nearly incomprehensible. He devotes some of his most difficult writing
to satirically depicting a no-man's-land of relativistic time-space outside
the city, a unique topography that serves several formal, rhetorical, and
thematic purposes at once: to attack the contemporary obsession with
time, to parody the recently popularized image of Einstein's "relativ-
ity," to illustrate the penetration of spectacle into reality, and to satiri-
cally derange modernism's mediation of events through the perceptions
of characters. Yet in so radically disjoining his own ideology, the discur-
sive senses of the text, and its rhetorical address to specific contexts,
Lewis cast his authorial voice into a limbolike, dimensionless space
notably different from his modernist rivals. Whereas Woolf's choral
voicings and Joyce's stylistic ventriloquisms had allowed a notable
broadening of the field of "vocal" effects in the novel, precisely as
authorial voice was dispersed among a variety of narrating minds or styl-
istic models, Lewis's techniques repeatedly result in a mocking mimicry
that, for all the diversity of his models, evacuates each of nuance and
substance, rendering them one-dimensional and inane.

 The Childermass's two main characters, the reconstituted shades of
the old school chums and trench soldiers Pullman and Satters, wander
outside the gates of the "Magnetic City," which exerts strange effects
on the space around it. At first, Satters has difficulty adjusting to this
technological-metaphysical space and takes comic pratfalls: "After a few
steps he rears up before Pullman's shadow as it bars his path then trips
and sits down abruptly. Pullman kneels beside the stricken Satters who
sits staring and pointing while he blabs on blindly saluting all the lovely
sights. He recognizes Pullman and crows at him as he notices any
unusual movement on that object's part but he resists attempts to raise
his person from the sitting position."[73] Later, following Pullman's lead,
he adapts himself to it, but becomes thereby a kind of grotesque
machine: "He is obedient; a correct vitality is distributed throughout
the machine; he gets back the dead accuracy required for walking flexi-
bly from the hips and as though born a biped" (*Ch*, 20). Yet this equi-
librium is tenuous, since the space can alter unpredictably: "The scene
is steadily redistributed, vamped from position to position intermit-
tently at its boundaries. It revolves upon itself in a slow material mael-
strom. Satters sickly clings to his strapping little champion" (*Ch*, 42).

 Lewis similarly creates abrupt discontinuities in the book's rhetorical
and narrational positions. Even in the first section, before the incorpo-

THE SELF CONDEMNED 113

ration of long stretches of dialogized philosophical argument and other non-narrative discourse, he employs several different speech-genres in rapid, unmediated succession. These include

> Pseudo-neutral language for describing landscape: "The city lies in a plain, ornamented with mountains. . . . Beyond the oasis-plain is the desert. The sand-devils perform up to its northern and southern borders" (*Ch*, 9).

> Parody of Leopold Bloom's jerky internal monologues in *Ulysses*, filtered through an odd sort of indirect discourse: "Speculations as to the habitat and sport-status of the celestial water-fowl.—Food (fish-fry, frogs?). Speculations as to fish-life in these waters, lifeless they seem: more speculations involving chemistry of waters" (*Ch*, 10).

> Parody of Gertrude Stein: "Pulley has been most terribly helpful and kind there's no use excusing himself Pulley has been most terribly helpful and kind—most terribly helpful and he's been kind. He's been most terribly kind and helpful, there are two things, he's been most kind he's been terribly helpful, he's kind he can't help being— he's terribly" (*Ch*, 44).

> Inane dialogue and its immediate echo in indirect discourse:
> "Where did you spring from?"
> "I thought I'd take a turn. I couldn't sleep."
> "What are you doing here?"
> "I'm damned if I know?"
> They laugh. Damned if he knows if he's damned, and damned if he
> cares! So this is Heaven?
> Here we are and that's that!
> And let the devil take the hindmost! (*Ch*, 11)

> Grotesque tableau: "reptilian heads of painted wood, filled-out tin-foil or alloy, that strike round beneath the gusts of wind, and pigs made of inflated skins, in flight, bumped and tossed by serpents, among the pennants and embossed banners" (*Ch*, 15).

> Satiric comparison: "Fresh as a daisy, he reasserts their ordinary solid life-spell in common acts and great homeliness, of housewife-order" (*Ch*, 26).

It would be possible to extend this catalog much further, especially if one went beyond the relatively unified opening section into the disorderly pastiche that characterizes the latter two hundred pages of the

book. What is significant, however, is Lewis's implicit paralleling of the discontinuous hallucinatory spaces through which he hurries his characters and his text's discursive and rhetorical leaps from register to register. In representing a dissipating world in a veritable explosion of styles, Lewis tears to pieces the modernist text's organic unity of form and content and presents his own book as a tottering machine assembled out of the wreckage of modernist literature.

In *The Apes of God,* Lewis's episodic demolition of the upper-class bohemia of the Sitwell and Bloomsbury circles, he achieves a similar effect by making it difficult to attribute utterances to distinct speakers. He presents, for example, pseudodialogues in which each statement merely extends the inanity of the previous one, and each speaker becomes no more than an anonymous, perfectly interchangeable instrument of grammar's empty rehearsal of its forms:

"Do you know————!"
"Yes!"
"I had exactly the same impression Sib!"
"No really?"
"It was identical!"
"I do think that was a coincidence!"
"Wasn't it! I thought my ear must be deceiving me! It
would not be the first time!"
"Don't talk to me about one's ears! But I believe we must—"
"I don't believe our ears have played us false!"
"In this matter—I believe they haven't!"
"I am not positive—but I should be surprised if they had deceived us!"
"For once I do believe that mine has proved trustworthy!"
"Not more so than with mine!" (*AOG,* 362)

These lines, spoken by the Finnian Shaw family, reveal them to be a chattering collective machine. Lewis comically presents a discourse functioning in the absence of any reference (it is elided in the initial question) while dramatizing the way that the fiction of a referent can allow this hollow mechanism to grind on, simulating life.[74]

This faux speech is not, however, confined to the ostensible objects of satire, the "apes" among whom Horace Zagreus sends the young naif Dan to familiarize him with their ways. It equally characterizes the speech of the figure in the book representing the satirist's perspective, the anatomist of the apes, Zagreus himself. Zagreus incessantly stages prerehearsed discourses—"broadcasts," as they are often called—learned from his master, Pierpoint, whose words dominate the book but

who never himself appears. Thus after an exchange about satire, Horace breaks off:

"What did you think of it?" Horace asked suddenly, in almost a timid voice.
"What Horace?"
Horace saw that his duettist was cross.
"The scene Julius—what we have just done together Julius."
"I thought it was good! Was it all Pierpoint this time Horace?"
"Every word!"
"Very striking!" (*AOG,* 453)

Even Zagreus's laugh is borrowed from Pierpoint: "A loud peal of super-pierpointian laughter stormed the ears of the assembly. The swaying figure of Zagreus become the focus for all eyes whatever" (*AOG,* 506). This laughter is wholly feigned, as Pierpoint's secretary, Starr-Smith, explains to Dan: "'Zagreus has no sense of humour at all—although he laughs so much!'" (*AOG,* 508).

By continually underscoring that Zagreus's utterances are not his own, but only a recitation and a repetition of something already said by Pierpoint, Lewis foregrounds the radical loss of autonomy in his character's eclipse behind a preconstituted discourse. In this respect, Lewis gives a political explanation for that voiding of the subject which Beckett would later take up in *Watt* as a free-floating, contextless condition: "Watt spoke as one speaking to dictation, or reciting, parrot-like, a text, by long repetition become familiar."[75]

Starr-Smith, who attends the Finnian Shaw party dressed as a Blackshirt and who is referred to as "Blackshirt" or "the Fascist," also represents Pierpoint's perspective, defending him against Zagreus's too-free use of his words and doctrine. Some readers might assume that Lewis represents fascism as an alternative to the farcical decay of the ruling class that finds its exemplary image in the Finnian Shaws. Yet two objections make problematic the view of Starr-Smith as the fascist "fix" to an otherwise all-encompassing spectacle of decay. In the first place, Starr-Smith is as much compromised by the "broadcasting" of Pierpoint's words as Zagreus; he moreover engages in gratuitous acts of violence and closes ranks with Zagreus again at the end, sure signs of Lewis's unwillingness to stake his claims on this character. As Geoffrey Wagner writes of Starr-Smith and of the related fascist figure in *The Childermass,* Hyperides: "In his satire, Lewis often shows himself ready to poke fun at stupid traits by no means ridiculed in his criticism; it is true that the Fascist Starr-Smith of *The Apes* is almost the only man of good will in

the work, but Starr-Smith is frequently found 'broadcasting' in an obvious skit of Fascist oratory, while in *The Childermass* the Followers of Hyperides give what may be intended as a parody of similar rhetoric."[76] Still more important, Starr-Smith *is* not a fascist, but is only *dressed* as a fascist for the Finnian Shaw costume party. He apes a different master, but apes all the same. The slippage from the costumed Blackshirt to "the Fascist Starr-Smith" in Geoffrey Wagner's argument above is symptomatic, for Lewis goes out of his way to tempt the reader to identify "the Fascist Starr-Smith" as fascist and therefore as the locus in the text of Lewis's own fascistic leanings. Yet Lewis carefully bars this identification as well. Starr-Smith, he underscores, has only donned fascist drag, just as the Blackshirt only mouths the absent Pierpoint's ideas:

Why do you suppose I am here with two more, who are volunteers, as 'fascists' of all things, to-night? Nothing to do with *Fascismo*—the last thing—can you guess? It's because I picked up three khaki shirts for a few pence and dyed them black— the whole outfit for the three of us did not cost fifteen bob! That is the reason." (*AOG,* 509)

This disavowal, however, does not put an end to the vertiginous problems of the "fascist's" identity. Starr-Smith is only dressed as a fascist; yet on what authority does he thereby claim that he is no fascist? What is the difference between "playing a fascist" and "being a fascist," especially since fascism is a doctrine of action and "propaganda of the deed"? Lewis sets this costumed play at being a fascist at a party in apposition with the costumed spectacle of a black- or brown-shirted political party of fascists.[77] Fascism for Lewis here, like femininity for Joan Riviere, appears as a masquerade—a costume, a set of signs to be deployed, an aesthetic construct extending theatricality into the political sphere.[78] The apparent antipode of the decadence of the upper classes, fascism's revolutionary gestures are no less a misappropriation of the artist's mimetic privilege than is the fashionable "aping" of the upper-class bohemia. The aristocratic class origins of Starr-Smith's model, Oswald Mosley, would have reinforced Lewis's depiction of fascist spectacle as the extension of aping by other means.[79]

No character's point of view provides the reader with a perspective from which to judge the other characters and their actions. Each of the various perspectives taken up—the naif Dan, the practical joker Zagreus, the cynical "split-man" Ratner, the homosexual gold digger Margolin, the faux fascist Starr-Smith—offer positions from which other characters appear in a satiric light. The idiotic innocence of Dan and the puri-

tanical rigidity of Starr-Smith play off against the cynical amorality, the giddy childishness, and the mannered hedonism of others. Yet every position that is provisionally adopted only exposes the stupidity and degradation of every other one.

Lewis does, however, hold out the possibility of an Archimedean point outside the represented action, one akin to the author's own relation to his created characters: the mysterious Pierpoint. Lewis coyly puns on Pierpoint's name: he is, Lewis hints, the "peer point," the anthropomorphic point of view from which the spectacle as a whole might be surveyed. His would be a god's-eye view that could measure how far this creation has fallen. Pierpoint's orchestration of the various characters' broadcasts and skits, his metafictional puppeteering, reflects the satiric machinations of Lewis as author of *The Apes of God*. With the absconded deity Pierpoint, the reader is led to hope for a margin of authenticity nowhere else available.

Lewis's rhetorical intention, however, is far more complex than that of persuading readers to accept Pierpoint's philosophy, a doctrine markedly similar to that advanced by Lewis in his polemical works of the late twenties, *The Art of Being Ruled, Time and Western Man, The Dithyrambic Spectator, The Diabolical Principle,* and *Paleface*. In fact, even Lewis's critical prose does not so much aim to persuade as to foreground the act and technical apparatus of persuasion, to reveal the forms of power, the "art" by which one is ruled. As Dasenbrock suggests (discussing *The Art of Being Ruled*):

What Lewis wants to do . . . is to create a theater in which his readers come to be suspicious of all ideologies and to question all fixed points of view. He wants us not to think the puppets are real and we are fighting over something important but to ask who is the puppet master and how is he trying to dupe us through the show. Lewis is, of course, the puppet master of his world, so he would be being inconsistent and untrue to what he hopes to accomplish if he were to deliver a fixed position and set ideology in the world of the text.[80]

Lewis's late modernism differs from the classical satire of the eighteenth century, Daniel Schenker suggests, insofar as Lewis lacks definite stylistic and doctrinal means for persuasion.[81] In fact, one could legitimately argue that Lewis was altogether suspicious of persuasion, of any use of the word in and as action. But this posture of total suspicion is, of course, an aporetic one, given that he aggressively aims to persuade readers of this view in work after work.

Lewis's rhetorical attack on rhetoric accounts for the contradiction that Julian Symons identifies in Lewis's novels of the thirties (though I would disagree with Symons that the contradiction is mainly confined to these novels): "All of them are essentially critiques of meaningless mindless 'action.' . . . We are confronted, however by the inescapable fact that the novels are the work of a man fascinated by the violence they condemn. . . . It could even be said that Lewis's style, ejaculatory, assertive, loaded with images and jokes, is an embodiment of action, and certainly it is active rather than passive like the styles of most novelists."[82] Actually, both Lewis's fiction and his critical works (which in the late twenties emerged from the same original matrix of prose, *The Man of the World*) share this contradictory or aporetic antirhetorical rhetoric, this evasive ideology of ideological suspicion. It leads Lewis into the intellectual contortions and inconsistencies in his critical works and the narrative discontinuities and reversals in his fiction. Lewis's texts, insofar as they represent a world in which spectacle and reality have become indistinguishable, are caught in this same bind, dramatizing their own status as diversionary spectacle from another scene, as decoys and props of an absent power, as persuasions made fatal by persuasiveness. Paradoxically, they say to the reader, buffeted and dazed by Lewis's bellicose prose, "Do not *have read* this book."

These reflections should help to reveal the aporetic aspects of Pierpoint, the internal (but absented) puppet-master figure of *The Apes of God*. Zagreus, Starr-Smith, and others in the book are compromised not by their divergence from Pierpoint's critical views but by their apish imitation of them, their inability to express any true individuality of speech and thought. The reader's acceptance of Pierpoint's statements as maxims to be adopted and reused would, it follows, put him or her in the very same position as the apes. Lewis establishes these rhetorical antinomies as a spur to independence from persuasion, not excluding from this universal suspicion his own pet themes. If the reader fails to attend to Pierpoint's doctrine, satirically enacted in the book, s/he becomes (or is already) an ape. Yet if s/he takes Pierpoint's doctrine as anything more than a thorn for hidebound thought, then s/he is all the more ape for thinking that autonomy may be had from another's critical discourse.

In *Time and Western Man*, Lewis formulated this problem in an enigmatic theological reflection: "Only with a transcendent God is it possible to secure a true individualism" (*TWM*, 434). The guilt of the char-

acters in *The Apes of God* is that they fail to detach themselves from their creator, of whom they are the mere apes and puppets. Correlatively, however, the godlike Pierpoint is diminished through his "metafictional" presence in his created world. He appears constantly, but through his apish, puppetlike representatives: through Zagreus, his propagandist; through Starr-Smith, his strong-arm man; through Ratner, his publisher. He is in this sense secondary to them, even as they imitate his model. They "interpret" him, both as a musician interprets a score and as an explicator interprets a text. In turn, the interpretations begin to eclipse the original altogether. If the modernist author organized his/her works through an ironic distance from the characters, while revealing the traces of a rich awareness in the symbolic unity of style and invented form, then Pierpoint is the modernist author no longer able to perform the difficult balancing act modernist writing demands. His avatars have taken on a largely spurious but destructive freedom from his authority, forcing him to show his controlling hand too openly to maintain a consistent posture of ironic distance.

Pierpoint's figure shuttles back and forth between political and aesthetic critique. Politically, he represents the ruling hand increasingly forced to show itself behind the culturalized politics of liberal democracy. Through Pierpoint, Lewis dramatizes the mobilization of bodies by disembodied voices and ideas ("broadcasts") and the concomitant loss of authentic individuality in contemporary society. His interventions, including the dispatch of his "fascist" agent Starr-Smith to the Finnian Shaw party, reflect the more open exercise of power that will follow on the disintegration of liberalism. In political-critical works like *The Lion and the Fox* and *The Art of Being Ruled*, Lewis suggests that for the "ruled," himself among them, the open exercise of power in fascist and communist countries might be preferable to liberal democracy's production of consensus through culture. Yet while in no way himself an advocate of feminism, homosexuality, youth cult, and other culturalized forms of revolt against traditional authority, Lewis was not being disingenuous when he expressed his provisional approval of them. For these tendencies, as such representative of all Lewis hated in liberalism, were also in his view the forces leading it most forcefully into crisis and hopefully to its death. The key issue for Lewis at this time was not to oppose the inexorably advancing destruction of democratic consensus but to negotiate the blighted period of transition and to survive. Pierpoint represents not so much a solution to the crisis of liberalism, a new

authority principle emerging behind the spectacle of its decay, as the ambiguity of the crisis itself, holding the potential for either catastrophe or renewal.

Aesthetically, Pierpoint's figure satirizes a particular social situation of the modernist writer in the late twenties: the reappropriation of radically innovative art within an economy of discourse (journalistic, commercial, critical, academic, connoisseurial) that had taken on a life of its own. The encroachments of the broader economy on art's relatively circumscribed domain and art's compromises with extra-artistic trends remained a consistent theme in Lewis's work after 1926: in his analytical opposition of creative and interpretive activity in *Time and Western Man;* in his satirical depiction in *Snooty Baronet* of publicity in the publishing industry; his unflattering presentation of René Harding's vulgarizer "Rotter" in *Self-Condemned;* even in his rueful autobiographical reflections in *Rude Assignments* about the dissipation of his talents on polemics to the detriment of his fiction. By compromising even the detached author figure and semblable Pierpoint, Lewis creates a fictional cosmos reflecting his dismay with the real one. He offers his readers only an unstable space of words in which every place from which to speak is already, from the beginning, dislocated; and in which modernism's unique authorial voice endures, but degraded to the tinny broadcasts of a stereotyped discourse.

CHAPTER 4

Beyond Rescue

Djuna Barnes

> *I'm completely lost—an island floating away over the horizon.*
> Letter of Djuna Barnes to Wolfgang Hildesheimer,
> Christmas 1965[?][1]

I

In 1937, as most readers of *Nightwood* are aware, Djuna Barnes's friend and editor T. S. Eliot lent the prestige of his name to her novel, with a short preface. Though the famous poet-editor had been finicky and (in his own words) "lacking in imagination" during the editorial process, Eliot genuinely admired the power and integrity of Barnes's writing and supported the book as wholeheartedly as a man nicknamed "Possum" could manage. Barnes, for her part, was sincerely grateful for Eliot's help and for the tribute he rendered her. For the present-day reader, however, it is difficult to deny that something is amiss in Eliot's preface. One has the impression of true minds at cross-purposes; of incongruities between what Eliot says the book is and what the book, as read today, would seem to be. In recent criticism, indeed, Eliot's preface has been much maligned, either as representing a supposedly hegemonic "male modernism" or as seeming a kind of joke, the phlegmatic Eliot so far missing the point of Barnes's passionate prose as to be comical.

It is not my purpose here either to rehearse or refute the arguments against Eliot's reading of *Nightwood*. Nonetheless, I believe it is necessary to take Eliot's preface at its word, as a historically important "guide

for the perplexed" reader of Barnes, rather than dismiss it as mere "posturing," as does Barnes's biographer Phillip Herring.[2] For it represents not just any response to Barnes's book but that of the single most influential figure in the modernist criticism of the 1930s and 1940s. For that reason alone the preface has an ineffaceable documentary value, as a striking testimony to the assumptions of that criticism in the face of a work that challenges modernist precepts. In his skittish engagement with Barnes's text, Eliot brings to light key concepts and expectations that any up-to-date reader of modernist writing would likely have shared with the author of "Prufrock" and "The Waste Land." Moreover, as Eliot himself underscores, his prefacing remarks are not simply an exemplary response to Barnes's book but a *privileged* one. He was aware that his preface could and would intervene between the book and its readers, steering them toward certain ways of understanding and protecting them from error. Eliot was acutely aware of the "priority" he had as editor and literary king maker, and here he adopts the posture of the celebrated author offering a critical introduction, to be read before the unaccommodating creative work it discusses. His editorial benevolence, however, extended to a bit of well-meant management of *Nightwood*'s image. Wherever Barnes's extravagance threatened to slip the bonds of modernist discipline, Eliot preempted her errancy, shepherding her back with a cautionary wag of the finger toward the antechambers of the modern literary canon.

Eliot begins his preface with an almost obligatory gesture of humility before Barnes's work; its autonomy and self-sufficiency render anything that he might say not just superfluous but even "impertinent." Yet while he can add nothing to the work, he may clear up a few misunderstandings (misunderstanding for Eliot being, like sin for Augustine, purely privative in nature). Eliot thus seeks to preempt a number of "false" interpretations to which Barnes's otherwise autotelic text, minus his supplementary preface, might easily give rise. Eliot wastes no great time in preliminaries; he gets right to work with a series of negative judgments, informing the reader what Barnes's book *is not*.

Nightwood, in Eliot's view, is not simply a sample of literary extravagance, a rhetorical display without the motivation of an equally rich content: "I do not want to suggest that the distinction of the book is primarily verbal, and still less that the astonishing language covers a vacuity of content."[3] Following from this point, it is not "poetic prose" (xii). It is not a collocation of fragments but constitutes "a whole pattern" (xiii). This pattern is not merely imposed by a single "vital" character, Dr.

Matthew O'Connor, "alone in a gallery of dummies" (xiv); nor is it "simply a collection of individual portraits" (xiv). Finally, it is not "a psychopathic study" (xv). It is a moral and literary totality—a knot of destiny and chance most closely resembling Elizabethan tragedy (xvi).

Eliot is explicit about his concern to find in *Nightwood* "profounder significance" (xiv) than mere verbal pyrotechnics, fragmentary vignettes (however brilliant), or psychopathology would allow. He takes pains to reinforce the anthropomorphic metaphor that links textual devices to fictional persons; he insists that Barnes's characters are "alive," that their actions and sufferings have meaning. The supplement of the preface serves to ratify the formal synthesis that it will insist is already in the work (but difficult to discern, like the truth or the path of righteousness). Eliot pulls out a whole stock of modernist tropes for recuperating the "profounder significance" of texts that seem but a heap of broken images. Anticipating Roland Barthes's distinction of readerly and writerly texts, he appeals to the intransitive "written" quality of *Nightwood*, as opposed to the mere communicative discourse of journalism and naturalistic novels. Underlying its surface disjunctions is *Nightwood*'s "prose rhythm" (xii), which lends it a powerful dramatic and musical unity. Dr. O'Connor does not overrun this unity but helps to constitute it, through his "deep humility," "hypersensitive awareness," and "desperate disinterestedness" (he has taken on an Eliotic face latterly). Through a careful composition of character and narrational personae, Barnes manages to ward off the dual danger of excessive interiority and exteriority; her figures are neither Hamlet with his problems nor the sketchy social ciphers of Emile Zola and Theodore Dreiser.

Above all, Barnes avoids the impression of automatism—a perilous threat to fictional personhood. Barnes's characters are neither the puppets of her text (as is the case with the novels of Eliot's friend Wyndham Lewis) nor mere playthings of their own neuroses and perversions. They are free and alive, with significant passions and pains. Any suspicion of uncanniness in Barnes's characters is carefully dispelled by Eliot. In *Nightwood*'s nocturnal gallery, he discovers the exact opposite of the uncanny romantic automaton, who reveals apparently human movements to be but mechanical operations. In Eliot's view, Barnes's reader is instead surprised to learn that what had seemed safely removed from life can unexpectedly seize hold of him: "Sometimes in a phrase the characters spring to life so suddenly that one is taken aback, as if one had touched a wax-work figure and discovered that it was a live policeman" (xiv).

Although tempting, it would be perverse to suggest that precisely because Eliot denies all this—the excesses of style, the incoherences of form, the mechanistic qualities of character in *Nightwood*—the very opposite must be true. On the contrary, while one would surely beg to differ with Eliot, his sensitivity to the problem points in Barnes's text is undeniable. It is as if his possum whiskers had twitched at each moment of interpretational or moral danger in *Nightwood*. He sensed, moreover, that a great deal was at stake in these points of difficulty: the formal unity of the work, the degree to which the characters manifest moral awareness, the accessibility of the text to a totalizing synthesis in reading or interpretation, the problem of verbal excess, the problem of psychopathology, the problem of character vitality and of the uncanny. If it were not possible to "rescue" the text from misunderstanding on these points (which, to fix the wriggling Eliot with a pin, are rather pervasive for a book of only 170 pages!); if it were not possible to recover the work's rhythmic unity, its writerly value, its moral cohesion, its disinterested awareness, its "whole pattern," then *Nightwood* might be lost. Lost to modernism, that is, to Eliot's symbolic and moral cosmos.

It is to this dangerous, and for Eliot, perceptible yet unthinkable possibility—that Barnes's work might have already moved in another symbolic order, "beyond rescue," beyond the redemptive ruses of modernist technique and aesthetic ideology—that I now turn.

II

Essential to Barnes's whole literary corpus is a certain "positionless" quality, its generic and categorial uncertainty and its correlative unsettling of literary historical oppositions like modernism and postmodernism.[4] Barnes captured well her peculiar lack of place in Eliot's "ideal order" of tradition,[5] when she referred to herself as "the most famous unknown in the world." Eliot's concept of tradition stressed the continuity and wholeness of that order; it was ill-equipped to deal with centrifugal works like Barnes's that manifested (in Paul Mann's words) a "counterhistorical force, a force pitched against its conscription by this or that masterplot."[6] Moreover, Barnes treated skeptically, even satirically, Eliot's recommended means for entering tradition's monumental corridor. Her works are indeed rife with images of the "surrender of self," "self-sacrifice," "extinction of personality," "depersonalization"—the privileged terms in Eliot's poetics of impersonality. Yet they

call in question the aesthetic payoff that was to result in compensation. The processes that for Eliot would make the artistic monument find their disenchanted corollaries in Barnes as shell shock, psychic regression, and rigor mortis.

Barnes employs literary techniques akin to and in part derived from Joyce's flamboyant displays of style, Eliot's borrowings from literary history, and Pound's thematic montage of fragments. Yet her use of these modernist techniques far exceeds what Craig Owens calls the "self-critical tendency of modernism"—its self-reflexive and ironic foregrounding of the literary device—and approaches the "deconstructive impulse" Owens sees as characteristic of postmodernism.[7] Barnes's extreme stylistic mannerism and runaway figural language obtrude through her ramshackle large-scale forms, hinting at the radical loss of boundaries, the promiscuous blurring of categories, the setting in play of the signifier often associated with later postmodernism.

Implicit in her deconstructive impulse is an attack on the redemptive or recuperative mission attributed to artistic form (and by extension, autonomous art as a social practice) by modernist writers and critics. As Owens writes:

Postmodernism neither brackets nor suspends the referent but works instead to problematize the activity of reference. When the postmodernist work speaks of itself, it is no longer to proclaim its autonomy, its self-sufficiency, its transcendence; rather, it is to narrate its own contingency, insufficiency, lack of transcendence. . . . [A]s such, its deconstructive thrust is aimed not only against the contemporary myths that furnish its subject matter, but also against the symbolic, totalizing impulse which characterizes modernist art.[8]

While Owens means to celebrate the postmodernist jettisoning of modernist pretensions, the disenchantment of modernism's redemptive myth may, ultimately, prove more melancholy than liberating. Modernism met a crucial psychological and ideological need for artists and intellectuals. It invested the artwork and the labor of *making* art with a value independent of its actual social functionality in modern capitalist society. To lose faith in the modernist myth was to recognize that art no longer had an essential function; that it could offer no comprehensive answers to spiritual, sexual, or social problems. It was to realize that the arcadia of the text or painting was not significantly different from anywhere else. Art offered no secure position from which to oppose oneself to the rest of the social world.

Barnes knowingly adopts this disenchanted loss of position and consciously explores it as a thematic concern. It follows, in her view, from the contingency of social life. Women, and hence women writers, are especially affected, for the "very Condition of Woman is so subject to Hazard, so complex, and so grievous, that to place her at one Moment is but to displace her at the next."[9] At the same time, however, it also reflects an ontological condition, that purgatorial state of earthly existence similar to that in which Beckett's clowns wobble and wander (Barnes's syntax here likewise resembles the comic grammatical displays in Beckett's *Watt*).[10] As she concludes about women's lot:

> Some have it that they cannot do, have, be, think, act, get, give, go, come, right in anyway. Others that they cannot do, have, be, think, act, get, give, go wrong in any way, others set them between two Stools saying that they can, yet cannot, that they have and have not, that they think yet think nothing, that they give and yet take, that they are both right and much wrong, that in fact, they swing between two Conditions like a Bell's Clapper, that can never be said to be anywhere, neither in the Centre, nor to the Side, for that which is always moving, is in no settled State long enough to be either damned or transfigured. (*LA*, 48)

Barnes's style in this and similar passages partakes of both the uncanniness of a writing-machine, cranking out variation after variation of the verb phrase, and a tottering giddiness provoking laughter at the sentence's mechanical fits and starts. Its manner no longer serves to highlight technical finesse as the mark of an author's mind and hand, working in concert to transfigure shards of experience into riches of aesthetic form. Instead, it evinces the overpowering of intention by systematic constraints, of individuating style by depersonalized structures of grammar. This bumpy ride through grammatical space threatens at any moment to careen out of the controlling hands of the author, sending the whole work into the ravine. It is only through a precarious shifting from space to space, style to style, that one fends off this perilous artistic fate.

Barnes also enacts this loss of definite position through her representation of character. In his *Theory of the Novel*, Georg Lukács designated the typical condition of the modern novelistic character, whose subjective state was irreparably dissonant with the objective world, as "transcendentally homeless."[11] Out of this dissonance, from the transformative interactions of character and context, the novelistic narrative unfolds. The problem of Barnes's characters, however, is not modernist

alienation, the self's "transcendental homelessness" in the world. It is rather a danger reflecting the new context of mass politics, economic slump, and urban violence in the late twenties and thirties—that both self and world will be eclipsed within a pure, placeless immanence: chthonic nature, mythic terror, the id, death, the night at the end of history. Not the suffering of individuation, experienced as Lukácsian homelessness, but the seduction of indifferentiation, a recession into the background, is their burden as characters.

Such a condition does not impel narrative progression; their passion leads to no redemption. It engenders instead stasis and recurrence, the fixation of characters in compulsive rounds. Thus Barnes's Dr. O'Connor, who is intimate with the "night," the "sea" that holds the faceless "fish" of impersonal sexual encounters,[12] is depicted as both petrified and indistinct in shape—"a sort of petropus of the twilight" (N, 78), as he puts it.[13] O'Connor elsewhere says of himself that "he's been everywhere at the wrong time and has now become anonymous" (N, 71). As it approaches its extreme, then, the placelessness that afflicts Barnes's characters threatens to become spatial dissolution and, as in Beckett, to affect their capacity to be nominated as textual personae, characters. O'Connor's nocturnal nomadism, his being "everywhere at the wrong time," portends the condition of anonymity, just as Molloy's wanderings prefigure his still more profound disintegration into the "Unnameable."

An alternative figure for the return to immanence (to be discussed at length later) is that of *decapitation,* a total loss of conscious agency and complete corporeal automatism. Already in her early journalism, Barnes had associated decapitation with another traditional image of automatism, one used likewise by Lewis and Beckett: the puppet. This figure serves her satirical designs, by comically deflating the gravity of human passions and sorrows and by enacting scenes of cruelty on bodies that can experience no pain. In a story printed in the *Morning Telegraph* on 8 July 1917, Barnes meditates on the untragic character of marionettes:

They say to each other, "Madame, how do you do—it is an exceedingly delightful day, the Bois is sunny, let us take a stroll," and when the stroll has been accomplished the young swain finds nothing to regret in the discovery that his inamorata has returned minus a head. He looks at her coquettishly . . . and thereupon proceeds to adore her in her new condition without sorrow and without regret.

Their passions are always more violent than their retribution, their

beginnings more fatal than their end; for them the beginning is struggle, mighty raisings of hands and creaking of joints and flourishing of swords, but their deaths are only defeat, not tragedy.[14]

In her mature fiction, Barnes's static, stylized characters gesture repeatedly toward their *semblables* in the puppet world. The majority of Barnes's characterization, it is true, takes place this side of anonymous or acephalic limit-experience. Yet as her doomed figures approach a point of indifference with their inanimate ground (in language or in represented space), any possibility for tragic uplift declines into a laughable pathos of defeat. In their sleepwalking and compulsive action, Barnes's characters mock the modernist appeal to disinterested awareness as a means of rescuing the "profounder significance" of their doings. Barnes herself offers no redemption to her characters, not even a tragic one, but allows only a deconstructive margin of difference *from* them to emerge in her text: a mortifying laugh that, in its shock, may momentarily arrest their fatal course.

III

In the late nineteenth century, a number of critics and historians have observed, the family and the traditional gender relations undergirding it became a central concern of authors working out their relation to modernity.[15] Henry Adams, for example, wrote that the American man "could not run his machine and a woman too." The outcome of men's accelerated pursuit of modernity was that women strayed from their natural "axis": "The woman's force had counted as inertia of rotation, and her axis of rotation had been the cradle and the family. . . . [I]t was surely true that, if her force were to be diverted from its axis, it must find a new field, and the family must pay for it. So far as she succeeded, she must become sexless like the bees."[16] Other artists, however, would draw on this same symbolic cluster to define a more positive relation to modernity. Thus Baudelaire, as Walter Benjamin notes, affirmed such "anti-natural" figures as the impotent male and the barren woman, as well as the androgyne, the lesbian, and the prostitute. Benjamin relates these figures to Baudelaire's affirmation of urban life: "The renunciation of the 'natural' should be dealt with first in relation to the metropolis as the subject of the poem."[17]

Elsewhere Benjamin suggests a broader provenance for this revaluation of nonreproductive sexual forms: "The basic motif of *Jugendstil* is

that of the transfiguration of sterility. The body is depicted predominantly in those forms which precede sexual maturity. This thought is to be linked with that of the regressive interpretation of technology" (42–43). For Baudelaire, the figure of the lesbian is likewise a recognition of modernity *and* a protest against technology (39). The modernity of lesbianism rests in its abstraction of love and elimination of woman's "natural" function of reproduction: "The Lesbian woman carries spiritualization (*Vergeistigung*) into even the womb. There she plants the lily-banner of 'pure' love, which knows neither pregnancy nor family" (43). At the same time, however, Baudelaire refuses to recognize any relation between his lesbian figure and the emancipation of women in such public professions as journalism or in factory work. He thus gives "a purely sexual accent to this evolving tendency in women" (39).

On the leading edge of Anglo-American modernism, Gertrude Stein's family epic, *The Making of Americans,* for example, stylistically enacts the antinomy of family and modernity. Over the course of its hundreds of pages, Stein's new, experimental style emerges as the family's history dissipates its authority as a narrative source. In her retrospective lecture, "The Gradual Making of the Making of Americans," she likened—or perhaps attributed—this progressive radicalizing of style to an entropic slowing of the generational wheel: "In writing The Making of Americans [the years] rolled around less quickly. In writing A Long Gay Book, they did not roll around at all, and therefore it did not go on it led to Tender Buttons and many other things. It may even have led to war but that is of no importance."[18]

Barnes's stylistic demolition of rigidly chronological genres like the chronicle (*Ryder*) and the almanac (*Ladies Almanack*) reveals an analogous confrontation between modernity and genealogically grounded duration. Like her symbolist and decadent forerunners and her modernist compeers, she also ambivalently embraces modernity through an ostentatious use of "anti-natural" figures, including the lesbian, the vampire, the nomadic Jew, the hermaphrodite, and the transvestite. Nevertheless, she dissipates any redemptive aura invested in these figures by earlier writers. In what follows, I discuss the implications of Barnes's engagement with issues of filiation and her "denaturing" of gender. I concentrate on her two major books preceding *Nightwood, Ryder* and *Ladies Almanack,* then discuss *Nightwood* in the latter half of the chapter.

Ryder, published in 1928,[19] seems at first glance to suggest the neat filial order of the family chronicle, but it delivers nothing of the sort.

Instead, it presents a heterogeneous set of short texts, poached from a variety of period styles and genres and loosely organized around the irregular Ryder clan and its friends and neighbors. While the passage of time can be discerned through its discontinuous chapters, the narrative careens wildly between parable and bawdy tale, satire and homily, folktale and mock-epistle. Louis Kannenstine suggests that *Ryder* stages "the death of the social or domestic novel of generations that had dominated the nineteenth century."[20] Yet while it is certainly true that *Ryder* dismantles the domestic novel's conventions, its formal principle lies ultimately neither with a modernist genealogical myth (as with Faulkner) nor with ironic, self-critical allusion to a traditional genre. *Ryder* is formally distinct from more integrated modernist works by its loose, "choric articulation"—the nonsymbolic couplings and breaks that make of the Ryder cosmos a "riant spaciousness," a hilarious machinery of conflicting desire and drives (see chapter 2 above).

Ryder's solidly patronymic title marks, one discovers by the fourth chapter, not paternal authority, but rather *interruption* and conscious rejection of patrilinearity. Wendell Ryder's mother, Sophia, "gave him no father's name but stayed by her own" (*R*, 17). One reason, so she claims, was that her son was conceived immaculately in a dream, when the astral body of Beethoven passed through her own—the birth of the grotesque out of the spirit of music. The other is "that she had learned to dislike John Peel," her husband of that time (*R*, 17). Resembling at once Barnes's own grandmother and Dame Evangeline Musset in *Ladies Almanack*, Sophia Ryder is a worldly and unconventional woman who has married several times; as her name indicates she "is wise to" the ways of men. Outside of the normative family, she plays the indulgent "Mother" to all—to her own prodigal son, Wendell, to the men from whom she begs money to support her brood, and to the fallen women she takes under her protecting wing. In her rejection of patriarchal authority and her *affiliative* conception of motherhood, Sophia embodies the decadence of filial genealogy and the rise of a new, independent womanhood.[21]

At the same time, however, she symbolizes a breakup of the ability of *cultural* tradition to provide bearings for the modern individual. The walls of her bedroom, on which she hangs pictures, prints, and eventually newspaper clippings, form the image of a historical process in which tradition is effaced and scattered by the rise of information. Barnes recounts in order the images matting Sophia's walls. First are the women

of history and culture she admires: George Eliot, Brontë, Elizabeth Stanton, Ouida, Catherine the Great, Beatrice Cenci, Lotta Crabtree, and several spirit-visitants identified only by allegorical epithets. Then the men she admires: a railroad magnate, Savonarola, a Samoan chief, Dante, and Oscar Wilde among them—free of any chronological succession and, in any case, hardly the model of a tight-knit family line! Then images of death and suffering, which include among pictures of torture, murder, and capital punishment that of pregnancy: "the filling of the belly, known as the Extreme Agony" (*R*, 13). At a certain point in her youth, these pictures began to be obscured by those of her Swedish lover, Alex, which eventually filled the whole wall. Barnes pauses here to comment:

Sophia's walls, like the telltale rings of the oak, gave up her conditions, as anyone might have discovered an they had taken a bucket of water to it, for she never removed, she covered over.

At forty these pictures were an inch deep, at sixty, a good two inches from the wall; the originals were, as she herself was, nothing erased but much submerged. (*R*, 13)

Barnes's metaphor of the slow-growing oak would seem to imply that Sophia is a deep source of tradition, surveying the *longue durée* of history. Yet as with modernity itself, each new fashion of her heart and intellect is discontinuous with the previous one, consigning it to her "heap of broken images." One can discern here a satirical depiction of technically reproduced memory analogous to Lewis's more elaborate gramophonic-cinematic "utopia," in which the family picnic can be reenacted on sound film, complete with bawling children and pesky mosquitoes, while political heroes of the past repeat their famous speeches; both *Ryder* and *Time and Western Man* appeared within a year of one another and offered a vision of history flattened into images and recomposed. The final stage of Sophia's image archive is reached when the cultural canon is definitively submerged by the tide of information, mass culture, and journalism:

Even Alex had gone, he, who had for so long held sway, slowly ebbed, and in his stead rose that last tide, clippings from newspapers. For in the end this was her court,—false prophet, false general, the pretty girl untimely raped, some woman aptly killed, some captain who claimed discovery of the North Pole, some Jack who had climbed a steeply top; all in a conglomerate juxtaposition, and under all, smiling in forlorn inevitability, Beatrice Cenci, Shakespeare and the Divine Dante. (*R*, 14)

Sophia's cultural canon ends in a Rauschenberg-like pastiche of degraded fragments, selected and arranged idiosyncratically, and connected only by their spatial contiguity.

On Sophia's wall, culture has itself become the idiosyncratic body Horkheimer and Adorno discuss in *Dialectic of Enlightenment,* which stiffens and is assimilated to its surroundings—as the gallery of photos has become like an oak tree in the forest of information. As I suggested in chapter 2, however, this same mimetic assimilation to space is integral to the dynamics of laughter. Sophia's picture collection disaggregates images from their contextual and chronological position and reassembles them in a riotous, riant spaciousness. In a world where Savonarola lies down with Oscar Wilde—no postmillennial reconciliation of lion and lamb, only the everyday cosmos of technically reproducible images—the canon of culture has become salvageable only at the expense of making it subjectively configured, idiosyncratic, laughable.

Barnes leaves ironically unresolved the positive and negative aspects of Sophia's modernistic revolt. The ambivalence of Barnes's attitude to the freedom Sophia assumes is concentrated, above all, in the figure of Wendell. He is, she suggests, in more ways than just the biological, the dubious result of Sophia's choice. While casting himself as biblical patriarch and natural man, Wendell unwittingly embodies the indiscriminate release of productive forces that are part and parcel of the most advanced Americanism and technological modernity. Through Barnes's mocking pseudo-Chaucerian depiction of Wendell can be discerned a deformed representative of Max Weber's "Protestant Ethos," who justifies frugality by reference to religious calling. Likewise Barnes's black humor sets in contiguity images of baby making and meat-packing, natural propagation and slaughter for market:

> Then Wendell worked his other wits as well . . .
> How bread from bran he mightë roll and bake,
> That child and cattle fodder from one bin,
> For kine, he held, were kith, and infants kin.
> And other ways he'd twist to save a coin;
> While spendeth he most lavish of his loin
> Most saving was of gold and silver bright,
> . . . Thus he did preach:
> "Store every sacking strong, for shirt and breech,
> For hams come diapered as babes y-clout,
> Yes, what y-ham wears in, y-babe wears out." (*R,* 55)

Not for nothing was *Ryder* published on the brink of a worldwide depression; overproduction—of children, guns, or butter—must end in bankruptcy and violence. Yet Wendell's dearest wish is to reproduce himself indefinitely, perpetually remaking the world over in his image. As three incidents recounted in the late pages of *Ryder* clearly suggest, this multiplicative drive is self-consuming, holding the seeds of its own demise.

The first of these portentous incidents is recounted in the chapter entitled "Ryder—His Race." Barnes preludes her narration with a "treatise on carnivora," noting, "Of all carnivora man holds woman most dear" (*R*, 205). Juxtaposing women who are the object of men's love to women who devour the flesh of animals, Barnes employs a Rabelaisian technique for generating grotesque effects by crossing two distant semantic series.[22] This "treatise" on carnivora prepares the defeat of Wendell's heroic propagation recounted later in the chapter, the "exposé of much nothing" (*R*, 205) in the barren body of the elderly Lady Bridesleep. It allegorizes the flaw in Wendell's narcissistic vision, in which—like the male modernist artist—he asserts his creative mastery while failing to recognize his total dependence on the women who surround him—mother, wives, daughters, and mistresses.[23] This dependence leads him to "conquer" yet more women, which further gnaws away at his autonomy: a self-renewing yet self-defeating process. If Wendell is like an American Noah, presiding over the repopulation of a new world, then Barnes presents his women as hunkered down in the hold of the ark, polishing off the flesh of some irreplaceable species.[24]

Wendell comes one day to Lady Terrance Bridesleep, proposing to sleep with her. She accepts: "Who was she at sixty that upon the turn-spit of her attraction a man should baste and be a man for all that?" (*R*, 208). Before the momentous event takes place, Wendell offers a weighty rationale for his sexual conquests:

I, my love, am to be Father of All Things. For this was I created, and to this will I cleave. Now this is the Race that shall be Ryder— those who can sing like the lark, coo like the dove, moo like the cow, buzz like the bee, cheep like the cricket, bark like the dog, mew like the cat, neigh like the stallion, roar like the bull, crow like the cock, bray like the ass, sob like the owl, bleat like the lamb, growl like the lion, whine like the seal, to say nothing of screeching like the parrots and all sundry cryings, wailings, belchings, gnashing, sighing, sobbing, screaming, such as one hears the world over, but from a thousand several throats. . . . Some shall be prophets, some sophists, some scoundrels, some virgins, some bawds, some priests, some

doxies, some vassals, some freemen, some slaves, some mongers, some pam-
phleteers, some eunuchs, some hermaphrodites, some nobles, some pussy-
winks, some panders, some jades, some lawyers, some doctors, some presi-
dents, some thieves; pro and con, for and against, though never one
bourgeois or like to other men as we now know them, but at the fertile pitch
of genius. (*R*, 210)

Like a manic Whitman, Wendell envisions a total and simultaneous mas-
tery of all means of expression—an overcoming of the ordinary bour-
geois existence in the *fiat lux* of genius. Here, more clearly than any-
where else in *Ryder*, Barnes satirically underscores the unhappy analogy
of Wendell to the modernist artist, thrown back on the "fertility" of his
own subjective invention.[25]

In Lady Bridesleep, however, Wendell meets the exasperation of his
design:

In the dawn, where Wendell lay crowing like a cock, and most extraordi-
narily pleased, Lady Terrance arose, and turned to him smiling. "What shall
we call him?" inquired Wendell in huge pride.
 "Nothing and Never," said Lady Terrance sweetly. "He shall accomplish
all the others leave undone. You need No Child also, my good man, all
fathers have one. On him you shall hang that part of your ambition too
heavy for mortal. And now," she said to the maid, who answered her ring,
"bring me the calf's head that you'll find on the ice." (*R*, 211)

Barnes returns to the image of carnivorous woman, devouring the
world's creatures as they puncture the pride of men. Wendell must, in
Lady Bridesleep, confront the allegorical representative of time and
death—the oblivion against which his modernistic dream will founder.
She presages the fate of his projected revolution of the word, as the mul-
titudinous sounds of his "race" recede into a background of deathly
silence.[26] The chapter concludes with Wendell's stunned response, a
rare spasm of reticence in this loquacious text bearing his name: "Wen-
dell opened his mouth, but no sound came" (*R*, 211).

 The other two incidents can be dealt with more briefly. In the chap-
ter "Fine Bitches All, and Molly Dance," Barnes illustrates an inverted
world, in which animals are strictly bred according to genealogical order
while humans rut like the beasts of the field. Molly Dance, a dog
breeder, is a female likeness of Wendell Ryder, with her numerous chil-
dren, her sexual promiscuity, and her revisionary cosmology. She takes
her pleasure as it comes and makes no attempt to determine the pater-
nity of her children. Wendell, troubled by this loss of distinction, offers

her a figment of certainty: *he* will sire her next child, then she will know its father. Wendell, like the modernist artist, seeks, through his conscious act of creation, to reconstitute a symbolic order against the featureless face of chaos. Unfortunately for Wendell, his plans once again come to naught. For Molly reveals the power of female promiscuity to unravel the symbolic order of patrimony:

"Well," said Molly . . . , "how shall she, or I, or you, or another know but that Dan, the corner policeman, be he? For not two nights ago he had the same idea, and that only goes to show you," she added, "that one man's thoughts are not worth much more than another's." (*R*, 199)

Wendell, the would-be author of a homemade world, is reduced to an interchangeable part in a hetaeric, maternal cosmos.

Wendell's genealogical vision will, unbeknownst to him, suffer a third blow. In the chapter entitled, significantly, "Three Great Moments of History," Dr. Matthew O'Connor catches a boy who has stolen a jar of honey. He sits him down and treats him to a typically oblique O'Connor speech, which in its course brings up the name of Wendell Ryder. The boy reveals that he is one of Ryder's bastard children and that in reaction to his father's thoughtless promiscuity, he has foresworn having anything to do with women.[27] The chapter ends with the implication that Matthew O'Connor will initiate the youth into gay love:

"This," said Doctor Matthew O'Connor, "changes the whole aspect of the argument. To love thy fellowmen is also a necessity." And with that he did gently put an arm around the lad as, with the other hand, he turned the pot right side up, to save what little there was left of a sweet matter. (*R*, 236)

As the tender eroticism of O'Connor's metaphorical righting the overturned honey pot conveys, this initiation is the afterimage of Wendell's mechanical (re)productivity.

Ryder ends on a note of impasse, with what, in spite of its pastoral setting, can be understood as the ironic revenge of modernity on the "creator" who too closely identifies himself with its innovative impulse. As Wendell's world crumbles around him—his mother dying, his wives preparing to leave him, his children turned against him, the money gone—he goes out into the night and sits in the fields amid the animals. The book ends with a mimetic regression, a collapse of the distinction between Wendell and his surroundings:

And everything and its shape became clear in the dark, by tens and tens they ranged, and lifted the lids and looked at him; in the air and in the trees and

on the earth and from under the earth, and regarded him long, and he for-
bore to hide his face. They seemed close ranged, and now they seemed far
ranged, and they moved now near, now far, as a wave comes and goes, and
they lifted their lids and regarded him, and spoke not in their many tongues,
and they went a far way, and there was a little rest, and they came close, and
there was none. Closing in about him nearer, and swinging out wide and
from him far, and came in near and near, and as a wave, closed over him,
and he drowned, and arose while he yet might go. And whom should he
disappoint? (*R*, 242)

The extraordinary beauty of this ending, reminiscent of the pantheistic
climax of Flaubert's *The Temptation of Saint Antony*, should not
obscure the satiric harshness of Barnes's conclusion: Wendell's com-
plete identification of himself with the innovative impulse of mod-
ernism, his "perpetual extinction of personality" in the (pro)creative
act, is literally realized in madness.

 Ladies Almanack, which appeared contemporaneously with *Ryder*,
takes up a number of the same themes and images, while likewise rum-
maging the ragbag of literary styles for its models. Presenting itself as
"the book all ladies should carry" (*LA*, motto of the second illustra-
tion), *Ladies Almanack* combines a salacious roman à clef, satirizing the
members of the lesbian salon of Barnes's friend Natalie Barney, with an
experiment in literary parody. Barnes herself described it as "a mild
satire on the somewhat shoddy 'loves' of present day Sapho's [*sic*]."[28]
Each month of the "almanack" introduces a different character or mode
of discourse, but the course of the "year" refers to the life span of the
head "lady," Dame Evangeline Musset (representing Natalie Barney, a
grande dame of both lesbian and French modernist salon culture).[29] In
twelve months, it illustrates Dame Musset's various "rescue" missions
out "upon that exceedingly thin ice to which it has pleased god, more
and more to call frail woman, there so conducting herself that none
were put to the chagrin of sinking for the third time!" (*LA*, fron-
tispiece).

 While the intersections with *Ryder* are numerous, there are signifi-
cant differences between the two books. Most obvious is the shift from
the largely male-centered cosmos of *Ryder* (however pseudopatronymic
it might be) to the exclusively female world of *Ladies Almanack*. With
this shift the focus changes from the family to lesbian affiliation and
nonreproductive sexuality. Moreover, the books' publication took dif-
ferent forms. Whereas *Ryder* was issued under Barnes's own name by
Horace Liveright, *Ladies Almanack* was privately printed with author-

ship attributed only to "A Lady of Fashion."[30] Barnes's use of a pseudonym for *Ladies Almanack* can be plausibly explained by her uneasiness with being identified with Natalie Barney's lesbian salon and hence as a lesbian herself.[31] Yet Barnes's particular choice of pseudonyms ("A Lady of Fashion") implies not just a dissimilating veil but also a tightly woven tissue of themes.

Fashion, as Baudelaire noted, is intimately connected with modernity and hence with the artworks of modernism. In his famous essay on Constantin Guys, "The Painter of Modern Life," Baudelaire defined modern art as the distillation of fashion. The modern artist "makes it his business to extract from fashion whatever element it may contain of poetry within history, to distill the eternal from the transitory."[32] Later in the same essay, Baudelaire takes up the question of fashion again, discovering in it a utopian impulse to improve on nature and everyday life: "Fashion should . . . be considered as a symptom of the taste for the ideal which floats on the surface of all the crude, terrestrial and loathsome bric-á-brac that the natural life accumulates in the human brain: as a sublime deformation of Nature, or rather a permanent and repeated attempt at her *reformation*" (32–33). For Apollinaire, a beloved figure among the pre–World War I expatriates in Paris, fashion had a close kinship to a new stylistic freedom in modernist writing. In a hilarious passage in *The Poet Assassinated*, the character Tristouse Ballerinette describes the year's fashion:

"This year," said Tristouse, "fashions are bizarre and common, simple and full of fantasy. Any material from nature's domain can now be introduced into the composition of women's clothes. . . . Fish bones are being worn a lot on hats. . . . Steel, wool, sandstone, and the file have made an abrupt entry into the vestmentary arts. . . . Feathers now decorate not only hats, but shoes, gloves, and next year they'll be on umbrellas. . . . Notice that they're beginning to dress in live animals. . . . Dresses embellished with coffee beans, cloves, cloves of garlic, onions, and bunches of raisins, these will be perfect for social calls. Fashion . . . no longer looks down on anything. It ennobles everything. It does for materials what the Romantics did for words."[33]

Despite its humorous form, Apollinaire's "fashion report" asserts an important equation: modern literature's ability to incorporate the fanciful and bizarre alongside the common and even abject is akin to fashion's magical power to "ennoble everything."

Fashion does have its down side, however: it is short-lived. Nothing is more obsolete than last year's fashion, nothing more quaint than the

fashion of past decades. Similarly, modernism's absolute commitment to "the New" had as its corollary that yesterday's artistic rage could be tomorrow's old hat. Fashion binds together in one image the newest newness and its double, the always already obsolete. Its radiance and melancholy are the Janus face of modernity, and modernism reflects first one, then the other visage. In *Ladies Almanack*, "fashion" satirically refers to a modernist mode of enunciation, in which (as in Joyce and Pound) styles may be tried on as a lady tries on a dress. Moreover, Barnes is crucially concerned in this work to view lesbian community through the dual temporal optic of fashion: its modernistic aura of newness, its beauty and flamboyance; and its potential fragility and ephemerality. Lesbian community, like fashion, constitutes for Barnes the very scene of modernity.

Barnes suggests—in a rather backhanded way—that lesbianism has recently become fashionable, in the pejorative sense of "trendy." Thus Dame Musset (representing the senior Amazon Natalie Barney), whose very look bespeaks her immunity to fashion, complains:

"In my day," said Dame Musset, and at once the look of the Pope, which she carried about with her as a Habit waned a little, and there was seen to shine forth the Cunning of a Monk in Holy Orders, in some country too old for Tradition, "in my day I was a Pioneer and a Menace, it was not then as it is now, *chic* and pointless to a degree, but as daring as a Crusade, for where now it leaves a woman talkative, so that we have not a Secret among us, then it left her in Tears and Trepidation." (*LA,* 34)

Yet while Barnes may well take a swipe at the fashionable "ladies" of Barney's salon, she equally implicates the "lady of fashion" writing the book. For as part of the company of newcomers to this fashion, she is a betrayer of secrets, bearing the concomitant guilt of using community to make literature.

Barnes retains this ironic stance in representing Dame Musset's circle, expressing a deep ambivalence that goes beyond the barbed satire of the roman à clef. In a number of her positive traits—her openness, her freethinking, her frank sensuality, and her personal magnetism—Musset resembles both Sophia and Wendell Ryder. Her character suggests a possible synthesis of the best of their traits, an ideal of the modern character of which Sophia and Wendell were the damaged halves. I think the overall lighthearted tone of the book favors this view. Nevertheless, Barnes tempers her celebration with a sizable, if subtly presented, dose of skepticism. This can be seen in three aspects of the book.

The first is generic: the almanac format. As a calendar, it has a dual

temporal valency, referring on the one hand to the naturally regenerating cycles of nature, which renew the products of the past in the same form, on the other to the annual cycles of fashion, which obliterate them from memory. The passage of the year is either redemptive or catastrophic. Almanacs, moreover, tend to segment the year into a schedule of *planting,* to which other factors like weather are correlated. Yet given the affiliative nature of this community, the organic-generative connotations of that structuring of time stands in ironic tension with Barnes's implication, in a kind of sly generic pun, that no seed will fall in this furrow. The implications of the almanac form waver back and forth between generativity and lack of issue, structure and destruction, continuity and the approach of a final end. The ambiguity of this generic allusion may then imply, as Barnes writes in her August chapter, that the satiric almanac offers no sure guidance, as it can represent "no settled State long enough to be either damned or transfigured" (*LA*, 48).

In addition to the popular and practical genre of the almanac, *Ladies Almanack* also has a clear relation to the tradition of pastoral literature. This, too, commonly made allegorical allusions to definite figures of the court, of literary and intellectual circles, or of coteries and salons. If Dame Musset's salon circle can be said to resemble a kind of idyllic pastoral community, then the specific literary analogy between *Ladies Almanack* and one evident model for Barnes's "pastoral," Spenser's *The Shepheardes Calendar,* suggests a more melancholy outlook than the playful tone would at first glance suggest. The vulnerability of the closed community to historical mutability and death is a dominant theme of Spenser's pastoral and the genre as a whole. I am not, of course, arguing that Barnes is merely serving up an old pastoral chestnut but rather suggesting that she allows the allusion to pastoral to collide with and perspectivize her more lighthearted intentions.

She underscores her doubts, introduced by the generic vehicle, through the explicit comments of the character Patience Scalpel (by the "key," Mina Loy). Significantly, Scalpel brings up the question of *reproduction,* calling in question the self-sufficiency of an all-women community. After a tirade against pairing "like to like," she pauses and asks, "Are good Mothers to supply them with Luxuries in the next Generation; for they themselves will have no Shes, unless some Her puts them forth! Well I'm not the Woman for it! They well have to pluck where they may. My Daughters shall go amarrying!" (*LA*, 13). Only if some women continue to give birth, argues Scalpel, will Dame Musset find new "ladies" to take under her wing.

In a subtle manipulation of typographic space and image-text relation, however, Barnes divides Scalpel's "cutting" words and places an image of the child Evangeline Musset emerging birthlike from the space between Scalpel's words. Below the icon of Musset is a banner that reads "Thus Evangeline Began Her Career." The folds of the banner open outward, and in conjunction with the frontal view of the child and the white space between the two halves of the text, suggest an abstracted image of a woman's spread legs; either Musset is emerging from the vagina (figured by the shadows above her left side) or she forms its outline. Barnes offers here a myth of origin, in a catastrophic confrontation of the filiative and affiliative ideals. Mobilizing the ordinarily "margin" elements of graphic and typographic design against the senses of the text—a discourse, dominant both materially (in the book format) and ideologically (in the book's social context)—Barnes literally opens the space from which the lesbian heroine will emerge. To put it in a formula: the heroine of modernistic affiliative (lesbian) community is born from the literal rupture of the filiative discourse that Patience Scalpel represents.

In its depiction of the "making of a lesbian" as a parodic simulacrum of birth, however, Barnes's drawing also subtly *illustrates* Patience Scalpel's argument: this community's progeny exists only on paper, as works of literature and art. In fact, Barnes views lesbianism as peculiarly tied to a "textualization" of desire, the mediation of social relations through eroticized acts of writing and reading—of which *Ladies Almanack* is itself a prime example. Already in *Ladies Almanack* the various aspects of same-sex love are linked by analogy to different modes of reading. These modes of reading are delineated on a "horizontal" axis, along which there are qualitative differences, even contradictions: the different "months" of the calendar, representing as they do diverse figures in the Barney circle and diverse facets of lesbian community, and some presented by Barnes more positively than others. At the same time, Barnes also implies a "vertical" axis of reading, by overlaying her narrative line (the life of Dame Musset) on an abstract, spatialized grid (the calendar or zodiacal form, which allows side-by-side comparisons); her allegorical representations of stylized "ladies" on the referential allusions to a coterie; her textual depictions on the pictorial and typographical images. Each of these laminations may lead to conflicts of interpretation. Each new thickening of the text arrests the identifications of readers, blocking their curiosity to know "what lesbianism is," barring their investment of desire in "the" meaning of lesbian sociabil-

LADIES ALMANACK 13

Starry Eyes aloft, where a Peewit was yet content to mate it hot among the Branches, making for himself a Covey in the olden Formula, "they love the striking Hour, nor would breed the Moments that go to it. Sluts !" she said pleasantly after a little thought, "Are

good Mothers to supply them with
Luxuries in the next Generation ;
for they them- selves will have no
Shes, unless some Her puts them
forth ! Well I'm not the Woman
for it ! They well have to pluck
where they may. My Daughters
shall go amarry- ing !"

Figure 7. Illustration from Djuna Barnes, *Ladies Almanack*.

ity, as if such a thing existed, in the singular. As I will suggest in the following section, *Nightwood* amplifies the analogy between lesbianism and reading and self-reflexively interrogates it, to the point of refusing the entanglements of textuality and desire, the costs of "reading" the other and of imputing meanings to her story.

Finally, and perhaps most subtly, Barnes also embeds temporal irony in the linguistic texture of the work. Obvious to any reader is the unusual, archaic diction of *Ladies Almanack*. What is perhaps less obvious is that the overwhelming majority of the truly arcane words—words for which the typical reader must appeal to the wisdom of the *Oxford English Dictionary*—refer to items of clothing or fabrics. Ensconced in *Ladies Almanack* are scores of uncommon words of "fashion" (along with many other familiar clothing terms). "Blister," "belcher," "tippet" (7), "dimity" (12), "bugles" (15), "riband" (19), "four-in-hand," "Busby" (31), "gusset" (43), "plackets" (47), "underkirtel" (66), "duvet" (67), and "snood" (69) are some of the more flamboyantly strange.

Barnes manages three things with this diction. She highlights the gendering of language through its reference to sex-specific spheres of social life. Since sewing, clothing, and fashion were traditionally women's spheres, the language that refers to them can be used as an exclusive code by women. To be a "lady of fashion" is, from this perspective, to be privy to secrets (the same ones that as a lady of fashion one must betray). At the same time, she suggests the temporal backdrop that shadows this community of women. For a number of these words, many of which refer to specialized Renaissance and nineteenth-century garments, must have been obscure even to Barnes's female contemporaries. These words are pointedly *outmoded*, designating fashions long past and forgotten, hence also evoking the temporal predicament of the "ladies of fashion," doomed to aging and mortality.

Finally, such words satirically conjure an analogy between extravagant rhetoric and grotesque display of the body. They suggest the body's prosthesis by strange, inanimate appendages (a metonymic substitution) and its deformation though aging, which renders its parts as ostentatiously unfunctional as arcane and outmoded words (a metaphoric substitution). As the *Oxford English Dictionary* indicates, the earliest use of the word *prosthesis*, in a 1553 book of rhetorics, had a grammatical and rhetorical sense: "The addition of a letter or syllable at the beginning of a word." An example from the nineteenth century, points to the normative bias against such apparently superfluous, nonstandardized usage: "'Prosthesis' belongs to a . . . class of terms . . . denoting arbitrary processes, whose intrusion into the realm of language should be viewed with . . . suspicion." In the context of standard, modern spelling, the extra "k" of "almanack"[34] can be read as an exemplary instance of this phenomenon. Like the monocle sported by the Natalie Barney devotée Una Troubridge or the painter Romaine Brook's stylish top hat, this supplementary letter in the title announces a whole perverse body of linguistic excesses hidden between the cover of Barnes's little book, pointing ultimately to that "suspicious" excess of the female body when it is unbound from its reproductive functions and untamed by norms of filiative culture.

Barnes may have found inspiration for this figural-prosthetic conception of fashion in the flamboyant but increasingly pathetic figure of her Greenwich Village friend Baroness Elsa von Freytag-Loringhoven (the baroness committed suicide in 1927, and Barnes unsuccessfully tried to edit her poetry and write her biography).[35] In her sartorial sense, the baroness was a walking translation of the Apollinaire passage

quoted above. Summing up various accounts of her eccentric outfits, Steven Watson reports:

Her head was often shaved—or half-shaved—and then shellacked or paint-ed vermillion. She alternately adorned her head with a coal scuttle, a French soldier's helmet, ice cream spoons, or even a lit birthday cake crowning a face smeared with yellow powder and black lipstick. Her wardrobe includ-ed a bolero jacket, a loud Scottish kilt, and a patchy fur coat, but these served merely as a base. An adept seamstress, she applied to her costume Kewpie dolls and stuffed birds, flattened tin cans, cigarette premiums, and chande-lier pendants. On her bustle she installed an electric taillight. Friends of the baroness were often startled to find their own possessions turning up in her attire.[36]

Yet if she embodied in real life the poetic miracle of Apollinaire's idea of fashion, the baroness also gave it a dadaistic spin, shifting the extrava-gances of fashion from a metaphor of the poetic qualities of the modern to a literal enactment of its underlying logic: the magical, and poten-tially monstrous, supplanting of the female body by things. The ribald humor of the baroness's fashion sense poised her sartorial gesture between a utopian celebration of the poetic transfiguration of the body and satiric protest over its reification as commodity and device, an ambi-guity seen also in Hugo Ball's machine-man costumes in the dada nights at Zurich's Cabaret Voltaire, though with differently gendered over-tones. In her very person, on the one hand, von Freytag-Loringhoven anticipated the profane illumination of the urban world, the technolog-ical interpenetration of body and image that Walter Benjamin celebrated at the end of his "Surrealism" essay.[37] At the same time, however, an undeniable note of hysteria lurked in her gestures, rising at times to the pitch of madness. The very freedom of her poetic sense in reinventing her appearance revealed an underlying eclipse of the self, a will to self-extirpation that would be definitively consummated by her suicide. In his critique of surrealist freedom, Theodor Adorno aptly summed up the Janus face of that anarchistic revolt by which the baroness lived and died: "In the face of total reification, which throws it back upon itself and upon its protest, a subject that has become absolute, that has full control of itself and is free of all consideration of the empirical world, reveals itself to be inanimate, something virtually dead."[38]

In *Ladies Almanack,* Barnes takes this double optic on fashion another step toward the cancellation of its utopian side. Unlike Apolli-naire, who plays up the sheer formal inventiveness of the *newest* fash-ion as the double of modernist art, Barnes treats the extravagance of

outmoded fashion as akin to a dismembered or grotesque body, reassembled pastichelike into the body of the beloved. Barnes's illustration for October, which comically literalizes the blazon of traditional love poetry, presents in turn the ideal single parts of the woman's body for praise: "The Eye Of The Scullion / The Legs Of Moll / Whose Buttocks Were A Girls / But The Hand Of Queen Ann / The Breasts of Haughty," reads the caption from top to bottom and left to right. The textual context, however, is Dame Musset's complaint that women's body's are put together by chance, not assembled piecemeal as would, in her view, be ideal:

"Oh monstrous Pot!" she sighed, "oh heinous Potter, oh refined, refined, refined Joke, that once smashed to bits it must go a go-going, and when once concocted must eternally be another's Whim! We should be able to order our Ladies as we would, and not as they come. Could any haphazard be as choice as I could pick and prefer, if this Dearing were left scattered about at Leg-counter and Head-rack?" (*LA*, 67)

It is from the clash of two connotative fields—dismemberment and desire—that Barnes's satiric image emerges. A further sense of "a lady of fashion" suggests itself here, its genitive taken in the strongest sense: the idealized lady constructed by desire is wholly "of" fashion, fashioned out of corporeal pieces, themselves individually fashioned in excess of any unified body, then fitted and bought like items of designer wear from "Leg-counter" and "Head-rack."

Barnes's gesture is ambiguous. Playfully, she asserts an aesthetics and erotics of lesbian love. Yet by framing all-women community in the language of fashion, the idiom of the lady of fashion who has authored and illustrated the text, she also registers its somber predicament. Barnes confronts the positive affiliative relation, which reflects modernity's welcome erosion of patriarchal, filiative authority, with the melancholy time-consciousness that is modernity's shadow. This time-consciousness is registered above all in images of the fragile, mortal, idiosyncratic female body, denatured by cosmetic and technical prostheses and subject to satiric deformation and dismemberment.

IV

Of Barnes's four major works—*Ryder, Ladies Almanack, Nightwood,* and *The Antiphon*—it is undoubtedly *Nightwood* that has attracted the most critical commentary, as well as popular readership. Its subject mat-

64 L A D I E S A L M A N A C

June of Bosom to the utter third-storey W
from which point of Vantage Dame Muss€

seen her winking a]
Eye at the little Sc ̣
Pantry Window op ̣
whom the Bed-airer
ed her Wiles and \
short yet thrifty Gl ̣
direction of Musset,
she not ? For Flan
Jew on Christian,]
throughout her g ̣
fathers to the tun
an aristocratic Arte
many a crude (

give her the uncertainty now in the Hooves
one Heathen and one Gentlewoman, and to
yet Angle before she stopped to think and t

Figure 8. Illustration from Djuna Barnes, *Ladies Almanack*.

ter is closely, even passionately linked to Barnes's biographical situation,
her lesbian love relation with Thelma Wood and her friendships and
enmities in the Paris expatriate circles. The autobiographical compo-
nent of the work has become even more evident as an important body
of unpublished materials, especially Barnes's letters to Thelma Wood
and Emily Coleman and the earlier drafts of the novel, has become
more generally known. In themselves, these are fascinating reading, and
they have shed crucial light on the nature of a powerful but recalcitrant
masterpiece of late modernist fiction. The recent publication of Her-
ring's solidly researched biography of Barnes, which replaces Andrew
Field's flawed and dubiously speculative one, and Cheryl Plumb's new
edition of *Nightwood,* which restores deleted passages and offers much

additional information about the text, will surely reinforce the appeal of (auto)biographical readings of Barnes's novel.

While the role of Barnes's personal experiences and the history of the text are of undeniable importance in the *genesis* of *Nightwood*, however, it nonetheless remains an open question whether such a "contextual" approach represents the best way of coming to terms with the work. Better put, the central questions of *Nightwood* may be what pertinence biographical facts have as context for its text and whether its text does not, by its nature, connect with its context in an unconventional way, perhaps only "representational" in a very specific and limited measure. Barnes's book, with all its difficulties and peculiarities, poses in a particularly intense way problems of reading that to a greater or lesser extent pervade any literary work: the divergence of authorial intention and a reader's interpretation; the mutability of interpretations as new facts about the author and new concerns emerge on the horizon of reading; and perhaps most important here, the divergent status of a text as an artifact of authorial labor and as the basis for a reader's production of meanings, the necessary shift in register between the genesis of a text and its reception. While some books may attempt to conceal or mitigate such issues of reading, others exacerbate them to the point where they can be ignored only at the cost of serious misunderstanding; *Nightwood* is certainly one of the latter. Barnes herself, moreover, actively invites reflection on the status of reading by giving it a central role in the passion play of her characters: their actions are mediated by prewritten scripts of various sorts, and they are caught up in interpreting and misinterpreting stories and in elaborating them further according to their own designs and desires. At the heart of her composition of *Nightwood,* then, Barnes self-consciously explores problems of interpretation, desire, and identification in reading or listening to stories, which cannot help but represent a comment on how her own readers should approach the book before them.

In light of these considerations, I want to argue for a reading of *Nightwood* that sets aside the biographical approach and takes up the problems of interpretation posed by the book as central, not just to its "literary" meaning, but also to its political and historical implications. The potential "illegibility" of the world is not simply a metafictional game for Barnes, nor is it a contingent obscurity that might be cleared up if only one had more personal documents with which to construct the autobiographical "subtext" of the story; it is an anguishing historical problem, which, I will argue, is the central issue of the book. In a more

polemical vein, I would go further and claim that the biographical-contextualist impulse in criticism of *Nightwood* fails to attend to this problem, displacing problems of *reading* onto problems of research, reducing the hermeneutic predicaments of the work to a problem of access to documents. In emphasizing *represented* acts of speech as the point where the text's historical nature can be made explicit by "restoring" the documentary background to literary figures, such an approach elides the rhetorical act that Barnes's book as a whole, in its troubling lack of coherence and legibility, performed in its historical situation. This global "speech act" of the book as a whole is every bit as historical as those individually represented speech acts, which may correspond to documentary data; the book's "speech," however, may be as much determined by the refusal, resistance, parodic deformation, and misprision of context as by translation and representation of it. Furthermore, the rhetorical complexities of Barnes's relation to events and experience, which make *Nightwood* so apparently hermetic, are essential to understanding even those singular experiences represented *within* the book's diegetic frame; for these narrated experiences are themselves deeply marked by Barnes's doubts about the possibility of representing experience as such. The counterhistorical thrust of the work, ultimately, constitutes a more profound, if more mediated, address to Barnes's historical situation than any immediately reconstructible correspondence with documentary evidence.

• • •

Within its primarily comic-satiric frame, *Ladies Almanack* already anticipates the more somber reaches of Barnes's masterpiece, *Nightwood* (1936). *Nightwood,* however, would push Barnes's melancholy awareness of loss and her flamboyantly disfigured imagery toward a new extreme: the progressive breakdown of character, the disintegration of the indices of "self" in fiction. *Nightwood*'s plot line boils down to a few spare events: a baron of Jewish descent (Felix Volkbein) meets a young women (Robin Vote) in the company of an unlicensed doctor (Matthew O'Connor), who is soon also revealed to be a transvestite. The baron and Robin marry, have a honeymoon, and conceive a child, whom the baron wants to carry forth his family line. The child causes Robin great suffering in labor, and her resentment about the experience spells the end of the marriage; the child, meanwhile, is a feeble half-idiot. Robin meets her next partner, Nora Flood, at a circus, and they live together

happily for a while. Robin begins to wander, and Nora stays home alone or follows Robin from bar to bar as she makes her night treks. Finally, Robin is taken over by another woman, Jenny Petherbridge, who takes Robin back to America with her. The exposition of these events, however, takes up only a limited part of the book. The events are told and retold, varied and interpreted, in several different contexts and in the voices of a variety of characters. It is, in fact, in this enormous excess of *narration* over episode that the "modernist" aspect of *Nightwood* lies.

None of Barnes's major works, from *Ryder* to the post–World War II verse drama *The Antiphon,* reveals much concern for large-scale form, plotting, or character development in a conventional sense. Notable instead are their rich stylization of sentence and luxuriant proliferations of trope. As Phillip Herring suggests on the basis of manuscript evidence and personal testimonies, Barnes had "no editorial skills" and "little clear sense of what was and was not digressive or irrelevant"; she arranged chapters in piles on the floor, with only tentative and improvised ideas for the large-scale form of the book.[39] The ultimate "form" of her works is a montage of fragments, partly overlapping and in a contingent order. It is held together as much by its consistency of style and figural language as by its plotting or even character voice. Indeed, the endless succession of images often tends to work against character development, since it renders the voices uniform, as, for example, in the long exchanges between Nora and the doctor in the fifth chapter, "Watchman, What of the Night?"—a veritable battle of lapidary witticisms, sinewy metaphors, and operatically wrought anecdotes.

Barnes's modernist predecessors had long before begun to turn the screw of irony in order to evade identification of the author's perspective with the literary conventions employed, the events represented, and the limited perspectives of the characters in the work. As such, this evasion already implied a loss of faith in the ability of fictional form to encompass and reconcile the contradictions represented there.[40] The modernist gambit, however, was to situate this loss within the horizons of the work, to fold it back into the narrative premises of the story, most often by filtering events through a narrating figure, internal observer, or "stream of consciousness." Elaborate narration, as evidence of a labor of consciousness struggling to comprehend and represent experienced events, took on central prominence, often (as in Henry James or Joseph Conrad) taking on equal or greater importance than the narrated events themselves. By masterfully juggling the partial perspectives of narrators and ironically exposing these narrators' shortcomings, modernist

authors could balance conflicting demands for formal cohesion and fidelity to a bewildering modern world.[41] Appearances could be saved, as the contradictions of life were transfigured into the complexities of literary form.

These contradictions are, however, particularly daunting in Barnes's novel. For framing the melodramatic plot about the fated love relation of Nora Flood and Robin Vote, and in my view, rivaling it for importance, is the pathetic "disqualification" of all characters, both major and minor (Plumb in *N,* xvii). At its most basic level, this "disqualification" has a social meaning, referring to the exclusion or estrangement of the characters from sexual, racial, and occupational norms. The circus performer, the Jew, the declassed or faux aristocrat, and the homosexual are among the most prominent of the alienated "types" that form the backdrop for the lesbian drama of Nora and Robin. If the term "disqualification" is taken literally, however, it yields a further, still more radical meaning: the progressive loss of *qualities* as such. Like her Austrian contemporary Robert Musil, Barnes sets out to depict a recent social development, the reciprocal appearance of a derealized social world and the "disqualified" characters appropriate to it, the emergence of a new type of social being, the "man without qualities." In *Nightwood,* however, the space of this disqualification is not explicitly the rationalized world of technology and collective power but its shadowy afterimage in the irrational realm of sleep and "night":

"I used to think," Nora said, "that people just went to sleep, or if they did not go to sleep, that they were themselves, but now," she lit a cigarette and her hands trembled, "now I see that the night does something to a person's identity, even when asleep."

"Ah!" exclaimed the doctor. "Let a man lay himself down in the Great Bed and his 'identity' is no longer his own, his 'trust' is not with him, and his 'willingness' is turned over and is of another permission. His distress is wild and anonymous." (*N,* 70)

The ontological uncertainty of this world, its dispossession of meanings and identities, faces the writer with a peculiar challenge.

Barnes's attempt to meet this challenge, in fact, pushed the resources of modernist narration to the point of exasperation. For precisely here was the weak link in modernist aesthetic ideology: the investment of narration with the task of "saving" the meaning of "disqualified" events and materials. As Vincent Pecora argues, the metaphor of "rescue" through form became increasingly untenable as literary modernism developed:

"It is the vain attempt at a rescue . . . of some notion of self as form that is modern narrative's founding contradiction."[42] In relation to *Nightwood,* one can specify this metaphor of rescue in two domains, critical to the unfolding of the book itself: rescue as a problem of plot and of interpretation. The problem of rescue, generally speaking, lends *Nightwood* what little plot it has: How should the characters act to "save" themselves and each other from self-destruction? Will Nora be able to pull Robin out of her downward spiral? Will Dr. O'Connor be able to console Nora? Will his religious faith save Dr. O'Connor from his profound loneliness? Robin makes this dimension of "rescue" explicit, when she hurls it as an accusation at Nora in the streets of Paris; bending over an old whore to whom she has given money, Robin points to Nora and says, "These women—they are all like her. . . . They are all good—they all want to save us" (*N,* 120). Matthew O'Connor, likewise, recognizes his role as saving his friends, which torments him because of his inadequacy to the task: "I was doing well enough . . . until you kicked my stone over, and out I came, all moss and eyes; and here I sit . . . laboring to comfort you. Am I supposed to render up my paradise—that splendid acclimation—for the comfort of weeping women and howling boys?" (*N,* 126–127). Yet "rescue" also has a hermeneutic dimension in Barnes's book, insofar as her characters' interpretations of the events, their interminable hashing over of the same stories in various versions, all but supplant the plot, which is quite limited in scope. Here the crucial questions become: How can the seemingly pointless sufferings of the characters be viewed as meaningful? How can one salvage meaning from failed relationships (i.e., through genealogy, through memory, through religion, as frameworks for reading and understanding lived experience)?

The interpretational dilemmas of the characters are shared by the reader of Barnes's novel. The reader becomes an arbiter between conflicting versions and evaluations of the story made by the different characters, in their attempts to secure its meaning for their own interpretive frame. Seen otherwise, the characters and their version of events function as internal ciphers of the problems of reading posed by the book as a whole; they subsist as allegories of the struggle to invest the book with "personal" meanings, to struggle against the implications of automatism and textual excess, in order to lend anthropomorphic "personhood" to a textual ensemble and differentiate out of a mass of prose a few individualized images of voice and body. In this light, too, a crucial distinction exists between *Nightwood* and earlier works of modernist writing. For in *Nightwood,* the excess of narration over narrated event is

comprehended by no overarching symbolic unity, however loose, whether that be provided by a "mythic" or literary analogue (as was *Ulysses*, for example), a guiding allegorical image (the journey to the lighthouse and the painting in *To the Lighthouse*), or a dominant psychological agent (as in James's or Conrad's narrative involutions). The basic metaphor of Barnes's book, "Night," is significant only for its negativity, its absence of definite meaning; "wood," too, is the archetypal space of error and the undoing of identity.[43] Both are effective as metaphor primarily in *resisting* understanding, in scattering the self in an indefinite space. The "night," as its interpreter and spokesman Dr. O'Connor suggests, can only be "comprehended" improperly, through a violent allegorization, a dressing up of "the unknowable in the garments of the known" (*N*, 114), an ostentatiously false figuration akin to his own cross-dressing, to foray into the shadowy spaces of Paris's public urinals.

Significantly, then, in her treatment of "rescue"—both as an issue of plot and as a problem of interpretation—Barnes consistently emphasizes *failures* of rescue, the futility of redemptive strategies in keeping her characters together, whole, and credibly personlike. She meticulously explores the strategies of redemption employed by her major characters, Felix, Nora, Jenny, and Dr. O'Connor, in each case systematically demolishing them in turn. As readers, we are led to witness the spectacle of these figures' progressive disintegration, as they lapse one by one into compulsive repetition, bestial regression, and madness. By handling her characters in this way, however, Barnes also undercuts the interpretive ground of the reader, who sought in the characters allegorical clues about how to understand the book as whole: as an allegory of historical decline (Felix), as the tragedy or purgatory of desire (Nora), as regression and animal atavism (Robin), as sin and earthly trial (Dr. O'Connor). The reader is left to choose between the flawed positions of unmoored characters, only partly realized, or to "identify" with an acephalic vacancy presiding over the whole.

V

The actions of each of *Nightwood*'s major characters signify a particular strategy for redeeming their loss of stable ground and for orienting themselves within the dim, featureless present. These strategies, moreover, are directly linked to ways of appropriating and using stories, both

orally recounted and textually preserved. Thus, they function as self-reflexive markers of particular types of reading. Specifically, they cast a satiric light on the entanglements of individual desire with processes of reading, which come forth especially in the identification of a character's personhood with a text of a particular type. Obviously, since at least Cervantes's *Don Quixote,* the integuments of reading and subjectivity have been the stuff of self-conscious fiction. Barnes, however, offers a particularly negative version of this theme, since she offers little in the way of compensation for the skepticism her procedure implies, whether in the form of ethical insight (as evoked by the rich interplay of Don Quixote's mad desire and the gritty reality from which it escapes) or of ludic pleasure (as with much metafiction from *Tristram Shandy* to *Mulligan Stew*).[44]

"Count" Felix Volkbein, for example, wants to reconstruct, through an aesthetically guided montage of fragments, a valid historical tradition based on filial lineage (a strategy akin to Wendell Ryder's foiled attempt to reconstitute patrilinearity with Molly Dance). Surrounding himself with portraits, texts of history, and theatricalized rehearsals of rituals, Felix attempts to create an aesthetic simulacrum of an aristocratic genealogy. He chooses Robin Vote as the means by which he can carry out his plan, for as an American, in Felix's view, she is without determinate history. "With an American," Felix says to Dr. O'Connor, "anything can be done" (*N,* 37). Robin is a blank sheet for the text he hopes to write upon her body—his son, his lineage, and ultimately, the whole history of European nobility. Significantly, in courting her, he arrives at her apartment the first time "carrying two volumes on the life of the Bourbons" (*N,* 39). On their honeymoon in Vienna, Felix shows Robin his home city but is himself estranged from it. Even this experience is mediated by a text, for "his memory was confused and hazy, and he found himself repeating what he had read, for it was what he knew best" (*N,* 40).

Felix's marriage is destroyed by his blind attempt to identify, by fiat, his own situation with Robin with the preconstituted text of tradition, to interpolate the "unwritten" character of Robin into this collection of stories. The breakup of their marriage comes when Robin disowns their child and makes evident the failure of Felix's attempt to author his own story as the continuation of the historical genealogies:

As he came toward her, she said in a fury, "I didn't want him!" Raising her hand she struck him across the face.

He stepped away, he dropped his monocle and caught at it swinging, he took his breath backward. He waited a whole second, trying to appear casual. "You didn't want him," he said. He bent down pretending to disentangle his ribbon, "It seems I could not accomplish that." (*N*, 45)

His plans are definitively wrecked by the offspring of his short-lived marriage with Robin, the enfeebled son who shares Felix's father's name, Guido Volkbein. With this child, significantly, Barnes forecloses not just the filiative relation—the patronym—but also any affiliative compensation for its loss. Guido wishes to become a priest and wears on his chest the sign of the Virgin; but as Felix himself realizes, his son may very well die young or be unable to withstand the rigors of taking holy orders. In Guido, Felix's desire to participate in a superindividual tradition is foreclosed.

When Felix returns to the story in "Where the Tree Falls," some ten years after the events with Robin in "La Somnambule," he has become an author on religious matters, writing long disquisitions on problems of Catholicism and sending them as letters to the pope. Transferring his shattered hopes for his son from the earthly to the spiritual aristocracy, Baron Volkbein still engages in futile acts of "authorship," a willful attempt to write himself into the fabric of history. To his letters, however, "Felix received no answer. He had expected none. He wrote to clear some doubt in his mind. He knew that in all probability the child would never be 'chosen.' If he were, the Baron hoped that it would be in Austria, among his own people, and to that end he finally decided to make his home in Vienna" (*N*, 92).

Even when his genealogical dream has been foiled, Felix still clings to the redemptive scheme, recast in the form of a modernist iconoclasm. Thus in his parting dialogue with Dr. O'Connor, Felix offers a self-criticism of his past dealings with Robin. He had no clear idea of Robin, he admits, only an image. And an image is flawed in its partiality, its exclusion of time: "An image is a stop the mind makes between uncertainties" (*N*, 93). Felix goes on to suggest that on the basis of the image, we form a false conception of eternity, the eternal as the invariant. By breaking the image, or by accepting its shattering from without, or by viewing the image as perpetually to-be-shattered even in its present intactness, one discovers the meaning of the eternal. Felix's excursus on the image recalls Baudelaire's protomodernist poetics, in which the artist redeems flashes of eternal beauty and timeless value from the transitory, degraded, ugly constellations of the everyday modern world.

In his response, Dr. O'Connor seconds Felix's new aesthetic of "modern life," in which the momentary image and the enduring ruin converge. "Seek no further for calamity," O'Connor tells Felix, "you have it in your son" (*N*, 101). Yet to Nora, in the next chapter, O'Connor betrays his own lack of faith in this prescription. There he confesses the futility of Felix's efforts, describing him as "screaming up against tradition like a bat against a window-pane" (*N*, 127).[45]

Nora Flood's redemptive strategy might be called "cataleptic," to employ a term used by Barnes to describe Robin's suspended, incomplete gestures (*N*, 61). She projects Robin into death, where she can be preserved against change: "To keep her . . . Nora knew now that there was no way but death. In death Robin would belong to her" (*N*, 52). Yet to live with the "dead" Robin, Nora is forced to accommodate herself to a deathlike state—to become a night watcher, to dwell in dreams among her dead family members, and even, at the end of the "Night Watch" chapter, to simulate death throes: "Nora fell to her knees, so that her eyes were not withdrawn by her volition, but dropped from their orbit by the falling of her body. . . . She closed her eyes, and at that moment she knew an awful happiness. . . . [B]ut as she closed her eyes, Nora said 'Ah!' with the intolerable automatism of the last 'Ah!' in a body struck at the moment of its final breath" (*N*, 57). Moreover, in this petrification of Robin, Nora places her beloved in the terrible position of Poe's Mr. Valdemar, who out of his mesmeric trance pronounces "I am dead" and begs to sleep or be wakened.[46] Nora recounts to the doctor how the end of her relationship with Robin happened. After a violent night and an early morning reconciliation, Robin falls into a deep sleep. Unable to bear such contradictions, Nora slaps Robin awake to tell her it's over. Like Mr. Valdemar, Robin flakes away before Nora's eyes: "I saw her come awake and turn befouled before me, she who had managed in that sleep to keep whole. . . . No rot had touched her until then, and there before my eyes I saw her corrupt all at once and withering, because I had struck her sleep away, and I went mad and I've been mad ever since" (*N*, 121). Here Barnes clearly connects the desire to redeem and a nihilism turned, as Friedrich Nietzsche saw, against life itself. The salvation of the beloved from time requires Nora first to bury her alive, then to witness the horrible cinema of her decay.

As with Felix's marriage, Nora's relationship with Robin serves Barnes as a site of reflection on the fatal nature of identification. Barnes draws a subtle parallel between the disappointed Felix and the bereft Nora, both lovers of Robin, in making them both writers of letters in

their final chapters. Whereas Felix is still, in his letters to the pope, playing out a spiritualized version of his aristocratic fantasies, Nora is still snared in the terminated plot line of her life with Robin. At the beginning of "Go Down, Matthew," years after Robin's departure with Jenny, Nora is writing a letter, presumably to Robin. Dr. O'Connor opens the chapter with a complaint, berating Nora for trying still to squeeze a meaning out of her tormented desire: "'Can't you be quiet now?' the doctor said. He had come in late one afternoon to find Nora writing a letter. 'Can't you be done now, can't you give up, now be still, now that you know what the world is about, knowing it's about nothing?'" (*N*, 105). If we take this scene as a self-reflexive representation of authorship, then the doctor's complaint takes aim at Nora's inability to stop writing the same old story, to achieve closure; coming as it does in the last long chapter of a book whose plot was finished many pages earlier, it points toward *Nightwood*'s own problem of closure. Nora had identified her own desire with "Robin," which wrote Robin into a personal myth, making her a figment of Nora's own desire: "have you ever loved someone and it became yourself?" (*N*, 126). In the end, she attempts to appropriate and understand her experience by repeating the actions of her created character, a further refolding of the scene of identification, a figurative reenactment of Robin's life. Nora looks for Robin in other girls, yet at the same time seeks to place herself in the position of Robin, the "debauchée." This double position bespeaks an identification that collapses the distinction of fiction and author, subject and object; as Nora confesses:

In the beginning, after Robin went away with Jenny to America, I searched for her in the ports. Not literally, in another way. . . . I sought Robin in Marseilles, in Tangier, in Naples, to understand her, to do away with my terror. I said to myself, I will do what she has done, I will love what she has loved, then I will find her again. At first it seemed that all I should have to do would be to become 'debauched,' to find the girls that she had loved; but I found that they were only little girls that she had forgotten. I haunted the cafés where Robin had lived her night life; I drank with the men, I danced with the women, but all I knew was that others had slept with my lover and my child. (*N*, 129)

Having objectified Robin as a "fiction" in her own mind and in her writing, Nora is then left with the dilemma of how to have done with the character she has created. Even the death of the real Robin would be no solution, since she has been so thoroughly supplanted by the fiction Nora had imposed on her: "Once, when she was sleeping, I wanted her

to die. Now that would stop nothing" (*N,* 108). Compelled, however, to mimic the acts of her own fictional creation, Nora loses her own sense of reality, adapting to a fictional cosmos of desire, a life without qualities. To live among the mind's living statues is to assimilate oneself to a night world, to repeat in a vacuum the hollow gestures of the dead.

Jenny Petherbridge would redeem by acquisition and collecting. The savagery of Barnes's depiction—seconded even by the normally benign Felix—requires little comment. Jenny embodies secondariness and compulsive repetition. Obsessed with possessing objects, she ends up being possessed by them. Thus, in the last chapter, when Robin lights a candle in a church, Jenny hurries in afterward, blows it out, and lights it again. In her intense desire to have Robin, she surrenders to the fascination of the least thing Robin has touched.

Barnes carefully underscores the close tie of Jenny's appropriation with a particular relation to language. Jenny's own storytelling is automatonlike; she reels off a narrative sequence like a gramophone:

Hovering, trembling, tip-toeing, she would unwind anecdote after anecdote in a light rapid lisping voice which one always expected to change, to drop and to become the 'every day' voice; but it never did. The stories were humorous, well told. She would smile, toss her hands up, widen her eyes; immediately everyone in the room had a certain feeling of something lost, sensing that there was one person who was missing the importance of the moment, who had not heard the story—the teller herself. (*N,* 59)

Jenny's crucial narrative role, as the woman who steals Robin from Nora, is connected by simile to Jenny's derivative use of speech: "As, from the solid archives of usage, she had stolen or appropriated the dignity of speech, so she appropriated the most passionate love that she knew, Nora's for Robin" (*N,* 60). Further reinforcing this connection, Barnes establishes that Jenny first comes to desire Robin not from seeing her but in hearing the story of Robin's passionate relationship with Nora: "Jenny knew about Nora immediately; to know Robin ten minutes was to know about Nora. Robin spoke of her in long, rambling, impassioned sentences. It had caught Jenny by the ear—she listened, and both loves seemed to be one and her own. From that moment the catastrophe was inevitable" (*N,* 61). Jenny was "caught by the ear," falling in love with a story. Her overweening identification, as an auditor-reader, with Robin's and Nora's tale indeed proves "catastrophic," for it not only sets in motion the dismal decline of Nora, Robin, and herself but also affects even Felix and Dr. O'Connor.

This appropriative identification, this blurring of reader and text, extends to Barnes's own text, in which Jenny's chapter, "The Squatter," recapitulates details of the previous chapter, "Night Watch," which was dominated by Nora. Thus Barnes subtly contaminates her description of Jenny in the chapter entitled "The Squatter," with Nora's mock death pang a few pages earlier.[47] This association suggests that Jenny, in her attempt to supplant Nora with Robin, will be destined to carry the repetition to its completion and likewise suffer the torment of abandonment. Alluding to and echoing Nora's spasmodic collapse in the "Night Watch" chapter, Barnes writes of Jenny: "She frequently talked about something being the 'death of her,' and certainly anything could have been had she been the first to suffer it. The words that fell from her mouth seemed to have been lent to her; had she been forced to invent a vocabulary for herself, it would have been a vocabulary of two words, 'ah' and 'oh'" (N, 59). A network of resonances subsists between Nora, who collapses when she sees Jenny with Robin, and this apparently distinct, satirical description of Jenny herself. Nora, in suffering the likeness of death, speaks the words Jenny *would* speak were she to invent a vocabulary—the inarticulate vocables of "awful happiness" and "intolerable automatism"; expressions of laughter, weeping, and sexual pleasure. In turn Nora "dies" from the blow that would "be the death of" Jenny were she to suffer it herself. Not only does Barnes suggest a single external power overcoming these woman, breaking down their differences and assimilating them to the same depersonalized surroundings (the "nightwood"); she also robs *Jenny's* suffering of significance. Like all Jenny's other acquisitions, it is a linguistic simulacrum, a degraded copy of someone else's vocables. Nora possessed the original; Jenny is just a "squatter," sniffing around the expelled Robin.

Dr. O'Connor holds out a tenuous thread of religious salvation.[48] That strategy, while perhaps the most humane and accommodating in the book, nevertheless proves a failure. For O'Connor finds himself unable to accommodate the fate of his friends and his own implication in their suffering within a Catholic moral paradigm, even one as paradox-rich as his own. Not only can he not really help them; he is forced to betray them in his perplexity. As a background voice in O'Connor's final drunken monologue remarks, the doctor is "always getting everyone into trouble by excusing them, because he can't excuse himself" (N, 134). His willingness to love and forgive his friends only puts the seal on their doom. The final horizon of *Nightwood*, as O'Connor confesses, is that of wordless suffering, "nothing, but wrath

and weeping" (*N,* 136). Poetry makes nothing happen, not even when it masquerades as religion.

O'Connor, however, plays another role, distinct from being a character among other characters, each with their own "solutions": he is a reader of the whole. As I noted in my introductory chapter, the condition of generalized mimetism—which blurs distinctions between the subject and the object, the real and the simulated, the figural and the literal—makes the "legibility" of events a crucial issue for modernist literature. At stake is ultimately the possibility of mastering the unspeakable through discourse: a central aspect, as I have suggested, of Anglo-American modernism's dominant strain. O'Connor, in his hermeneutic function, holds out a glimmer of hope in a mystical interpretation of the events, a reading in which the passion of suffering, written on the surface of the body of the sufferer, points to a deep, hidden truth. This mystical mode, in tension with its uncanny double, mimicking its operation on a surface without depth, is the last refuge of modernism's gesture of symbolic "rescue" in *Nightwood.*

VI

In his essay "The Arts of Dying: Celibatory Machines," Michel de Certeau describes two modes of writing, the mystical and the celibatory. Both refer to a repertoire of techniques for transforming language and particular types of relations between language and meaning. Mystic discourse, de Certeau writes, is produced by a kind of "wounding," "a labor of putting language to death."[49] Such wounding

acts upon *semantic* formations. It infiltrates an order of discourse. It plays on *meanings,* throwing them off balance through the systematic use of oxymorons and catachresis . . . and also through the systematic practice of "stooping to indecent similes," "carrying oneself to holy excess as though mad or deranged"; and through an "immodesty" whose goal is not to generate a surplus of meaning, but on the contrary to induce a de-fection of meaning in order to demonstrate the existence of an "off-stage" (ob-scene) in language. (160)[50]

The rhetorical and lexical abuse of language creates a vocabulary that, de Certeau argues, has a reference point in the suffering body. Through a tearing of the surface of ordinary language a communication is set up with the hidden passions convulsing the flesh. "That interspace," he

concludes, "is the place where feelings injuring the body and paradoxes damaging the discourse have their immaterial meeting point" (160).

Is this invisible tangency between the body and language the goal of Barnes's tormented metaphors and paradoxes? Alan Singer has noted the way in which Barnes's strategies of figuration and the existence of her "characters" and "plots" are inextricable. In *Nightwood*, he claims, "the concept of character itself is altered by a catachrestic perspective."[51] From this perspective, Barnes's characters would appear in the field of the text always already refracted through a language being "put to death." And the meaning produced by such a text would be a mystical one, akin to the "radiance" shining from the face of the tortured prisoner in Kafka's Penal Colony or Nora's own "awful happiness" at the end of "Night Watch," a sudden light thrown out in the exercise of joy before death.[52]

In *Speculum of the Other Woman*, Luce Irigaray coins the neologism "La Mystérique" (summing up mystery, hysteria, and mysticism in a single feminine noun), to designate a particular form of mystical un-knowledge, the undoing of predicative language and categories in a specifically female *jouissance:*

She is still darkness to herself through and through, nor does she understand the world surrounding her. In his undifferentiated blindness he will be able to achieve distinctness only by a certain number of cuts, severings. . . . [P]ain enables her to feel herself again and to gather her strength. This strength soon becomes exalted in such a flood of potency that she is taken to be possessed. Therefore she is condemned by confessors or inexperienced voyeurs who are horrified to see or hear her fall stricken to the ground, toss and turn, shriek, grunt, groan convulsively, stiffen, and then fall into a strange sleep.[53]

This passage is of particular interest if overlaid on *Nightwood*'s final chapter, "The Possessed," in which "the somnambule" Robin Vote falls to the ground in Nora's chapel and becomes like Nora's dog before collapsing. From Irigaray's perspective, Robin could be seen as possessed by "la mystérique," and her final metamorphosis—which has so horrified critics—would represent the acme of mystical ecstasy. Evident in Irigaray's description is the way in which "la mystérique" heightens the ambiguity of mystic signs to an absolute, which in turn thematizes the issue of hermeneutic perspective. From one view, "she"—"la mystérique"—is divine communication; from the other, abject breakdown and madness. This duality of perspective suggests a hermeneutic undecidability entailed, perhaps, by any radical disturbance of individual

subjectivity, and hence a crux of late modernist works that reflect such an experience of shock, disintegration, or loss. What I described earlier (with reference to the end of *Ryder*) as mimetic assimilation—a partial surrender to death in the loss of difference from the surrounding—in Irigaray's account takes on a more positive shading. Mimetic regression and the mystical intensities of "joy before death" or the passions of "la mystérique" would be related ways of conceptualizing the potential volatility of the subject of late modernity.

Dr. O'Connor, in any case, is adept at reading mystical discourse, as a number of importantly placed anecdotes reveal. This discourse is a language of the body, its excretions and discharges the medium of its writing. From the perspective of this writing, O'Connor is able to offer a "rhetorical" critique of the American's relation to the body and flesh. The problem, he claims, is that the American mistakes the literal for the figural, taking the metaphor of washing one's sins clean as a matter of actual absterging of the body, as if cleanliness really were next to godliness: "We wash away our sense of sin, and what does that bath secure us? Sin, shining bright and hard. In what does a Latin bathe? True dust. We have made the literal error. We have used water, we are thus too sharply reminded" (*N*, 76). O'Connor goes on to compare the sheets of a European's bed, stained with the secretions and ejaculations of night, to the newspaper. If the newspaper is the record of the day, the filthy bed sheets are the record of the night (*N*, 76). One may read the writing of the body to discover the history of night, with its passions, its sufferings, its anonymity and crime. O'Connor's criticism of the "literal error" has as its correlate an implicit theory of reading, a hermeneutics of the night text written out of the body's depths. He recalls the corporeal discourse of classic mystic writing, with its sympathetic wounds and stigmata, its ecstasies and lassitudes, its sudden ebbs and flows of blood, mucus, and tears.

Other privileged media of mystical discourse are animals and children, probably because of their distance from propositional language. In his first appearance in *Nightwood*, for example, the doctor narrates a devastating war experience—an artillery attack "where the bombs began tearing the heart out of you"—through an anecdote about a cow he was holding onto in the dark: "I knew all at once that the tragedy of the beast can be two legs more awful than a man's. . . . [A] flash of lightning went by and I saw the cow turning her head straight back so her horns made two moons against her shoulders, the tears soused all over her great black eyes" (*N*, 19–20). He experienced in his own terror a

communication, a language of passion outside of language, passed from sufferer to sufferer: "I put my hand on the poor bitch of a cow and her hide was running water under my hand . . . jerking against my hand as if she wanted to go, standing still in one spot; and I thought, there are directions and speeds that no one has calculated, for believe it or not that cow had gone somewhere very fast that we didn't know of, and yet was still standing there" (N, 20). Whereas this early anecdote is part of one of O'Connor's monologues, he later uses a similar one—"the case of the horse who knew too much" (N, 96)—to answer Felix's question, why did Robin marry him? The manifest incoherence of this story as a response reveals the connection between Barnes's catachrestic language and O'Connor's habit of mystical interpretation.[54] The only way O'Connor can answer Felix's question is to interpret Robin's bodily pain in bearing Guido as a mystical sign, a harbinger of the idiot-child's nearness to God.

O'Connor's propensity to mystical interpretation is also underscored by a strange, otherwise opaque detail in "Watchman, What of the Night?" O'Connor tells Nora that he considered stealing a few of Jenny's books, which, he says, "I would have spirited away if they hadn't been bound in calf—for I might steal the mind of Petronius, as well I knew, but never the skin of a calf" (N, 87). Barnes distinguishes two modes of writing here, employed in her own text. Petronius represents, of course, traditional moral and social satire. The doctor can accept Petronius's "mind," since its satiric mockery serves an ethical end. But the calf skin, like a living page, is inscribed with a more sacrosanct writing, readable only by a mystically adept interpreter: the history of an individual creature's suffering unto death. If O'Connor can convincingly establish a transcendent meaning through mystical interpretation, he can offer the hope of escaping the amoral immanence of the late modernist's world: the purgatory of earthly life from which one can be neither damned nor saved.

O'Connor has a tremendous authority as the mystegogue of *Nightwood*. Yet Barnes also injects hints of doubt in her depiction of the doctor. Early on, she suggests that he may simply talk the loudest and longest and thus naturally get people's ear. And as is often remarked, he invents when he is uncertain what to say. Yet most important, Barnes places at the center of *Nightwood* a crucial instance where O'Connor *fails* to read the signs properly and proceeds to construct a version of events based on this misinterpretation. In "Watchman, What of the Night?" after much prevarication, O'Connor tells Nora the story of

how Jenny and Robin met at the opera. Yet we know from the previous chapter that Jenny and Robin had already been together a year before that night. O'Connor's mistaken construction of the story centers on his own guilt in the relationship of Robin and Jenny, his pitying of Jenny and hence betrayal of Nora. O'Connor's eagerness to allegorize these events on the basis of a misreading into his typical narrative of sin, suffering, and atonement raises doubts about the accuracy of his interpretations.[55]

More than once, moreover, Barnes intimates that O'Connor is vulnerable to "decapitation"—symbolically registering her own text's susceptibility to a loss of hermeneutical agency. In his first appearance, with no apparent prompting from the context, O'Connor brings up "one thing that has always troubled me . . . this matter of the guillotine" (N, 20). He tells how he once met an executioner who "leaned forward and drew a finger across [my neck] and said, 'As much hair as thick as that makes it a little difficult,' and at that moment I got heart failure for the rest of my life" (N, 20). In "Go Down, Matthew," O'Connor tells Nora a story of a horse (a privileged image in his mystical interpretation) killed in the war and decapitated. This becomes for him a trope for the memory of something lost, for the phantom bond that subsists between the sign and its absent object:

Once in the war I saw a dead horse that had been lying against the ground. Time and the birds, and its own last concentration had removed the body a great way from the head. As I looked upon that head, my memory weighed for the lost body; and because of that missing quantity even heavier hung that head along the ground. So love, when it has gone, taking time with it, leaves a memory of its weight. (N, 108)

While O'Connor takes the detached head as a figure for the *possibility* of a memorial reconnection with its lost body, a reading of the head as the sign of the absent whole, the choice of images would appear to qualify this possibility. For the operation requires the interpretive labor of the doctor, who selectively chooses between plausible interpretations of the meaning of the "sign." The doctor here interprets the missing head as a metonymy of the absent body, thus as a figure of the unifying role of memory, rather than as a metaphor of his own lost head, as a figure of death or madness, the loss of the power to read and interpret at all. One interpretation of the mystical sign becomes the means by which O'Connor blinds himself to the possibility of other, less consolatory interpretations.

At the climax of his last conversation with Nora, O'Connor mockingly offers her decapitation as a solution to her dilemmas, in a figure that seems to irrupt out of his own fears: "Personally, if I could, I would instigate Meat-Axe Day, and out of the goodness of my heart I would whack your head off along with a couple of others. Every man should be allowed one day and a hatchet just to ease his heart" (*N,* 108). O'Connor speaks (ironically, of course) the language of the revolutionary Terrorist, the words of the Terror personified. But as Maurice Blanchot cogently remarks of the Terrorists, "The Terror they personify does not come from the death they inflict on others but from the death they inflict on themselves. . . . [T]heir thinking . . . has the freedom of a decapitated head."[56] The decapitator has already surrendered his autonomy and assimilated himself to an implacable mechanical logic, as if he himself were already dead. Nora will shortly blurt out this very secret. To O'Connor she remarks, "You know what none of us know until we have died. You were dead in the beginning" (*N,* 125–126).

The irony of O'Connor's cruel comfort to Nora is that it betrays the strong fascination that headlessness, the instantaneous and total unburdening of thought, holds for him. As he tells a barman: "To think is to be sick" (N, 158). That fascination is also Barnes's, for the decapitation of O'Connor is a never fully realized figure for a radical emptying of *Nightwood*'s figural depth, after which its language would continue to mimic the production of meaning in the absence of a reading, interpreting "head."

Barnes generally gives her text over to the mystical interpretations of O'Connor. What I want to suggest in conclusion is that *Nightwood* contains another possibility for reading, one that both entices and frightens Barnes but that in any case will repeatedly break through O'Connor's nearly encompassing commentary. In the interstices of O'Connor's interminable monologues, Barnes hints at a radically superficial mode of linguistic functioning that undercuts the ground of any "deep" interpretation like that which the doctor attempts. This second way of reading does not explicate the speech of desire, whether it express the heart's agony for an absent beloved or the soul's outcry before the absence of God; it rather explores the entanglement of language in automatisms of pleasure and pain. It retraces the surface circling and drift of signs, movements that produce derisive *semblances* of deeper meaning, mocking modernism's attempt to redeem the incoherent surface appearances by referring them to convulsed depths of thought and passion. The work of art, this superficial hermeneutics asserts, is not a

unique, suffering body but a self-deforming, self-restoring machine. I would call this way of reading *Nightwood* a Duchampian interpretation.

The Duchampian mode is, by late modernity at least, the inescapable satiric shadow of any modernistic appeal to depth.[57] It haunts any appeal to the unsayable as the effect of a set of technical ruses, emptying out "the scriptural myth" by rendering its devices transparent. As de Certeau writes, referring to Franz Kafka, Marcel Duchamp, and Raymond Roussel:

> Although derision and torture remain the mainsprings of narrative, they no longer depend on a belief that it is possible to gear into something "unsayable." The only roaming that takes place is within oneself, in the form of homophonous drifts, obscene metaphors, puns traversing the stratified meaning of a given sound, slips of the tongue—in short, the turns of phrase circumscribed by language.[58]

Mystical discourse is an all-or-nothing gambit. In her shattering loss of subjectivity at the end of *Nightwood,* Robin is either experiencing divine metamorphosis (whether sublime or abject) *or* being convulsed in an automatism without agency. Either way, this concluding metamorphosis designates a limit-experience. But in the first case it would be a total communication, in the latter "the solitude of a discourse discoursing with itself" (161), *locus solus.*

In his study *Duchamp's TRANS/Formers,* Jean-François Lyotard proposes that Duchamp's compositional techniques are intended to produce "dissimulating metamorphoses" within the frames of his works:

> But when Duchamp says: my Bride is a projection onto a plane surface of a tri-dimensional Bride, who, in turn, is the projection of a quadri-dimensional Bride, far from suggesting a construction *en abîme,* an abyss of signs each effacing itself before the next, he opens, on the contrary, a group of spaces where all these Brides, and others, will be present, whether visually or not: spaces of dissimulating metamorphoses. That is why he "talks machine" and "paints machine": the important thing being that figures of force should be transformed strangely.[59]

With its uncanny communication between apparently unrelated scenes and seemingly distinct characters, *Nightwood* offers a striking analogy to the Duchampian *Large Glass* that Lyotard takes as his example. Barnes, like Duchamp, obsessively arranges structural partitions across which a dissymmetry plays. The most notable of her "simple machines"[60] is the overall structure of the book itself, which divides in half with the sentence: "It was not long after this that Nora and Robin separated; a lit-

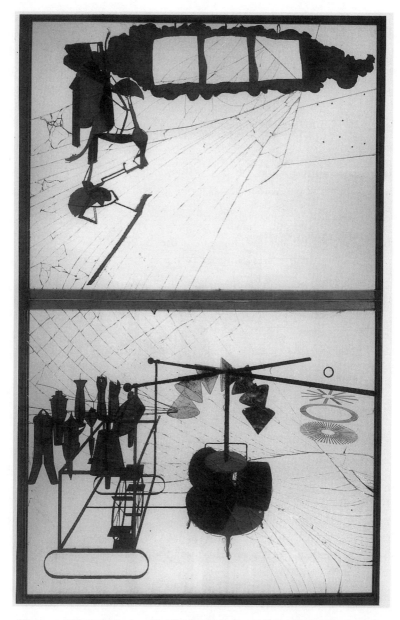

Figure 9. Marcel Duchamp, *The Bride Stripped Bare by Her Bachelors, Even (The Large Glass)*, 1915–1923. © Artists Rights Society (ARS), New York / ADAGP, Paris / Estate of Marcel Duchamp. Reproduced with the permission of the Philadelphia Museum of Art: Bequest of Katherine S. Dreier. Photo by Graydon Wood, 1992.

tle later Jenny and Robin sailed for America" (*N*, 67). After this, with
the notable exception of the brief last chapter, which unbalances the
symmetry, the story is over; with the fifth chapter (of eight) the autopsy
begins. Yet such partitional structures pervade the book, ranging from
rudimentary versions like Matthew O'Connor's hilariously anguished
exposure of his penis ("Tiny O'Toole") in church while beseeching
God, "what is permanent of me, me or him?" (*N*, 111), to more com-
plex assemblages.

The crucial scene that concludes the "Night Watch" chapter, Nora's
death spasms upon seeing Robin in the garden with another woman,
takes place at the windowsill, thus employing the same transparent parti-
tion and the same spatial division of above and below as Duchamp's celi-
bate dance of bride and bachelors. Nora wakes and goes to the window,
then sees "a double shadow falling from the statue, as if it were multiply-
ing" (*N*, 56). In the first glimmer of dawn she catches "the light of
Robin's eyes, the fear in them developing their luminosity until, by the
intensity of their double regard, Robin's eyes and hers met." This specu-
lar symmetry is unsettled, however, when the body of another woman
appears, presumably Jenny's. Barnes makes still more intricate the pat-
tern of symmetries and dissymmetries with a further detail: the woman's
head is turned down, "that the added eyes might not augment the illu-
mination." The last clauses of the paragraph describe the woman's down-
ward pressure on Robin: "her legs slackened in the hang of the embrace."
Across the partitions, through the glass, and from below to above, the
equilibrium of the system is suddenly broken, as if by the woman's weight
on Robin. Yet it is *Nora*, up above, who is set in motion: "Unable to turn
her eyes away, incapable of speech . . . Nora fell to her knees, so that her
eyes were not withdrawn by her volition, but dropped from their orbit
by the falling of her body" (*N*, 56). The scene ends with Nora closing
her eyes and crying out "'Ah!' with the intolerable automatism of the
last 'Ah!' in a body struck at the moment of its final breath." The second
clause syntactically literalizes the metaphor implied between Nora's
"Ah!" and a death cry. As both sentence and chapter issue into silence
and blank space, figural depth contracts to a disfigured tautology, as the
two poles of the figure fatally merge in one impersonal syntactic device.

It could be argued that such a reading is willfully detached, and could
only be made at a cruel distance from the moving portrayal of these
women's experience. Only with a total lack of empathy could one not
share Nora's pain, the assumption of which makes the architecture of

the "Night Watch" scene emotionally vivid. Indeed, were I to claim this interpretation as exclusive, such criticisms would be justified. I am arguing, however, that to any empathetic reading seeking *Nightwood*'s "profounder significance," another reading clings, a shadow reading that Barnes allows us to glimpse in the mocking penumbra it casts, with its eyes turned down that they "might not augment the illumination" (*N*, 56). This second presence is desire's other, which derides its capacity to invest meaning in a world of things and bodies. The presence of this double warns against too close an identification of one's desire with another, the torment and fatality of such identification for both.

Barnes created characters that invite empathy, and one central character who perpetually invites us to empathize, as he himself does. Yet she also dramatized how deadly such a loss of distance can be. To deny the presence of this shadow, to stake one's reading of *Nightwood* on an identification with its characters or its stated outlook, is to miss the force of Barnes's interrogation of a fundamental mechanism of modernist art: its desperate appeal to desire, to the labor of negation, of torture and death, as a wellspring of meaning recoverable through discourse. Barnes poses to her readers the blasphemous, indecent question whether discursive representation of "desire"—erotic and theologic—might not simply be a ruse of domination; whether "meaning" is not a fiction elaborated to mask a diffuse and largely senseless violence.[61]

Djuna Barnes began *Ryder* with a chapter entitled "Jesus Mundane." "By Way of Introduction"—not just to *Ryder* but to her whole career as a novelist—she offered a warning against the dangerous idea of "salvation," and against those who, like her high modernist elders and contemporaries, would set themselves up as its purveyors, purifiers of the language of the tribe:

> Go not with fanatics who see beyond thee and thine . . . for such need thee not, nor see thee, nor know thy lamenting, so confounded are they with thy damnation and the damnation of thy offspring. . . . Alike are they distracted with thy salvation and the salvation of thy people. . . . Thy rendezvous is not with the Last Station, but with small comforts, like to apples in the hand, and small cups quenching, and words that go neither here nor there, but traffic with the outer ear, and gossip at the gates of thy insufficient agony. (*R*, 3)

Cutting against the grain of modernism's desire to bring to speech the wordless "depths" of meaning, Barnes admonishes her readers against

interpretation: "Reach not beyond the image" (3); "Bargain not in unknown figures" (4). Yet of course she writes for none other than modernist readers, for men and women constitutionally incapable of taking this advice. Before turning to the unhappy, laughable story of Ryder, she thus turns to her all-too-Ryderesque readers, and to herself perhaps, and pronounces: "These things are as the back of thy head to thee. Thou hast not seen them" (5).

CHAPTER 5

Improved Out of
All Knowledge

Samuel Beckett

In chapter 3, I suggested how the case of Wyndham
Lewis necessitates that we reconsider such inherited ideas of modernist
literary history as "the men of 1914." A large part of Lewis's career, and
the overwhelming majority of his published work, represented an ongo-
ing attempt to show why that extraordinary convergence of innovative
writing could only be an ephemeral effort, and why the desire to
mythologize that moment, as has indeed been done since then, was
wrong-headed. Focusing his critical energies both on broad social-
political developments such as the postwar youth cult and on new tech-
nologies of representation, Lewis came to two conclusions about high
modernist writing: that its emphasis on form and style was implicitly
political in nature and that its aesthetic way of viewing and practicing
politics had become increasingly unviable. As my readings seek to show,
Djuna Barnes's work, too, should give pause before the efforts of crit-
ics to subsume her into a historical picture of a vital, expatriate mod-
ernism, even if in her case most accounts have specified this modernism
as feminist or "sapphic" in its concerns. As I have demonstrated, Barnes
saw the rise of all-women affiliative communities and the breakup of tra-
ditional genealogical or domestic novel form as part and parcel of the
same broad modernist tendencies. Barnes's writing emerges out of a sit-
uation in which this modernization of sexuality could be assumed to be
already complete and irreversible—at least for American and British
artists living in Paris in the interwar years. Yet while Barnes was in no
way nostalgic for the filiative bonds of family and patriarchal authority—

from which she had personally suffered much—she, like Lewis, remained skeptical about the strong positive claims made for modernism as a way of living and of making art. Both writers, I have argued, evolved particular late modernist approaches to fiction to express this skepticism; both explored the ambiguities and ambivalences of their position as "modernists" who no longer found the redemptive pretenses of modernist art credible.

Samuel Beckett's work has suffered from similar misunderstandings as that of these elder peers, especially given the impressive length of his artistic career and his evolving but consistent corpus that spans from imitative pastiches of late Joyce to uncompromising postmodern minimalism. Although I must focus my discussion only on Beckett's prewar, English-language writings, I will venture the claim that the concept of late modernism helps us to situate and understand the majority of Beckett's works, both fiction and drama, from *More Pricks Than Kicks* through the postwar French trilogy and early plays up to his return to prose writing in *How It Is*. This chapter represents a kind of genealogical account which, in demonstrating how Beckett came to call high modernist poetics in question and to evolve a late modernist approach to fiction writing, takes a first step toward fleshing out that claim and making it a critically useful proposition. A more comprehensive development of this idea, however, will have to await further discussion of Beckett's whole body of writing, a task beyond the limited scope of this chapter.

I

Prior to his first major work as a writer of fiction, the young Samuel Beckett made his mark as a critic and advocate of modernist writing. In 1929 , at age twenty-three, he was among the handpicked contributors to a volume of encomium and explication of James Joyce's magnum opus in progress, eventually to become *Finnegans Wake*. Beckett's essay for the volume, "Dante . . . Bruno . Vico . . Joyce," exhibits the young Trinity graduate's formidable learning and analytic skills, along with his unsteady tone, which from page to page careens from pedantry to snarling polemic, between scornful detachment and the enthusiasm of a true believer in Joyce's "revolution of the word." In 1930, after an exchange year in Paris as a lecturer at the École Normale Supérieure, he was commissioned to write a monograph on the writings of Marcel

Proust (published 1931). And throughout the midthirties, he continued his critical work by reviewing contemporary Irish and European literature for newspapers and literary periodicals.

These critical essays provide a crucial point of reference in tracing the formation of Samuel Beckett as a writer shaped by both the specifically Irish cultural context and continental modernist literary trends. Recent critics such as Richard Kearney, J. C. C. Mays, and John P. Harrington have argued that these early critical texts reveal the previously underestimated extent of Beckett's cognizance of and involvement in Irish cultural debates. In his essays and reviews, they suggest, Beckett worked out an artistic and cultural-political stance against the backdrop of an almost absurdly restrictive censorship law and a rising tide of anticosmopolitan Catholic nativism.[1] Yet while such contextual readings of this early work fill an important gap in the Beckett criticism, more relevant for my purpose is Beckett's early encounter with modernist tendencies ranging from the cosmopolitanism of English-speaking expatriates in France to the cultural differences of French, German, Italian, and Spanish modernist writers.

Both the Joyce and the Proust essays reveal their author as a committed modernist initiate. In the Joyce essay, Beckett provokes his reader with a sneering swipe at the habit of "rapid skimming and absorption of the scant cream of sense," a kind of reading that might be appropriate to the mawkish realism of the Victorian novel and its contemporary heirs but not to *Work in Progress*'s pages and pages of "direct expression."[2] Similarly, Beckett notes with approval Proust's disdain for descriptive literature, "for the realists and naturalists worshipping the offal of experience, prostrate before the epidermis and the swift epilepsy, and content to transcribe the surface, the facade, behind which the Idea is prisoner."[3] He argues that in contrast to naturalistic description, "the Proustian procedure is that of Apollo flaying Marsyas and capturing without sentiment the essence, the Phrygian waters" (*Proust,* 59).

Overall, Beckett stresses the modernists' attempt, through formal innovation and involution, to tap into the source and essence of literature. Language, form, and content constitute a unity that supersedes any "partial" system of values. The artist must concentrate firmly on the world to be disclosed within the work of art, not on some part of the world he might reflect, in a conventionalized mimesis, by means of it: "For Proust the quality of language is more important than any system of ethics or aesthetics. Indeed he makes no attempt to dissociate form from content. The one is a concretion of the other, the revelation of a

world" (*Proust*, 67). Correlatively, Beckett champions works in which the text's meaning devolves on the material and formal properties of its artistic language, projecting a new form of hieroglyphic immediacy, a writing free of the codes and conventions governing ordinary signification yet marked by the deepest rigor of craft. Beckett calls this communication "direct expression" in the Joyce essay (*Disjecta*, 26) and "autosymbolism" in *Proust* (60). By attending to the intrinsic qualities of literature—above all, to literature's existence in and as language—he implies, the writer risks the freedom of experience outside the stable mental, moral, and linguistic frames that render everyday life intelligible. Experience beyond these limits is close kin to madness, both because unintelligibility appears mad to those content to stay within the commonplace and because the line between radical art and insanity is all too easily crossed. Yet willingness to suffer for authentic experience is, in the critical view of the young Beckett, the test of the modern artist's integrity.

Beckett delineates here a rationale for modernist literature similar to that later articulated by Michel Foucault in *Les mots et les choses* (The Order of Things). In its efforts to uncover the essence and source of language, Foucault argues, modern literature confronts those structures that constitute the limits of "the world"—a world mediated by the grids and codes of intelligibility, by the architecture of propositions rendering the unknown knowable. Literature becomes a "counterdiscourse" to the discourses of the natural and human sciences: a collocation of darknesses in the midst of their illuminating sentences, a mutism and madness at the heart of reasonable speech. Literature, Foucault writes, "encloses itself within a radical intransitivity . . . and becomes merely a manifestation of a language which has no other law than that of affirming . . . its own precipitous existence."[4] In Foucault's view, this intransitive language emerges most clearly in relation to real madness—for example, that of the writers Raymond Roussel and Antonin Artaud— because the experience of limits that literature represents points to an impossible, unbearable, in-sane experience of spaces and intensities outside these limits.[5] In his earlier study *Madness and Civilization*, Foucault argues that madness is the moment of truth of the work of modern art and at the same time its abolition. Modern art and madness are imbricated in a paradoxical dialectic:

There is no madness except as the final instant of the work of art—the work endlessly drives madness to its limits; *where there is a work of art, there is no madness;* and yet madness is contemporary with the work of art, since it

inaugurates the time of its truth. The moment when, together, the work of art and madness are born and fulfilled is the beginning of the time when the world finds itself arraigned by that work of art and responsible before it for what it is.[6]

Taken to its acme, modernist art realizes the "absence of the work"— the madness that was all along the truth of the modernist artwork yet unrealizable as (that) work. Both madness and its manifestation in the modernist artwork contest the "reasonable" world of knowledge, labor, and rationalized bureaucratic power.

Analogously, Beckett appeals to a holistic mental experience as essential to art, an experience able to include not just the rationally or traditionally sanctioned but also the radically new or "other." In a defense of the poet Denis Devlin in a 1938 review, he thus asserts the comprehensive scope of artistic consciousness against restrictive demands for "clarity": "The time is perhaps not altogether too green for the vile suggestion that art has nothing to do with clarity, does not dabble in the clear and does not make clear, any more than the light of day (or night) makes the subsolar, -lunar and -stellar excrement. Art is the sun, moon, and stars of the mind, the whole mind" (*Disjecta*, 94). The "whole mind," Beckett implies, includes not just the rational portions but those that are irrational, silent, or mad as well. Devlin's creativity, he concludes, allows "a minimum of rational interference"; his "is a mind aware of its luminaries" (*Disjecta*, 94). In a dialogue between Belacqua and "the Mandarin" in *Dream of Fair to Middling Women*, the abandoned precursor of *More Pricks Than Kicks*, Belacqua offers a related view of Beethoven and Rimbaud: "I was speaking of . . . the incoherent continuum as expressed by, say, Rimbaud and Beethoven. . . . The terms of whose statements serve merely to delimit the reality of the insane areas of silence, whose audibilities are no more than punctuation in a statement of silences. How do they get from point to point."[7] The "statements" of modern art return to the source of music or literature, revealing in their singular concentration on sound or language an alterity inherent to the medium: the silence and in-significance from which music and language emerge. They set figure and ground in play, exposing the limits of humanly produced significance by making sensible, as a kind of dim halo around the work, the madness and contingency kept at bay by the artist's imposition of aesthetic necessity.

These arguments of Beckett and Foucault, intended to defend and legitimate modernist writing, also reflect general assumptions and

concerns of modernism. Although peculiarly inflected, their concern with a self-reflective, self-referential, essentializing practice of intransitive writing can be seen as participating in high modernism's foregrounding of *epistemological* problems in their relation to writing.[8] Modernist literature stages a crisis in the linkage between the mind and reality, between subject and object: "the rupture," as Beckett put it in his 1934 review of "Recent Irish Poetry," "of the lines of communication" (*Disjecta*, 70). For Beckett, the crucial point about this epistemological "breakdown" is not any one particular response of the writer; there are several he entertains as valid:

> The artist who is aware of this [rupture] may state the space that intervenes between him and the world of objects; he may state it as no-man's-land, Hellespont or vacuum, according as he happens to be feeling resentful, nostalgic or merely depressed. . . . Or he may celebrate the cold comforts of apperception. He may even record his findings, if he is a man of great personal courage. (*Disjecta*, 70)

Rather than this or that response, none of which may on grounds of *content* be favored, the degree of *awareness* embodied in the work is the ultimate standard of value. This consciousness is, above all, cultivated in and communicated through the intrinsic nature of writing.

In its essentials, Beckett's position is not unlike the classic modernist position articulated more than three decades earlier by Joseph Conrad in the preface to *The Nigger of the Narcissus*. Conrad's artist, confronted by the "enigmatical spectacle" of the world, "descends within himself, and in that lonely region of stress and strife . . . finds the terms of his appeal"; he is abandoned to "the stammerings of his conscience and to the outspoken consciousness of the difficulties of his work."[9] Beckett, in turn, as late as 1934, reaffirms the heroic ethos of high modernism, in which the artist, tough enough to relinquish his illusions, may risk sanity and social approval for lucid awareness of his situation. Part of Beckett's "untimely" commitment, in his critical work, to a high modernist stance may follow from the apparent backwardness of the Irish context that he addressed in his early writings. As John Harrington puts it with understated irony, "common thought in Ireland or out of Ireland would question whether Dublin in the 1930s was an indubitably representative example of a 'modern society.'"[10] In answering with regard to his own case, Beckett might have quoted his own "Dante and the Lobster," from the quickly censored *More Pricks Than Kicks*: "It is not." Beckett had to travel to London to be psychoanalyzed, for in the

Ireland of the time Dr. Freud's talking cure was proscribed as a temptation to atheism and sexual license. If in France and Britain claims for modernism's oppositional character were already subject to doubt, the Free State surely would have seemed to Beckett still in need of some modernistic kicking against the pricks.

In a 1938 review published in *transition*, Beckett argued that the objective situation itself dictated a modernist response from the writer. The social situation—the modernist crisis of both subject and object, the political context of fascism and communism—required art to return to its essence as question, as what Foucault calls "counterdiscourse": "Art has always been this—pure interrogation, rhetorical question less the rhetoric—whatever else it may have been obliged by the 'social reality' to appear, but never more freely so than now, when social reality (*pace* ex-comrade Radek) has severed the connexion" (*Disjecta*, 91). The artist's challenge to the status quo, whether that of Ireland or of Europe, of literary habit or of repressive political regimes, lies in his consciousness of art's social separation. He must vigilantly occupy the autonomous space of literature and maintain his awareness against any illusions of reconciliation.

II

For since when were Watt's concerns with what things were, in reality?

Samuel Beckett, *Watt*

So far the picture I have given of Beckett is that of a young critic committed to the defense and legitimation of high modernist writing in the tradition of Conrad, Joyce, Proust, Eliot, and others. Yet this image refers primarily to his criticism, which is also to say, to his role as a reviewer and commentator within the *Irish* literary context. Recent investigations of both genre and nationality, however, should alert us to possible differences between and within genres of cultural production, especially as these generic distinctions intersect with national ones (the "French novel," the "English novel," etc.). To take a simple example, thus, "modernism" may look quite different in a particular span of years depending on whether one is examining the English, the Russian, the German, or the Argentine context. Similarly, within the limited context of "Anglo-American writers in Paris in the 1920s," there may be

relevant distinctions between developments in the novel, in lyric poetry, and in the singular invented genres of a writer like Gertrude Stein.

Accordingly, distinctions between criticism and other literary genres and between the Irish setting and the Parisian environment may prove to be decisively relevant to reading Beckett's work historically.[11] It is easy enough to understand how an artist working in several genres or media might have advanced at a different pace in one than in another. To take an extraliterary case, it was often remarked that John Coltrane's soprano saxophone playing always seemed to be about six months behind his pathbreaking tenor work. Yet if this is intuitively easy to grasp, such an observation has nevertheless left surprisingly little mark on the historical frameworks of literary study, which deal uneasily with multiple contexts and untidy careers. In the fascinating case of Beckett, a writer who worked in multiple genres and wrote within an intricate national-linguistic complex (Irish/English/French), the interplay of various contexts makes for a particularly complicated picture, in which many different rhythms of development can be observed within a single author's corpus.[12] I want to trace out one part of this picture, and in turn, account for the challenge Beckett as a late modernist poses for literary history and criticism, precisely because of the resistance his writing mounts against the schemes for situating his works and, through critical interpretation, rendering them meaningful.

Insofar as Beckett presented himself as a critic in the arena of Irish cultural politics, I suggest, he adopted a high modernist stance, with its cosmopolitan emphases on consciousness, epistemological concerns, and the refinements of an autonomous literary writing. His early fictions *More Pricks Than Kicks* and *Murphy,* however, addressed a different audience, an international community reading Anglo-American and continental modernist writing, even as these works still present recognizably Irish contents and characters. In composing and trying to publish these books, the Irish tyro had to confront the "actuality" of the small but sophisticated community within which modernist fiction was written and read. In this process, Beckett began to subject the high modernist stance—his own, with regard to the narrow horizons of his native Ireland—to a withering reexamination. Precisely at the moment, then, that he is articulating a coherent modernist *critical* position, advocating the modernism he discerns in the fiction and poetry of other writers, he is also working to sabotage its functioning in his own fiction. Perceptible already in *More Pricks Than Kicks* and even in parts of the *Proust* essay, Beckett's unease with the modernist posture plays a deter-

mining role in the tone, characters, and action of *Murphy* and *Watt*. Along with his divided position with respect to audience and context, the functional distinction between criticism and fiction as modes of writing shaped Beckett's ambivalent modernism. Whereas the young critic felt it necessary, on the whole, to defend the modernist tendency within which he wished to situate his own work, Beckett's stance became far more vexed and agonistic when it came to applying his critical positions to the writing of fiction. Perhaps at first defensively and only later as a "positive" strategy, Beckett would turn to parody and self-ridicule to call in question a number of modernist authorship's basic assumptions.

I have noted that Beckett's explicit aesthetic—like that of earlier modernists and of the early "modernistic" Foucault—emphasizes epistemological problems and the concomitant value of "awareness" as a response to these problems. The primary evidence of this epistemological awareness is the writer's self-conscious handling of literary point of view and other formal and discursive aspects of the text. These formal aspects, skillfully manipulated, create the impression of a particular mind struggling within itself to lend order to the phenomena it confronts. This struggle is often a defensive one, a struggle to maintain autonomy against overpowering external forces, and it in turn frequently constitutes a self-reflexive figure of the *author's* struggle to master discursively the recalcitrant matter of the modern world. This battle for autonomy, moreover, may exact a high price on the struggling consciousness dramatized in the modernist work. As Patricia Waugh notes, "In modernist fiction the struggle for personal autonomy can be continued only through *opposition* to existing social institutions and conventions. This struggle necessarily involves individual alienation and often ends with mental dissolution."[13]

The status of consciousness in Beckett's fiction has from very early on occupied his critics. Jacqueline Hoefer, in her 1959 article on *Watt*, suggested that *Watt* could be read as a "philosophical satire" on logical positivism and related Beckett's fiction to Ludwig Wittgenstein's *Tractatus Logico-Philosophicus*.[14] Hugh Kenner, in his classic *Samuel Beckett: A Critical Study,* read Beckett's trilogy as a reductio ad absurdum of Cartesian and post-Cartesian philosophy in its "fatal dream of being, knowing, and moving like a god."[15] In the wake of these early studies, numerous articles and books relating Beckett to existentialism, phenomenology, Jungian psychology, Lacanian psychoanalysis, and deconstruction have appeared, becoming mainstays of the criticism. In

introducing his own reading of Beckett, Eric P. Levy gives an apt summary of this tendency:

The aspect of Beckett's fiction exciting the most controversy is the preoccupation with self-consciousness. Critics have had great difficulty determining the appropriate frame of reference in which to understand the introspection of the Beckettian narrator. Is this self-consciousness primarily that of the artist trying to grasp his own creative act or is it that of a person withdrawing from the world of others either through insanity or sheer impotence? In contrast, does this self-consciousness involve something more basic—an exploration of the very nature of the self? If so, is this self to be construed in Cartesian, Hegelian, Kierkegaardian, Sartrian, or neo-Freudian terms, to list just a few explanations attempted?[16]

Levy goes on to offer another interpretation of this self-consciousness, in terms of Beckett's supposed epistemological concern: "Beckett's fiction no longer concerns merely the objective pole of experience . . . but now addresses the very process of structuring experience into the poles of subject and object" (4).

I do not wish to discount the value of this body of criticism, which has provided many important insights into Beckett's work. Nevertheless, by recontextualizing Beckett as a late modernist who puts in doubt the presuppositions of modernist writing, I must reopen the question of how important epistemological problems really are to Beckett, as well as question the "epistemological bias" of the criticism. Provisionally, I would claim that epistemology—that corpus of issues about how the mind may connect with the world "outside," about the nature of consciousness and its problems in knowing the world—is largely without consequence for Beckett. I am not just suggesting that an essentially modernist Beckett can be read against the grain "without epistemology" (as Gerald L. Bruns has done brilliantly with Wallace Stevens).[17] I am making the more sweeping claim that Beckett—in his early fiction at least—has little interest in the mind and its vicissitudes as such. From her correspondence with Beckett about his reading (in 1929 or 1930) of the Austrian philosopher of language Fritz Mauthner, Linda Ben-Zvi cites the following significant verse:

For me it came down to:
Thought words
Words inane
Thought inane
Such was my levity.[18]

Nor is this just retrospective revision on the part of a writer no longer taking seriously the philosophical enthusiasms of his youth. In a letter of July 1930 to his close friend Thomas MacGreevy, Beckett discussed his recent reading of Arthur Schopenhauer: "I am reading Schopenhauer. Everyone laughs at that. . . . But I am not reading philosophy, nor caring whether he is right or wrong or a good or worthless metaphysician."[19] Having returned to Schopenhauer in September 1937 during a bout of illness, Beckett once again writes to MacGreevy: "it is a pleasure also to find a philosopher that can be read like a poet."[20]

It is my contention in what follows that Beckett's repeatedly asserted "levity" about philosophical thought should be taken seriously. One can, I am furthermore arguing, track Beckett's turn from modernism along the lines of escape marked out by this unburdening of epistemology, this uncoupling of rhetoric from questions of truth, this vaporization of weight into lightness, unbearable as it might later prove to be. Insofar as epistemological questions appear in Beckett's early work, it is by way of parodic reference to a modernist stance from which he is taking leave. Or as Beckett himself wrote in a review published in 1945, "There is at least this to be said for mind, that it can dispel mind" (*Disjecta*, 95). Accordingly, in his confrontation with earlier modernist paradigms, Beckett debunks modernism's epistemological concerns and depicts the mind's autonomy as hopelessly vulnerable to the extramental and excremental contingencies of the body as the object of pleasure, pain, social power, and death.[21] As Charles R. Lyons has suggested, comparing the implicit concerns of Beckett's plays with Foucault's late investigations of self-formation, Beckett abandons the (typically modernist) focus on subjectivity and the question of knowing in favor of "exploring" (a trope often literalized by his nomadic characters) the conditions that inform and infirm the subject.[22] Beckett declines problems of consciousness into matters of suffering and solace, domination and servitude, while exposing how social relations like mastery, solidarity, and free encounter depend little or not at all on their "groundability" in knowledge.[23]

III

In his rhetorical adoption of epistemological questions only to void their rhetoric of its epistemological importance, Beckett takes a significant literary risk. For problems of consciousness and knowledge served modernist writers as crucial points of departure for formal and

linguistic choices, as they composed works of fiction outside of tradi-
tional models of plot and character. The degree of awareness the writer
exhibited in handling these problems served as the ultimate standard for
the integrity and value of the work, while the literary qualities of the
work were, reflexively, taken as evidence of this awareness. Beckett takes
a step outside of the specular closure this value system presumes, an
autonomy of both author and work from extra-artistic determination,
to call in question the whole centering of literary value in consciousness
and to unleash the "idiocy" of language freed from the burden of inten-
tion and truth. Put otherwise, and taking more distance from mod-
ernism's aesthetic ideology: Beckett breaks the modernist juncture
between textual *figures* of subjectivity (whether tropes or larger-scale
forms) and knowledge, the presupposition that aesthetic value and
truth converge in such figures and that the author's task is to seek inde-
fatigably to uncover them from their hiding places (suppressed tradi-
tions, mythic archetypes, the unconscious, the etymological depths of
language) and renew them for the present ("Make It New"). He aims
instead to desublimate, wholesale, such figures of consciousness strain-
ing after the fleeting beauty of anguished truth.

In his early fiction, from *More Pricks Than Kicks* to *Watt*, Beckett
desublimates consciousness not just through wicked parody of the
seedy intellectual- or artist-type characters in his works, in the flaws and
foibles of his comic *semblables*, but also in making his own act of writ-
ing ridiculous, his risible handling of literary enunciation and narration.
If the character Murphy, for example, in keeping with Henri Bergson's
definition of the comic, exhibits a mechanical inelasticity, an inability to
adjust to the modern, bureaucratic-commercial London that lies out-
side his mind, that maladjustment is equally a feature of Beckett's com-
position of *Murphy*. His ostentatiously clumsy handling of chronology;
his prosaic cross-referencing from section to section, typical of academic
and technical discourse but not literary narrative; the battery of clichés,
asides, arcanities, and malapropisms—all these exhibit at the level of
narrativity the same loss of control in the face of social rationalization
that makes Murphy a comic figure *in* the text. The specular closure of
author and language is broken by a third factor, a force irrupting from
without: a technological-social force, which leaves its trace in the
automatisms, the creaking syntactical rat traps, the "mechanical inelas-
ticity" of those very images of voice, body, and affectivity that should,
yet cannot, converge into mimetically plausible "characters." Instead of
projecting meanings for a future hermeneutic reading, a labor of dis-

closing truths blocked and mocked in advance by deliberate erasures and dead-end allusions, Beckett's late modernist works assiduously *cancel* meanings, *suspend* interpretations, in defensive laughter. To the modernist investment of form with a pregnancy of meaning, Beckett counterposes the (in-, de-) forming principle of "riant spaciousness."

Beckett's compositional risk-taking extends into his relation with cultural tradition. For modernist writers saw consciousness not simply as an index of cultural crisis but also as an agency for the redemption of the past, especially as embodied in texts. In his provocative essay "Against *Ulysses*," Leo Bersani draws out the way in which Joyce's modernism envisages literature, pulverized and reconstituted within *Ulysses*, as the salvation of culture as such:

Ulysses indulges massively in quotation . . . but quoting in Joyce is the opposite of self-effacement. It is an act of appropriation, which can be performed without Joyce's voice ever being heard. . . . Joyce miraculously reconciles uncompromising mimesis with a solipsistic structure. Western culture is saved, indeed glorified, through literary metempsychosis: it dies in the Joycean parody and pastiche, but, once removed from historical time, it is resurrected as a timeless design. Far from contesting the authority of culture, *Ulysses* reinvents our relation to Western culture in terms of exegetical devotion, that is, as the exegesis of *Ulysses* itself.[24]

In contrast, Beckett presents the cultural allusion as inconsequential, at best an effect of language's incessant dialogue ("Hearing nothing I am none the less a prey to communications"), at worst an automatism, a kind of reflex action or mental dribbling ("Anything rather than these college quips").[25] As Bersani notes:

Beckett's authentic avant-gardism consists in a break not only with the myths fostered by cultural discourse but, more radically, with cultural discourse itself. The mystery of his work is how it is not only sustained but even begun, for intertexuality in Beckett . . . is not a principle of cultural continuity . . . but the occasion for a kind of psychotic raving. Cultural memories exist in the minds of Beckett's characters like fossils belonging to another age.[26]

I might quibble with Bersani's use of the term "avant-gardism," which raises more questions than it resolves; but seen in light of what I take to be his intent, to illustrate Beckett's break from the modernist use of allusion, the point is well taken.[27]

The strains in Beckett's relations with Joyce, both literary and personal, can already be seen in the unpublished *Dream of Fair to Middling*

Women and its successor, *More Pricks Than Kicks.*[28] As the linguistic textures of *Dream* reveal, Beckett tried out the *Finnegans Wake* style. The excerpted chapter entitled "Sedendo et Quiesciendo," published in the March 1932 *transition* and obviously linked to the stories collected in *More Pricks Than Kicks* (it concerns Belacqua's trip to Germany to visit the "Smeraldina"), rings like an excised section of *Work in Progress:*

In Perpignan exiled dream-Dantes screaming in the planetrees and freezing the sun with peacock feathers and at last at least a rudimentary black swan with the bloodbeak and HIC! for the bladderjerk of the little Catalan postman. Oh who can hold a fire in his hand by thinking on the frosty Caucasus. Here oh here oh art thou pale with weariness. I hope yes after a continental third-class insomnia among the reluctantly military philologists asleep and armed as to nasals and dentals. Laughter. (*DFMW,* 64)[29]

By the end of the first paragraph, Beckett has run through many of *Finnegans Wake*'s signature mannerisms: references to sleep ("dream-Dantes," "weariness," "insomnia," "asleep"), the coupling of myth and popular song (Prometheus: "Oh who can hold a fire in his hand by thinking on the frosty Caucasus"), comically recontextualized literary tags ("art thou pale with weariness"), sonic declinations of words (hero: "Here oh here oh"), and punning references to language and interpretation (armed to the teeth: "military philologists," "armed as to nasals and dentals"). The problem with all this is, of course, that technically skillful and ironically self-aware as it might be, it is a dead end if one's name is not James Joyce but Samuel Beckett. It may be argued, of course, that Beckett is consciously parodying Joyce here, and certainly Beckett is aware that he is not offering his reader the "pages and pages" of "direct expression" that he claimed for his elder's *Work in Progress* in "Dante . . . Bruno . Vico . . Joyce." At the same time, however, it is easy to detect the lack of a determinate and independent voice in *Dream of Fair to Middling Women* as a whole, and Beckett was not wrong when he remarked of "Sedendo et Quiesciendo" that it "stinks of Joyce in spite of most earnest endeavours to endow it with my own odours."[30]

 In his *Dream of Fair to Middling Women,* which never came together into a publishable work, Beckett ironically expressed doubts about his ability to master his complex material and give it a unified form. One passage, for example, involves Belacqua's vision of a book: "'If I ever do drop a book, which God forbid, trade being what it is, it will be ramshackle, tumbledown, a bone-shaker, held together with bits of twine, and at the same time as innocent of the slightest velleity of coming

unstuck as Mr. Wright's original flying-machine that could never be persuaded to leave the ground.' But there he was probably wrong" (*Disjecta*, 50; *DFMW,* 139 –140). Beckett later cannibalized the rejected manuscript of *Dream* for his short story collection *More Pricks Than Kicks.* The declining course of this work, from a *Finnegans Wake* -like novel to a *Dubliners* -like short story collection, would seem to indicate that Beckett's swerve from the Joycean model was in the first instance impelled by his inability to handle the complicated mode of writing that Joyce had evolved over years of dedicated literary work. Yet as Harrington argues, Beckett was no more able to develop a positive revisionary relationship to *Dubliners* than he was able to beat Joyce at his own (language-) game in the mode of the *Wake*. For unlike Joyce, Beckett was unable to facilitate any dialogue between his representations of Irish cultural paralysis and the possibilities of renewal implied in the sophisticated narrative consciousness arranging the stories. In fact, for Beckett, *Dubliners* was one more part of the problem, one more cultural encrustation among others. "In *More Pricks Than Kicks,*" Harrington writes, "the example of *Dubliners* appears unsalvageably rigid. . . . Beckett's use of *Dubliners,* updating without positive revision, could not be assimilated by a literary culture committed to some social salvation."[31]

Where Beckett made an advance in *More Pricks Than Kicks* was, instead, in his relation to his *own* earlier text, a relation that he would later generalize to intertextuality as such. A clue to the nature of this relation can be found in the last story, "Draff," which recounts the events following the death of the book's antihero Belacqua due to an accident during routine surgery. Beckett writes of Belacqua's friend and successor in the affections of the redoubtable Smeraldina, Capper "Hairy" Quin:

Belacqua dead and buried, Hairy seemed to have taken on a new lease of life. . . . Perhaps the explanation of this was that while Belacqua was alive Hairy could not be himself, or, if you prefer, could be nothing else. Whereas now the defunct, such of his parts at least as might be made to fit, could be pressed into service, incorporated in the daily ellipses of Capper Quin without his having to face the risk of exposure. Already Belacqua was not wholly dead, but merely mutilated.[32]

Within this passage is a subtle nod to the intertextual logic of *More Pricks Than Kicks,* its mutilation and partial incorporation of the failed *Dream of Fair to Middling Women,* which also had Belacqua's life as its central thread. In turn, mutilated "incorporation" will become

crucial to the radical unhinging of narrative authority in *Murphy* and *Watt*.[33] The footnote to *Watt*'s addenda explicitly points to this process (which, as the manuscripts show, accurately reflects Beckett's composition of the book): "The following precious and illuminating material should be carefully studied. Only fatigue and disgust prevented its incorporation."[34]

In these passages, the first indications of a technique that furnished an astounding continuity to Beckett's literary production over six decades make their appearance: the reappropriation of his own texts in "mutilated" or "defaced" form. To the modernist sublimation of culture in the self-reflexive mastery of literary language and form, Beckett counterposes an aesthetic of entropic decay, deformation, debasement, and disfiguration. To the modernist self-presentation of consciousness, Beckett opposes a deliberately "surgical" handling of textual matter, "self-depiction as autodefacement."[35] It is even possible to read this development in his fiction as a reactivation of a latency already present in the *Proust* essay, but muted there by Beckett's explicit adherence to a high modernist stance. Like a rot hidden within this modernist polemic is a derisive counterdiscourse, waiting for the proper conditions to emerge. It speaks of deformation, of decantation, of malignancy:

There is no escape from yesterday because yesterday has deformed us, or been deformed by us. The mood is of no importance. Deformation has taken place. (*Proust*, 2)

The individual is the seat of a constant process of decantation, decantation from the vessel containing the fluid of future time, sluggish, pale and monochrome, to the vessel containing the fluid of past time, agitated and multicoloured by the phenomena of its hours. (*Proust*, 4–5)

My analysis of that central catastrophe [the Marcel-Albertine liaison] will clarify this too abstract and arbitrary statement of Proust's pessimism. But for every tumour a scalpel and a compress. Memory and Habit are attributes of the Time cancer. (*Proust*, 7)

Under the aegis of remarks about Proust's attitude to time, Beckett is setting in place a framework through which to begin to think for himself, beyond modernism's redemptive project, about cultural memory and intertextuality. In leaving behind modernism's attempt to reassemble the fragments of culture in the form of a grand anamnesis (for memory is an "attribute of the time cancer"), he isolates with increasing economy and precision culture's self-consuming tendencies: its autodefacement in its entanglement with time and history, the ways in which

without fail "deformation has taken place," whatever the mood might be in which we greet the discarded torso.

By 1938 , the date of *Murphy*'s publication, Beckett had, by his own testimony, rejected Joycean modernism—with its redemptive emphasis on consciousness, literary mastery, and cultural anamnesis—and was weighing as a possible alternative the "logographic" practice of Gertrude Stein. In a letter to a German correspondent, Axel Kaun, dated 9 July 1937 , Beckett expresses his aggressive desire to tear the conventions of language to shreds: "As we cannot eliminate language all at once, we should at least leave nothing undone that might contribute to its falling into disrepute. To bore one hole after another into it, until what lurks behind it—be it something or nothing—begins to seep through."[36] "With such a program," Beckett continues, "the latest work of Joyce has nothing to do" (*Disjecta*, 172). Far from destroying language (and implicitly, the cultural heritage reposing there), Joyce apotheosizes the word. In contrast, Gertrude Stein, by practice if not wholly by intention, is more destructive. Her reduction of language into assemblable bits attacks the word's embeddedness in petrified cultural, semantic, and grammatical systems, treating it nominalistically and making the texture of language "porous" (*Disjecta*, 172 –173).[37] On this basis, Beckett goes on to discount the idea of a unitary modernism that would lump Stein and Joyce together. Their methods, he claims, represent tendencies and intentions as opposed as medieval nominalism and realism. He concludes, however, by arguing that Stein's ironizing of language does not go far enough, for his purposes: "It is not enough for the game to lose some of its sacred seriousness. It should stop" (*Disjecta*, 173).

Beckett only gradually, in his late works, achieved the radicality of language that these remarks would imply was his goal. His early fiction instead concentrates on higher levels of literary organization—narration, character, plotting—and over time introduces a more innovative linguistic texture (evident, for example, in *Watt*). In part, this concentration on "literary" over (strictly speaking) "linguistic" concerns (despite his stated intentions) reflects his choice of genre: fiction, rather than lyric or a hybrid genre like Stein's or his own late prose-lyric, which might have given more immediate range to linguistic experiment.[38] In a broader sense, however, it also signals Beckett's emergence from the modernist aesthetic he had advocated in his criticism. If consciousness was this aesthetic's castle of purity, then the formal conventions of modernist fiction, with its finely developed techniques for representing consciousness, was the point at which to lay siege on that citadel.

IV

Murphy, probably more than any other of Beckett's fictional works, offers an explicit social analysis of its eponymous hero's tendency to regress—supposedly into pure consciousness—as a doomed form of symbolic resistance analogous to that of modernist art. Beckett establishes this analogy through his general depiction of Murphy as a pompous, worthless bohemian intellectual, but also in the book's specific meditations on form, abstraction, and beauty. In the character of Murphy, Beckett skeptically explores a trend that, even after World War II, he would champion in his few critical essays on the visual arts: modern art's increasing tendency to become abstract or even purely conceptual.

Murphy, bluntly put, is a portrait of the artist who no longer works, from whom works should not be expected. For Murphy's art is expressed not *in* works but in not working. Celia, his Irish prostitute girlfriend, represents a kind of aesthetic halfway station for Murphy, on the way to the pure conceptuality of his inner world. She offers him a potentially harmonious compromise between embodied sensuality and abstraction, the "music" of her sexual rhythms. Similarly, briefly spared by her relation to Murphy from selling her beauty on the streets, Celia is able to share with him for a short time the aesthetic life. Yet Murphy is torn between the cash nexus, sensual beauty, and pure conceptuality as competing claims on the modern artist. His eventual attempt, in his job as an attendant at the mental asylum, to satisfy his needs for money while pursuing his conceptual utopia fails ludicrously. Yet not without a paradoxical outcome: aesthetic beauty is thrown back out on the street, for after Murphy's untimely death, Celia must resume her prostitution. As if by a kind of dialectical cunning, Murphy's absolutism, his pursuit of total autonomy from any shared, socially determined world, destroys the aesthetic life and subordinates it in the most brutal way to economic necessity.

Beckett situates Murphy within a definite ensemble of social institutions and forces, and his regressive withdrawal can be seen as a response to increasing pressures threatening the presumably autonomous subject of consciousness. His character, then, viewed in relation to this social background, provides an index of Beckett's doubts about consciousness as a basis of artistic value. In turn, by openly airing Beckett's late modernist skepticism toward the modernist investment in art, *Murphy* offers

a perspective from which the *historical* meaning of Beckett's later, more contextually reticent works might be reconstructed.

．　．　．

The novel begins with Murphy naked in his rocking chair, in a West End (West Brompton) flat that has been condemned. After six months of residence, "he would have to buckle to and start eating, drinking, sleeping, and putting his clothes on and off, in quite alien surroundings."[39] Outside a newsboy is plying his wares, and his shouts sound to the abstracted Murphy like "Quid pro quo!" Already by the end of the first paragraph, Beckett has suggested a good deal of contextual information: Murphy is a resident of London, a metropolis that is undergoing rapid change, and that in turn subjects its denizens to sudden, involuntary, and frequent adjustment to "alien surroundings." This environment is unified by the cash nexus, the exchange principle, the quid pro quo of money and institutional power.

Later in the book, Beckett returns to the neighborhood of this first apartment to provide still more precise information. Cooper, a detective engaged by the Dublin trio of Neary, Wylie, and Miss Counihan to find Murphy, picks up Murphy's trail and follows him to West Brompton. At the corner of Murphy's mew, he sees "a glorious gin-palace," a pub "superior to any he had ever seen" (*Mur*, 120). Cooper goes in and drinks until closing time, when "doors closed, the shutters rattled down, the wings of the grille came together. The defence of West Brompton, against West Brompton, was taking no chances" (*Mur*, 120). Besides providing a joke at the expense of the hapless native of Cork, this information also gives a point of reference for the condemning of Murphy's flat. The neighborhood is being "gentrified." Thus, when Cooper returns to Brompton after a weeklong dipsomaniac binge to take up the track of Murphy, he finds a disconcerting scene: "The ruins of the mew were being carted away, to make room for an architecture more in keeping with the palace on the corner" (*Mur*, 122).

In his first apartment, Murphy had an agreement with the landlady, whereby the rent bill to be paid by his uncle in Holland (his "Dutch uncle") would be "cooked": they would charge him higher than the actual rent and split the difference (*Mur*, 19). With the small income this scheme provided, Murphy could survive without working. But the landlady of his new apartment, significantly situated between the Cattle

Market and the Pentonville prison, refuses to participate. Murphy is forced by circumstances and the blandishments of his prostitute-companion Celia to seek work. Although he avoids it assiduously, work eventually finds him, in the form of a plea by the Dublin pot-poet Austin Ticklepenny, who accosts Murphy in the British Museum, to serve as a replacement for him as an attendant at the Magdalen Mental Mercyseat sanatorium. Murphy's final transplantation, into a tiny garret in the M.M.M., eventually leads to his accidental death, after a gas heating contraption rigged up by Ticklepenny goes wrong. Murphy's narrative course is not simply a comic distortion of a quite ordinary urban experience, frequent changes of rented residences; it is explicitly the contingencies of urban speculation and development, the quid pro quo of city life, that is the "prime mover" of Murphy's story. To put it bluntly, urban capitalism, and not the epistemological dilemmas of mind and body, is the motivating force behind Murphy's perilous course from West Brompton to Islington to the suburban mental institution where he meets his death. Murphy's mind/body drama, so heavily the focus of critics, is at best a defensive protest against the contingent social forces that constantly undermine his illusory autonomy.

Beckett underscores this tension between Murphy's striving for pure consciousness and the rationalizing dynamics of urban "progress" in two other scenes, framing his fateful encounter with Ticklepenny. Not wishing to lose Celia, who goads him to seek work, Murphy applies for a "smart boy" position at a chandlery in Gray's Inn Road. He is not just turned down; he is brutalized with insult and scorn:

"'E ain't smart," said the chandler, "not by a long chork 'e ain't."

"Nor 'e ain't a boy," said the chandler's semi-private convenience, "not to my mind 'e ain't."

"'E don't look rightly human to me," said the chandler's eldest waste product, "not rightly." (*Mur*, 77)

Worn down by his tribulations, Murphy looks for a place to sit down:

There was nowhere. There had once been a small public garden south of the Royal Free Hospital, but now part of it lay buried under one of those malignant proliferations of urban tissue know as service flats and the rest was reserved for the bacteria. (*Mur*, 77)

Service flats are something like protocondominiums, in which services, especially domestic, are paid for in the price of the rent. (Clearly such upscale housing is out of the reach of the seedy bohemian Murphy, the emigrée prostitute Celia, and their ilk.) Speculative development, in

league with the institutional iron cage of market, hospital, asylum, and prison, is closing in on Murphy's mental refuge. His regressive fantasy explicitly unfolds as a protest against social rationalization:

He leaned weakly against the railings of the Royal Free Hospital, multiplying his vows to erase this vision of Zion's antipodes for ever from his repertory if only he were immediately wafted to his rocking-chair and allowed to rock for five minutes. To sit down was no longer enough, he must insist now on lying down. Any old clod of the well-known English turf would do, on which he might lie down, cease to take notice and enter the landscapes where there were no chandlers and no exclusive residential cancers, but only himself improved out of all knowledge. (*Mur,* 79)

Nevertheless, Murphy is foiled in this desire by his own weariness and the lack of public space in the city. Having nowhere to lie down, he has no choice but to have tea "an hour before he was due to salivate" (*Mur,* 79) and go to the British Museum to contemplate the antiquities. After his encounter at the museum with Ticklepenny, who convinces Murphy to take over his post at the mental institution, and further adventures with Miss Rosie Dew, whose dog eats the cookies Murphy has laid out on the grass, Murphy finally gets his long-needed chance to regress. After some vain attempts to think through his situation, he lets go:

He . . . disconnected his mind from the gross importunities of sensation and reflection and composed himself on the hollow of his back for the torpor he had been craving to enter for the past five hours. . . . Nothing can stop me now, was his last thought before he lapsed into consciousness, and nothing will stop me. In effect, nothing did turn up to stop him and he slipped away, from the pensums and prizes, from Celia, chandlers, public highways, etc., from Celia, buses, public gardens, etc., to where there were no pensums and no prizes, but only Murphy himself, improved out of all knowledge. (*Mur,* 105)

This time, Beckett's repetition of the cliché "improved out of all knowledge" and his punning suggestion of the phrase "(col)lapsed into (un)consciousness" underscore that Murphy's mental autonomy is really a lapse *from* consciousness, a jettisoning of knowledge so as to deny the alterity of a social world that may cause suffering. Yet subtly, Beckett also suggests the fragile and illusory nature of Murphy's defense. When he writes that "in effect, nothing did turn up to stop him," he implies that Murphy's success was a contingent one. Something could have just as easily happened along to disturb him: like the policeman that keeps Murphy's precursor Belacqua moving along in the story "A Wet Night," for instance.[40]

For a short while, Murphy will consider the mental asylum where he works as a refuge from the outer world of service flats, cops, and the quid pro quo. Perhaps here, in the solipsistic enclosure of madness, he can achieve his long-sought mental autonomy from the contingencies of everyday life. Yet Beckett subtly exposes the shadow of a heteronomous social power darkening even the arcadian glades of the Magdalen Mental Mercyseat—on the one hand, in the economic privilege of the patients, which allows them to live in a private, relatively benign institution; on the other, through the bullying head nurses Tom "Bim" and Tim "Bom" Clinch. These latter figures are highly significant, because, through a largely occulted allusion, Beckett mocks not just the comic face of social domination but also his own quixotic search for a modernist utopia in the Joycean "revolution of the word."

The names "Bim" and "Bom" allude to a pair of clowns, first played in 1891 by Ivan Radunskii and Felix Kortezi. While Bim remained the exclusive property of Radunskii for the more than half century that Bim-Bom was active, Kortezi's Bom was replaced by four different partners up through 1946.[41] Radunskii and his partners were formerly jesters in the circuses of czarist Petersburg and Moscow, latterly made to perform in public spectacles in the Soviet Union. Throughout their career, they combined satire and publicistic commentary with song and acrobatic clowning, using brooms, saws, frying pans, visiting cards, and reading stands as improbable musical instruments. They toured in Paris, Budapest, Berlin, Prague, and other European capitals and were frequently recorded on gramophone and film. After the revolution, their act spawned numerous imitators whose names reproduced their model's original phonemic stammer in countless new guises: Din-Don, Bib-Bob, Fis-Dis, Viis-Vais, and Rim-Rom.[42]

Bim and Bom were, in effect, the fools of despotic power. They were known for their absurdist antihumor, their banal non-sequiturs concealing a sly social satire. In Alexander Serafimovich's novel of the Russian Revolution, a gramophone recording of Bim-Bom's play *The Laugh* grips the advancing Red Army troops in a paralyzing spasm of laughter, nearly bringing the revolution to a halt. It is only when a grimly determined Bolshevik smashes the reactionary gramophone that the day is saved.[43] Yet despite Bim-Bom's "counterrevolutionary activities" (at least in literature) during the civil war and their topical satire of Bolshevik foibles, they flourished even during the dark years of Stalinist terror. Radunskii died at the age of eighty-two in 1955.

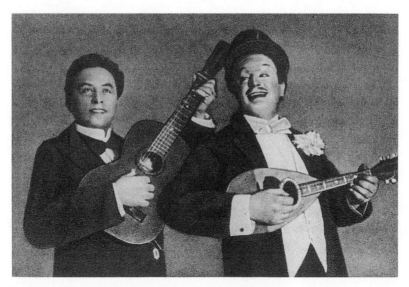

Figure 10. The Russian clowns Bim and Bom in 1906.

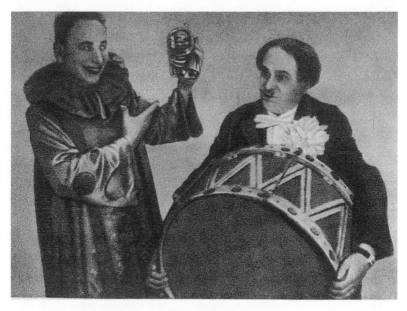

Figure 11. The Russian clowns Bim and Bom in 1926.

The Russian clowns seem to have captured Beckett's imagination enough that, fifteen years after their première appearance in his work in *Murphy*, he considered using their names again for the two clowns of *Waiting for Godot*, where early drafts refer to Didi and Gogo as "Bim" and "Bom," the "Stalinist comedians"; he also used the names for two characters in the late play *What Where*.[44] It is possible that Beckett may have first encountered them in the epilogue of Richard Aldington's novel *The Colonel's Daughter*, where, inexplicably finding themselves in a postwar English landscape, they engage in some metafictional jesting. When Aldington's Bim betrays his nervousness about being in the land of "Baldwin the Boujois," with its roving bands of bloodthirsty, foxhunting Whites, Bom offers him a peculiarly Beckettian reassurance: "'We're under diplomatic protection—for what that's worth from the Whites. We're the Epilogue.'"[45] Bim and Bom, however, had earlier circulation in the English-speaking world in Fülöp-Miller's 1926 account of the communist revolution in culture and everyday life, *The Mind and Face of Bolshevism*, which in turn Wyndham Lewis recounted in a significant polemic in the second issue of his journal *The Enemy* (September 1927), the leading edge of Lewis's pitched battle in the late twenties with *transition*, Joyce, Stein, and others of the modernist vanguard. In the first issue (January 1927), Lewis had published the first version of his critique of Joyce, "An Analysis of the Mind of James Joyce," included shortly after as a chapter in *Time and Western Man*. Given that Beckett's initial involvement with both Joyce and the *transition* circle dates from these years, it is difficult to imagine he would not have been familiar with the venomous attacks of Lewis on his master and idol and on his new literary acquaintances. This intertextual web thus forms a crucial part of the historical meaning of Beckett's later employment of Bim and Bom in *Murphy*, and to a brief reconstruction of it I now turn.

The Enemy ran for three issues from 1927 to 1929 and was almost exclusively an instrument for Lewis's attacks on rivals, critics, and ex-friends. The first issue carried Lewis's notorious savaging of Pound, Stein, and Joyce, "The Revolutionary Simpleton," which later constituted the first part of *Time and Western Man*. This attack was answered by the editors of *transition* ("First Aid to the Enemy") and by Joyce ("The Mookses and the Gripes" episode of *Finnegans Wake*) in *transition*. Lewis returned to the attack in full force in the spring of 1929, with his third and final issue's blast against *transition*, "The Diabolical Principle." This polemic appeared while *transition*'s defense of Joyce's *Work in Progress, Our Examination Round His Factification for Incamination*

of Work in Progress, to which Beckett contributed his "Dante . . . Bruno .
Vico . . Joyce" essay, was in preparation. In "The Diabolical Principle,"
Lewis sharpened his previous attack on *transition*'s favored circle
of artists, arguing that their "revolution of the word," far from tran-
scending and transfiguring the degraded social world, delusively reflected
the leveling of language and thought resulting from social rational-
ization and massification. The aesthetic anarchism of *transition* was,
in Lewis's view, little more than a fig leaf for collectivization.[46] (I offer
here a much-cooled-down summary of Lewis's wild, scattershot
argument.)

Lewis announced and anticipated at length his forthcoming pillory
of *transition* in the editorial note of the previous issue, which featured
his slap at the "Paleface" of modernist primitivism. In "Paleface," under
the chapter heading "'Black Laughter' in Russia," Lewis introduces,
through a long quotation from Fülöp-Miller's book on Soviet Russia,
the Bolshevik clowns Bim and Bom. After the triumphantly announced
social experiments of the Bolsheviks had begun to fail, the story goes, a
mocking irony began to emerge among the people. Soon, the report
explains,

the dreaded masters of the Red Kremlin themselves trembled at this rising
of laughers and jokers. In order to prevent an elemental outburst of all-
dissolving universal mirth and to deprive this grave danger of all significance,
the authorities hit on the clever idea of having recourse to an old institu-
tion, which has always been inseparably bound up with despotism, the office
of the court fool. . . .

. . . "Bim" and "Bom" were the names of the two "merry councilors" of
the new tsar, the mass man; they alone among the hundred millions of Rus-
sians were granted the right to express their opinions freely; they might
mock, criticise, and deride the rulers at a time when the most rigorous per-
secution and terrorism prevailed throughout the whole country.

. . . In spite of their impudent criticisms, Bim and Bom were neverthe-
less one of the chief supports of the Bolshevik régime: the universal dis-
content would have burst all bounds if it had not been dissolved by the two
clowns. . . . Their attacks were never directed against the whole, but only
against details, and thus they contrived to divert attention from essentials.
Besides, every one of their jokes contained a hidden warning to the laugh-
ter lovers: "Take care: Look out, we know you! We are aware of what you
are thinking and feeling!"[47]

Read through the prism of this passage and the context of the debate
between Lewis and *transition* in which it is embedded, Beckett's choice
of Bim and Bom for his twin male nurses takes on a deeper and more

unsettling resonance. First, it sharpens and politicizes Beckett's antiu-
topian debunking of Murphy's failed solidarity with the inhabitants of
the asylum. In the context of the midthirties, it allegorically depicts the
often grotesque futility and self-delusion of many artists' attempt to
embrace communism. Beckett satirically exposes the regime of domi-
nation behind the rhymed depersonalized self of madness (Murphy's
utopia) and the super-personal self (the communist utopia) of the mili-
tant intellectual.

Second, it humorously seconds Lewis's contention that the mod-
ernist revolution of the word subtly conforms to the social order it pro-
fesses to transcend. For oddly enough, though apparently opposed to
the vulgar managerial mentality of his clownish bosses, Murphy does
their work far more efficiently than a more conventional warder: "His
success with the patients was little short of scandalous. . . . [T]he
patients should have identified Murphy with Bom & Co. . . . The great
majority failed to do so. . . . Whatever they were in the habit of doing
for Bom & Co., they did more readily for Murphy. And in certain mat-
ters where Bom & Co. were obliged to coerce them, or restrain them,
they would suffer Murphy to persuade them" (*Mur,* 182). If the men-
tal asylum is, in fact, a microcosmic society, then Beckett depicts here
one of the cruxes of modern politics: the relation between force and
consent in the governing of society. Like the radical artist whose oppo-
sitional gestures are exhibited as evidence of the state's tolerance, Mur-
phy represents for the asylum a margin of dissidence recuperated by the
system of power, fostering consent rather than provoking repression.[48]
The oppositional intellectual, represented by Murphy, becomes the
unwitting tool of the "art of being ruled." To put it somewhat differ-
ently: if the mental patients represent a general withdrawal from the dis-
course and activity of "normal" life, they "suffer" Murphy to persuade
them, to bring them back into the discursive fold, where power may be
more subtly effectuated on bodies. Murphy, in his aesthetic longing for
a transfiguration of everyday experience, becomes the happy colonizer
of social heterogeneity. Where before existed only the crude subdia-
logue of rejection and answering violence, Murphy establishes a con-
sensual discourse, thus converting brute power to perlocutionary
speech.

Finally, the specter of "repressive tolerance" conjured by the Soviet
clowns Bim and Bom haunts Beckett's own literary project, as he him-
self was painfully aware. Late modernist fiction recognizes its own fatal
complicity with the fallen world it explores; it offers not a utopian exit

but a riant expression of impasse. Laughter, Beckett suggests, occupies the thin edge between subversion and recuperation, between the freedom to dissent and the imperfect surveillance that anticipates and pre-empts that freedom. There is, he suggests in *Murphy*, no longer any clearly defined inside or outside of social power, and hence no lasting asylum from it in art, madness, Proustian remembrance, or any other modernist locus of transcendence. No clear-cut opposition of society and its carceral institutions, and hence no utopian exteriors. Only resistances and withdrawals, stations in the relay between forest and hospital, beachhead and holding cell: neutral points—the crossroads, the waiting room, the ditch, the bed—where a stiffening burst of laughter might sound, for a moment, to lend relief.[49]

V

Beckett replaces self-reflexive consciousness as a literary organizing principle with means that emphasize social and semantic contingency and an irreducible alterity at the heart of the word (including the word "I"). His choice of titles, for example, offers an index of this shift. In an essay on "the language of modernist fiction," David Lodge suggestively observes the difference between the titles of earlier realist novels and those of modernist fiction: "The Edwardian realists, like the Victorians before them, tended to use the names of places or persons for titles (*Kipps, New Grub Street, Anna of the Five Towns, The Forsyte Saga*), while the moderns tended to favour metaphorical or quasi-metaphorical titles (*Heart of Darkness, The Wings of the Dove, A Passage to India, The Rainbow, Parade's End, To The Lighthouse, Ulysses, Finnegans Wake*)."[50] Beckett's first work, *More Pricks Than Kicks*, would appear to fit in with the modernist "metaphorical" titles, although his punning conjunction of the Bible with the "pricks" of Dublin bohemia already dispels much of the aura of profundity that surrounds his predecessors' resonant titles. His next five novels, however, break with this pattern: *Murphy, Watt, Molloy, Malone Dies*, and *The Unnameable*.[51] Yet while these titles are drily unevocative, they nevertheless hardly represent a return to the realistic, "metonymic" titles of the Victorian and Edwardian novels. Instead, Beckett's titles are purposely empty signs: abstractions, "common" names, or even puns that redouble the contingency of the reference of an undistinguished name like Watt (what?) or Murphy to a particular "character."[52]

Beckett also employs such contingent devices as the pun or parodic allusion in the figuration of his characters. In a joke that could refer as much to the comic artist-creator as to its ostensible divine target, the narrator muses in *Murphy:* "What but an imperfect sense of humour could have made such a mess of chaos. In the beginning was the pun. And so on" (65). Punning is implicated in the genesis of a character like Murphy, with his rocking chair complement. In her excellent study of Beckett's comic devices, Ruby Cohn notes the "book-long importance" of the "combined misplaced literalism and pun, 'off his rocker.'"[53] This figure, she notes, itself totters between literal and figural senses, the polarities of which are antithetical: "In the world's eyes, Murphy is 'off his rocker' when he is rocking blissfully and nakedly. But for Murphy, that is the best way of retiring into his microcosm. It is in the macrocosm, literally off his rocker, that *he* feels figuratively off it" (53).[54]

Cohn's insightful analysis could be extended. Just as Murphy's inversion of values sets the literal and figural dimensions in mutually opposed play, the real inversion of the rocker in chapter 3 sets in motion another oscillation played out over the course of the narrative: between Murphy's suspension of bodily life in his rocking-induced trances and the punctuation of real bodily death. At the end of chapter 1, Murphy is rocking, and the narrator tells us, "Soon his body would be quiet, soon he would be free" (*Mur,* 9). Looming death, in the form of a heart palpitation, interrupts Murphy's rocking, and he overturns the chair. Celia finds him in chapter 3 in a discomfited state:

Murphy was as last heard of, with this difference however, that the rocking-chair was now on top. Thus inverted his only direct contact with the floor was that made by his face, which was ground against it. His attitude roughly speaking was that of a very inexperienced diver about to enter the water, except that his arms were not extended to break the concussion, but fastened behind him. (*Mur,* 28)

Beckett performs this comic violence not just against Murphy but also against the natural spatiality of his figure of the rocking chair. In doing so, he loads further puns onto an already teetering construction: Murphy, like the idealist Hegel in the view of Marx, "stands the real world on its head," while "ground" can either be taken to mean a "foundation" (and this might be taken as a philosophical, an architectural, or an anatomical reference) or the past participle of "to grind" (a mechanical action akin to that of the rocker). Not only, then, does Beckett play

between the connotations of "off" and "on" his rocker, he also plays on the idealist and basely material senses of "standing on one's head" and "inversion" (later developed in its sexual sense in the person of pot-poet Austin Ticklepenny).

This figural cluster, generated out of puns and wordplay, in turn disperses into narrative functions, key plot nuclei, in fact. Rear-up and face-down, Murphy greets Celia, who, significantly, notices for the first time Murphy's huge birthmark on his right buttock. More than two hundred pages later, this scene recurs in altered form. At the end of chapter 11, Murphy goes up to his mew and rocks for the last time. The narrator again tells us, "Soon his body was quiet" (*Mur,* 253), and we shortly learn that Murphy has once again been interrupted by death, this time definitively, in the form of an accident with the gas line. Murphy's charred corpse, in need of identification, must once again be turned over in an ironic repetition of the previous "upending." Celia, having once by accident seen Murphy's birthmark, is now able to identify him by its remnants. In the final end, Murphy's whole system of values is overturned: neither his name nor his mind is any proof of identity, but only this scarlet maculation of his basest part.

The comic figural and narrative functions of the rocking chair do not, however, exhaust the effectiveness of this image in *Murphy.* For along with its basic comic tenor it carries disquieting resonances. I would suggest that these overtones come from Beckett's evocation of an unsatisfying, irritating, even sadistic sexual apparatus—as if in the text's imaginary the bound, naked Murphy, blankly staring out into the semidark of the room, were the uncanny double of a man tortured (or burned, as indeed the case is) to death. Here the comparison to contemporaneous sculptural work of Alberto Giacometti (with whom by 1939, Beckett had formed a lasting friendship)[55] is striking.[56] Giacometti's work of the 1930s, influenced by his contact with the surrealists and with the circle around Georges Bataille's *Documents,* took the surrealist interest in the poetically resonant object into a previously unexplored area: perverse and sadistic eroticism, figured in Giacometti's work by frustrating gamelike assemblages. An example with close imagistic analogies to Murphy's rocker is the 1931 work, *Suspended Ball.* It consists of an upturned, crescentlike wedge over which a ball is suspended by a wire. The ball rests on the wedge's sharp concave edge and is grooved along the axis where it makes contact. Its simple, machine-like elements are ambiguously coded: masculine/feminine, mobile/static, animate/dead, erotic/celibate.

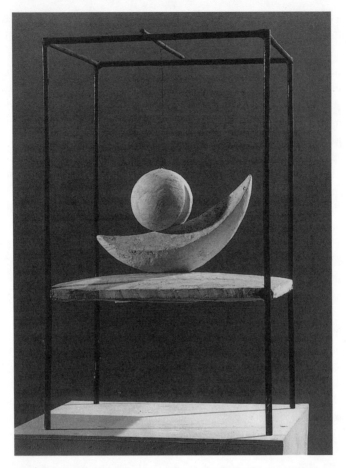

Figure 12. Alberto Giacometti, *Suspended Ball*, 1930–1931. Plaster and metal, 61 × 36 × 33.5 cm. © Artists Rights Society (ARS), New York / ADAGP, Paris. Reproduced with the permission of the Alberto Giacometti Foundation, Kunsthaus Zürich.

Rosalind Krauss has suggested that Giacometti employs techniques similar to Marcel Duchamp's in his *Large Glass* (which I discussed in conjunction with Barnes in chapter 4), while escalating Duchamp's urbane coldness into a more violent sadism. *Suspended Ball*, she writes,

is . . . like Duchamp's *Large Glass,* an apparatus for the disconnection of the sexes, the nonfulfillment of desire. But *Suspended Ball* is more explicitly sadistic than *The Bride Stripped Bare.* For the sliding action that visibly

relates the sculpture's grooved sphere to its wedge-shaped partner suggests not only the act of caressing but that of cutting: recapitulating, for example, the stunning gesture from the opening of *Chien Andalou,* as a razor slices through an opened eye.[57]

Beckett's chair might also be accurately characterized, in its mediation between Murphy and Celia, as "an apparatus for the disconnection of the sexes." It draws Murphy close to the part of himself that he loves (the mind) and away from that part of himself that he hates, which in turn draws him to Celia and the euphemistically designated "music" he makes with her. Yet, like Giacometti's sculpture, it is haunted by a sexualized violence quite different from the unfortunate couple's verbal "cutting of the tripes" out of one another when they are together.

My comparison of Murphy's rocker to Giacometti's *Suspended Ball* is intended to shed light on a peculiar, derisive logic of disfiguration or automutilation in these works. Immanent to their central images is an instability, an exposure of the abstracted human figure to a defacing violence coming from beyond its limits. This violence is not so much figured—that is, successfully represented by an intentional consciousness—as *dramatized* in the shattering of the figure's integrity, an index of the mind's failure to contain exterior violence by representing it. The corporeal figure, continually de-formed by the very oscillations of its mechanism, becomes no more than the tangency of continually shifting rays of interpretations, simultaneously determined and discredited by a ceaseless mobility. As Krauss writes (again referring to Giacometti's *Suspended Ball*), "In its continual movement, its constant 'alteration,' this play of meaning is thus the enactment in the symbolic realm of the literal motion of the work's pendular action."[58] Yet the "play" Krauss describes might just as well be called the interdiction of play, no more play, since it enacts in the symbolic realm that realm's contingency as a whole, its vulnerability to an outer violence in which meaning unravels and dissipates.

Murphy's last rock, in fact, is a desperate attempt to defend himself against that disfiguring violence. After his chess game and his disillusioning recognition that the perfect withdrawal achieved by the schizophrenic Mr. Endon is closed to him, Murphy abandons his rounds and goes outside into the night air. He strips off his clothes and lies down in the grass. He tries to imagine, without success, the faces of Celia, his mother, his father. His mental images become more and more fragmentary until "scraps of bodies, of landscapes, hands, eyes, lines and colours evoking nothing, rose and climbed out of sight before him, as

though reeled upward off a spool level with his throat. It was his experience that this should be stopped, whenever possible, before the deeper coils were reached" (*Mur*, 252). Murphy is in danger—the anatomical precision of "a spool level with his throat" should not be missed—of "losing his head." He hastens to his garret to rock his mind into peace, but meets a painful, disfiguring death instead.

This fate is not only a ludicrous fulfillment of the threat Murphy sought to evade. It is also an elaborate redoubling of the sexual-sadistic visual pun already implicit in Murphy's chair. The agent of Murphy's death is the makeshift heating system rigged up by the homosexual ex-poet Ticklepenny. Having found a gas line in the WC below Murphy's garret and a small radiator, Ticklepenny uses an assortment of odd parts to make the connections:

The extremes having thus been established, nothing remained but to make them meet. This was a difficulty whose fascinations were familiar to him from the days when as a pot poet he had laboured so long and so lovingly to join the ends of his pentameters. He solved it in less than two hours by means of a series of discarded feed tubes eked out with caesurae of glass, thanks to which gas was now being poured into the radiator. (*Mur*, 172)

Murphy, comically, will be done in by the faulty construction of a bad poet. But the whole scene that Beckett establishes by means of this apparatus stages Murphy's death as a grotesque mechanical simulacrum of intercourse and orgasm. The naked Murphy, bound to his chair, rocking back and forth, eyes open, in the dark; the tight, womblike space of the garret filling up with the moisture of Murphy's breath and the acrid scent of gas; Ticklepenny's phallic contraption worming in from below; Murphy's rocking faster and faster—the sudden explosion. Seen as an elaborate visual pun, the scene of Murphy's literal disfiguration and defacement (his only remaining feature being his posterior birthmark) contains an underlying sadistic phantasm: Murphy tied up and sodomized by a dysfunctional machine.

The debasing character of Beckett's punning, both verbal and imagistic, can be clarified by comparison to that of his predecessor (and hero of the surrealist and ex-surrealist French writers with whom Beckett had contact), Raymond Roussel.[59] Roussel used techniques like taking two homonymic sentences (more easily found in French than English) as the beginning and end of a story, and writing a narrative to provide a motivated relation between their accidentally contiguous statements. In his posthumously published testament, *How I Wrote Certain of My Books*

(1935), Roussel unveils the even more recondite set of techniques by which he created his fantastic novels, *Locus Solus* and *Impressions of Africa*. These books were systematic concatenations of images generated out of puns. Thus, to take just one example, he would take an ordinary expression of two parts joined by a preposition—*revers* (lapel) *à marguerite* (daisy, often worn in a buttonhole)—and substitute for the constitutive terms secondary meanings: *revers* (military defeat) *à Marguerite* (woman's name). The first, generative seed would never appear in the text, but rather the narrative unfolding of the second, improbable image: "hence the battle of Tez lost by Yaour dressed as Faust's Marguerite."[60] Roussel's stories float eerily above everyday speech, pointing to the blank spaces in it while concealing the secret filaments that tether his literary wonderland to the banal cosmos of clichés. Foucault sees Roussel's technique as a kind of animation and personification of the structural features of language itself: "It's as if the form imposed on the text by the rules of the game took on its own being in the world acted out and imitated on stage; as if the structure imposed by language became the spontaneous life of people and things."[61] Yet this "animation" is bound in a disquieting way to death and repetition. It is a way of mortifying language through its infection with chance (the pun) while opening out the already-said onto a fantastic vista beyond life and death (the fantastic image that unfolds narratively). As Foucault writes, Roussel's writing "does not attempt creation, but by going beyond destruction, it seeks the same language it has just massacred, finding it again identical and whole" (45).

Beckett's use of the pun and related techniques is neither as extensive nor as systematic as Roussel's. Its function is more localized, focused destructively on the conventional structures he employs concurrently. By opening up a *void of motivation* (the linguistic and phantasmatic substructure of Murphy's chair) at the center of motivating structures like intrigue (Who will find Murphy first?) and point of view (the omniscient narrator), Beckett dramatizes the corrosion of novelistic conventions by a contingency and violence traversing language, society, and perhaps even being as such.

Roussel's *Africa* and even more clearly his *Locus Solus* represent a kind of last solace of artistic autonomy: the transfiguration of the commonplace into a linguistic utopia, the cliché into the unheard-of, and the linguistic rule into a magical machine. In contrast, Beckett's word- and image-play tends to what we might call "automimetism," manifest in Beckett's signature use of echoing repetitions and seemingly

unmotivated associations through similarity. In Beckett's fiction, the language begins to *resemble,* intransitively, without a precisely situatable model. This contagious resemblance weakens the impression of the work's autonomy: something not precisely determinable seems to afflict the text, causing a blurring of distinct structures and a leakage of figures into their context (including the linguistic environment).[62] Rather than open up a literary free space beyond repetition and death, Beckett's pun is entropic or even violent, mutilating the literary figure and draining the life from it.

This automimetism affects the image of characters throughout Beckett's work. Common to all of his central characters is their surrender to an intransitive and often-repetitive movement, Molloy's circling, Watt's spavined gait, Murphy's rocking, or Belacqua's "gress":

Not the least charm of this pure blank movement, this "gress" or "gression," was its aptness to receive, with or without the approval of the subject, in all their integrity the faint inscriptions of the outer world. Exempt from destination, it had not to shun the unforeseen nor turn aside from the agreeable odds and ends of vaudeville that are liable to crop up. This sensitiveness was not the least charm of this roaming that began by being blank, not the least charm of this pure act the alacrity with which it welcomed defilement.[63]

What appears here under the guise of Belacqua's grotesque aestheticism will, with only slight modulation, become the more regressive motilities of Murphy, Watt, and Molloy.

Another index of this mimetism is Beckett's use of "pseudocouples," whose names imply that their only difference is a minimal phonemic one and hence that their existence is logical rather than substantial: *Murphy*'s male nurses Tom "Bim" and Tim "Bom" Clinch, *Watt*'s punningly hypothetical Art and Con Lynch, *Godot*'s Didi and Gogo, *Happy Days*' Winnie and Willie, or *How It Is*'s exquisitely mimimalized Pim and Bom, along with Bem, Kram and Krim. Here character has regressed back into the schemata of language from which the history of literature liberated it—the precise opposite of Roussel's animating transcendence of linguistic rules and conventional expressions.

Beckett's most consummate images of automimetic regression, however, involve the unmediated fusion of body and language, as if consciousness and meaning had volatilized, leaving language's material hull conjoined to the spiritless automatism of the body. This elision of consciousness is poignantly illustrated in Watt's reflexive disturbances in motility and syntax: "As Watt walked, so now he talked back to front."[64]

Yet, as presented in the novel, Watt's systematic breakdown of spatial and linguistic orientation forms a kind of uncanny double of the linguistic experiments of the modernist poet. (Likewise, the narrator "Sam," with his desperate attempt to master discursively the mad errancy of Watt, and with his comical delirium of chronology and point of view, parodically represents the modernist fiction writer.) At first, Watt's permutations amount to a lyricizing of his speech:

Day of most, night of part, Knott with now. Now till up, little seen oh, little heard so oh. Night till morning from. Heard I this, saw I this then what. Thing quiet, dim. Ears, eyes, failing now also. Hush in, mist in, moved I so. (*Watt*, 164).

Beckett underscores this quality by having Watt's interlocutor "Sam" give a rhetorical analysis, itself not unpoetic in its anaphora, of Watt's discourse:

> From this it will perhaps be suspected:
> that the inversion affected, not the order of the
> sentences, but that of words only;
> that the inversion was imperfect;
> that ellipse was frequent;
> that euphony was a preoccupation;
> that spontaneity was perhaps not absent;
> that there was perhaps more than a reversal of
> discourse;
> that the thought was perhaps inverted. (*Watt*, 164)

Yet Watt's increasingly extreme "revolution of the word" has little to do with artistic intentionality or self-conscious purification of the language of the tribe. Instead, it testifies to Watt's loss of autonomy, his increasing subjection to an impersonal language-machine—be it true that at first the "inversion was imperfect," that for some time still, "spontaneity was perhaps not absent" from Watt's deranged kennings.

Epilogue

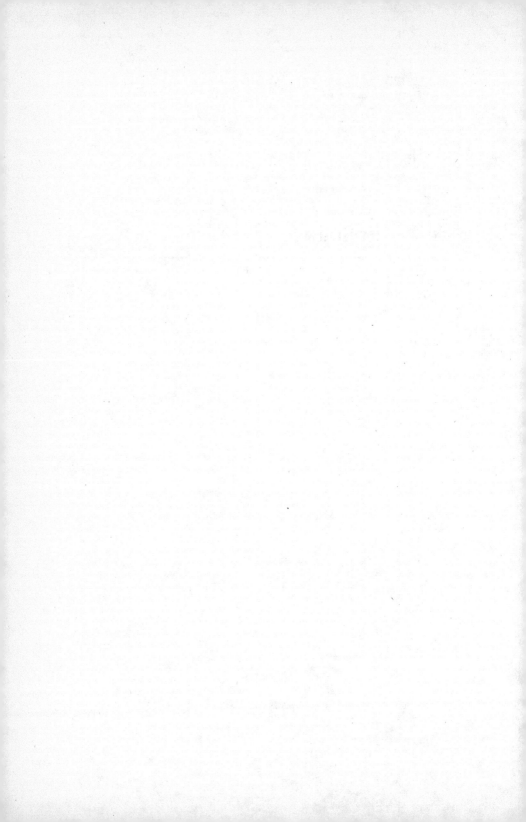

More or Less Silent

Mina Loy's Novel Insel

> *A conspicuous liver, so personal he might have served as his own fluoroscope, clear as a pale coral was painted as only the Masters painted. He had no need to portray. His pictures grew, out of him, seeding through the interatomic spaces in his digital substance to urge tenacious roots into a plane surface.*
>
> Mina Loy, *Insel*

I

Mina Loy's posthumously published novel, *Insel,* narrates an interlude in the personal life of two artists, a poet and a painter, at a transitional moment in the context in which their art would have been produced and received.[1] The two artists kill time together—talking, strolling, sitting in cafés, telling stories to one another—in the Paris of the early 1930s, before their separate departures from the city and passage beyond the French borders and the frontiers of the book as well. Loy's eponymous artist-hero, the half-starved and hallucinated "Insel," derives closely from the German surrealist painter Richard Oelze. Oelze had come to Paris just before the Nazi seizure of power in Germany, and Loy had met him in her talent scouting for her son-in-law Julian Levy's New York art gallery. Insel's foil, the narrator, fellow artist, and purchasing agent, Mrs. Jones, bears a distinct likeness to Mina Loy herself.[2]

Loy's choice of an exiled German protagonist and the political

ferment in and around the surrealist movement in 1930s Paris might lead one to expect more explicit reflection in the novel of the period's social climate. Moreover, her turn at this time to a relatively straight-forward prose fiction, a striking choice of genre given Loy's use of frac-tured lyric and manifesto-like forms in her early works, might suggest an attempt to represent her social context in more comprehensive and discursive fashion. Such expectations, however, are soon dashed by a reading of the novel. Loy, at first glance, appears to have little interest in the world outside the murky idealities and seedy realities of her artist protagonist. The inconsequential encounters of Insel and Mrs. Jones seem confined by the walls of their apartments and of the cafés in which they pass the hours, while their "context" extends only as far as a nar-row coterie of avant-garde artists, art collectors, and expatriate hangers-on. It would thus seem easy to characterize Loy's book as a historical curiosity at best, a tidbit for modernist anecdote hunters to set on their shelves below Hemingway's *A Moveable Feast,* somewhere among the memoirs of Jimmy the Barman, Kiki the model, and Jack the publisher of banned books.

Viewed through the optic of late modernism that I have developed in this book, however, a different picture of Loy's novel and its relation to its historical and political context may emerge. The figure of the artist in her book constitutes the crucial locus in which this relation may be discerned, for in *Insel* the protagonist figure literally *embodies* the predicaments of the artist during this time. Insel's very body, both sub-ject and object of his paintings, has been thoroughly penetrated by a technology of seeing and recording. As "fluoroscope," he sees through the bodies he turns to painting; yet what he "sees through" above all is his own disappearing presence as an artist. In rendering himself as the "fluoroscope" he has become, he at the same time exposes the remains of an avant-garde on the verge of disappearance: a few pale, floating organs rendered luminously visible by the very machinery that has dis-solved their organic "context."

Insel should be considered Loy's singular attempt to employ in the 1930s context a particular literary genre, the artist-novel or *Kün-stler(in)roman,* and as her self-conscious exploration of the pressures that context puts on the typical figure of the artist within that generic tradition. The emergence of the *Künstler(in)roman,* which came into its own in the eighteenth century, presupposed two specific historical conditions, each of which faced a peculiar challenge in the 1930s. For the artist to become the specific object of novelistic depiction and nar-

ration, artwork and the producer of artworks had to appear distinct from other kinds of work and producers. Art, in short, needed a relative *autonomy* from other social spheres like the state or the immediate market, and artists—rather than, say, patrons or sponsors—had to be seen as the crucial, central factor in the production of art. Second, and moreover, art had to have achieved not only distinction but also *privilege* among other cultural practices that might supply a novelist with models for characters. Artist-novels presupposed a general mythology about the special status of artists and the making of art, cultural values that these novels in turn served to elaborate, reinforce, and extend.

Modernism, as I have suggested, reasserted and deepened the creative artist's claim to independence from the public's demands, while focusing value judgments about art self-reflexively on the intrinsic qualities of the artwork itself. This emphasis on the aesthetic realm was not so much a repression of ethical and political concerns, however, as a rethinking of them in artistic terms. By ignoring the public and concentrating on the artwork as the touchstone of value, the modernist artist might, they believed, ultimately serve posterity better. Joyce's *Portrait of the Artist as a Young Man* is, in this respect, an exemplary modernist *Künstlerroman;* the young artist-hero vows, somewhat ironically, to forge in the spiritual smithy of his art the uncreated conscience of the race. One of Mina Loy's notebook entries strikes a similar chord: "Modernism is a prophet crying in the wilderness that Humanity is wasting its time."[3]

By the late twenties, however, as I have shown, the prophetic role of the modernist artist had been severely challenged by the convergence of several major currents. Modernism itself had aged, and its claims to represent the future had often proven hollow. Its imperative to innovate threatened modernism's adherents with personal and artistic exhaustion, exemplified most poignantly, perhaps, by the suicides of Harry Crosby and Hart Crane. In 1951, in the third part of his autobiography, William Carlos Williams would look back at the truly-great and would-be-great figures of his past and offered a page-and-a-half catalog of deaths, disappearances, long silences, and compromised survivals. *Ubi sunt?* he asks elegiacally of his comrades in the revolution of the word. I quote only the last paragraph, which ends by mentioning Mina Loy:

Harold Loeb—where?—but back in Wall Street; Ford Madox Ford dead; Henry Miller married and living with his wife and children on a half-

mile-high mountain near Carmel, California, from which he seldom descends. Lola Ridge dead; Djuna Barnes living in poverty somewhere, not, at least writing; Bob Brown, having lost his money, surviving in Brazil; Carl Sandburg turned long since from the poem; Alfred Kreymborg a member of the Institute of Arts and Letters; Mina Loy, Eugene O'Neill—more or less silent.[4]

Contributing to the internal exhaustion of the movement was, of course, the pressure of the depression context and the decade-long geopolitical crisis that followed. Crucial in this process, above all for the American expatriates, were the economic hard times and ensuing currency fluctuations that made short shrift of the community and publication infrastructure of the post–World War I modernist scene. Opportunities to live cheaply in Europe, writing reviews or sponging off the better endowed, publishing in limited circulation journals and with shoestring presses, became ever fewer. When late in 1931 Beckett gave up his teaching post at Trinity and resolved to return to the literary life in Paris, he complained to Thomas MacGreevy of his unpropitious timing: "It's madness really to go away now with the exchange u.s.w but it really is now or never."[5] Henry Miller, who arrived in Paris in 1930, experienced the hardship of the new climate firsthand, both in his personal life and in his literary career. *Tropic of Cancer* suffered two years of delays after Jack Kahane's original acceptance of it for publication by the Obelisk Press in 1932. Eighteen months into the process, Kahane informed Miller that "as long as the world financial crisis lasted he could not publish any books" and that there was no public to buy them.[6] Only in September 1934 did the book appear, and only in 1936 was Kahane willing to take on another of Miller's several completed books, this time his collection of character sketches and New York memories, *Black Spring*. Mina Loy's artist-novel *Insel*, begun during this period when she herself had almost ceased writing poetry, registers and reflects on this changed situation for artists—this new context that shook the twin pillars of modernist faith, the autonomy and the privilege of art as such.

As a generic form, the artist-novel is sensitive to current social conceptions of artists and responds to the contexts in which the arts exist. Yet it goes beyond simply representing these conditions; it also represents the artist's struggle in coming to terms with or resisting the given situation. As Herbert Marcuse notes in his 1922 doctoral thesis on the German artist-novel, "It follows that . . . the cultural currents of the

moment exert the most powerful influence on the nature and form of the artist-novel, indeed, that in the absence of great creative personalities they precisely determine the manner and direction of the artist-novel."[7] Loy's *Insel* unfolds in such a situation, in which the heroic personalities of the previous decades—Picasso, Kandinsky, Stravinsky, Duchamp, Joyce—were already history, while the personalities who had succeeded them were not able to impose their individual stamp on the age.[8] Both Insel and Richard Oelze, his real-life model, were resolutely *minor* painters. Loy presents Insel, moreover, as talented but erratic, undisciplined, and unrealized. Her narrator tells Insel: "The artist's vindication does not lie in 'what happens to him' but in what shape he comes out" (31). All the more significant, then, are her continual references to his chaos and formlessness, his unproductivity and spiritual drift. At best, Insel is a cipher of the artist's loss of position and defined social *Gestalt*.

Loy's explicit analysis of the crisis does not go beyond judging Insel's insufficiency of genius and artistic will, and hence she never apparently faces head-on the objective conditions blocking the emergence of that leading personality she desires. Her artist-novel is a tale of two minor artists who fail to give form to themselves in a corpus of works. Insel and Mrs. Jones meet, not as promised, in a mutual converse of genius, but on grounds of their complementary failure. It is notable, in fact, that Loy staked her own artistic "figure" in these later years on her success in giving form to this artist-novel. In a letter, she writes, "I must finish my novel—it is very sad but if I don't finish it I shall be finished myself—how difficult all these years writing alone."[9]

This failure—the failure of the artists represented in Loy's novel and her failure to write the artist-novel that would genuinely come to terms with her situation—should not, however, be understood solely as a negative matter. For as historical testimony it has positive significance. It came not from a lack of genius, of which Loy had more than her share, but from historical pressures on the figure of the artist that had rendered untenable the modernist artist-novel, insofar as it offered a merely *aesthetic* resolution to the crisis of art. Such a solution had become realizable only at the cost of what Adorno called "extorted reconciliation," in the form of manifest nostalgia or self-delusion. Loy's artistic integrity led her to confront her own desire for a self-deluding solution and satirically to hollow out from within that false consolation held out by her artist-hero and the artist-novel that bore his name.

II

In his most widely known essay, "The Artwork in the Age of Its Technical Reproducibility," Walter Benjamin attributes to the traditional artwork an "aura" of residual sacredness, which derives from its relative withdrawal from everyday life. He goes on to give an account of this aura's progressive diminishment due to the influence of technically reproducible media like photography and film. Before the full-scale introduction of reproduction technology, Benjamin argues, the aura of artworks rested on their qualities of uniqueness, authenticity, and historical endurance. The photographic reproduction of singular artworks and, more recently, the production of new works to which reproducibility is inherent begin to erode that aura. In the twentieth century, the unprecedented extension of technically reproducible images and the avant-garde's active challenge to traditional notions of art converge at a decisive point: they put the notion of art as such in doubt. Both the new technical means and the new contexts threaten the relative autonomy in which traditional art is produced and consumed.[10]

The 1930s were years in which the collective intruded into the question of art. It was a decade of total mobilization, mass layoffs and mass strikes, unemployed marches and public works, fascist rallies and the Popular Front, rearmament and lightning war. The flight of artists out of Germany had begun before the seizure of power in 1933; the "inner emigration" continued through the Nazi years, as the total state progressively consolidated its grip on previously unsubordinated spaces of culture and thought. As Beckett traveled through Germany in 1936–1937, he was at first surprised to find that works of modern art in the permanent collections of major museums had been placed off-limits to the public; later he was surprised when, on rare occasions, he found himself in a provincial museum behind the curve of the cultural *Gleichschaltung*, with "degenerate" masterpieces still on open display. In the United States artists and writers lent their talents to public projects and New Deal organizations. At the First Congress of Soviet Writers in 1934, Andrei Zhdanov promulgated the doctrine of socialist realism. In 1935, E. M. Forster pronounced to the communist-sponsored Congress of Writers in Defence of Culture in Paris:

If there is another war, writers of the individualistic and liberalizing type, like myself and Mr. Aldous Huxley, will be swept away. I am sure that we shall be swept away, and I think furthermore that there may be another war. . . . This being so, my job, and the job of those who feel with me, is an

interim job. We have just to go on tinkering as well as we can with our old tools until the crash comes. When the crash comes, nothing is any good. After it—if there is an after—the task of civilization will be carried on by people whose training has been different from my own.[11]

The stamp of the masses, indeed, was over all, and even in Loy's quirky artist-novel. But where? Where in this novel of visionary rantings and café colloquies is there the least hint of the noise of the times? The collective does have its representatives in Loy's novel, yet they dwell with uncharacteristic quietness and do not announce their presence as such. Not as crowds or political parties or clashing armies, but merely in the guise of two artistic media: the lamp shade and the photograph. Innocuous in appearance, but explosive in content, they together pose a fundamental challenge to the artist's tale in which they make their appearance, capturing in their devastating flash the image of the individual artistic mind in aimless drift.

● ● ●

By the later 1920s, Mina Loy was writing very little poetry. She had dedicated herself to, among other things, the production of decorative lamp shades. For a writer so engaged with the problematic of genius and vision, this was a resonant choice of craft. It is as if she had taken the traditional metaphor of the imagination and restored it to literality: the image thrown by the mind's candle became a kind of projection machine. Peggy Guggenheim (who, as Djuna Barnes's host during the writing of *Nightwood* and Samuel Beckett's importuning lover and hanger-on, might be designated the central patroness of late modernism) was Loy's financial supporter in the lamp shade business. In her memoirs, Guggenheim writes, "About this time Mina Loy and I embarked on a great business venture. With her usual genius she had invented three new forms of lampshade. One was a globe of the world with a light inside it. One was a shade with boats whose sails were in relief. . . . Her third invention was a double-cellophane shade with paper cut-outs in between, which cast beautiful shadows."[12] A lighted globe, sea and wind, the cinema: each a metaphor of a mobile space extending over the reaches of the planet. Yet unlike the version of these metaphors in the poet Loy's futurist-influenced proclamations, they are now realized cheaply (Guggenheim noted) and mechanically. Their production involves a separation of conception and production, a division of mental and manual labor: "She had a workshop next to Laurence's studio on the Avenue du Maine where

Prize Lamp Shades from Nina Loy of Paris

*These Remarkable Designs for Lamp Shades Received the Highest Honors
at a Recent Exhibition of Interior Decoration in Paris*

Below — A lamp shade entitled "The Red Fish". The effect of this lamp shade as in all of those in which Mlle. Loy uses a fish motif, is as though the fish were swimming through the water in an aquarium, very clever and exceedingly life-like

Above—A parchment lamp shade carrying an allover design of water plant. The effect is extremely interesting and the plant leaves are so painted that they have quite the effect of dripping water. The base of this lamp is of the finest French porcelain

Above—Design for a lamp shade of a shadowy parrakeet, the bird having quite the effect of being painted inside the shade as though you were looking at it through a glass. The shade is of parchment and the lamp base is porcelain

Below—The Corvette is a design from an old war boat evidently ploughing along in full action. The colors are beautiful. The porcelain base of this lamp is in one tone, the right setting for the brilliant painting of the shade

Below—La Goelette is the name of the design of this enchanting lamp shade. It is an ancient boat which was called "the swallow of the sea" because it was such an excellent little racer, worked out in true sea colors

National Feature Photos

Figure 13. "Prize Lamp Shades from Nina [*sic*] Loy of Paris," from *Arts and Decoration* magazine, July 1927. With permission of Roger Conover for the Estate of Mina Loy.

she employed a lot of girls. I ran the shop and she and Joella, her daugh-
ter, ran the workshop" (67). If the "invention"—that is, the design—of
these artworks showed Loy's "usual genius," their production an-
nounced the presence of a different, more abstract and powerful genius:
the genius of capital, harnessing the energies of multitudes in processes
of collective labor and political movements.

The lamp shades appear only once in *Insel,* close to the end. The
attraction between the narrator and Insel is fading. His remarks no
longer charm her:

The still life that intrigued him was a pattern of a "detail" to be strewn about
the surface of clear lamp shades. Through equidistant holes punched in a
crystalline square, I had carefully urged in extension, a still celluloid coil of
the color that Schiaparelli had since called *shocking pink.* . . . I had picked it
up in the Bon Marché.

Out of this harmless even pretty object an ignorant bully had con-
structed for me, according to his own conceptions, a libido threaded with
some viciousness impossible to construe.

I was astounded. (166–167)

And rightly so; for Mrs. Jones's indignation at Insel's wild psycho-
analysis of her lamps is not mere prudishness but follows as a logical
consequence of an aesthetic stance held by her creator.

In this comical scene of competing interpretations, two images of art
battle for life. The one clings to the clichés of depth and expression, to
the phantoms of the spirit, while the other embraces the "degradation"
of the avant-garde impulse to decoration and commerce. The "econom-
ical nudity" (Loy's term) of the bohemian would-be visionary faces off
against the disillusioned avant-gardist's reconciliation with the Bon
Marché. Perhaps, as *Insel*'s ambivalence suggests, Loy herself remained
vulnerable to the myths of bohemia. But it may be that the department
stores were simply more efficient at realizing the logic of technical repro-
ducibility that she had embraced. In any case, Loy got out of the market,
as Guggenheim reports: "In Paris all her ideas were stolen, and although
she had copyrights she had to give up her business. It was impossible for
her to conduct it without a business man and a lot more capital" (71).

. . .

Mina Loy's first published work, "Aphorisms on Futurism," had
appeared in 1914 in Alfred Stieglitz's magazine *Camera Work*. There

she announced a "crisis in consciousness," caused, she suggests, by the lag in its ability to absorb the new forms "offered by creative genius." "It is the new form," she writes, "for however great a period of time it may remain a mere irritant—that molds consciousness to the necessary amplitude for holding it."[13]

Two decades later, she would once again treat the crisis of consciousness, but now that of the "creative genius" herself. For the real new forms, "camera work" in all its manifestations, progressed in the pulsation of an artery, the flip of a switch and a click of the shutter, at sixteen frames per second. The ground of the future was shifting, even for a onetime futurist. In the character of Insel, and in the book of that same title, Mina Loy confronted a liquidating impulse that the camera—or her own lamp shades—had already brought into reality. Not a disturbance of collective consciousness by the inventions of individual genius, but rather the daemonic genius of the collective itself, in which consciousness was being reinvented—or abolished—beyond the individual.

In Loy's novel, significantly, Mrs. Jones is presented as a film enthusiast. More than once in the book, her meetings with Insel are punctuated by visits to the cinema. Her descriptions of the artist, in turn, strongly recall Benjamin's account of the fate of aura in the age of technical reproducibility. These descriptions fall into three major groups: images of Insel's sterility and lack of development; Insel's radiant "man-of-light"; and Insel's "loss of halo." These images recur in numerous variants throughout the book, seeming to form among themselves a virtual sequence. Descriptions of Insel's undeveloped state precede those of a visionary illumination of his body, in which he throws out hypnotic *Strahlen* (rays or radiation). Finally comes a disenchanting loss of aura, when he appears "unpleasant bereft of his radiance" (101). These three images of Insel correspond to a before and after state, with the "eternal present" of Insel's radiance periodically intervening. It is as if Insel, before the maternal witness of Mrs. Jones, were compelled to play out on his own flesh the final passion of auratic art.

Mrs. Jones regularly imagines Insel's body as having the qualities of photographic film or of a projected image. Early in the book, she describes Insel as resembling a not-yet-developed photograph. Quoting Insel's ramblings, she interweaves with the painter's words her own fantasy-laden reflection of them: "'While I appeared irretrievably idle, *Ich habe mich entwickelt*—I was developing' [Insel said]. . . . And this *Entwicklung* I would not estimate blurred my view of Insel. I saw his

image grown suddenly faint, imploring the shadow of a woman—'to only wait—in the end—I shall achieve glory'" (24–25). This passage employs a pun to which Loy will recur: the dual sense of *Entwicklung*, development, as evolution and maturation or as photographic processing. Moreover, it explicitly associates technical reproducibility and the female spectator: it is the "shadow of a woman" that is cast over Insel's undeveloped image, and it is before her eyes that he must develop.[14]

The irony of this passage lies in its reference to Insel's obsession with his appearance, which in his view must be repulsive to women. So long as he is obsessed in this way, he is willing to engage in an eroticized— though not sexual—game of appearances with Mrs. Jones. It is in these encounters that his aura flashes up, his "glory" momentarily shines forth. Insel's aura is indeed dependent on his repulsiveness, the air of distance that makes him untouchable. Correlatively, when in the end Insel is released from his obsession, when his body can be approached and touched, so too his radiance disappears. Like Benjamin, then, Loy treats the problem of aura in terms of the object's virtual nearness and distance. Through her overlay of the artist-figure and the object of sexual desire, however, she brings out the erotic dimension latent in Benjamin's notion of aura and explores its articulation along the lines of sexual difference.

In another description of Insel, Mrs. Jones explicitly uses the term "aura." His transparency, sensitivity, and seriality all mark Insel as filmlike: "Insel was made of extremely diaphanous stuff. Between the shrunken contour of his present volume his original 'serial mold' was filled in with some intangible aural matter remaining in place despite his anatomical shrinkage. An aura that enveloped him with an extra eternal sensibility" (64). Here, in a significant merging of auditory and visual connotations, Loy uses the word *aural* as a punning adjectival form of *aura*. With his "intangible aural matter," thus, Insel would seem to personify an intertransparency of word and image which, properly "developed," would overthrow the limits of the senses and represent no less than a total revolution in artistic language. A further passage reinforces this implication. Insel spontaneously produces, but makes no use of, the verbal-visual language that Mrs. Jones herself seeks, presumably as that which would resolve her own artistic problems, her own longings for a modernist solution to the crisis she senses. She drinks in Insel's "aural" synesthesia, which blurs the radiance of the visible with the audibility of language: "the ebullient calm behind Insel's eyelids, where cerebral rays

of imprecision, lengthening across an area of perfectibility, were inter-
cepted by resonant images audible to the eye, visible to the ear" (110).
Insel sees his salvation in an end to his obsession with his ugliness, and
Mrs. Jones helps to free him from this complex. Yet in doing so, she
betrays her own notion of rescuing Insel, her attempt to focus the hap-
less painter's visionary light in a singular work of art. Loy's figural lan-
guage suggests the role of technological media in destroying the artist's
aura, for ironically, in speaking of her desire to make something of Insel,
she talks of elevating his "sculpture of hallucination" to "the visionary
film" (60). While she explicitly conjures up the unique work of art as
the true redemption of Insel's degraded figure, her image of the
"visionary film" represents at best a defensive compromise with the
threatening technological medium.

In other descriptions, Insel appears not as a photographic or film
image but as the machinery for recording and projecting such images.
In these descriptions, Loy underscores Insel's strong tendency toward
automatism, which stands in stark contrast to romantic and modernist
myths of artistic individuality and autonomy. Early on, for example,
Mrs. Jones mentions Insel's "conjurative power of projecting images"
(53). In the course of the novel, Loy will elaborate this conceit into a
whole apparatus for projecting images:

I noticed that I received [his conceptions] very much in the guise of pho-
tographic negatives so hollow and dusky they became in transmission,
vaguely accentuated with inverted light—.
 [T]he transparencies his presence superposed on the living scene became
crowded with flimsy skyscrapers. (62–63)

His astounding vibratory flux required a more delicate instrument than the
eye for registration. Some infrared or there invisible ray he gave off, was
immediately transferred on one's neural current to some dark room in the
brain for instantaneous development in all its brilliancy. (96)

Again implied in this figure is not simply the merging of the artist's body
with the optical apparatus, but also the female spectator's role in bring-
ing the images to appearance. This spectator's presence here is ambigu-
ous. If in one sense, as the film viewer par excellence, Mrs. Jones bears
responsibility for the fading of Insel's aura, the faintness of the mori-
bund painter's "rays," at the same time she will serve as the reagent that
will allow him to "develop," that can bring his artistic genius to light.

Loy carefully establishes a parallelism between the eclipse of painting
by photography and an ascendance of feminine sexuality. Early in the

novel Insel presents Mrs. Jones with a gift, as the initiation of their quasi-erotic courtship:

This . . . is the first drawing of a new series—all my future work will be based on it. I intend my technique to become more and more minute, until, the grain becoming entirely invisible, it will look like a photograph. Then, when my monsters do evolve, they will create the illusion that they really exist; that they *have* been photographed. (53)

Insel's subordination of painting to photography rhymes with the dominance over him of Mrs. Jones, the older, more intelligent, more worldly woman. In his defensive struggle against the technically reproducible image, Insel asymptotically approaches a minimum of difference from it. In a clear act of mimetic assimilation to the technical device, he attempts to sharpen his painterly technique to rival the exactness of the camera's automatic registration. His triumph in this regard is, Loy underscores, nonetheless Pyrrhic. For as he succeeds in mimicking the visible appearance of the photograph, his painting also takes on photography's *primary* characteristic, which marks the photographic image before any concrete qualities come into play: its sheer potential to replicate and be replicated in turn, its intrinsic bond with repetition, its reproducibility as such. And this repetition, essential to the very technical definition of photography, undermines the claims to visionary originality Insel sought to prove in cunning battle with the forms and qualities of the photographic image. In turn, by further underscoring the *illusory* character of the objects Insel "photographs" through his painterly technique, his "monsters," Loy reflects on the eclipse of the object as such in the photographed cosmos. The real-world object that occasions the photograph is in no way an "original" of which the photographic image is the copy. On the contrary, the retrospective acts of development and printing, which render the image visible and replicable, establish the mirage of the object as origin, as the image's absent source.

Insel's ambiguous relation to photography is also embodied in his painterly member, his hand. Loy suggests Mrs. Jones's fascination with this hand by devoting a long, elaborate paragraph to its description. Seeing its powerful, rugged base, Mrs. Jones asks Insel whether he were not an engraver rather than a lithographer in his pre-painting career (engraving being a more muscular handcraft). "But out of this atavistic base," she notes,

his fingers grew into the new sensibility of a younger generation . . . his fingers clung together like a kind of pulpoid antennae, seemingly inert in their

superfine sensibility, being aquiver with such minuscule vibrations they scarcely needed to move—fingers almost alarmingly fresh and pink . . . the idle digits of some pampered daughter; and their fresh tips huddled together . . . to more and more microscopically focus his infinitesimal touch. (140–141)

Insel's hand embodies a telescoped decadence ("superfine sensibility") as well as a sex change ("the idle digits of some pampered daughter"). It is at once powerful and vestigial, while its antennalike sensitivity and vibratory qualities connote equally a kind of insect life and mechanism, the same uncanny automatism that Roger Caillois identified with the praying mantis in his 1935 article in the surrealist journal *Minotaure*.[15] It captures the ambiguity of the endangered painter's grasp, poised between the engraver's masculine grip on the tool and the photographer's enervated, feminized caress of the camera's shutter.

Mrs. Jones ends her narrative on an indecisive note, unwilling to relinquish definitively the myth of redemption through art, but also unable to deny Insel's failure to realize it. After getting over his obsession, in which he believed himself repulsive to women, Insel becomes repulsively sensuous in the eyes of Mrs. Jones, who had previously been attracted to just that "man-of-light" Insel had become during his sexual impasse. Retrospectively, Mrs. Jones admits that she could be so deeply disillusioned by him in the end only because she had so grossly overestimated him earlier, projecting her own fantasies and desires on his ludicrous antics: "Had I recalled the earlier iridescent Insel, it could only have been a figment of *my* insanity" (170). Implicitly, she recognizes the dependence of Insel's flaring and fading aura on their displaced eroticism, his ephemeral resublimation as an "original," a unique artist, before her gazing, spectatorial eye. The endurance of his aura depended on a particular relation *between* them, a mutual play across the divide of sexual difference, and not an essence *within* Insel. Insel's aura could be present only so long as its realization—Mrs. Jones's desire to give it tangible form in an enduring work of art—was deferred. It could no more tolerate artistic than sexual consummation.

As Insel and Mrs. Jones are parting, she contemplates an act of verbal revenge for the disappointment and suffering he has caused her; she would claim, cruelly, as the film-viewing female spectator, to have sapped the painter of his last lingering residues of aura. "I longed to get even with Insel," she reports, "to say 'I have absorbed all your *Strahlen*.' Now what are you going to do?" (178). But at this crucial pass she holds her tongue, breaking off the narrative and remaining, as William

Carlos Williams put it, "more or less silent." No more capable of saving the artistic aura than he is, but more conscious of its doom, she refuses claim to Insel's dwindling rays, however satisfying it might be to her to "steal" them from him—

Because firstly it was not true, and secondly, it might inspire in him a worse obsession; for one thing one feared as all else menacing Insel was some climax in which his depredatory radioactivity must inevitably give out.

So all I said was "Good-bye." (178)

Notes

Chapter 1

1. Astadur Eysteinsson, in his book *The Concept of Modernism* (Ithaca: Cornell University Press, 1990), offers a wide-ranging survey of the diverse hypotheses that artists, critics, and literary historians have offered about modernism and the related concepts of postmodernism and the avant-garde. Modernism has alternately been seen as a form of cultural decadence and as a renewal sweeping away decadent Victorianism; as continuous with romanticism, aestheticism, or naturalism and as a break with these previous movements; as a reflection of historical conditions and as a flight from them; as a revolutionary culture and as a reactionary one; as the "hegemonic" form of culture and as a marginal ivory-tower culture. These varying conceptions reflect both the ideological commitments of the authors and the more or less unconscious rhetorical structures of historical and critical writing. Hayden White has, in several essays and books, sought to reveal the prefigurative web in which history is enmeshed: *Metahistory: The Historical Imagination in Nineteenth-Century Europe* (Baltimore: Johns Hopkins University Press, 1973); *Tropics of Discourse: Essays in Cultural Criticism* (Baltimore: Johns Hopkins University Press, 1978); and *The Content of the Form: Narrative Discourse and Historical Representation* (Baltimore: Johns Hopkins University Press, 1987). See also Paul Veyne, *Writing History*, trans. Mina Moore-Rinvolucri (Middletown, Conn.: Wesleyan University Press, 1984).

2. Two recent accounts of France in the interwar years which contribute significantly to a revised picture are Eugen Weber, *The Hollow Years: France in the 1930s* (New York: W. W. Norton, 1994), and Romy Golan, *Modernity and Nostalgia: Art and Politics in France Between the Wars* (New Haven: Yale University Press, 1995). The cultural-political interest of this period in Austria has been especially well documented by the architectural historian Manfredo Tafuri

in "Austromarxismo e città: 'Das rote Wien,'" *Contropiano* 2 (1971): 259–311; *The Sphere and Labyrinth: Avant-Gardes and Architecture from Piranesi to the 1970s,* trans. Pellegrino d'Acierno and Robert Connolly (Cambridge, Mass.: MIT Press, 1987); and (with Francesco dal Co) *Modern Architecture* 1 and 2, trans. Robert Erich Wolf (Milan: Electa, 1976).

3. Two exceptions are the new, two-volume study by Bonnie Kime Scott, *Refiguring Modernism,* 1: *The Women of 1928;* 2: *Postmodern Feminist Readings of Woolf, West, and Barnes* (Bloomington: Indiana University Press, 1995); and in the American context, Walter Kalaidjian, *American Culture Between the Wars: Revisionary Modernism and Postmodern Critique* (New York: Columbia University Press, 1993). There is also a highly suggestive discussion of the later works of key "high" modernists in Bob Perelman, *The Trouble with Genius: Reading Pound, Joyce, Stein, and Zukofsky* (Berkeley: University of California Press, 1994).

4. In an essay devoted primarily to early modernism, Fredric Jameson has suggested the parallelism of the end of modernism and the restructuring of imperialism as a world system. It is this parallelism that for him suggests that debates around modernism represent more than just arbitrary assignments of historiographic boundaries: "However extrinsic and extraliterary the fact of imperialism may at first seem, there is at least a chronological justification for exploring its influence. . . . But when . . . the parallel also seems to hold at the other end of such chronological series and the end of modernism to coincide with the restructuring of the classical imperialist world system, our curiosity as to possible interrelationships can surely only be sharpened." Jameson, "Modernism and Imperialism," in Terry Eagleton, Fredric Jameson, and Edward W. Said, *Nationalism, Colonialism, and Literature* (Minneapolis: University of Minnesota Press, 1990), 45.

5. The assumption that this "aging" has already irreversibly affected modernist art underlies Peter Bürger's article "The Decline of Modernism," in *The Decline of Modernism,* trans. Nicholas Walker (University Park: Pennsylvania State University Press, 1992), 32–47. Though critically directed especially at Theodor Adorno's discussions of modernist music, Bürger's hypothesis of an institutional undermining of modernism could find support in the developments in other media and genres.

6. A view that, for example, Phillip Brian Harper has in part developed in his recent study, *Framing the Margins: The Social Logic of Postmodern Culture* (New York: Oxford University Press, 1994).

7. George Orwell, "Review of *Tropic of Cancer* by Henry Miller," *New English Weekly,* 14 November 1935; reprinted in *The Collected Essays, Journalism and Letters of George Orwell,* 1: *An Age Like This, 1920–1940,* ed. Sonia Orwell and Ian Angus (London: Secker & Warburg, 1968), 154–156.

8. George Orwell, "Inside the Whale" (1940), in *A Collection of Essays* (San Diego: Harcourt Brace Jovanovich, 1981), 252.

9. Charles Jencks, "Postmodern vs. Late-Modern," in *Zeitgeist in Babel: The Post-Modernist Controversy,* ed. Ingeborg Hoesterey (Bloomington: Indiana University Press, 1991), 4–21.

10. Fredric Jameson, *Postmodernism, or, the Cultural Logic of Late Capitalism* (Durham: University of North Carolina Press, 1991), 305.

11. Fredric Jameson, *Fables of Aggression: Wyndham Lewis, the Modernist as Fascist* (Berkeley: University of California Press, 1979), 19.

12. Alan Wilde, *Horizons of Assent: Modernism, Postmodernism, and the Ironic Imagination* (Baltimore: Johns Hopkins University Press, 1981), 120–121.

13. Brian McHale, *Postmodernist Fiction* (New York: Methuen, 1987), 12.

14. I take this concept from Oskar Negt's essay on Ernst Bloch, "The Non-Synchronous Heritage and the Problem of Propaganda," *New German Critique* 9 (1976): 58.

15. Maurice Blanchot calls such writing, which emerges from points of opacity to the narrative exposition of history, "demise writing." Blanchot, *The Writing of the Disaster*, trans. Ann Smock (Lincoln: University of Nebraska Press, 1986), 33. For a discussion of heterotopias, see Michel Foucault, "Of Other Spaces," *Diacritics* 16, no. 1 (1986): 22–27.

16. John Hawkes, "Symposium: Fiction Today," *Massachusetts Review* 3, no. 4 (1962): 784–788.

17. For an analogous study of French writing of the 1930s and 1940s, see Allan Stoekl, *Politics, Writing, Mutilation: The Cases of Bataille, Blanchot, Leiris, and Ponge* (Minneapolis: University of Minnesota Press, 1985).

18. Walter Benjamin, *The Origin of German Tragic Drama*, trans. John Osborne (London: New Left Books, 1977), 176.

19. Walter Benjamin, "Krisis des Romans: Zu Döblins *Berlin Alexanderplatz*," in *Gesammelte Schriften* III, ed. Hella Tiedemann-Bartels (Frankfurt am Main: Suhrkamp, 1972), 230–236.

20. André Gide, "Journal of *The Counterfeiters*," in *The Counterfeiters* [French orig. 1927] (New York: Vintage Books, 1951), 416.

21. Peter Nicholls, "Divergences: Modernism, Postmodernism, Jameson and Lyotard," *Critical Quarterly* 33, no. 3 (1991): 1–18. See also Nicholls's recent book-length study, in which he develops this idea of "divergences" into an account of multiple histories of modernism, that is, of distinct "modernisms": Nicholls, *Modernisms: A Literary Guide* (Berkeley: University of California Press, 1995).

22. Jean-François Lyotard, *Discours, figure* (Paris: Klincksieck, 1971). For English translations, see "The Dream-Work Does Not Think," trans. Mary Lydon, in *The Lyotard Reader*, ed. Andrew Benjamin (Oxford: Basil Blackwell, 1989), 19–55; and "The Connivances of Desire with the Figural," in *Driftworks* (New York: Semiotext(e), 1984), 57–68. A helpful discussion of Lyotard's theory of discourse and the figural appears in Geoffrey Bennington, *Lyotard: Writing the Event* (New York: Columbia University Press, 1988), 56–102.

23. On the existence and definition of this mainstream, see Douwe Fokkema and Elrud Ibsch, *Modernist Conjectures: A Mainstream in European Literature, 1910–1940* (London: C. Hurst, 1987).

24. For a discussion of the rise of the prose poem as a transgressive form of "counterdiscourse," see the third part of Richard Terdiman, *Discourse/*

Counterdiscourse: The Theory and Practice of Symbolic Resistance in Nineteenth-Century France (Ithaca: Cornell University Press, 1985), 261–343.

25. Richard Ellmann, Interview with Samuel Beckett, quoted in James Knowlson, *Damned to Fame: The Life of Samuel Beckett* (New York: Simon & Schuster, 1996), 108.

26. Beckett to MacGreevy, probably June 1930, quoted in Knowlson, *Damned to Fame*, 121.

27. T. S. Eliot, "*Ulysses,* Order, and Myth" (1923), in *Selected Prose of T. S. Eliot,* ed. Frank Kermode (New York: Harcourt Brace Jovanovich, 1975), 175–178.

28. Beckett, notebook entry, 15 January 1937, quoted in Knowlson, *Damned to Fame*, 228.

29. Wyndham Lewis, *The Childermass* (London: John Calder, 1928), 81.

30. Djuna Barnes, *Nightwood: The Original Version and Related Drafts* [1936, 1937, 1962], ed. Cheryl J. Plumb (Normal, Ill.: Dalkey Archive Press, 1995), 65.

31. Samuel Beckett, *Watt* (New York: Grove Press, 1953), 124–125.

32. This process is closely akin to what M. M. Bakhtin, with reference to a general history of genres, called "novelization." Of particular interest here are two central aspects of Bakhtin's account: his emphasis, on the one hand, on the opening of literary forms to contingency and contemporaneity; and, on the other hand, his account of laughter's central role in the process of novelization as the instrument of a "comical operation of dismemberment," reflected both formally and thematically. See Bakhtin, "Epic and Novel," in *The Dialogic Imagination,* ed. Michael Holquist, trans. Caryl Emerson and Michael Holquist (Austin: University of Texas Press, 1981), 3–40; esp. 22–24. In addition, Bakhtin's relation of Dostoevsky's works to Menippean satire has broad relevance to my characterization of late modernism. See Bakhtin, *Problems of Dostoevsky's Poetics,* ed. and trans. Caryl Emerson (Minneapolis: University of Minnesota Press, 1984), 101–180.

33. C. Barry Chabot, "The Problem of the Postmodern," in *Zeitgeist in Babel: The Post-Modernist Controversy,* 30.

34. Author's note (1920) to Joseph Conrad, *Under Western Eyes* [1911] (London: Penguin Books, 1985), 49–50.

35. Art Berman suggests that "high modernism" as a distinct mode emerges together with a formalist critical discourse to legitimate a particular, hegemonic conception of modernist writing, excluding other possibilities latent in earlier modernist experimentation; see Berman, *Preface to Modernism* (Urbana: University of Illinois Press, 1994), 60ff.

36. Bürger, "The Decline of Modernism," 44.

37. Wyndam Lewis, *Men Without Art,* ed. Seamus Cooney (Santa Rosa: Black Sparrow Press, 1987), 89. Lewis's emphasis.

Chapter 2

1. Wyndham Lewis, *Blasting and Bombardiering: An Autobiography (1914–1926)* (London: John Calder, 1982), 1.

2. And as his biographer Jeffrey Meyers notes, "The sudden reputation and notoriety that Lewis achieved in 1914 as the leader of the Vorticists and editor of *Blast* had disappeared when peace broke out in 1919." Meyers, *The Enemy: A Biography of Wyndham Lewis* (London: Routledge & Kegan Paul, 1980), 102.

3. Lewis, *Blasting and Bombardiering*, 5.

4. For a historical examination of these and related myths, see Robert Wohl, *The Generation of 1914* (Cambridge, Mass.: Harvard University Press, 1979), 85–121. Wyndham Lewis criticized the myth of a "missing" or "blank" generation in *The Old Gang and the New Gang* (London: Desmond Harmsworth, 1933).

5. Any full discussion of nonliterary modernism lies outside of the scope of this book, but a few indices in other artistic fields suggests a similar rhythm of crisis commencing in the late twenties. Focusing on architecture and urban planning, Manfredo Tafuri points to 1931 as the year in which "the crisis was felt in all sectors and at all levels." Tafuri, *Architecture and Utopia: Design and Capitalist Development* (Cambridge, Mass.: MIT Press, 1976), 48. K. Michael Hays, in his recent book, *Modernism and the Posthumanist Subject: The Architecture of Hannes Meyer and Ludwig Hilberseimer* (Cambridge, Mass.: MIT Press, 1992), indicates a "posthumanist" paradigm shift beginning in the late twenties in the architecture of Hannes Meyer and Ludwig Hilberseimer. Laurent Jenny has traced the crisis of early surrealism through a debate, beginning in 1930 and culminating in the latter years of the decade, about the nature and function of automatism. Roughly summarized, he sees a shift from the notion of automatism as the expression of inner, psychic facts (essentially a Freudian update of romantic poetics) to that of delirious interpretation, in which a deliberate course of destruction of socially sanctioned meanings is pursued. The former emphasizes individual self-expression; the latter emphasizes social effect and encourages a more immediate political link between artistic practices and the nonartistic collective. Jenny, "From Breton to Dali: The Adventures of Automatism," *October* 51 (1989): 105–114.

6. I follow Theodor Adorno's definition of artistic autonomy as art's "crystallizing into an entity unto itself—rather than complying with existing social norms and qualifying itself as 'socially useful.'" Adorno, *Ästhetische Theorie* (Frankfurt am Main: Suhrkamp, 1970), 335; my translation. This autonomous status, he argues, offers a resistance to society in the mere existence of a sphere unsubordinated to its norms and instrumentalities. Art's social status lies precisely in its difference from other modes of social practice (335). Peter Bürger, following Adorno, suggests that the aesthetics of Kant and Schiller, which emphasize "a sensuousness . . . that was not part of any means-ends relationships," provide a philosophical formulation of art's autonomy. Bürger, *Theory of the Avant-Garde*, trans. Michael Shaw (Minneapolis: University of Minnesota Press, 1984), 46.

7. Wambly Bald, *On the Left Bank, 1929–1933*, ed. Benjamin Franklin V (Athens: Ohio University Press, 1987), 74.

8. F. Scott Fitzgerald complained: "By 1928, Paris had grown suffocating. With each new shipment of Americans spewed up by the boom the quality fell off, until toward the end there was something sinister about the crazy

boatloads." Fitzgerald, quoted in Malcolm Cowley, *Exile's Return: A Literary Odyssey of the 1920s* (New York: Penguin Books, 1969), 240.

9. In his study *Strukturwandel der Öffentlichkeit* (Darmstadt: Luchterhand, 1962), esp. 69–75, Jürgen Habermas traces the emergence in the eighteenth century of a general "public sphere" out of the critical discussion of literature. Literature served as a conveyor and mediator of fundamental values. Modernism broke that contract, negating publicly held norms in favor of the special demands of the artist and his or her coterie of followers and friends. Yet the radicality of this gesture was paid for by its loss of effectivity: it compromised in advance the position from which autonomous art pronounced an implicit judgment over the society from which it set itself apart.

10. Fredric Jameson, *The Political Unconscious* (Ithaca: Cornell University Press, 1981), 280. In "Reflections in Conclusion," Jameson offers a more general view of modernism (i.e., not strictly focused on modernist *narrative*), which provides a useful qualification to the strong statement quoted above: "Modernism would then not be so much a way of avoiding social content—in any case an impossibility for beings like ourselves who are 'condemned' to history and to the implacable sociability of even the most apparently private of experiences—as rather of managing and containing it, secluding it out of sight in the very form itself, by means of specific techniques of framing and displacement which can be identified with precision." "Reflections in Conclusion," in *Aesthetics and Politics* (London: New Left Books, 1977), 202.

11. David Jones, *In Parenthesis* (London: Faber and Faber, 1937), xv.

12. For a general account of the post–World War I reconstruction of the European economies, see Charles S. Maier, *Recasting Bourgeois Europe: Stabilization in France, Germany, and Italy in the Decade After World War I* (Princeton: Princeton University Press, 1975); Maier argues that postwar Europe was marked by the emergence of corporatism as a means of stabilizing society, a tendency also reflected within and directly fostered by the United States. Alfred Sohn-Rethel, *The Economy and Class Structure of German Fascism*, trans. Martin Sohn-Rethel (London: CSE Books, 1978), provides an inside look, based on Sohn-Rethel's experience working within an employer's organization, of the economic and political integration of German capital during the Weimar Republic; he too emphasizes the importance of American financing in the rationalization of German heavy industry. Arthur Marwick documents the changes in British society due to mobilization of resources and labor power for World War I, in *The Deluge: British Society and the First World War* (New York: W. W. Norton, 1965). E. J. Hobsbawm, *Industry and Empire: From 1750 to the Present Day* (Harmondsworth: Penguin Books, 1968, 1969), 207–224, depicts the broad economic and politicoeconomic trends between the wars in Britain. He notes that while in Britain the apparatus for state controls on industry was quickly dismantled after both world wars, the "private" forms of integration advanced precipitously between the wars: "In 1914," he notes, "Britain was perhaps the least concentrated of the great industrial economies, and in 1939 one of the most" (214).

13. On this point, see Antonio Carlo, "The Crisis of the State in the Thirties," *Telos* 46 (1980–1981): 62–80. While the state had always played a role in

the economy, Carlo argues, the nature and direction of its interventions changed with the crisis of 1929: from "directed" capitalism, in which the state tries to direct the economy into certain channels but does not act to stave off cyclical crises, to "organized" capitalism, in which the state intervenes to sustain markets and profits against cyclical tendencies. This greater degree of intervention also entailed a reorganized, intensified state power, of which fascism, Stalinism, and the New Deal social welfare state represented alternative visions and forms. See also Antonio Negri, "La teoria capitalistica dello stato nel '29: John M. Keynes," *Contropiano* 1 (1968): 3–40.

14. Max Weber, "Science as a Vocation," trans. Hans H. Gerth and C. Wright Mills, in *Max Weber: Sociological Writings*, ed. Wolf Heydebrand (New York: Continuum, 1994), 302–303.

15. For further discussion of Weber's displacement of politics, see Fredric Jameson, "The Vanishing Mediator; or, Max Weber as Storyteller," in *The Ideologies of Theory: Essays 1971–1986*, 2: *The Syntax of History* (Minneapolis: University of Minnesota Press, 1988), 3–34.

16. Ludwig Mies van der Rohe, "The New Age" (1930), reprinted in *The Bauhaus: Weimar, Dessau, Berlin, Chicago* (Cambridge, Mass.: MIT Press, 1969), 169.

17. This tendency to objectification was distinct from earlier abstraction, which tended to focus not so much on the object as on the presentation of inner states or moods (as with Kandinsky) or of the "nonobjective world" (Malevich) of ideal intellectual entities. The *faktura* of Russian constructivism and the emphasis on functionality in the Bauhaus, postwar tendencies that dovetailed into socially useful fields like industrial design and typography, in contrast represented rationalizing interventions into the structure, production, and distribution of objects.

18. Popova, quoted in Christina Lodder, *Russian Constructivism* (New Haven: Yale University Press, 1983), 175–176.

19. Lodder, *Russian Constructivism*, 175.

20. On this point, see Benjamin H. D. Buchloh, "From Faktura to Factography," *October* 30 (1984): 82–119.

21. Sergei Tretiakov, "Biographie des Dings" [trans. from Russian], in *Gesichter der Avantgarde: Porträts, Essays, Briefe* (Berlin and Weimar: Aufbau Verlag, 1991), 106.

22. The Bauhaus use of photography and photomontage is an obvious example. More surprising, however, is the integral role of photography in the work of Le Corbusier; see Beatriz Columina's superb study, *Privacy and Publicity: Modern Architecture as Mass Media* (Cambridge, Mass.: MIT Press, 1994).

23. Cf. the related examples of Hilberseimer and Meyer, discussed by Hays in *Modernism and the Posthumanist Subject*.

24. For a discussion of this ongoing interpenetration of aesthetic design and functional system, see Jean Baudrillard, "Design and Environment, or How Political Economy Escalates into Cyberblitz," in *For a Critique of the Political Economy of the Sign*, trans. Charles Levin (St. Louis: Telos Press, 1981), 185–203.

25. Louis Zukofsky's early "objectivist" program provides a concrete example. In his 1931 essay, "An Objective," he writes:

A poem. The context based on a world—Idle metaphor—a lime base—a fibre—not merely a charged vacuum tube—an aerie of personation—The desire for inclusiveness— The desire for an inclusive object.
 A poem. This object in process—The poem as a job—A classic—

In *Prepositions: The Collected Critical Essays of Louis Zukofsky* (Berkeley: University of California Press, 1981), 15. Zukofsky saw objectification as the basis of ethical integrity: sincerity, rather than the rampant subjectivity of sloppy writing ("an aerie of personation"). At the same time it guaranteed enduring literary value: "A classic—." In a later interview, Zukofsky would comment on his stance of the thirties: "The objectivist . . . is one person, not a group, and as I define him he is interested in living with things as they exist, and as a 'wordsman,' he is a craftsman who puts words together into an object." Interview ("Sincerity and Objectification") with Zukofsky, in *Louis Zukofsky: Man and Poet*, ed. Carroll F. Terrell (Orono, Maine: National Poetry Foundation, 1979), 268.

26. Literature would have to wait for post–World War II developments in cybernetics, computers, and mass media before anything analogous to radical constructivism in architecture and the visual arts could emerge. This differential rhythm of development may account for the widely divergent characterizations of *post* modernism, depending on whether the critic stresses architecture and the visual arts, with their postmodern historicism and rejection of abstraction, or literature, in which postmodernism is often equated with formal abstraction and radical self-reflexivity.

27. André Breton, "What Is Surrealism?" in *What Is Surrealism? Selected Writings*, ed. Franklin Rosemont (New York: Monad Press, 1978), 138.

28. André Breton, "Surrealist Situation of the Object" (1935), in *Manifestoes of Surrealism*, trans. Richard Seaver and Helen R. Lane (Ann Arbor: University of Michigan Press, 1969), 263. Cf. "Crisis of the Object" (1936), "Surrealist Exhibition of Objects" (1936), and "The Object-Poem" (1942) for further discussion of surrealism and the object; all three essays are collected in Breton, *Surrealism and Painting*, trans. Simon Watson Taylor (New York: Harper and Row, 1972), 275–280, 282–283, 284–285.

29. Henri Lefebvre, *The Production of Space*, trans. Donald Nicholson-Smith (Oxford: Basil Blackwell, 1991), 19.

30. Franco Moretti, "From *The Waste Land* to the Artificial Paradise," in *Signs Taken for Wonders: Essays in the Sociology of Literary Forms*, trans. Susan Fischer, David Forgacs, and David Miller (London: Verso, 1988), 235.

31. Tafuri, *Architecture and Utopia*, 72–73.

32. Tafuri, *Architecture and Utopia*, 74.

33. Orwell, "Inside the Whale," 250.

34. Wyndham Lewis, *The Childermass* (London: John Calder, 1928), 320. Nor was this ending simply right-wing nihilism. Left-wing writers seemed compelled to end books in analogous ways. Thus, in 1925, John Dos Passos sent Jimmy Herf of *Manhattan Transfer* stepping out to nowhere: "'How fur ye

goin?' 'I dunno. . . . Pretty far.'" Dos Passos, *Manhattan Transfer* (Boston: Houghton Mifflin, 1953), 404. In his 1929 novel, *Berlin Alexanderplatz,* Alfred Döblin has his untragic hero Franz Bieberkopf marching off, in imagination, to another war: "The way leads to freedom, to freedom it goes. The old world must crumble. Awake, wind of dawn!//And get in step, and right and left and right and left, marching: marching on, we tramp to war, a hundred minstrels march before . . . one stands fast, another's killed, one rushes past, another's voice is stilled, drrum, brrumm, drrumm!" Döblin, *Berlin Alexanderplatz,* trans. Eugene Jolas (New York: Frederick Ungar, 1961), 635.

35. For a discussion of the later fate of the object as a site of both material presence and meaning, see Jean Baudrillard's first book, *Le système des objets* (Paris: Gallimard, 1968). Translated excerpts from this work appear in Baudrillard, *Selected Writings,* ed. Mark Poster (Palo Alto: Stanford University Press, 1988), 10–28; and in Baudrillard, *Revenge of the Crystal: Selected Writings on the Modern Object and Its Destiny, 1968–1983,* ed. Paul Foss and Julian Pefanis (London: Pluto Press, 1990), 35–61.

36. Georg Simmel, "Metropolis and Mental Life," in *On Individuality and Social Forms,* ed. Donald N. Levine (Chicago: University of Chicago Press, 1971), 335; translation modified. Published in German as "Die Großstädte und das Geistesleben" (1903), in Georg Simmel, *Brücke und Tür,* ed. Michael Landmann and Margarete Susmann (Stuttgart: Koehler, 1957).

37. Jürgen Habermas, "Modernity versus Postmodernity," *New German Critique* 22 (1981): 3–14.

38. Massimo Cacciari, *Metropolis: Saggi sulla grande città di Sombart, Endell, Scheffler e Simmel* (Rome: Officina, 1973), 9–10. I cite from the English translation provided in part 1 of Cacciari, *Architecture and Nihilism: On the Philosophy of Modern Architecture,* trans. Stephen Sartarelli (New Haven: Yale University Press, 1993), 4. For further discussion of Cacciari's concept of Metropolis, see my review of this volume in *Textual Practice* 10, no. 2 (1996).

39. Hermann Broch, *Massenwahntheorie: Beiträge zu einer Psychologie der Politik,* ed. Paul Michael Lützeler (Frankfurt am Main: Suhrkamp, 1979), 70.

40. Samuel Beckett, *Murphy* (New York: Grove Press, 1957), 66.

41. Georges Bataille, *The Accursed Share: An Essay on General Economy,* 3 vols., trans. Robert Hurley (New York: Zone Books, 1988/1991).

42. Baudrillard, "Design and Environment," 192.

43. In "From Adorno to Marx: De-Aestheticizing the Modern," in *Modernism and Hegemony: A Materialist Critique of Aesthetic Agencies* (Minneapolis: University of Minnesota Press, 1990), 3–31, Neil Larsen challenges Adorno's generalization of specific problems of representing *class* in political society to problems of representation in art, which then becomes a primary locus of resistance for Adorno. See also Jaime Concha's foreword to Larsen's book: "From the Modernism of Adorno to the Contemporaneity of Marx," ix-xxi.

44. Theodor Adorno, *Minima Moralia: Reflections from Damaged Life,* trans. E. F. N. Jephcott (London: Verso, 1974), 236.

45. *Minima Moralia,* 238.

46. *Minima Moralia,* 54.

47. It is useful here to compare Adorno's conception of trauma with that offered by Kaja Silverman in her recent essay "Historical Trauma and Male Subjectivity," in Silverman, *Male Subjectivity at the Margins* (New York: Routledge, 1992), 52–121. Adorno emphasizes the repetition and compulsive behavior, both for the individual and for the collective, that follow on the inassimilable event of trauma. This event is in one sense "never experienced," because it exceeds the subjective means by which events become individual and historical memory. In another (and for Adorno terrible) sense, however, the event has never *ceased* to be experienced, even in its apparent passage, because of its continuing grip on the psychic life of the traumatized subject. In clear contrast to Adorno's focus on the overpowering *event* of trauma and its subjective persistence, Silverman emphasizes the *effects* of trauma, particularly as they traverse the divide of sexual difference. She thus defines historical trauma as "any historical event, whether socially engineered or of natural occurrence, which brings a large group of male subjects into such an intimate relation with lack that they are at least for the moment unable to sustain an imaginary relation with the phallus, and so withdraw their belief from the dominant fiction. Suddenly, the latter is radically de-realized, and the social formation finds itself without a mechanism for achieving consensus" (55). The event, in Silverman's account, is largely contingent; it can be natural or social in origin. Her crucial interest lies in the crisis this event precipitates in the male subject. For Adorno, in contrast, the specificity of the traumatic historical event—the convergence of world war, fascism, and culture industry in the 1930s and 1940s—is necessary to account for the fate of the subject in these times. Adorno saw this fate as part of a larger historical narrative, as an outcome of the domination of nature through technology and of political domination by the state. While Silverman offers an important perspective on the gender specificity of Adorno's notion of trauma, Adorno nevertheless raises the serious question whether the traumatic destruction of the "dominant fiction" represents grounds for hope. Silverman assumes that the power over subjects (state power, economic power, sexual and racial oppression) is grounded on a "prior reality," a "stable core around which a nation's and a period's 'reality' cohere" (41)—the fiction of phallic power on which ideological belief is predicated. Adorno, however, takes up the problem of the continued existence of power after the traumatic destruction of the (male) subject's grounding fiction. In his view, power is even more efficacious for this dispossession of the subject, its dissipation into what Jean Baudrillard would later call "the ecstasy of communication." In the place of centered belief, an objectless desire for "the new" fostered by postwar consumerism and culture industry emerges within the traumatized subject, which, paradoxically, perpetuates the trauma's efficacy in psychic life. For Adorno, then, the event of trauma and the transformation of "damaged life" into consumerism (with the consumer's desire for commodified "newness" understood as the deaestheticized face of modernism) are two moments of a single historical process following World War I.

48. Lewis, *Blasting and Bombardiering*, 342. Lewis employed this image of the "magnetic" force of the war earlier, in his novel *The Childermass*, in which

the dead souls of the fallen soldiers of World War I wait in a camp outside the gates of the "Magnetic City," hoping to be drawn into its inner sanctum.

49. I follow Jonathan Crary's suggestion that it is possible to situate the emergence of what Guy Debord called "the society of the spectacle" in the late twenties and thirties. As indices of this emergence, he points to the perfection of television technology, the generalized appearance of sound film, and the cultural politics of fascism. Moreover, he views surrealism and Walter Benjamin's Arcades Project as left-wing, avant-garde attempts to come to terms with a new "organization of perceptual consumption" in these years. Crary, "Spectacle, Attention, Counter-Memory," *October* 50 (1988): 97–107. For Debord's theses on spectacle, see his *Society of the Spectacle* (Detroit: Black and Red, 1983).

50. On this point, cf. Peter Nicholls's important article on Wyndham Lewis, "Apes and Familiars: Modernism, Mimesis and the Work of Wyndham Lewis," *Textual Practice* 6, no. 3 (1992): 421–438. I differ from Nicholls in my historical framing of this issue and in certain aspects of the concept of mimesis and mimetism. Nicholls distinguishes at least three contemporaneous strains of modernism in his essay: a European avant-gardism; a modernism associated with Conrad, Woolf, and Lawrence; and a modernism associated with "the men of 1914," Pound, Joyce, Eliot, and Lewis. In my view, even the early Lewis should not be too quickly assimilated to this quartet of writers and his polemical assertions of difference from them must be given their due. A key factor, I would argue, is Lewis's direct involvement in combat during the war years, as it affected his career, his political-cultural views, and his personality; the other three were noncombatants and made crucial advances in their work precisely during the period Lewis was serving in the trenches. Though Nicholls does not take up these biographical factors, he does later consider Lewis's distinction from a theoretical point of view—the relation of mimetism to intertextuality. He connects Lewis's rejection of Pound, Joyce, and Eliot to their practice of intertextual appropriation. Lewis, he argues, attempts to block the processes of identification and assimilation by emphasizing spatial exteriority, separation of bodies, and deadness. Art, as satiric violence, counters "the passivity of a generalized social mimetism" (432). Nicholls discusses the concept of mimetism through the theoretical writings of Philippe Lacoue-Labarthe, Jacques Derrida, Mikkel Borch-Jacobsen, and René Girard. Mimetism was already part of the theoretical discourse and debate of the thirties, however, among such intellectuals as Walter Benjamin, Roger Caillois, Theodor Adorno, Pierre Klossowski, and others. Accordingly, my discussion of mimetism, while indebted to Nicholls's work, returns to this intellectual context, which I understand to form a theoretical corollary to the literary responses of late modernist writers.

51. Wyndham Lewis, *The Diabolical Principle and The Dithyrambic Spectator* (New York: Haskell House, 1971), 238.

52. Wyndham Lewis, *The Art of Being Ruled,* ed. Reed Way Dasenbrock (Santa Rosa: Black Sparrow Press, 1989), 157. Cited in text as *AOBR*.

53. In the latter text, Lewis recurs to the exact example used in *The Art of Being Ruled* to criticize surrealism: "Art at its fullest is a very great force indeed, a magical force, a sort of *life,* a very great 'reality.' It is *that* reality, that magic,

that force, that this 'dream-aesthetic' proposes to merge with life, exactly on the same principle as the Producers at the Moscow theatres today merge audience and performer, stage and auditorium." *The Diabolical Principle and the Dithyrambic Spectator,* 69. For an account of Lewis's battles with *transition,* see Dougald McMillan, *transition: The History of a Literary Era, 1927–1938* (New York: George Braziller, 1975), 204–231.

54. Lewis, *Men Without Art,* ed. Seamus Cooney (Santa Rosa: Black Sparrow Press, 1987), 103. Cited in text as *MWA.*

55. Barnes, quoted by Meryl Altman, "*The Antiphon:* 'No Audience At All?'" in *Silence and Power: A Reevaluation of Djuna Barnes,* ed. Mary Lynn Broe (Carbondale: Southern Illinois University Press, 1991), 275.

56. Samuel Beckett, *Disjecta: Miscellaneous Writings and a Dramatic Fragment,* ed. Ruby Cohn (New York: Grove Press, 1984), 70.

57. Beckett, *Disjecta,* 82.

58. For further discussion of this interpermeability of subject and object, see my article "From City-Dreams to the Dreaming Collective: Walter Benjamin's Political Dream Interpretation," *Philosophy and Social Criticism* 22, no. 6 (1996): 87–111.

59. Lewis, *Blasting and Bombardiering,* 16.

60. Most poignantly with the fatal accidents of Victor and Margot in *The Revenge for Love* and Hester in *Self-Condemned.*

61. Peter Bürger, in his article "Dissolution of the Subject and the Hardened Self: Modernity and the Avant-Garde in Wyndham Lewis's Novel *Tarr,*" reads Lewis's first novel as revealing "two equally aporetic forms of life in the crisis period of bourgeois society, the defensive armored self of the professional person on the one hand and the diffused identity of the proto-fascist character on the other." In Bürger, *The Decline of Modernism,* trans. Nicholas Walker (University Park: Pennsylvania State University Press, 1992), 136. I find Bürger's schematization of these two elements at war in Lewis's concept of subjectivity (as revealed in his fictional and theoretical works) highly suggestive. Far less convincing, in my view, is Bürger's rather mechanical attempt to align these two "poles" of Lewis's subject with "modern" and "avant-garde" respectively. I see this move as a largely unargued attempt to leap from suppositions about subjectivity as exhibited by Lewis's texts to Lewis's own subjectivity as a producer of artworks. While this move is not in itself illegitimate, it would require a more concrete and nuanced articulation than is possible with a simple opposition of "modern" and "avant-garde," as components of Lewis's artistic personality.

62. Thomas Mann, quoted in Peter Sloterdijk, *The Critique of Cynical Reason,* trans. Michael Eldred, Theory and History of Literature 40 (Minneapolis: University of Minnesota Press, 1987), 532.

63. Sigmund Freud, *Beyond the Pleasure Principle,* trans. James Strachey (New York: W. W. Norton, 1961), 21.

64. See also Helmut Lethen's study of "coldness" as a mode of behavior in Germany between the world wars, *Verhaltenslehren der Kälte: Lebensversuche zwischen den Kriegen* (Frankfurt am Main: Suhrkamp, 1994).

65. Max Horkheimer and Theodor W. Adorno, *Dialectic of Enlightenment,* trans. John Cumming (New York: Continuum, 1972), 180.

66. André Bazin, "Charlie Chaplin," in *What Is Cinema?* Vol 1., ed. Hugh Gray (Berkeley: University of California Press, 1967), 149.

67. Roger Caillois, "Mimetisme et psychasthénie légendaire," *Minotaure* 7 (1935): 4–10. English translation: "Mimicry and Legendary Psychasthenia," trans. John Shepley, *October* 31 (1984): 16–32. Cf. Denis Hollier's discussion of Caillois's essay, "Mimesis and Castration 1937," trans. William Rodarmor, *October* 31 (1984): 3–15.

68. Julia Kristeva, "Place Names," in *Desire in Language: A Semiotic Approach to Literature and Art*, ed. Leon S. Roudiez, trans. Thomas Gora, Alice Jardine, and Leon S. Roudiez (New York: Columbia University Press, 1980), 283.

69. Wyndham Lewis, *Tarr: The 1918 Version*, ed. Paul O'Keefe (Santa Rosa: Black Sparrow Press, 1990), 42.

70. Lewis, *Tarr*, 43.

71. Wyndham Lewis, "When John Bull Laughs" (1938), in *Creatures of Habit, Creatures of Change: Essays on Art, Literature, and Society, 1914–1956*, ed. Paul Edwards (Santa Rosa: Black Sparrow Press, 1989), 282.

72. Georges Bataille, "Un-knowing: Laughter and Tears," *October* 36 (1986): 97.

73. M. M. Bakhtin, *Problems of Dostoyevsky's Poetics*, ed. and trans. Caryl Emerson (Minneapolis: University of Minnesota Press, 1984), 163.

74. The classic study of this process of "reduction" and sedimentation of laughter in texts is Bakhtin's *Rabelais and His World*, trans. Hélène Iswolsky (Bloomington: Indiana University Press,1984), especially his opening chapter, "Rabelais in the History of Laughter," 59–145.

75. Sigmund Freud, *Jokes and Their Relation to the Unconscious*, trans. and ed. James Strachey (New York: W. W. Norton, 1960), 117.

76. Helmut Plessner, *Laughing and Crying: A Study of the Limits of Human Behavior*, trans. James Spencer Churchill and Marjorie Grene (Evanston: Northwestern University Press, 1970), 25.

77. Samuel Beckett, *Endgame* (New York: Grove Press, 1958), 18.

78. In his 1934 article, "Studies in the Art of Laughter," Lewis discusses satire in terms that suggest Beckett's use of the term "tragicomedy" in characterizing *Waiting for Godot*. Lewis writes: "Satire, some satire, does undoubtedly stand half-way between Tragedy and Comedy. It may be a hybrid of these two. Or it may be a *grinning* tragedy, as it were. Or, yet again, it may be a comedy full of dangerous electrical action, and shattered with outbursts of tears." "Satire Defended," in Lewis, *Enemy Salvoes: Selected Literary Criticism*, ed. C. J. Fox (London: Vision Press, 1975), 48.

79. Samuel Beckett, *Watt* (New York: Grove Press, 1953), 48.

80. Beckett, *Murphy*, 41.

81. Djuna Barnes, *Nightwood: The Original Version and Related Drafts* [1936, 1937, 1962], ed. Cheryl J. Plumb (Normal, Ill.: Dalkey Archive Press, 1995), 21. Cited in text as *N*.

82. In my chapter on Barnes I discuss Matthew O'Connor's role as hermeneutic mediator between the reader and the text. As I will show, the stakes of interpreting the world presented in the book constitute a central theme of Barnes.

83. Fredric Jameson, in his discussion of Lewis, discusses at length the

"centrifugal" tendencies in Lewis's style. Jameson goes on to examine the strategies of "recontainment" Lewis used to organize his texts on the large-scale, "molar" (as opposed to "molecular") dimension. While I am skeptical about Jameson's strong emphasis on the unifying, "reterritorializing" aspect of Lewis—which I see as generally weak and usually overpowered in the fiction by Lewis's "deterritorialization" of form—I believe Jameson's approach nonetheless discloses a fundamental characteristic of late modernism, in Lewis and other writers. (Jameson, in fact, refers to Beckett's *Watt* in passing.) See Fredric Jameson, *Fables of Aggression: Wyndham Lewis, the Modernist as Fascist* (Berkeley: University of California Press, 1979), esp. chap. 2, "Agons of the Pseudo-Couple."

84. See also my essay "Dismantling Authenticity: Beckett, Adorno, and the 'Post-War,'" *Textual Practice* 8, no. 1 (1994): 43–57.

Chapter 3

1. Letter of Lewis to Julian Symons, 21 November 1937, in *The Letters of Wyndham Lewis*, ed. W. K. Rose (New York: New Directions, 1963), 246.

2. Wyndham Lewis, *Rude Assignment: An Intellectual Autobiography*, ed. Toby Foshay (Santa Barbara: Black Sparrow Press, 1984), 148–149. Cited in text as *RA*.

3. Wyndham Lewis, *Blasting and Bombardiering: An Autobiography, 1914–1926* (London: John Calder, 1937), 6. Cited in text as *B&B*.

4. Lewis advances a political analysis of male homosexuality in *The Art of Being Ruled*, especially the section entitled "Man and Shaman": *The Art of Being Ruled*, ed. Reed Way Dasenbrock (Santa Rosa: Black Sparrow Press, 1989), 239–273.

5. Virginia Woolf, *Mrs. Dalloway* [1925] (San Diego: Harcourt Brace Jovanovich, 1981), 81.

6. Wyndham Lewis, *The Apes of God* [1930] (Santa Barbara: Black Sparrow Press, 1984), 624. Cited in text as *AOG*.

7. Antonio Gramsci, *Selections from the Prison Notebooks*, ed. Quintin Hoare and Geoffrey Nowell Smith (New York: International Publishers, 1971), 223.

8. Oswald Mosley, *The Greater Britain* (Chelsea: British Union of Fascists, 1932), 23–24.

9. By June 1930, according to Stevenson and Cook, there were 2 million out of work in Britain and a total of 11 million in 33 countries. John Stevenson and Chris Cook, *Britain in the Depression: Society and Politics, 1929–1939* (London: Longman, 1977, 1994), 9.

10. See Mosley, *The Greater Britain*, 19: "The Modern Movement is by no means confined to Great Britain; it comes to all the great countries in turn as their hour of crisis approaches, and in each country it naturally assumes a form and a character suited to that nation. As a world-wide movement, it has come to be known as Fascism, and it is therefore right to use that name."

11. This question has become, perhaps, *the* crucial question for the Lewis criticism. Attempts to answer it have included a number of source-influence and contextual studies, most prominently: Geoffrey Wagner, *Wyndham Lewis: A*

Portrait of the Artist as the Enemy (New Haven: Yale University Press, 1957), derives his political views from French neoclassicism; Vincent Sherry, *Ezra Pound, Wyndham Lewis, and Radical Modernism,* follows Wagner's lead on this point; D. G. Bridson, *The Filibuster: A Study of the Political Ideas of Wyndham Lewis* (New York: Oxford University Press, 1993), challenges the conclusions of Wagner by considering the precise context in which Lewis's political statements were made; Fredric Jameson, *Fables of Aggression: Wyndham Lewis, the Modernist as Fascist* (Berkeley: University of California Press, 1979), interprets Lewis's work as exemplifying the historical affiliations between fascism and modernism while cogently criticizing modernism's evasion of politics; SueEllen Campbell, *The Enemy Opposite: The Outlaw Criticism of Wyndham Lewis* (Athens: Ohio University Press, 1988), focuses on the rhetorical and critical strategies of Lewis's "Enemy criticism"; Tom Normand, *Wyndham Lewis the Artist: Holding the Mirror Up to Politics* (Cambridge: Cambridge University Press, 1992), considers Lewis's development of a political iconography in his art and literary works to reflect and comment on current social life; David Ayers, *Wyndham Lewis and Western Man* (London: Macmillan, 1992), argues that anti-Semitism was central to Lewis's literary and political ideas; Reed Way Dasenbrock, "Wyndham Lewis's Fascist Imagination and the Fiction of Paranoia," in *Fascism, Aesthetics, and Culture,* ed. Richard J. Golsan (Hanover: University Press of New England, 1992), 81–97, considers the paradoxes of Lewis's radical suspicion of ideology and its tendency to shade over into political paranoia; Andrew Hewitt, "Wyndham Lewis: Fascism, Modernism, and the Politics of Homosexuality," *ELH* 60 (1993): 527–544, concentrates on Lewis's attitudes toward homosexuality as the pivotal aspect of his fascist allegiances. This list is by no means exhaustive; it is intended to illustrate the scope and diversity of positions about the problem of Lewis's political views and the relation of his writing to them.

12. See Lewis's letter to the Jonathan Cape director, G. Wren Howard, of November 1936 in *The Letters of Wyndham Lewis,* 240.

13. Wyndham Lewis, *Men Without Art* [1934], ed. Seamus Cooney (Santa Rosa: Black Sparrow Press, 1987), 137. Cited in text as *MWA.*

14. Richards himself was relatively positive about Lewis's work, and in the forties and fifties struck up a correspondence and friendship. See the fascinating documentation published in *Wyndham Lewis and I. A. Richards: A Friendship Documented, 1928–57,* ed. John Constable and S. J. M. Watson (Cambridge: Skate Press, 1989). Included in this collection is Richards's approving review of *Time and Western Man* in the 9 March 1928 issue of the *Cambridge Review.* In the twenties and thirties, however, the admiration was not mutual. Constable and Watson suggest that Lewis may have seen Richards as a rival for the attention and friendship of T. S. Eliot, whom Lewis saw as a potential ally against those on whom he was waging polemical warfare. Lewis even went so far as to offer to share with Eliot the masthead of his periodical *The Enemy* when it seemed that *The Criterion* would fold. "Last week after hearing of its suspension, I saw Eliot," Lewis wrote. "I suggested that he and a few of the more important of his staff of reviewers, should come over into The Enemy lock stock and barrel." Letter of 16 December 1927 to Herbert Read, *Letters of Wyndham Lewis,* 172–173. Cited in text as *LWL.*

15. William Empson, "The Cult of Unnaturalism," in *Argufying: Essays on*

Literature and Culture, ed. John Haffenden (Iowa City: University of Iowa Press, 1987), 627.

16. F. R. Leavis, "Mr. Eliot, Mr. Wyndham Lewis and Lawrence" (1934), reprinted in *The Common Pursuit* (London: Hogarth Press, 1952), 243.

17. T. R. Barnes, Review of Porteus (1933), in *A Selection from Scrutiny* I, ed. F. R. Leavis (Cambridge: Cambridge University Press, 1968), 131.

18. Normand, *Wyndham Lewis the Artist,* 51.

19. Paul Edwards, Afterword, in Wyndham Lewis, *Time and Western Man,* ed. Paul Edwards (Santa Rosa: Black Sparrow Press, 1993), 482.

20. Edwards, in his afterword to *Time and Western Man,* 481–498, presents a detailed account of the transformation of *The Man of the World* into separately published texts. My synthesis, which has somewhat different emphases than Edwards's essay, is indebted to his philological research.

21. Wyndham Lewis, Letter to Ezra Pound, 29 April 1925, in *Pound/Lewis: The Letters of Ezra Pound and Wyndham Lewis,* ed. Timothy Materer (New York: New Directions, 1985), 144. Cited in text as *P/L.*

22. See Lewis's letter to Pound, 7 May 1925, in *Pound/Lewis,* 147. *Enemy of the Stars* would not be reissued until 1932, when it appeared with Desmond Harmsworth.

23. For biographical discussion of these figures and their activities, see Hugh Ford, *Published in Paris: American and British Writers, Printers, and Publishers in Paris, 1920–1939* (New York: Pushcart Press, 1975); Noel Riley Fitch, *Sylvia Beach and the Lost Generation: A History of Literary Paris in the Twenties and Thirties* (New York: W. W. Norton, 1983); and Shari Benstock, *Women of the Left Bank: Paris, 1900–1940* (Austin: University of Texas Press, 1986).

24. Edwards, Afterword to *Time and Western Man,* 487. On the convergence and divergence of the "men of 1914," see Dennis Brown, *Intertextual Dynamics Within the Literary Group—Joyce, Lewis, Pound and Eliot* (Houndmills: Macmillan, 1990); Julian Symons, *Makers of the New: The Revolution in Literature, 1912–1939* (London: André Deutsch, 1987).

25. Pound to Lewis, 6 June 1925, in *Pound/Lewis,* 149.

26. Lewis to Pound, 11 June 1925, in *Pound/Lewis,* 150.

27. As Edwards points out, Lewis was also granted patronage by Sir Nicholas and Lady Waterhouse in 1926, which gave him greater financial independence from the modernist community in Paris and London (afterword to *Time and Western Man,* 489).

28. Tom Normand suggests an analogous trajectory toward "naturalism" in Lewis's painting: "In the final years of the 1930s Lewis was to produce his most accomplished work as a painter. Subtly unorthodox, cerebral and censorious, this work was all the more remarkable because it was completed in a portraiture that bordered on the naturalistic" (*Wyndham Lewis the Artist,* 128).

29. On Lewis's late turn away from satire, see Reed Way Dasenbrock, *The Literary Vorticism of Ezra Pound and Wyndham Lewis: Towards the Condition of Painting* (Baltimore: Johns Hopkins University Press, 1985), 183–190.

30. Edwards, afterword to *Time and Western Man,* 463.

31. Edwards, afterword to *Time and Western Man,* 463. Of course, aside from purely ideological differences, the mimetic, "realist" bias of much Marx-

ist criticism would have precluded a sympathetic view of Lewis's far-from-classical fictional prose.

32. Ferenc Fehér, "Ideology as Demiurge in Modern Art," *Praxis* 3 (1976): 185-186.

33. Stephen Spender, "Writers and Politics," *Partisan Review* 34, no. 3 (1967): 359-381.

34. Virginia Woolf, *The Waves* (San Diego: Harcourt Brace Jovanovich, 1931), 135.

35. For a similar point with respect to academic readings of Joyce and Pound, see Bob Perelman, *The Trouble with Genius: Reading Pound, Joyce, Stein, and Zukofsky* (Berkeley: University of California Press, 1994).

36. Peter Nicholls, *Modernisms: A Literary Guide* (Berkeley: University of California Press, 1995), 11.

37. Astradur Eysteinsson, *The Concept of Modernism* (Ithaca: Cornell University Press, 1990), 6-7.

38. Bernard Lafourcade, "Metaphor-Metonymy-Collage: Post-Modernist Aspects of Lewis's Style," *Enemy News* 25 (1987): 7.

39. Daniel Schenker, *Wyndham Lewis: Religion and Modernism* (Tuscaloosa: University of Alabama Press, 1992), 45.

40. Timothy Materer, *Wyndham Lewis the Novelist* (Detroit: Wayne State University Press, 1976), 161.

41. Dasenbrock, *Literary Vorticism*, 135.

42. David Graver has characterized well the performative aspects of the original format of the play. He sees in the presentation of *Enemy of the Stars* a "displacement of performance" onto the page and its semiotic elements. See "Vorticist Performance and Aesthetic Turbulence in *Enemy of the Stars*," *PMLA* 107, no. 3 (1992): 482-496.

43. For the complex relations of professionalism and modernism, see Lawrence Rainey, "The Price of Modernism: Reconsidering the Publication of *The Waste Land*," *Critical Quarterly* 31, no. 4 (1989): 21-47; Bruce Robbins, "Modernism in History, Modernism in Power," in *Modernism Reconsidered,* ed. Robert Kiely (Cambridge, Mass.: Harvard University Press, 1983), 229-245; David A. Hollinger, "The Canon and Its Keepers: Modernism and Mid-Twentieth Century," in *In the American Province: Studies in the History and Historiography of Ideas* (Baltimore: Johns Hopkins University Press, 1985), 74-91; Lisa Tickner, "Men's Work? Masculinity and Modernism," *Differences* 4, no. 5 (1992): 1-37; and Bridget Elliott and Jo-Ann Wallace, "Professionalism, Genre, and the Sister(s') Arts," in Elliott and Wallace, *Women Artists and Writers: Modernist (Im)positionings* (New York: Routledge, 1994), 56-89.

44. Reprinted in *The Letters of Ezra Pound, 1907-1941,* ed. D. D. Paige (New York: Harcourt, Brace, and World, 1950), 43-44.

45. U.S. copyright © 1963 by Wyndham Lewis. Used by permission of New Directions Publishing Corporation. U.K. and elsewhere © Wyndham Lewis and the Estate of Mrs. G. A. Wyndham Lewis, by kind permission of the Wyndham Lewis Memorial Trust (a registered charity).

46. On this point, see Jennifer Wicke, *Advertising Fictions: Literature, Advertisement, and Social Reading* (New York: Columbia University Press,

1988), 124: "By the time of the writing of *Ulysses* advertising . . . [is] so firmly ensconced as the necessary accompaniment to production of all kinds that literature begins to be colonized by it. *Ulysses* records this process, but by no means succumbs passively to advertising's takeover. The novel incorporates the interloper, and puts advertising language to work for its own purposes."

47. Bradford Morrow and Bernard Lafourcade, *A Bibliography of the Writings of Wyndham Lewis* (Santa Barbara: Black Sparrow Press, 1978), 57–58. See also Omar S. Pound and Philip Grover, *Wyndham Lewis: A Descriptive Bibliography* (Folkestone, Kent: Archon Books, 1978).

48. Wyndham Lewis, *Paleface: The Philosophy of the 'Melting-Pot'* (London: Chatto & Windus, 1929), 100.

49. Northrop Frye, "Neo-Classical Agony," *Hudson Review* 10, no. 4 (1957): 597–598.

50. Lewis felt a kinship in this respect to the painter Francis Bacon. In a review of Bacon from 17 November 1949, Lewis wrote: "Liquid whitish accents are delicately dropped upon the sable ground, like blobs of mucus—or else there is the cold white glitter of an eyeball, or of an eye distended with despairing insult behind a shouting mouth, distended also to hurl insults. Otherwise, it is a baleful regard from the mask of a decayed clubman or business executive—so decayed that usually part of the head is rotting away into space." Wyndham Lewis, "Round the Galleries," in *Wyndham Lewis on Art: Collected Writings, 1913–1956*, ed. Walter Michel and C. J. Fox (New York: Funk and Wagnalls, 1969), 393–394. Stylistically, the language of this review is far closer to the expressionistic prose of *The Childermass* or *The Apes of God* than to most of Lewis's fictional prose of the 1940s.

51. Dasenbrock, *Literary Vorticism*, 158.

52. Dasenbrock, *Literary Vorticism*, 165–168.

53. Douglas Messerli, "The Role of Voice in Nonmodernist Fiction," *Contemporary Literature* 25, no. 3 (1984): 281–304; see also Norman Friedman, "Point of View in Fiction: The Development of a Critical Concept," in *The Novel: Modern Essays in Criticism*, ed. Robert Murray Davis (Englewood Cliffs, N.J.: Prentice-Hall, 1969), 142–171.

54. Messerli, "The Role of Voice," 289.

55. Messerli, "The Role of Voice," 286.

56. David Bordwell, *Narration in the Fiction Film* (Madison: University of Wisconsin Press, 1985), 4–7.

57. Bordwell, *Narration in the Fiction Film*, 7–9.

58. Wayne C. Booth, *The Rhetoric of Fiction* (Chicago: University of Chicago Press, 1961), 149–165.

59. Christian Metz, "The Impersonal Enunciation, or the Site of Film (In the margin of recent works on enunciation in cinema)," *New Literary History* 22, no. 3 (1991): 747.

60. On this point, see Jacques Aumont et al., *Aesthetics of Film,* trans. and rev. Richard Neupert (Austin: University of Texas Press, 1992), 35–36; see also Michel Chion, *Audio-Vision: Sound on Screen,* trans. Claudia Gorbman (New York: Columbia University Press, 1994).

61. Details about this work have been drawn from Elizabeth Salter, *Edith*

Sitwell (London: Bloomsbury Books, 1979) and *The Sitwells and the Arts of the 1920s and 1930s* (London: National Portrait Gallery, ca. 1994), as well as from Sitwell's autobiography, cited below.

62. Edith Sitwell, *I Was Taken Care Of* (New York: Atheneum, 1965), 140.

63. Leavis, quoted in Salter, *Edith Sitwell*, 12.

64. O. Pound and Grover, *Wyndham Lewis: A Descriptive Bibliography*, 165–166.

65. Wyndham Lewis, *Engine Fight-Talk. The Song of the Militant Romance. If So the Man You Are. One-Way Song. Envoi.* (London: Faber and Faber, 1933), 25.

66. Wyndham Lewis, *Time and Western Man* [1927], ed. Paul Edwards (Santa Rosa: Black Sparrow Press, 1993) 249–250. Cited in text as *TWM*.

67. See "The Prose-Song of Gertrude Stein" and "An Analysis of the Mind of James Joyce," in *Time and Western Man*, 59–66 and 73–110. For the Joyce-Lewis relationship, see Paul Edwards, "'Clodoveo' and 'Belcanto': Wyndham Lewis and James Joyce," *Blast 3*: 126–133; and Scott W. Klein, *The Fictions of James Joyce and Wyndham Lewis: Monsters of Nature and Design* (Cambridge: Cambridge University Press, 1994). Lewis might have found an example ready-to-hand in the "Hades" chapter of *Ulysses*, in which Leopold Bloom thinks of the gramophone as the auditory equivalent of the photograph, and of both as a means of preserving the memory of the dead against forgetting: "Have a gramophone in every grave or keep it in the house. After dinner on a Sunday. Put on poor old greatgrandfather. Kraahraark! Hellohellohello amawfullyglad kraark awfullygladaseeagain hellohello amawf krpthsth. Remind you of the voice like the photograph reminds you of the face." James Joyce, *Ulysses: The Corrected Text*, ed. Hans Walter Gabler, with Wolfhard Steppe and Claus Melchior (New York: Vintage Books, 1986), 93. Indeed, in an 1878 article for the *North American Review*, Thomas Edison had already mentioned this function as one among ten that he projected for the newly invented phonograph: "The 'Family Record'—a registry of sayings, reminiscences, etc., by members of a family in their own voices, and of the last words of dying persons." Edison, quoted in Michael Chanan, *Repeated Takes: A Short History of Recording and Its Effects on Music* (London: Verso, 1995), 3. See also Jacques Derrida, "Ulysses Gramophone: Her Say Yes in Joyce," in *Acts of Literature*, ed. Derek Attridge (New York: Routledge, 1992), 253–309, for a discussion of Joyce's novel as a "gramophonic," "anamnestic and hypermnesic" machine.

68. Steve Neale, *Cinema and Technology: Image, Sound, Color* (Bloomington: Indiana University Press, 1985), 73. See also Patrick Ogle, "The Development of Sound Systems: The Commercial Era," *Film Reader 2* (1977): 198–212; and Douglas Gomery, "Failure and Success: Vocafilm and RCA Photophone Innovate Sound," *Film Reader 2* (1977): 213–221.

69. Ogle, "Development of Sound Systems," 203.

70. Wyndham Lewis, *The Childermass* (London: John Calder, 1928), 63.

71. U.S. copyright © 1963 by Wyndham Lewis. Used by permission of New Directions Publishing Corporation. U.K. and elsewhere © Wyndham Lewis and the Estate of Mrs. G. A. Wyndham Lewis, by kind permission of the Wyndham Lewis Memorial Trust (a registered charity).

72. Fredric Jameson's term.

73. *The Childermass*, 18. Cited in text as *Ch*.

74. The similarity (which may indicate influence) between passages like these in *The Apes of God* and Beckett's free-floating dialogues in *Waiting for Godot* and *Endgame* is striking. Both Lewis and Beckett explore the seepage of theater into human relations, rendering action inconsequential and conversation unreal. Such conversations, since they are "scripted" in advance, are also infinitely repeatable—eventually, as Beckett suggests in *Krapp's Last Tape* and several of the late plays, even when the speaker is dead.

75. Samuel Beckett, *Watt* (New York: Grove Press, 1953), 156.

76. Wagner, *Wyndham Lewis: A Portrait of the Artist as the Enemy*, 73.

77. On these issues of Starr-Smith's identity, see James English's excellent discussion of *The Apes of God* in *Comic Transactions: Literature, Humor, and the Politics of Community in Twentieth-Century Britain* (Ithaca: Cornell University Press, 1994), 67–97, esp. 96–97.

78. Joan Riviere, "Womanliness as a Masquerade," *International Journal of Psychoanalysis* 10 (1929): 303–313; cf. Stephen Heath, "Joan Riviere and the Masquerade," in *Formations of Fantasy*, ed. Victor Burgin, James Donald, and Cora Kaplan (London: Routledge, 1986), 45–61.

79. According to James English, Mosley was taken to fashioning himself after the German socialist leader Ferdinand Lasalle. *Comic Transactions*, 96.

80. Dasenbrock, "Wyndham Lewis's Fascist Imagination," 89.

81. Schenker, *Wyndham Lewis: Religion and Modernism*, 78.

82. Julian Symons, "The Thirties Novels," *Agenda* 7/3–8/1 (1969–1970): 47.

Chapter 4

1. Series I, Box 9, Djuna Barnes Collection, University of Maryland, College Park.

2. Phillip Herring, *Djuna: The Life and Work of Djuna Barnes* (New York: Viking, 1995), 233.

3. T. S. Eliot, Introduction to Djuna Barnes, *Nightwood* (New York: New Directions, 1937), xi. I cite this edition only for Eliot's introduction. For all other references to *Nightwood*, I cite the new corrected edition: Djuna Barnes, *Nightwood: The Original Version and Related Drafts*, ed. Cheryl J. Plumb (Normal, Ill.: Dalkey Archive Press, 1995). References to this edition are noted in my text as *N* followed by the page number.

4. Critics have had great difficulty in characterizing Barnes's work in literary historical terms. Louis Kannenstine, for example, describes it as "transitional": "As Miss Barnes's art can be seen as both related to its time and yet apart from it, it can be concluded that she is a transitional writer whose purpose was to get out of the mainstream and participate in a great tradition, and who now takes a place in her own time between the early innovators of this century and the later generations of experimental writers." Kannenstine, *The Art of Djuna Barnes: Duality and Damnation* (New York: New York University Press,

1977), xvii. Douglas Messerli takes *Nightwood* (along with Wyndham Lewis's *The Apes of God,* notably) as an exemplary instance of "non-modernist fiction." This term refers to works with an intrusive authorial voice that exceeds the boundaries of modernist personae and concerns itself more immediately with the reader. Messerli, "The Role of Voice in Non-Modernist Fiction," *Contemporary Literature* 25, no. 3 (1984): 281–304. Marilyn Reizbaum, following Jane Marcus, speaks of Barnes's "modernism of marginality," which compels a reexamination of the central categories by which modernism has been described and its canon selected. Reizbaum, "A 'Modernism of Marginality': The Link between James Joyce and Djuna Barnes," in *New Alliances in Joyce Studies,* ed. Bonnie Kime Scott (Cranbury, N.J.: Associated University Presses, 1988), 179–189. Most recently, Donna Gerstenberger describes Barnes as having a "free-floating relation" to both modernism and postmodernism: "Barnes clearly shares time and space with those we call our British and American modernist writers, a definition that has been increasingly generalized with the circulation of descriptive notions of postmodernism. What Barnes does not share is a clear adherence to some central tenets of modernism, even given modernism's shifting critical constructions." Gerstenberger, "Modern (Post) Modern: Djuna Barnes among the Others," *Review of Contemporary Fiction* 13, no. 3 (1993): 33–40.

5. I refer, of course, to Eliot's renowned essay of 1919, "Tradition and the Individual Talent." I cite freely from the text as printed in *Selected Prose of T. S. Eliot,* ed. Frank Kermode (New York: Harcourt Brace Jovanovich, 1975), 37–44.

6. Paul Mann, *The Theory-Death of the Avant-Garde* (Bloomington: Indiana University Press, 1991), 64.

7. Craig Owens, "The Allegorical Impulse: Towards a Theory of Post-Modernism," in *Art After Modernism: Rethinking Representation,* ed. Brian Wallis (New York: New Museum of Contemporary Art, 1984), 235.

8. Owens, "Allegorical Impulse," 235.

9. Djuna Barnes, *Ladies Almanack* (Elmwood Park, Ill.: Dalkey Archive Press, 1992), 55. Cited in text as *LA.*

10. In a notebook jotting, probably from November 1917, Barnes writes: "Even God could not keep straight the things he had planned in a line—." Series I, Box 1, Djuna Barnes Collection, University of Maryland, College Park.

11. Georg Lukács, *The Theory of the Novel,* trans. Anna Bostock (Cambridge, Mass.: MIT Press, 1971), 40–41.

12. "The face is what anglers catch in the daylight, but the sea is the night!" (*N,* 79).

13. Elsewhere, to Felix, O'Connor speaks of "the almost fossilized state of our recollection" (*N,* 100).

14. Djuna Barnes, "When the Puppets Come to Town," *Morning Telegraph,* 8 July 1917.

15. Dietmar Voss and Jochen C. Schütze argue that the family provides a privileged space for the bourgeois novel's presentation of individual fate as typical: "The novel is forced, according to its logic of form, to orient itself toward social spaces corresponding to the basic character of *that* familial space in which

individual and class history were still mediated in a particular way." Voss and Schütze, "Postmodernism in Context: Perspectives of a Structural Change in Society, Literature, and Literary Criticism," *New German Critique* 47 (1989): 122. In the modernist novel, they argue, familial space is still crucial, but the link between class and individual becomes problematic, and subjective consciousness and memory take on a preponderant importance (122–123). Only with such "advanced montage novels" as those of Alfred Döblin and John Dos Passos, they conclude, is the "image space" of the novel "emancipated from the horizon of the individually experienceable" (123), and thus logically also from its familial focus.

16. Henry Adams, *The Education of Henry Adams: An Autobiography* (Boston: Houghton Mifflin, 1961), 446.

17. Walter Benjamin, "Central Park," trans. Lloyd Spencer, *New German Critique* 34 (1985): 35.

18. Gertrude Stein, "The Gradual Making of the Making of Americans," in *Selected Writings of Gertrude Stein*, ed. Carl Van Vechten (New York: Vintage Books, 1962), 252.

19. Djuna Barnes, *Ryder* [1928] (Normal, Ill.: Dalkey Archive Press, 1990). Cited in text as *R*.

20. Kannenstine, "The Art of Djuna Barnes," 36.

21. For a discussion of filiation and affiliation in modern literature, see Edward Said, *The Text, the World, and the Critic* (Cambridge, Mass.: Harvard University Press, 1983), 16–17.

22. See M. M. Bakhtin, *The Dialogic Imagination,* trans. Caryl Emerson and Michael Holquist (Austin: University of Texas Press, 1981), 172ff., for Rabelais's use of this technique.

23. In her poem "The Ineffectual Marriage," Barnes's friend Mina Loy satirized the futurist writer Giovanni Papini in an analogous way. "Miovanni" pompously declares his visionary independence of time and space, including the mundane matter of the dinner "Gina" has cooked for him. The poem breaks off with an ironic note to the reader: "This narrative halted when I learned that the house which inspired it was the home of a mad woman." Loy's poem appeared originally in *Others: An Anthology of the New Verse,* ed. Alfred Kreymborg (New York: Alfred A. Knopf, 1917).

24. In returning to the settings and characters of *Ryder* in a tragic mood in her post–World War II play *The Antiphon,* Barnes will make this Noah analogy explicit. The father-polygamist in that play calls his house "Titus's Ark."

25. Elsewhere Sophia offers the following portrait of the artist: "[Wendell] plays, he writes, he can do many things; he has, only imagine! operas to his credit, with full orchestral directions planned, and executed amid the din of hungry children, on a deal table, littered with nothing more than the never-out-of-sight-of-the-hungry-and-the-distressed, bread and water" (178).

26. Barnes, like Beckett, at times saw the invention of speech—which for humanism differentiated humans from the animals—as a natural-historical disaster. In a film review, she once wrote of a mute character: "So exceedingly painful and poignant he makes silence, that I begin to wonder if we as a race have not made a great mistake in becoming articulate." Quoted in Kannenstine,

"The Art of Djuna Barnes," 15. Wendell Ryder threatens to generalize this mistake to the whole of creation.

27. In certain respects, this boy anticipates Felix's son Guido in *Nightwood,* who, in his feebleness and his desire to become a priest, destroys his father's vision of perpetuating the Volkbein lineage.

28. Letter to Peter Heggie, 5 September 1970, Series I, Box 1, Djuna Barnes Collection, University of Maryland, College Park.

29. For discussion of the various figures to whom *Ladies Almanack* is "keyed," see the essays by Frances M. Doughty, Susan Sniader Lanser, Frann Michel, and Karla Jay in *Silence and Power: A Reevaluation of Djuna Barnes,* ed. Mary Lynn Broe (Carbondale: Southern Illinois University Press, 1991), 137–193.

30. Though not funded by Natalie Barney, as Bridget Elliott and Jo-Ann Wallace claim in *Women Artists and Writers: Modernist (im)positionings* (New York: Routledge, 1994), 154. According to Phillip Herring, "Barney had nothing to do with its publication." It was paid for by Robert McAlmon, with Barnes herself footing the bill for reproduction of the drawings and William Bird supplying some production help. See Herring, *Djuna,* 149–153.

31. Karla Jay, for example, argues that on both social and economic grounds Barnes had to be careful about identifying herself as a lesbian. Jay, "The Outsider Among the Expatriates: Djuna Barnes' Satire on the Ladies of the *Almanack,*" in Broe, *Silence and Power,* 193.

32. Charles Baudelaire, "The Painter of Modern Life," in *The Painter of Modern Life and Other Essays,* trans. Jonathan Mayne (New York: Da Capo, 1964), 12.

33. Guillaume Apollinaire, *The Poet Assassinated and Other Stories,* trans. Ron Padgett (London: Grafton Books, 1985), 46–47.

34. The *OED* gives as variant spellings of the word *almanac*: "almenak, almanch(e), amminick, almanacke, and almanack."

35. See Herring, *Djuna,* 112–116, for Barnes and von Freytag-Loringhoven.

36. Steven Watson, *Strange Bedfellows: The First American Avant-Garde* (New York: Abbeville Press, 1991), 270.

37. Walter Benjamin, "Surrealism: The Last Snapshot of the European Intelligentsia," in *Reflections,* ed. Peter Demetz, trans. Edmund Jephcott (New York: Schocken Books, 1986), 192.

38. Theodor W. Adorno, "Looking Back on Surrealism," in *Notes to Literature,* vol. 1, ed. Rolf Tiedemann, trans. Shierry Weber Nicolsen (New York: Columbia University Press, 1991), 88.

39. Herring, *Djuna,* 218.

40. On this point, see Vincent P. Pecora, *Self and Form in Modern Narrative* (Baltimore: Johns Hopkins University Press, 1989), 17.

41. As Alan Wilde writes, "What we confront finally is a different kind of complexity: the heroism of consciousness making art of its own uncertainty and expressing in its very form, in the express rejection of an easy resolution, the difficult aesthetics of crisis." Wilde, *Horizons of Assent: Modernism, Postmodernism, and the Ironic Imagination* (Baltimore: Johns Hopkins University Press, 1981), 27.

42. Pecora, *Self and Form in Modern Narrative,* 30. In quite different terms, Leo Bersani has also criticized the redemptive appeal in modernism, as a devaluation of both art and historical experience: "The catastrophes of history matter much less if they are somehow compensated for in art, and art itself gets reduced to a kind of superior patching function, is enslaved to those very materials to which it presumably imparts value." *The Culture of Redemption* (Cambridge, Mass.: Harvard University Press, 1990), 1.

43. On this tradition, see Robert Pogue Harrison, *Forests: The Shadow of Civilization* (Chicago: University of Chicago Press, 1992).

44. In *Following Djuna: Women Lovers and the Erotics of Loss* (Bloomington: Indiana University Press, 1996), Carolyn Allen offers a sophisticated discussion of the problematic of identification in lesbian fiction, including that of Djuna Barnes. She seeks to reveal the "erotics of reading" set in play by lesbian fictions. The reader, in her oscillation between surrender to the text and mastery of it, is seduced by it; the movements of desire shaped by the reading are integral to the meaning of the text, and, alternately, the formal and figural elements of the text evoke certain perturbations of desire. This kind of reading, in turn, has given rise to a tradition of lesbian writing, as in the case of Bertha Harris, who was "seduced" in this way by the example of Barnes and her *Nightwood.* Although she places "identification" in scare quotes, and emphasizes "resemblance" over "sameness," Allen nonetheless envisages primarily identificatory ways of reading these texts, ways of reading in which the reader's erotic desire is directly engaged. Methodologically, she employs a homology between lived relations between women, representations of characters' relations with one another, and the relation of the reader to the lesbian text. My interpretation of *Nightwood* parts company with Allen's otherwise salutary focus on dynamics of reading at just this latter point. For in her treatment of the diegetic relations of characters in *Nightwood,* Allen treats them as empirically given and uses psychoanalytic concepts to analyze them. Her interest in the "exemplary" value of literary representations for questions of lesbian erotics as such overshadows a key aspect of the characters in *Nightwood:* they are, through and through, readers—obsessive producers, consumers, transmitters, interpreters, and advocates of texts. I would argue that through her handling of character-readers, Barnes puts obstacles in the way of her text's functioning as "exemplary." As I suggest in what follows, Barnes pushes this problem to the brink of a radical uncoupling of desire from the text, at the cost of its deconstruction as a meaningful narrative and the acceptance of its derisive loss of sense.

45. Cf. the opening chapter of *Ryder,* "Jesus Mundane," in which an unidentified voice delivers a homily on the image, which, read against Felix's statement, seems a warning for his sort: "Reach not beyond the image. For these idols and these lambrequins and these fluted candles . . . and the altar, and the chancel, and the nave, and aisles, are not for thee in the spirit, but for thee only in the outward manifestation; nor are the Beasts for thee, with the eyes back and the eyes front, nor for thee the bleeding of the heart, with its fire and its ice" (3-4).

46. In a striking letter of 1919 in which Barnes tells of a bedside vigil with a dying woman, she reveals her horrified fascination with the uncanny idea of life-

in-death: "Mary has been given up by 2 nurses, 2 doctors and a score of others at least 10 days back, but she still breathes. . . . It looks as if I might be left alone with her in the last hours. . . . The last doctor said that he could not see how she still lived—She sleeps with open eyes and has to gasp for every breath and no longer gets any clots up neither do her bowels move and she has not eaten more than half a glass of milk a day for 5 days—She is delirious but knows it is delirium while she is going through it, and she suffers a great deal—and yesterday she about killed me by trying to put her arms around me saying 'You see the way it is with me' and then 'Can't you help me?' Of course the most terrible— is that she has lived beyond her own death." Letter to Courtenay Lemon, 1919, Series I, Box 9, Djuna Barnes Collection, University of Maryland, College Park.

47. As Cheryl Plumb notes, this arrangement of chapters was not Barnes's original order but rather a suggestion of the editors: see pages xii–xiii of her introduction to *Nightwood*. Nonetheless, Barnes accepted this suggestion and never amended it in any later edition. Therefore, whatever the conditions of genesis of this particular ordering of the work, effects of the arrangement, such as I discuss here, must be seen as arising out of an objective situation of the text.

48. Barnes's flirtation with Catholicism as an answer should be seen in the context of a neo-Catholic tendency within modernism advocating a "rappel à l'ordre": Cocteau, de Chirico, and Eliot, most prominently. Barnes's mother, interestingly, gave a cultic interpretation of *Nightwood*'s significance for modern humanity: "Some day you will produce the almighty man or woman who will go down the ages as the typical character for man to emulate. And then you will have started a new religion, which we need more than ever since they— meaning mankind—has swept Christ into limbo."—Letter to Djuna Barnes, 3 November 1936, Series I, Box 2, Djuna Barnes Collection, University of Maryland, College Park.

49. Michel de Certeau, "The Arts of Dying: Celibatory Machines," in *Heterologies: Discourse on the Other,* trans. Brian Massumi (Minneapolis: University of Minnesota Press, 1986), 159.

50. In a letter to her mother, Barnes expressed her view of life as something "monstrous" and "obscene," "with the most obscene track of the end." Letter of 19 February 1923, Series I, Box 2, Djuna Barnes Collection, University of Maryland, College Park. More directly relevant here, however, is Barnes's strong resistance to T. S. Eliot's suggestion that she change her description of Robin's final fit of laughter as "obscene" to "unclean." Barnes glossed Eliot's page proof correction thus: "Sample of T.S.E.'s 'lack of imagination' (as he said)." Series II, Box 4, Djuna Barnes Collection, University of Maryland, College Park.

51. Alan Singer, *A Metaphorics of Fiction: Discontinuity and Discourse in the Modern Novel* (Tallahassee: Florida State University Press, 1983), 58.

52. Georges Bataille, "The Practice of Joy Before Death," in *Visions of Excess: Selected Writings, 1927–1939,* trans. Allan Stoekl (Minneapolis: University of Minnesota Press, 1985), 235–239.

53. Luce Irigaray, *Speculum of the Other Woman,* trans. Gillian C. Gill (Ithaca: Cornell University Press, 1985), 198.

54. This incoherence is especially manifest in the editions previous to the

recent restored edition. A connecting anecdote was cut, which exacerbates the gap between Felix's question and O'Connor's answer. However, the difference between the editions is a matter of degree, not of essence. Shortly after the "horse that knew too much" anecdote, Barnes herself underscores the mono-logic nature of O'Connor's response, indicating that she intended his answers to seem inappropriate and incongruous: "The doctor, as he grew older, in answering a question seemed, as old people do, to be speaking more and more to himself" (*N*, 101).

55. In this respect, O'Connor's fallible mysticism could be seen to cast its shadow over the spiritual interpretation urged on Barnes by her friend Emily Coleman. Coleman felt that *Nightwood*, despite its evident genius, failed to real-ize the tragic potential in the love of Robin and Nora; Dr. O'Connor's story-telling and homilizing distracted, Coleman thought, from this "central" tragic node. Coleman even went so far as to edit out some of O'Connor's more rib-ald stories before submitting the manuscript to Eliot (putatively anticipating his response) and to offer Eliot her own views about which passages might be cut. Coleman, however, believed that Barnes was capable of achieving a genuinely religious pathos. Thus, in a letter of 1 August 1935, Coleman told Barnes: "Poetry changes life for me: it is moral. I can never be quite the same after read-ing your chapter on Night, and what you say in your book about evil." In another letter of 27 August 1935, Coleman tells Barnes explicitly: "Your writ-ing is original mystic poetic writing." Barnes was considerably irritated over what she perceived as Coleman's meddling (despite Coleman's heroic efforts to get *Nightwood* published). I believe this irritation came not just from Barnes's legendary testiness and suspicion but also from Coleman's insistent failure to grasp the book's overall satiric design. (The correspondence with Coleman is in Series I, Box 3; Coleman's essay, in Series I, Box 4, Djuna Barnes Collection, University of Maryland, College Park.)

56. Maurice Blanchot, "Literature and the Right to Death," in *The Gaze of Orpheus*, trans. Lydia Davis (Barrytown, N.Y.: Station Hill, 1981), 39.

57. With his machinic assemblages, the Swiss artist Jean Tinguely explored a terrain analogous to Duchamp's. In mockery of claims made by modernist critics that abstract expressionist paintings gave access to the subconscious, archetypal depths of the painter's mind, Tinguely assembled a painting machine to produce huge numbers of technically perfect abstract paintings, each as "new" as the last. His ramshackle musical machines, in contrast, parodied mod-ernist serial music in its appeal to a rational, mathematical ideality. In both cases, however, Tinguely's mechanical supplanting of the creative artist satirizes mod-ernism's appeals to a transcendent source of meaning for the artwork, wherever that source might be situated.

58. De Certeau, "The Arts of Dying," 161. For an insightful discussion of an author less equivocally committed to this mode than Barnes, see Michel Fou-cault, *Death and the Labyrinth: The World of Raymond Roussel*, trans. Charles Ruas (Garden City, N.Y.: Doubleday, 1986).

59. Jean-François Lyotard, *Duchamp's TRANS/formers*, trans. Ian McLeod (Venice, Calif.: Lapis Press, 1990), 65, continued on 68.

60. Lyotard defines a simple machine as a device of two or more parts that

produce effects disjunctively distributed; that is, its parts move in opposed directions. Hence the most rudimentary possibility for making a machine is to erect a transparent partition, which both joins and disjoins the two halves. *Duchamp's TRANS/formers*, 41–47.

61. Leo Bersani and Ulysse Dutoit trace the connection between violence and representation in Bersani and Dutoit, *The Forms of Violence: Narrative in Assyrian Art and Modern Culture* (New York: Schocken Books, 1985). Bersani develops this perspective further in his provocative study, *The Culture of Redemption*.

Chapter 5

1. Richard Kearney, "Beckett: The Demythologizing Intellect," in *The Irish Mind: Exploring Intellectual Traditions,* ed. Richard Kearney (Dublin: Wolfhound Press, 1985), 267–293; J. C. C. Mays, "Mythologized Presences: *Murphy* in Its Time," in *Myth and Reality in Irish Literature,* ed. Joseph Rons-ley (Waterloo, Ont.: Wilfrid Laurier University Press, 1977), 198–218; John P. Harrington, *The Irish Beckett* (Syracuse: Syracuse University Press, 1991). See also David Lloyd, "Writing in the Shit: Beckett, Nationalism, and the Colonial Subject," in *Anomalous States: Irish Writing and the Post-Colonial Moment* (Durham: Duke University Press, 1993), 41–58; Mary Junker, *Beckett: The Irish Dimension* (Dublin: Wolfhound Press, 1995); John Fletcher, "Modernism and Samuel Beckett," in *Facets of European Modernism* (Norwich: University of East Anglia Press, 1985), 199–217; and Lois Gordon, *The World of Samuel Beckett, 1906–1946* (New Haven: Yale University Press, 1996), 7–31.

2. Samuel Beckett, "Dante . . . Bruno . Vico . . Joyce," in *Disjecta: Miscellaneous Writings and a Dramatic Fragment,* ed. Ruby Cohn (New York: Grove Press, 1984), 26.

3. Samuel Beckett, *Proust* (New York: Grove Press, 1957), 59. Hereafter cited in text as *Proust.*

4. Michel Foucault, *The Order of Things: An Archeology of the Human Sciences* (New York: Vintage Books, 1970), 300.

5. Foucault, *The Order of Things,* 384.

6. Michel Foucault, *Madness and Civilization: A History of Insanity in the Age of Reason,* trans. Richard Howard (New York: Vintage Books, 1965), 288–289.

7. Samuel Beckett, *Dream of Fair to Middling Women,* ed. Eoin O'Brien and Edith Fournier (New York: Arcade Publishing, 1992), 102 (cited in text as *DFMW*); *Disjecta,* 48.

8. For an insightful discussion of Foucault's relation to the cultural project of modernism, see John Rajchman, "Foucault, or the Ends of Modernism," *October* 24 (1983): 37–62; for the conception of an intransitive writing, see Roland Barthes, "To Write: An Intransitive Verb?" in *The Structuralist Controversy: The Languages of Criticism and the Sciences of Man* (Baltimore: Johns Hopkins University Press, 1972), 134–156. Notably, Barthes takes "the case of the Proustian narrator" as "exemplary": "he exists only in writing" (143).

9. Joseph Conrad, *The Nigger of the Narcissus* (London: Penguin Books, 1988), xlvii, l.

10. Harrington, *The Irish Beckett*, 48. John Fletcher writes of postindependence Dublin, "the city stood, in international terms, a bit higher than Monrovia, not so high as Copenhagen, and at about the same level as Bogotà" ("Modernism and Samuel Beckett," 199).

11. Such differences are, however, *historical*, not static, timeless essences. They are pertinent only as the shifting articulations of a hierarchical structure of relations, within which individual elements take on their meanings. As Louis Althusser suggests of such differential structures: "The present of one level is . . . the absence of another, and this co-existence of a 'presence' and absences is simply the effect of the structure of the whole in its articulated decentricity. What is thus grasped as absences in a localized presence is precisely the non-localization of the structure of the whole." Louis Althusser and Étienne Balibar, *Reading Capital*, trans. Ben Brewster (New York: Pantheon Books, 1970), 104. Yet Althusser's account also implies that the very differences that serve to localize literary artifacts in national and generic traditions, assigning them places in the historical narrative dedicated to these constructs, may also render them vulnerable to failure, subversion, and historical change. In their restless mobility, their consistent recombination and reconfiguration, such differences rattle the frames by which, in traditional historicist writing, their geographical and textual mobility would be slowed and controlled: the metahistorical borderlines of genre and nation. On this latter point, see Homi K. Bhabha, "DissemiNation: Time, Narrative, and the Margins of the Modern Nation," in *Nation and Narration*, ed. Homi K. Bhabha (London: Routledge, 1990), 291–322.

12. On this point, see H. Porter Abbott, "Late Modernism: Samuel Beckett and the Art of the Oeuvre," in *Around the Absurd: Essays on Modern and Postmodern Drama*, ed. Enoch Brater and Ruby Cohn (Ann Arbor: University of Michigan Press, 1990), 73–96. Abbott notes the peculiar rhythm of "return" that subsists between Beckett's prose and his dramatic works: "It was not nostalgia that animated Beckett when, at the moment he appeared to have abolished character from his prose fiction, he reinstated it so brilliantly on the stage. It has frequently been noted that when Beckett moves to a new genre or medium he appears to revert to an earlier stage of historical development from that to which he had brought the genre or medium in which he had been previously working" (85).

13. Patricia Waugh, *Metafiction: The Theory and Practice of Self-Conscious Fiction* (London: Methuen, 1984), 10.

14. Jacqueline Hoefer, "*Watt*," reprinted in *Samuel Beckett: A Collection of Critical Essays,* ed. Martin Esslin (Englewood Cliffs, N.J.: Prentice-Hall, 1965), 62–76.

15. Hugh Kenner, *Samuel Beckett: A Critical Study* (Berkeley: University of California Press, 1968), 132.

16. Eric P. Levy, *Beckett and the Voice of Species: A Study of the Prose Fiction* (Totowa, N.J.: Barnes & Noble Books, 1980), 1–2.

17. Gerald L. Bruns, "Stevens without Epistemology," in *Wallace Stevens:*

The Poetics of Modernism, ed. Albert Gelpi (Cambridge: Cambridge University Press, 1985), 24–40.

18. Beckett, quoted by Linda Ben-Zvi, "Fritz Mauthner for Company," *Journal of Beckett Studies* 9 (1984): 66.

19. Beckett to MacGreevy, July 1930, quoted in James Knowlson, *Damned to Fame: The Life of Samuel Beckett* (New York: Simon & Schuster, 1996), 122.

20. Beckett to MacGreevy, September 1937, quoted in Knowlson, *Damned to Fame,* 248. See also Beckett's script for *Film,* which offers a particularly explicit instance of this hollow use of philosophy: "*Esse est percipi.* / All extraneous perception suppressed, animal, human, divine, self-perception maintains in being. / Search of non-being in flight from extraneous perception breaking down in inescapability of self-perception. / No truth value attaches to above, regarded as merely structural and dramatic convenience." Samuel Beckett, *Film* (New York: Grove Press, 1969), 11.

21. Although his concerns are somewhat different from mine, I find support for my "anti-epistemological reading" of Beckett in M. Keith Booker's chapters on *Watt* and *The Lost Ones* in *Literature and Domination: Sex, Knowledge, and Power in Modern Literature* (Gainesville: University of Florida Press, 1993), 20–41, 142–160.

22. Charles R. Lyons, "Beckett, Shakespeare, and the Making of Theory," in Brater and Cohn, *Around the Absurd,* 117.

23. For example, one plausible way to interpret *Waiting for Godot* might be to consider whether "waiting" is not a valid form of solidarity, a way of being together no worse, and perhaps better, than many others. Wolfgang Iser has noted that Beckett's designed foiling of the audience's desire to know—who Godot is, whether he will come—eventually produces a kind of freedom or "levity" in the actions and speech of the characters: "As the meaning projections of the spectator are incapable of removing the indeterminacy of the situations, so the two main characters seem more and more free and unconcerned. They seem to be quite indifferent to the earnestness assumed by the spectator." Iser, "When Is the End Not the End? The Idea of Fiction in Beckett," in *On Beckett: Essays and Criticism,* ed. S. E. Gontarski (New York: Grove Press, 1986), 60. We might put this otherwise by saying that if Beckett's writing still has an "intransitive" quality to it, it is no longer because it refers back to the autonomy of a thinking consciousness, as did modernist writing, but rather to the autonomy of *social* forms and practices ungroundable by reliable knowledge: narrating, waiting, searching, playing.

24. Leo Bersani, "Against *Ulysses,*" in *The Culture of Redemption* (Cambridge, Mass.: Harvard University Press, 1990), 170.

25. Both quotes are from Beckett, *The Unnameable,* in *Three Novels: Molloy, Malone Dies, The Unnameable* (New York: Grove Press, 1955, 1956, 1958), 336, 348.

26. Bersani, "Against *Ulysses,*" 169.

27. This might seem a paradoxical statement given that I will explicate in detail Beckett's allusion to "the Stalinist comedians," Bim and Bom. This allusion, however, illustrates quite aptly how in his work a tidbit of cultural arcana may degenerate into a mere fragment of language, a kind of idiot's babble of

minimal differences: "bim, bom . . ." The responsibility for any unfortunate resuscitation of meaning lies wholly with the explicator.

28. For a detailed account of Joyce's influence on Beckett's works, see Barbara Reich Gluck, *Beckett and Joyce: Friendship and Fiction* (Lewisburg: Bucknell University Press, 1979). Cf. the essays on Joyce and Beckett by S. E. Gontarski, David Hayman, and Richard Pearce in the conference volume *The Seventh of Joyce*, ed. Bernard Benstock (Bloomington: Indiana University Press, 1982), 25–49.

29. Samuel Beckett, "Sedendo et Quiesciendo," *transition* 21 (1932): 13.

30. Beckett to Charles Prentice, 15 August 1932, quoted in Knowlson, *Damned to Fame*, 156.

31. Harrington, *The Irish Beckett*, 70.

32. Samuel Beckett, *More Pricks Than Kicks* (New York: Grove Press, 1972), 187.

33. Interestingly, in the early drafts of *Watt*, Watt's employer Mr. Knott was called Quin. See Ann Beer, "*Watt*, Knott, and Beckett's Bilingualism," *Journal of Beckett Studies* 10 (1985): 48ff. This suggests an occult relation between Mr. Knott's strange house and the punning source of his predecessor's name. "Capper Quin" of *More Pricks Than Kicks*, later declined as "Cooper" in *Murphy*, ultimately comes—according to J. C. C. Mays—from a Trappist monastery in Munster at Cappoquin. Mays, "Mythologized Presences," 215. This instance of mutilated incorporation is far from unique in Beckett's corpus; as more unpublished materials come to light examples will surely multiply. What is of interest, however, along with the thematic clues such connections provide, is their near-inscrutability in the published texts. Beckett retains just enough intertextual communication between works to suggest something missing, but not enough to allow us to reconstruct it or even know what there is to reconstruct.

34. Samuel Beckett, *Watt* (New York: Grove Press, 1959), 247; cf. Leslie Hill, *Beckett's Fiction in Different Words* (Cambridge: Cambridge University Press, 1990), 28: "*Watt*, as a novel, as the presence of the Addenda show, is marked in its very structure by this puzzle of failed incorporation."

35. Rosalind Krauss, "Antivision," *October* 36 (1986): 149. Krauss is referring to the work of Beckett's contemporary Georges Bataille.

36. The original is in German. I cite from Martin Esslin's translation, provided in the notes in *Disjecta*, 172. H. Porter Abbott, in his already-cited essay on Beckett as "late modernist," cites this letter as evidence of Beckett's continuing sympathy for "his modernist masters," meaning for Abbott, Proust and Joyce. But he ignores both what Beckett says in the Axel Kaun letter, taking Gertrude Stein's part against Joyce, and what that choice implied in the concrete context. Since *transition* was Joyce's most important supporter while *Finnegans Wake* was "in progress," and the same journal had "indicted" Gertrude Stein following the publication of *The Autobiography of Alice B. Toklas*, Beckett's choice provides further evidence of his rejection of *transition*'s program. As I have suggested, Beckett used the fulcrum of Lewis's aggressive antimodernist polemics and Stein's radical attack on "literary" language as a means of articulating his own late modernist stance.

37. Cathleen Culotta Andonian's 1989 bibliography of criticism, *Samuel*

Beckett: A Reference Guide (Boston: G. K. Hall, 1989), lists only one entry discussing Beckett and Stein together: a chapter in Bruce F. Kawin's book, *Telling It Again and Again: Repetition in Literature and Film* (Ithaca: Cornell University Press, 1972). That in the great industry of Beckett criticism almost nothing has been made of the Stein-Beckett connection, despite the clearly Steinian constructions in *Watt* and analogous uses of grammar and syntax in the late prose, can only testify to the immense academic attraction of the Joycean aesthetic, which legitimates the role of exegetes as the caretakers of culture, over one that calls in question the exegetical role.

38. For discussions of these hybrid styles see Marjorie Perloff, "'A Fine New Kind of Realism': Six Stein Styles in Search of a Reader," in *Poetic License: Essays on Modernist and Postmodernist Lyric* (Evanston, Ill.: Northwestern University Press, 1990), 145–159; and Perloff, "Between Verse and Prose: Beckett and the New Poetry," in *The Dance of the Intellect: Studies in the Poetry of the Pound Tradition* (Cambridge: Cambridge University Press, 1985), 135–154.

39. Sarmuel Beckett, *Murphy* (New York: Grove Press, 1957) 1. Cited in text as *Mur*.

40. Samuel Beckett, "A Wet Night," in *More Pricks Than Kicks* (New York: Grove Press, 1972), 47–84. Beckett, in fact, implies this parallel; he calls Murphy's fantasy of "embryonal repose" quoted in the previous passage his "Belacqua fantasy" (*Mur*, 78), referring both to Dante's denizen of purgatory and his own Dublin aesthete.

41. "Bim" published his memoirs in the year after Stalin's death; however, it is doubtful that the old clown needed to learn any new tricks for his new masters. Ivan Semenovich Radunskii, *Zapiski starogo klouna* (Memoirs of an Old Clown) (Moscow: Iskusstvo, 1954).

42. This account of Bim and Bom derives from *Tsirk: Malen'kaia Entsiklopediia* (Circus: A Little Encyclopedia), 2d ed., ed. I. A. Dmitriev et al. (Moscow: Press "Soviet Encyclopedia," 1979), 67; *Great Soviet Encyclopedia*, trans. of 3d ed. of *Bolshaia Sovetskaia Entsiklopediia*, ed. A. M. Prokorov (New York: Macmillan, 1973), 271; and Joel Schechter, "Bim, Bom and *The Laugh*," *Theater* (Winter/Spring 1980): 34–37.

43. See Schechter, "Bim, Bom, and *The Laugh*," for a discussion of Serafimovich's novel and a translation of *The Laugh*. The issue of *Theater* in which Schechter's article appears also includes a recording of Bim-Bom's play.

44. Deirdre Bair, *Samuel Beckett: A Biography* (New York: Harcourt Brace Jovanovich, 1978), 670, n.4.

45. Richard Aldington, *The Colonel's Daughter* [1931] (London: Hogarth Press, 1986), 351.

46. For the details of Lewis's debate with *transition*, see Dougald McMillan, *transition: The History of a Literary Era, 1927–1938* (New York: George Braziller, 1975), 204–231. See also pp.148–156, on Beckett's ambivalent relation to *transition*. Although he contributed to *transition*'s forum on Joyce's "Work in Progress," published poetry and prose works there, and signed the "Poetry Is Vertical" manifesto of 1931, he seems ultimately not to have been able to affirm Eugene Jolas's visionary poetics with any great conviction. As McMillan notes, "In their irreverent negative treatment of the interior

expression of a metaphysical longing Beckett's works are almost a parody of the search for metaphysical experience undertaken by Crane, Jolas, and many of the other *transition* writers" (152). "Almost," I believe, is too weak; Beckett explicitly parodies this search, satirizing above all the *transition* ephebe and aspiring modernist Samuel Beckett and discovering himself in self-reflexive laughter.

47. Fülöp-Miller, quoted by Lewis, "Paleface," *The Enemy* 2 (September 1927): 106–108.

48. Paul Mann has argued that this dialectical recuperation of marginal dissent is essential to the history and social functioning of the avant-garde. He writes: "In late capitalism the margin is not ostracized; it is discursively engaged. The fatality of recuperation proceeds not from any laws of nature but from dialectical engagement, the (never altogether conscious) commitment by any artist or movement to discursive exchange. The discourse of the avant-garde interests us not because it is an opportunity to promote or discredit another revolutionary romance but because it is the most fully articulated discourse of the technology of recuperation." Mann, *The Theory-Death of the Avant-Garde* (Bloomington: Indiana University Press, 1991), 15. In my view, Mann's theoretically articulate argument is already implicit in the late modernist works of Lewis and Beckett.

49. It is notable that Beckett's one enduring political engagement was with the French Resistance. He was decorated after the war for his wartime activity and until his death gave significant sums of money to a fund for Resistance veterans.

50. David Lodge, "The Language of Modernist Fiction: Metaphor and Metonymy," in *Modernism: A Guide to European Literature, 1890–1930,* ed. Malcolm Bradbury and James McFarlane (London: Penguin Books, 1976), 484.

51. In the later fiction (perhaps even with *The Unnameable,* if taken out of the name sequence) Beckett recurs to the "metaphorical" mode of titling: *How It Is, The Lost Ones,* "Imagination Dead Imagine," *Company, Worstward Ho, Ill Seen Ill Said,* and so on. This may reflect Beckett's tendency toward prose that uses "poetic" means: the increasing dominance, in Jakobson's terms, of "paradigmatic" devices like clusters of imagery and sound structure, while the "syntagmatic" dimension of the text, its narrational and other extensional structure, is progressively reduced.

52. After Murphy's death, at the inquest, the county coroner cheekily asks of Celia: "'And this young lady . . . who knew him in such detail, such opportune detail—. . . . Did Miss Kelly murmur Murphy . . . or Mr. Murphy?" (*Mur,* 268).

53. Ruby Cohn, *Samuel Beckett: The Comic Gamut* (New Brunswick, N.J.: Rutgers University Press, 1962), 53.

54. Beckett gives another faint echo of this pun in his portrayal of Neary, driven to distraction by Miss Counihan's rebuff of his attentions. Rescued by his former student Wylie at the Dublin Post Office, Neary is described as having "rocked blissfully on the right arm of his rescuer" (*Mur,* 43).

55. Bair, *Samuel Beckett,* 303. Bair cites a letter to George Reavey of 26 September 1939 as evidence.

56. Discussing the Beckett-Giacometti parallel (but of limited critical value) are Matti Megged, "Beckett and Giacometti," *Partisan Review* 49, no. 3

(1982): 400–406, and Megged, *Dialogue in the Void: Beckett and Giacometti* (New York: Lumen Books, 1985).

57. Rosalind Krauss, "No More Play," in *The Originality of the Avant-Garde and Other Modernist Myths* (Cambridge, Mass.: MIT Press, 1985), 57–58.

58. Krauss, "No More Play," 62.

59. During the twenties and early thirties, Roussel was the subject of articles by Philippe Soupault, Roger Vitrac, Salvador Dali, André Breton, and Michel Leiris; for English translations of all but Leiris's articles (included is another article by Leiris from 1954, but not two others from 1935 and 1936), see *Raymond Roussel: Life, Death and Works* (Atlas Anthology, no. 4) (London: Atlas Press, 1987). Translations from Roussel also appeared in *transition*. It would be surprising, then, if Beckett, actively reading and translating the French literary avant-garde, were not aware of Roussel's work.

60. Raymond Roussel, *How I Wrote Certain of My Books,* trans. Trevor Winkfield (New York: Sun, 1975), 5.

61. Michel Foucault, *Death and the Labyrinth: The World of Raymond Roussel,* trans. Charles Ruas (Garden City, N.Y.: Doubleday, 1986), 26.

62. See, for example, how the hospital in *Murphy,* the Magdalen Mental Mercyseat, becomes associated with Celia's "mercyseat," Murphy's sexual relief, through linguistic association. Thus, Celia the prostitute is recalled by (Mary) Magdalen; furthermore, Murphy's (or the narrator's) euphemism for sexual intercourse, "music," is conjured up by the initials M.M.M., like a moan of satisfaction (mmm . . .), and in turn self-consciously referred to the typographical conventions of the printed book (note, too, the intentionally faulty grammar of the sentence, eliding its actual subject, Murphy): "Late that afternoon, after many fruitless hours in the chair, it would be just about the time Celia was telling her story, M.M.M. stood suddenly for music, MUSIC, **MUSIC,** in brilliant, brevier and canon, or some such typographical scream, if the gentle compositor would be so friendly" (*Mur,* 236).

63. Beckett, *More Pricks Than Kicks,* 38.

64. Beckett, *Watt,* 164.

Chapter 6

1. Mina Loy, *Insel,* ed. Elizabeth Arnold (Santa Rosa: Black Sparrow Press, 1991), 103.

2. For the biographical background to Loy's composition of *Insel,* see Carolyn Burke, *Becoming Modern: The Life of Mina Loy* (Berkeley: University of California Press, 1996), 359–384.

3. Mina Loy, *The Last Lunar Baedeker,* ed. Roger Conover (Highlands, N.C.: Jargon, 1982), 311.

4. William Carlos Williams, *The Autobiography of William Carlos Williams* (New York: New Directions, 1948 / 1949 / 1951), 319.

5. Beckett to MacGreevy, 20 December 1931, quoted in James Knowlson, *Damned to Fame: The Life of Samuel Beckett* (New York: Simon & Schuster, 1996), 142.

6. Hugh Ford, *Published in Paris: American and British Writers, Printers, and Publishers in Paris, 1920–1939* (Yonkers, N.Y.: Pushcart, 1975), 365–366.

7. Herbert Marcuse, *Der deutsche Künstlerroman,* in *Schriften* I (Frankfurt am Main: Suhrkamp, 1978), 17–18. My translation.

8. See alsoTheodor W. Adorno, "Jene zwanziger Jahre," in *Kulturkritik und Gesellschaft* II (*Gesammelte Schriften* 10/2) (Frankfurt am Main: Suhrkamp Verlag, 1977), 504–505: "With distance it can be observed that many artists, whose nimbus is equated with that of the twenties, had in that decade already passed their zenith; Kandinsky, probably also Picasso, Schönberg, even Klee. As unquestionably as Schönberg's twelve-tone technique emerged as the fully logical outcome of his own achievements . . . just so unquestionably is something of the best lost upon the shift to systematic principles." My translation.

9. Loy, quoted in *Last Lunar Baedeker,* lxxv.

10. Benjamin's essay appears in two versions in his *Gesammelte Schriften* I, ed. Rolf Tiedemann and Hermann Schweppenhäuser (Frankfurt am Main: Suhrkamp, 1974), 431–469, 471–508. It appears in English translation as "The Work of Art in the Age of Mechanical Reproduction," in *Illuminations,* ed. Hannah Arendt, trans. Harry Zohn (New York: Schocken Books, 1968), 217–251.

11. E. M. Forster, "Liberty in England," in *Abinger Harvest* (London: Edward Arnold & Co., 1936), 67.

12. Peggy Guggenheim, *Out of this Century: Confessions of an Art Addict* (New York: Universe Books, 1979), 67. See also the colorful account of the lamp shade business in Jacqueline Bograd Weld, *Peggy: The Wayward Guggenheim* (New York: E. P. Dutton, 1986), chap. 11; Laurence Tacou-Rumney, *Peggy Guggenheim: A Collector's Album* (Paris: Flammarion, 1996), 58–59.

13. Mina Loy, *The Lost Lunar Baedeker,* ed. Roger L. Conover (New York: Farrar, Straus & Giroux, 1996), 151.

14. For the connection between mass culture and femininity in Weimar Germany, see the 1927 article by Siegfried Kracauer, "Die kleinen Ladenmädchen gehen ins Kino" ("The Little Shopgirls Go to the Movies") and "Das Ornament der Masse" ("The Mass Ornament"), in *Das Ornament der Masse* (Frankfurt am Main: Suhrkamp, 1963); English translation in Kracauer, *The Mass Ornament: Weimar Essays,* ed. and trans. Thomas Y. Levin (Cambridge: Cambridge University Press, 1995). See also Sabine Hake, "Girls and Crisis: The Other Side of Diversion," *New German Critique* 40 (1987): 147–164, and Patrice Petro's book-length study, *Joyless Streets: Women and Melodramatic Representation in Weimar Germany* (Princeton: Princeton University Press, 1989), esp. chap. 4, "Weimar Cinema and the Female Spectator."

15. Roger Caillois, "La Mante Religieuse," *Minotaure* 5 (1934): 23–26, and "Mimétisme et Psychasthénie Légendaire," *Minotaure* 7 (1935): 4–10.

Index

Compositor, Printer, and Binder: Braun-Brumfield, Inc.
Text: 10/13 Galliard
Display: Galliard